# ART HISTORY AND ITS INSTITUTIONS

What is art history? The answer depends on who asks the question. Museum staff, academics, art critics, collectors, dealers and artists themselves all stake competing claims to the aims, methods, and history of art history. Dependent on and sustained by different – and often competing – institutions, art history remains a multi-faceted field of study.

*Art History and Its Institutions* focuses on the professional and institutional formation of art history, showing how the discourses that shaped its creation continue to define the field today. Grouped into three sections, articles examine the sites where art history is taught and studied, the role of institutions in conferring legitimacy, the relationship between modernism and art history, and the systems that define and control it. From museums and universities to law courts and photography studios, the contributors explore a range of different institutions, revealing the complexity of their interaction and their impact on the discipline of art history.

*Contributors*: Frederick N. Bohrer, Kathryn Brush, David Carrier, Claire Farago, Ivan Gaskell, Marc Gotlieb, Helen Rees Leahy, Elizabeth Mansfield, Andrew McClellan, Mary G. Morton, Steven Nelson, Donald Preziosi, Eric Rosenberg, Catherine M. Soussloff, Christopher B. Steiner, Jacqueline Strecker, Greg M. Thomas, Philip Hotchkiss Walsh, Gabriel P. Weisberg.

**Elizabeth Mansfield** is Associate Professor of Art History at the University of the South, Sewanee, USA.

# ART HISTORY AND ITS INSTITUTIONS

## Foundations of a discipline

*Edited by Elizabeth Mansfield*

London and New York

First published 2002
by Routledge
11 New Fetter Lane, London EC4P 4EE

Simultaneously published in the USA and Canada
by Routledge
29 West 35th Street, New York, NY 10001

*Routledge is an imprint of the Taylor & Francis Group*

Typeset in Galliard by Taylor & Francis Books Ltd
Printed and bound in Great Britain by TJ International Ltd, Padstow, Cornwall

*British Library Cataloguing in Publication Data*
A catalogue record for this book is available from the British Library

*Library of Congress Cataloguing in Publication Data*
A catalog record for this book has been requested

ISBN 0–415–22868–9 (hbk)
ISBN 0–415–22869–7 (pbk)

# CONTENTS

CONTENTS

# ILLUSTRATIONS

# NOTES ON CONTRIBUTORS

**Frederick N. Bohrer** is Associate Professor and Department Co-chair at Hood College, where he teaches courses on the history of art, art historical methods, and museum studies. His book, *Orientalism and Visual Culture: Imagining Mesopotamia in Nineteenth-Century Europe*, is forthcoming.

**Kathryn Brush**, Associate Professor at the University of Western Ontario, has published widely in the fields of medieval art and art historiography. Her publications include *The Shaping of Art History: Wilhelm Voge, Adolph Goldschmidt, and the Study of Medieval Art* (1996).

**David Carrier**, Champney Family Professor, Case Western Reserve University/Cleveland Institute of Art, writes art criticism. His *Writing about Art, Museums, Art Galleries and Aesthetic Theory* is forthcoming.

**Claire Farago** is currently Professor at the University of Colorado-Boulder, where she teaches Renaissance art, historiography, and critical theory. Her publications include *Leonardo da Vinci's Paragone* (1992), *Reframing the Renaissance* (1995), and *Suffering History: Art, Identity, and the Ethics of Scholarship in New Mexico* (forthcoming).

**Ivan Gaskell** is Winthrop Curator, Fogg Art Museum, Harvard University. His scholarly contributions include *Vermeer's Wager: Speculations on Art History, Theory, and Art Museums* (2000) as well as six volumes in the series "Cambridge Studies in Philosophy and the Arts," edited with Salim Kemal.

**Marc Gotlieb**, Associate Professor at the University of Toronto, is currently researching teacher–student conflicts in the nineteenth century. His publications include *The Plight of Emulation: Ernest Meissonier and French Salon Painting* (1996).

**Helen Rees Leahy** is Director of the Masters Programme in Art Gallery and Museum Studies in the School of Art History and Archaeology, University of Manchester. She also works as an independent curator and museums consultant.

**Elizabeth Mansfield** teaches courses on post-Renaissance Western art and art historiography at the University of the South, Sewanee, where she is presently Associate Professor. She has published articles on nineteenth-century art history and historiography.

**Andrew McClellan** is Professor and Chair of Art History at Tufts University. He is author of *Inventing the Louvre: Art, Politics, and the Origins of the Modern Museum in Eighteenth-Century Paris* (1994) and is currently writing a book on contemporary museum issues.

**Mary G. Morton** is Associate Curator at the Museum of Fine Arts, Houston. Her areas of specialization include nineteenth-century European art, art history, and academic practice. Her doctoral dissertation addressed the implications of Hippolyte Taine's writings for art history.

**Steven Nelson**, an editor for *African Arts* and reviews editor for *Art Journal*, is Assistant Professor of Art History at UCLA. He is also the author of a forthcoming book concerning the indigenous significance and Western reception of Mousgoum architecture.

**Donald Preziosi** is Professor of Art History at UCLA, and a Research Associate in Art History and Visual Culture at Oxford. He is the author of eleven books, including *Rethinking Art History*, *The Art of Art History*, and the forthcoming *Brain of the Earth's Body*, his 2001 Slade Lectures at Oxford.

**Eric Rosenberg** teaches American art history at Tufts University, where he is Associate Professor in the Department of Art and Art History. He has published articles on Albert Pinkham Ryder, Thomas Eakins, and other aspects of modern American painting.

**Catherine M. Soussloff** directs the Graduate Program in Visual and Cultural Studies at the University of Rochester. A recent Getty Scholar and Clark Fellow, she authored *The Absolute Artist: The Historiography of a Concept* (1997) and edited the collection *Jewish Identity in Modern Art History* (1999).

**Christopher B. Steiner** is Lucy C. McDannel '22 Associate Professor and Chair of Art History and Director of Museum Studies at Connecticut College. He is the author of *African Art in Transit* (1994) and most recently edited with Ruth Phillips a collection of essays entitled *Unpacking Culture: Art and Commodity in Colonial and Postcolonial Worlds* (1999).

**Jacqueline Strecker**, Senior Curator of Art at the Australian War Memorial, has published and lectured widely on nineteenth and early twentieth century Australian and European art. In 1997 she was the Coordinating Curator of the Rembrandt exhibition at the National Gallery of Victoria.

**Greg M. Thomas** is Assocate Professor at the University of Hong Kong. His research interests include the visual representation of childhood in France and nineteenth-century colonial interactions. His *Art and Ecology in Nineteenth-Century France* was published in 2000.

**Philip Hotchkiss Walsh**, Assistant Professor at Northeastern University, writes on nineteenth-century French art and academic practices. He is presently completing a book-length study of the studio and teaching practices of Gustave Moreau.

**Gabriel P. Weisberg** is Professor of Art History at the University of Minnesota. Recent publications include *Beyond Impressionism: The Naturalist Impulse* (1992) and *Overcoming All Obstacles: The Women of the Academie Julian* (1999). He lately edited the anthology *Montmartre and the Making of Mass Culture* (2001).

# INTRODUCTION

*Elizabeth Mansfield*

Art history possesses its own mythology. Like all social organizations, an intellectual discipline coheres around a community with a shared history, a common language, and seemingly similar beliefs and goals. Fundamental to any social organization is a myth of its origins. Art history, as practiced and theorized in the West, enjoys a particularly active etiological impulse. Perhaps in an effort to minimize differences within the various endeavors described as "Art History," historiographers of the discipline are keen to assert and reassert our common intellectual heritage. We have an abundance of fathers. Among the most frequently cited are Giorgio Vasari (often called "the father of art history"); J.J. Winckelmann (busier than Vasari, he is known as "the father of archaeology" as well as "the father of modern art history"); Georg Hegel (Gombrich's "father of art history"); and recently Bernard Smith has been given the appellation "father of art history in Australia." An orphan discipline, apparently, art history goes motherless.

Genealogy, or rather biography, remains the preferred genre for art historiography. This is not surprising given that art history has long relied upon a biographical model for scholarly as well as popular discussion. That art historiography should similarly privilege the monographic approach testifies to the degree to which the discipline has naturalized and internalized its intellectual conventions. The recent proliferation of book-length studies devoted to the lives and writings of Vasari, Winckelmann, Karel van Mander, Giovanni Bellori, Aloïs Riegl, Bernard Berenson, Aby Warburg, Ernst Gombrich, Erwin Panofsky, and Michael Fried among others points to the predominance of the biographical approach for historiographers.

Hagiography may contribute to a discipline's mythic constitution, but it cannot fulfill the requirements of historiography. Mythology comes from within a culture, defining that culture according to its own terms and values. Historiography, on the other hand, must decipher, analyze, and interpret rather than mythologize a disciplinary culture. This involves examining the culture from within as well as without. Ideally, the historiographer maintains a critical position at once inside and outside a discipline. But this diffuse self-positioning cannot take place independently of institutional critique. As both products and

producers of culture (including intellectual and professional cultures), institutions often determine a discipline's center and periphery as well as its frontiers and wastelands. Institutional history, then, necessitates an ontological critique of a discipline insofar as it involves scrutiny from points within and without its presumed intellectual, cultural, idiomatic, epistemological, and professional borders.

This volume seeks to understand the history as well as the culture of art history through its institutions. Fundamentally, institutions are organizing principles. Cultures – whether intellectual, political, religious, ethnic, or regional – depend upon institutions to amass, distill, unify, and circulate their beliefs and conventions. In this way, institutions promulgate myth as they provide communal stability, history, and identity. Institutions may take physical form as a temple or schoolhouse or judicial chamber. But institutions may remain intangible as organizing principles such as customs or beliefs. The institutions of art history, then, are diverse. Ranging from material sites and organizations to jargon, professional ethics, pedagogy, codes of conduct, civil laws and moral canons, various institutions formed and continue to influence the discipline.

The discipline's institutional origins can be traced largely to the nineteenth century. Though the practice of art history dates back at least as far as the fifteenth century, its formation as a distinct professional or academic discipline took place centuries later. Nineteenth-century Western society sustained precisely the conditions necessary for the discipline's florescence. Characterized by industrial expansion and empire building as well as new forms of cultural and educational enfranchisement, the period offered firm purchase to a discipline with uncertain holds in commercial as well as cultural concerns. Art history found itself welcome in new institutions for urban leisure, commerce, science, public education, and national pageantry. The appearance of these institutions cannot, of course, be neatly bracketed by the years 1800 and 1900. Many developments associated with the nineteenth century – political and economic along with moral and aesthetic – percolate through adjacent eras. For this reason, the chapters written for this volume necessarily delineate an institutional history distinguished less by its chronology than its social and cultural character. With its *terminus a quo* marked by Enlightenment formulations of an ideal museum and its *terminus ad quem* designated by the vagaries of modern academic publishing, this volume affirms both the expediency and impossibility of periodizing art history's institutional origins.

Art history has a vexed institutional history. Myriad – and often competing – institutional forces combined to forge art history into a professional discipline during the nineteenth century. Museums, galleries, auction houses, publishers, cultural trusts, universities and academies, in addition to institutions such as magic lantern shows, department stores, and world fairs, left their imprint on the nascent discipline. The diverse activities now collectively termed art history are a direct consequence of these motley origins. Innately heterogeneous, the discipline has undoubtedly benefited from its rich institutional heritage. But

without a critical consciousness of this history, methodological or even practical differences can appear to be marks of a discipline "in crisis" rather than an inherently multifaceted field of inquiry. One way in which art history appears fragmented rather than multiform is the tendency of art historians to ally themselves along professional rather than philosophic lines. Institutional loyalties, in other words, often precede disciplinary interests. Museum professionals, for example, occasionally find themselves circumscribed in opposition to academics. For their part, academics come under fire for pursuing research methods deemed "irrelevant" or too theoretical. Art historians affiliated with a gallery or auction house, on the other hand, may be distinguished from their non-profit counterparts as motivated by commercial rather than other, more high minded concerns. At these moments, art historians find themselves concomitantly inside and outside their discipline. The present tendency for professional affiliations to rent or redefine the discipline makes essential an inquest into art history's institutional origins.

The institutions addressed in this volume, therefore, constitute an inevitably fluid definition of the concept. In its most general sense, an institution is simply that which institutes, or brings into being. Reechoing its liturgical as well as legal origins, the term suggests effects both evanescent and concrete, personal and social. Expanding on this definition, some recent theorists have characterized institutions as loci of social, or specifically political, power. Not surprisingly, Marxist and materialist thinkers have directed a great deal of attention to this notion of institutional behavior and discourse. In contrast to a pragmatic perception of institutions as uninflected social tools, Marxist-generated inquiries posit institutions as founts or conduits of ideology. As such, they provide essential means for social control. Louis Althusser offers a useful Marxist exploration of the functioning of institutions in his chapter "Ideology and Ideological State Apparatuses." Here, Althusser defines a class of institutions that are shaped by the very ideologies they propagate. These he calls Ideological State Apparatuses. A conduit for belief systems, Ideological State Apparatuses both receive and transmit ideologies. Althusser explains:

> I shall call Ideological State Apparatuses a certain number of realities which present themselves to the immediate observer in the form of distinct and specialized institutions ... Ideological State Apparatuses are part ... of the private domain [as in] Churches, Parties, cultural ventures, etc. etc., ... it is essential to say that for their part the Ideological State Apparatuses function massively and predominantly *by ideology*, but they also function secondarily by repression, even if ultimately, but only ultimately, this is very attenuated and concealed, even symbolic.[1]

Institutions, in this sense, cannot be considered apart from a culture's need to sustain its social beliefs and political system.

Other recent institutional theories classed broadly as poststructuralist offer a more diffuse understanding of institutions. Not simply sources of power or ideology, institutions are folded into discourse. Michel Foucault exemplifies this position when he writes:

> ... basically in any society, there are manifold relations of power which permeate, characterize and constitute the social body, and these relations of power cannot themselves be established, consolidated nor implemented without the production, accumulation, circulation and functioning of a discourse. There can be no possible exercise of power without a certain economy of discourses of truth which operates through and on the basis of this association.[2]

Expansively conceived and securely intertwined, discourses are systems of social networks. Discourse includes physical manifestations of a culture such as libraries or prisons as well as ephemeral vehicles like speech acts or gestures or scholarly publications. Power – or, in the case of an intellectual discipline, authority – is brought forth, organized, expressed, and ultimately made material by discourse.

The institutional models outlined above underlie the volume's tripartite organization. Part I, "Putting Art History in Its Place," includes chapters that address the establishment of literal sites or contexts for art historical practice. This section begins with my chapter on "Art History and Modernism," which traces the institutional origins of art history through an archaeological approach based on Walter Benjamin's incomplete *Arcades Project* (*Passagenwerk*). Benjamin's method encourages historiographers to explore the middens of cultural history as well as its tumuli. For art historiographers, this means finding the discipline's abandoned campsites as well as its fortified settlements like museums or academies. Among the sites I explore in my search for art history's institutional origins are Paris's first department stores, the scene of Poe's "Murders in the Rue Morgue," the Uffizi Gallery, and the fantastical Fonthill Abbey. Donald Preziosi pursues another notion of art history as place with his contribution "Hearing the Unsaid: Art History, Museology, and the Composition of the Self." Here, the discipline manifests itself in the West theologically and ritually via the museum. Preziosi traces in museum practice a dual history. One thread of this twin strand leads back to the Idealist traditions of the Enlightenment exemplified by Sir John Soane's house-museum. The other carries the expectations of early capitalism and nationalism and is illustrated by the 1851 Universal Exposition. This ambivalent institutional history, according to Preziosi, has given rise to a discipline with inherently conflicting beliefs and ambitions.

The museum's role in creating a form of secular theology is further analyzed by Andrew McClellan. His chapter "From Boullée to Bilbao: The Museum as Utopian Space" challenges recent critiques of the museum. The tendency to demonize the art museum as an oppressive agent of nationalism, cultural bias,

or aesthetic imperialism encounters here sharp refutation. McClellan rehabilitates the museum – and the mission of art history – through an analysis of the utopian architectural and verbal rhetoric that often suffuses museum building projects. Kathryn Brush, in "Marburg, Harvard, and Purpose-built Architecture for Art History, 1927," explores and affirms the ties between art history's intellectual, material, and social impetuses. Through her exemplary case studies – one German, one American – Brush shows how art history becomes architecture. Next, Philip Hotchkiss Walsh traces the establishment of art history at the embattled École des Beaux-Arts, revealing the roles played by scientific debate, political reform, and student activism. "Viollet-le-Duc and Taine at the École des Beaux-Arts" treats Viollet's humiliating retreat from his jeering students and Taine's triumphant ascent to the lectern as products of social as much as aesthetic concerns. This section concludes with Jacqueline Strecker's "Colonizing Culture: The Origins of Art History in Australia." In this chapter, art history's professional and academic presence in Australia is seen as a product of various colonial and post-colonial institutions. Strecker's account accommodates institutions as diverse as religious organizations, Mechanics' Institutes, and universal exhibitions in addition to galleries, academies, universities, and museums.

Part II, "Instituting a Canon: Placing the Center and Margins of Art History," concerns the role of institutions in establishing and transmitting disciplinary orthodoxy, authority, or heresy. Here the reader will find chapters dealing with institutional effects upon canon formation, scholarly legitimacy, professional success, or disciplinary resistance. The arguments presented in this section are introduced by David Carrier's "Deep Innovation and Mere Eccentricity: Six Case Studies of Innovation in Art History." Through a series of compelling case studies, Carrier shows how institutional discourse has – and continues to – set the boundaries of the discipline. Conferring "insider" status upon those scholars and texts that accede to disciplinary conventions, art history's institutions also determine what is outside the scope of serious scholarly consideration. And, as Carrier reveals, the conditions that dictate "outsider" status can range from faulty argumentation or methodological novelty to the vagaries of market forces on book publishers or journal editors.

Succeeding chapters in this section offer directed inquiries into questions raised by Carrier. Christopher B. Steiner and Ivan Gaskell invite further reorientation of the discipline's professional assumptions and standards through their analyses of the impact of art dealers and collectors on art history. Steiner's "The Taste of Angels in the Art of Darkness: Fashioning the Canon of African Art" shows how dilettantes and collectors have physically and ideologically defined African art history. African art history has long been skewed, narrowly or capriciously defined, according to Steiner, due to amateur collectors' limited and often romantic conception of African culture. Challenging long-standing attitudes toward "the trade," Ivan Gaskell reminds us that the art market remains one of art history's most enduring – and most infuential – institutions. Often marginalized by the discipline for their overt commercial concerns, dealers and

5

galleries serve as reminders that art history is a discipline – no matter where or how practiced – that remains linked inescapably to objects with market value (indeed, a market value that fluctuates in response to even the most rarified disciplinary activities). This actuality often leads to anxiety among art historians who believe their professional endeavor transcends material concerns, appealing instead to aesthetic, philosophic, or even moral concerns. And this anxiety propels the discipline's undervaluation of "the trade."

Shifting next to a discussion of the relationship between canon formation and art historical method is Marc Gotlieb's contribution "How Canons Disappear: The Case of Henri Regnault." In this chapter, Gotlieb evaluates the inconstancy and significance of Henri Regnault's critical reception from the time of his death in 1871 to the present day. The institutional and other forces that managed Regnault's apotheosis after his death in the Franco-Prussian War were, by the mid-twentieth century, pushed aside by shifting political as well as aesthetic alliances within the discipline. Gabriel P. Weisberg, in his chapter "Using Art History: The Louvre and Its Public Persona, 1848–52," likewise turns to France and the intersection of politics and art history in his chapter on the ideological re-formation of the Louvre during the Second Republic. Tracing the transformation of the museum under the direction of the ardently republican Philippe-Auguste Jeanron, Weisberg shows how cultural institutions were brought into the service of a new social order, an effort largely suspended after the *coup d'état* that delivered to Napoleon III his imperial throne. Claire Farago's "Silent Moves: On Excluding the Ethnographic Subject from the Discourse of Art History" finds art history's most insidious institutional influences to be the Protestant and Catholic Reformations, European imperialism, as well as the disciplines of anthropology and ethnology. Looking at Aby Warburg's legacy through the lens of Jean de Léry's sixteenth-century representations of New World cultures, Farago confronts the tendency of art historians to ignore or, worse, willfully misunderstand the anthropological or ethnographic origins and consequences of their methods. Mary G. Morton's analysis of Hippolyte Taine's art historical career provides a revealing example of the facility with which institutions confer, in Carrier's terms, insider or outsider status. In "Art History on the Academic Fringe: Taine's Philosphy of Art" Morton traces a career remarkable for its institutional resilience. Prior to his 1864 appointment as professor of art history at the École des Beaux-Arts, Taine made his name and reputation on the academic fringe. Because of his politically unpopular views, the first influential decade of Taine's career developed outside conventional institutional boundaries. Morton argues that this situation finds its rhetorical echo in Taine's art historical method.

The final section of this volume, "The Practice of Art History: Discourse and Method as Institution," features chapters that apply an institutional critique to the language, habits, and conventions of art history. In contrast to the material institutions examined in Part I, the chapters gathered here take their cue from Foucault's concept of an institution as part of a complex weave of material and

ephemeral signs that he terms discourse. Publishers, journals, newspapers, and other forums for scholarly exchange and disciplinary identity remain immeasurably powerful – and often invisible – institutions. Part III begins with Helen Rees Leahy's "'For Connoisseurs': *The Burlington Magazine* 1903–11." Rees Leahy's account of the foundation and fractious early years of the *Burlington* outlines the journal's growth as an institution. In addition, Rees Leahy makes clear the *Burlington*'s role in shaping other British arts institutions such as the National Gallery, the Royal Academy, and the Chantrey Bequest. Turning to another vehicle through which art history established its institutional character, Frederick N. Bohrer examines the influences of photography on the discipline. "Photographic Perspectives: Photography and the Institutional Formation of Art History" takes as its starting point the assertion that no other form of technology has influenced art history's institutional character as profoundly as photography. Every form of art historical practice remains indebted to the intervention of photography: research, pedagogy, exhibition, preservation and conservation as well as acquisition and sales.

The four chapters that bring Part III, and the volume, to its conclusion discuss the methods and language of art history as discursive institutions. In "Instituting Genius: The Formation of Biographical Art History in France," Greg M. Thomas presents a compelling, multilayered exploration of the interdependencies among art history publications, disciplinary methods, canon formation, political ideologies, and professional aspirations. Thomas posits the "naturalist biography" as a model derived from mid-nineteenth-century political as well as methodological concerns. Arguing that artists' biographies served a variety of art history's institutional interests, Thomas concludes with a provocative commentary on the significance of myth for history and historiography.

Eric Rosenberg's "A Preponderance of Practical Problems: The History of Art in the United States between 1886 and 1888" refocuses our attention on North America. Here, Rosenberg offers a close reading of the language of art history and criticism as it appeared in American journals between 1886 and 1888. Through a lens that converges social history and deconstruction, Rosenberg reveals the rhetorical consequences of art history's professionalization in the United States in the late nineteenth century. The uneven and contested institutional status of American art history is exposed in Steven Nelson's analysis of Freeman Murray's *Emancipation and the Freed in American Sculpture: A Study in Interpretation*, one of the earliest attempts to theorize as well as produce African-American art history. Nelson demonstrates how institutional influences as diverse as the Emancipation Proclamation, the American Negro Academy, the Declaration of Independence, the Civil War, and the conventions of nineteenth-century American art history served to propel as well as undermine Murray's project. Catherine M. Soussloff finds in turn-of-the-century photographic criticism a crucial moment in art history's institutional development. At once forming and formed by Art Photography, institutionalized art history divulges its assumptions and limitations as well as its ambitions

in its resolution of photography's aesthetic claims. Art Photography's engagement with scientific, social, and philosophic concerns mirrors art history's own ambiguous disciplinary status at the time. For this reason, Soussloff posits the discourse around Art Photography as a particularly apt vehicle for inquiries into art history's institutional history in Europe as well as North America.

The organization of *Art History and Its Institutions* will highlight points of intersection as well as divergence while aiding the reader's navigation of the issues presented. This may diminish the need for textual orienteering, but the path laid out by no means offers the only or even best route. Readers undoubtedly will encounter numerous unmarked intersections.

## NOTES

1  L. Althusser, "Ideology and Ideological State Apparatuses (Notes towards an Investigation)," in *Lenin and Philosophy and Other Essays*, New York, Monthly Review Press, 1971 [essay orig. pub. 1969], pp. 143–5.
2  M. Foucault, "Two Lectures," trans. A. Fontana and P. Pasquino, in C. Gordon, ed., *Power/Knowledge: Selected Interviews and Other Writings, 1972–1977*, New York, Pantheon, 1980, p. 93.

# Part I

# PUTTING ART HISTORY
# IN ITS PLACE

# 1

# ART HISTORY AND MODERNISM

## Elizabeth Mansfield

Art history stands apart from other humanistic disciplines. Galvanized into a professional, academic field during the nineteenth century, the discipline took shape in response to distinct and often novel institutional pressures. Humanistic inquiry in the West had, until the appearance of art history, largely traced its methods and goals to classical or medieval models. The fields of history, literature, and philosophy, for example, inherited institutional traditions and legitimacy from the academies of ancient Greece and the universities fostered by Scholasticism. Art history does not share this genealogy. Though its academic practices resemble those of the traditional humanities, art history maintains a distinctive disciplinary character. In practice, art history combines the authenticating and valuating mission of the connoisseur, the hagiographic indulgences of the biographer, the cataloguing impulse of the botanist, the alternately reflective and reflexive tendencies of the historian, and the philosopher's willingness to calibrate aesthetic transcendence. During the nineteenth century, these ambitious and contradictory pursuits were conjoined – by no means seamlessly – to form a new profession. Confidently secular, apologetically commercial, and ambivalently poised between scientific and philosophic aims, art history is a liberal discipline born of modernism.

Art history's unusual status complicates its institutional history. The institutions most often associated with art history's professionalization are the museum and the academy. Indeed, one could convincingly argue that the vocational history of art history begins with Jean-Dominique Vivant Denon's appointment as director of the Musée Napoléon in 1803 or Gustav Waagen's 1844 installation as professor of art history at the University of Berlin. As the most prominent and plentiful employers of professional art historians in the nineteenth century as today, the museum and the academy enjoy a justifiably high profile in histories of the discipline. They are not, however, the only institutions to guide art history's disciplinary formation. A much broader institutional history informs the field.

At this point, I wish to clarify my understanding of institutional history. By "institution," I refer generally to any organization or matrix capable of the sustained production and dissemination of social beliefs or customs.

Institutions, in this sense, may or may not manifest themselves as physical sites of social exchange. They must, however, function as vehicles for social discourse long enough to be able to claim an internal tradition or history.[1] Whether as tangible as a Catholic cathedral or as evanescent as technical jargon, institutional discourse helps to shape our perceptions of reality. Institutional history, then, involves the study of the development of these ideologically responsive organizations as well as their effects.

One of the main challenges facing a historiographer concerned with institutional practices is the opacity of institutional discourse. At most points embedded imperceptibly into social discourse, discrete moments of institutional pressure often remain below the radar of historiographic scrutiny. Louis Althusser has, perhaps most trenchantly, shown how modern institutions can both disguise and reveal the elusive and falsifying effect of ideology.[2] Multifarious in its relationship to ideology, institutional discourse participates in its reception, manipulation, and dissemination. Cultural institutions serve as capacitors of ideology, distorting and disguising their relation to social practice. We may, however, detect traces of their influence in our work. By treating our texts, methods, and policies as the realization of our institutional history, we begin to discern its effects. For example, the stories we write about art may in fact be read as myths insofar as they carry reassuring references to our disciplinary purpose and history. In particular, those stories that manage to absorb and sustain our scholarly attention may yield most readily to interpretation as myth.

Among the most persistent stories to arise in recent art historical scholarship concerns the history and significance of modernism. Hundreds of exhibitions, books, articles, and symposia have addressed this subject in the past decade. This scholarly preoccupation demands historiographic scrutiny. Undoubtedly, art historians find in modernism an intriguingly complex history as well as an interpretive challenge. What scholars who pursue this challenge generally fail to acknowledge is its inherent self-reflexivity. The history of modernism circumscribes the history of art history. Equally responsive to post-Enlightenment aesthetic and cultural debates, to the economic and social revolutions of the nineteenth century, and to the entrenchment of these once radical challenges, modernism and art history have followed parallel courses. Any exploration of modernism, then, produces a historiographic echo. Quietly resonating, this historiographic pulse somehow fails to captivate our scholarly attention.

\*\*\*

> The aim of art history, then, is to define the role of art, a role which has already been played out.
> Hans Belting, *The End of the History of Art?*

The concomitant maturation and, some would argue, disintegration of art history and modernism has been observed most pointedly by Hans Belting. In *The End of the History of Art?* (1987), Belting implies but does not pursue a

12

historical evaluation of art history's institutional relationship to modernism.[3] A possible model for such an inquiry may, however, be gleaned from T.J. Clark's *Farewell to an Idea: Episodes from a History of Modernism* (1999). In this summa, Clark proposes a history of modern art belayed to a history of socialism. Though adamantly unhistoriographic, Clark's book does offer a motive of discursive "codependency" that invites historiographic application. Initially lamenting that "clearly something of socialism and modernism has died," he then wonders: "If they died together, does that mean that in some sense they lived together, in century-long co-dependency?"[4] I find embedded in Clark's question its historiographic corollary: in what sense is the history of modernism the history of art history?

Before broaching the question of art history's relationship to modernism, a brief characterization of the latter is required. The recent explosion of publications attempting to chart modernism's fractious history indicates both an urgent desire to define modernism and a perception that this task remains incomplete. Modernism's unsettled relationship to scholarly discourse is, of course, fundamental to its nature. Rooted in the Industrial Revolution, modernism was forged in the repeated collisions between antithetical philosophical and political traditions.[5] Philosophically, modernism grows out of the positivist as well as the idealist traditions articulated in the eighteenth century and codified in the nineteenth. Politically, modernism's unstable alloy includes bases of mercantile capitalism as well as utopian socialism. Modernism, then, is a condition of tension, instability and, ultimately, irresolution. What is more, modernism participates in an unfulfilled dialectic. By this I mean to say that modernism exhibits a seemingly dialectical reliance upon antithetical impulses as well as a potential for synthetic resolution/revolution. This is the character ascribed to modernity by Clark.

Despite the teleological underpinnings of Clark's definition of modernity, it does provide a practical armature for an inquiry into modernism's relationship to art history. According to Clark, modernism is the cultural consequence of modernity, a social shift in which "the pursuit of a projected future – of goods, pleasures, freedoms, forms of control over nature, or infinities of information" supersedes dependence upon tradition, ritual, and "ancestor worship."[6] The political and aesthetic potentiality that Clark ascribes to modernity reveals itself most forcefully in the visual arts. Manifested first in Jacques-Louis David's *Death of Marat* (1793), modernist art makes its final appearance in American Abstract Expressionism of the 1950s. I agree with Clark's description of the relationship between modernism and modernity as well as his assertion that the latter is a largely nineteenth-century phenomenon bracketed by moments of intense political and cultural self-awareness in the eighteenth and twentieth centuries. I do not, however, share his optimistically Marxist faith that modernism carries a promise of resolution/revolution of class conflict. Modernism could never participate in a radical social realignment because modernism depends upon *irresolution*. To return to the Hephaestian metaphor, modernism is the hammer blow, not the resulting amalgam.

13

I wish to ascribe a similar condition to art history. Arising from conflicting epistemological positions, art history is unmistakably modern in its origins.[7] Evidence of its discordant nascence remains embedded in cultural institutions formed during the period of art history's methodological and professional standardization. The art museum provides a concrete example of the condition I describe. Few art museums existed prior to the nineteenth century because the social conditions required for their proliferation were not yet established.[8] Museums are profoundly modern institutions because they attempt to reconcile both a positive and intuitive impulse. The fundamental mission of the art museum – to collect, preserve, and exhibit works of art – testifies to its modernist roots. On the one hand, the museum defines art objects as quantifiable: they can be gathered, classified, and displayed like so many zoological specimens.[9] On the other hand, museums make a qualitative distinction in the works they choose to collect and exhibit by judging objects according to such ephemeral standards as "quality," "cultural significance," or "aesthetic merit." Or, as Walter Benjamin points out:

> Museums unquestionably belong to the dream houses of the collective. In considering them, one would want to emphasize the dialectic by which they come into contact, on the one hand, with scientific research and, on the other hand, with "the dreamy tide of bad taste."[10]

The museum, of course, is not the only art historical institution negotiating the legacy of modernism's Janus-faced origins. In the academy, the problem has recently manifested itself in the United States through the vocal debates surrounding traditional survey courses.[11] Despite persistent criticisms regarding the reductive nature of courses that neatly categorize artistic production according to periods and movements, few American art historians are willing to jettison completely this pedagogical framework. The determined attempt by the academy to reconcile the rival claims of positive and intuitive (or interpretive) approaches offers a tangible consequence of art history's manifold origins.

Our uneasiness with the ambiguity of our discipline is not new. Roger Fry, writing early in the century following art history's institutionalization, felt obliged in his inaugural address as Slade Professor of Art at Cambridge to justify his discipline's very existence in the university's curriculum. Emphasizing that art history "is inextricably involved in a number of studies which are regarded as eminently worthy of Academic status,"[12] Fry promises an art history "in which scientific methods will be followed wherever possible, where at all events the scientific attitude may be fostered and the sentimental attitude discouraged."[13] Conceding a few paragraphs later that "we must abandon all hope of making aesthetic judgments of universal validity," Fry leads his audience across the familiar – and rhetorically hallowed – terrain of dialectic. He then offers the hopeful synthesis that

In trying to show, first that the search for an objective standard of aesthetic values is hopeless and secondly that, could we attain it, the mere knowledge of that standard would be entirely useless to us, I have been trying to bring about something like a shift of perspective in our attitude to aesthetic values.[14]

This comment reveals itself to be something of a red herring, however, as his concluding remarks point to a different purpose:

It is possible, I think, by some such methods to circumvent our native prejudices and predilections and to acquire a more alert passivity in our attitude. And it is by cultivating such an attitude that we can best, I think, increase the delicacy and sensibility of our reception of the messages of the present artists. It is the fulness, richness and significance of our feelings in face of works of art that matters.[15]

Initially vowing allegiance to the discipline's positive or "scientific" strain, Fry ultimately offers a passionate defense of art history's association with aesthetic idealism. Fry's apologia bears close resemblance to his long and ardent defense of modern art. For example, in a 1917 address to the Fabian Society, later published as "Art and Life," he finds "something analogous in the new orientation of scientific and artistic endeavour." He goes on to explain that:

Science has turned its instruments in on human nature and begun to investigate its fundamental needs, and art has also turned its vision inwards, has begun to work upon the fundamental necessities of man's aesthetic functions ... On the other hand, the artist of the new movement is moving into a sphere more and more remote from that of the ordinary man. In proportion as art becomes purer the number of people to whom it appeals gets less.[16]

Mirroring his listeners' appreciation for scientific objectivity, urging them to relinquish their prejudices, then confessing that aesthetic perception remains available to only a gifted few, Fry attempts to gloss over the contradictions presented by academic art history as he had the discordances of modern art. In his use of similar rhetorical strategies, Fry invites comparison between art history and modernism and their uneasy institutional status.

While Clark and Fry's discussions indicate points of contact between art history and modernism, neither offers a means to explore the institutional bases for this connection.[17] For such a model, we must look outside the discipline. As previously mentioned, Louis Althusser's analysis of institutional discourse may be applied to the study of art history's disciplinary formation. Althusser ascribes to various cultural institutions the status of Ideological State Apparatus (ISA), which complements Marx's more fundamental and repressive State Apparatus.[18]

Althusser's ISAs subtly reveal the interdependency of politics and culture via institutional discourse. In addition, his critique implicates modernism as a discursive manifestation of high capitalism. Althusser may give us a useful means to analyze the effects of ISAs, but we still face the task of uncovering those institutions most germane to art history. Again, I wish to enlist an approach developed by a historian associated with the Frankfurt School. Specifically, Walter Benjamin's unfinished *Arcades Project (Passagenwerk)* will, I believe, provide a practical example to complement Althusser's theory of ISAs.

Expansive in its scope and complexity, the *Arcades Project* pursues the interconnected histories of modernism, capitalism, and post-revolutionary Paris. Its eventual – and unintended – publication as a collection of notes, observations, and related essays nonetheless conveys the ambitiousness of Benjamin's unrealized plan. Furthermore, the *Arcades Project* reveals his unbounded comprehension of the relationship between material history and representation. Throughout the work, Benjamin shows a determination to analyze history as a *representation* of ideologically responsive institutions (not unlike Althusser's ISAs). This fluid admixture of materialism and narrativity makes the *Arcades Project* an especially promising template for an institutionally focused history of art history. Constantly traversing and redrawing the boundaries between visual and verbal representation, art history – as well as art historiography – requires a method attentive to representational practices.[19]

The *Arcades Project* may also be taken as exemplary in its very *form*. It has been observed that the unfinished state of the *Arcades Project* endows it with a montage-like narrative analogous to the representational mode Benjamin advocated for social criticism.[20] Alternately fleeting and sustained, focused and indirect, the present state of the *Arcades Project* reveals that sidelong scrutiny is often best for observing the flickering effects of ideology. Benjamin's mode, therefore, as well as his method offer promising models for a study of art history as a discipline shaped by modernism and its institutions.

\*\*\*

> To look at a star by glances – to view it in a side-long way, by turning toward it the exterior portions of the retina ... is to behold the star distinctly – is to have the best appreciation of its lustre – a lustre which grows dim just in proportion as we turn our vision fully upon it ... By undue profundity we perplex and enfeeble thought; and it is possible to make even Venus herself vanish from the firmament by a scrutiny too sustained, too concentrated, or too direct.
>
> Edgar Allan Poe, "Murders in the Rue Morgue"

What, then, are the institutions of modernism? Where does high capitalism find new circuits for ideological exchange? Benjamin's response, dispersed throughout the *Arcades Project*, succinctly coalesces in the essay "Paris: The

Capital of the Nineteenth Century."[21] Here, he examines the development of modernism through the city's embrace of post-industrial cultural and commercial innovations. Modernism, according to Benjamin, is found in the new shopping arcades, in the wide boulevards of the city designed by Baron Haussmann, in the dark alleys described by Charles Baudelaire and Edgar Allan Poe, in the parlors and bedrooms of the middle class, in the stalls of the Opéra, and in the exposition pavilions. It is not, therefore, to the academy and the museum alone that we must look for institutions kindred with art history. Rather, Benjamin would direct us as well toward the department store, the advertising agency, the popular press, the commercial gallery, the law courts, and the union halls in our exploration of the institutional origins of art history.

\* \* \*

There are relations between department store and museum, and here the bazaar provides a link. The amassing of artworks in the museum brings them into communication with commodities, which – where they offer themselves en masse to passerby – awake in him the notion that some part of this should fall to him as well.

Walter Benjamin, *The Arcades Project*

It was the cathedral of modern business, strong and yet light, built for vast crowds of customers. In the central gallery on the ground floor, after the bargains near the door, came the tie, glove, and silk departments; ... and ... a colossal gallery decorated with excessive luxury, in which he even ventured to hold picture exhibitions.

Emile Zola, *The Ladies' Paradise*

The head of an agency should expect the art director to keep in touch with art organizations and attend art exhibitions. He should expect the art director to watch for "comers" among the younger artists and to help them develop their talents. Early recognition of a new artist of unusual ability may mean much to an agency.

*The Advertising Agency: Procedure and Practice* (1927)

Art history was formed by the same impulse that created the advertising agency, the department store and even the labor union: the need simultaneously to reveal and disguise the commodification of culture. Whether the commodity is a patent medicine, a marble sculpture, or a day's labor, its commercial worth and availability must be established while its desirability is heightened precisely by elevating its status beyond market standards. Marx ascribed to this situation a fetishistic character. For Marx, fetishism describes the process through which an object is tranformed into a commodity. The fetishized object bears no sign of its production; its value is determined strictly through its participation in a circuit

of market exchange. In semiotic terms, the fetish signifies monetary value as opposed to its own production. Mass produced, flawless, and attractively packaged, the fetish masks its own manufacture, its own history. The commodity-as-fetish described by Marx subverts expectations of authenticity or originality. Art history works both with and against this process. On the one hand, art history supports the commercial status of art by certifying the attribution, condition, age, and medium of a work. On the other hand, art history has developed categories such as "style" or "form" that facilitate aesthetic appreciation but defy commercial quantification. In other words, the discipline's historical enterprise functions contradictorily, both establishing commercial worth and asserting autonomy from market forces. To see this awkward tension in practice, one has only to visit a museum during a scheduled gallery talk or docent's tour. After elucidating the historic significance or aesthetic relevance of a new acquisition, for example, the lecturer may entertain questions. The naive but eager patron who asks the cost of the work will receive a disapproving look in place of an answer. The following notes will, I hope, enkindle an art historiography that seeks to address the impulses behind the patron's question as well as the lecturer's reticence. Rather than dismiss or skirt the ambiguous and contradictory nature of our endeavor, let us seek out its sources in the Benjaminian arcades of art history.

Because I must limit the scope of my exploration, I have selected two exemplary fragments from the history of art history. Each fragment corresponds to one of the polarities ascribed to the *Arcades Project* by Susan Buck-Morss in her important and innovative encounter with Benjamin, *The Dialectics of Seeing*.[22] Buck-Morss attributes to the *Arcades Project* a deep structure that – to severely and unavoidably simplify her analysis – resolves the *Arcades Project* into conceptual hemispheres: one of "dream" and another of "waking." The dream hemisphere is populated by "the prostitute, the gambler and the flâneur," who symbolically pursue "wish images," or the fetishistic pleasures promised by commodity culture. In the waking hemisphere, Buck-Morss finds instead "the collector, the ragpicker, and the detective," who allegorically circulate among the fossils and the ruins of pre-commodity culture. I believe the art historian moves comfortably between these hemispheres and may be identified with, among other Benjaminian characters, the *flâneur* as well as the detective.

* * *

> Marx speaks of the fetish character of the commodity. "This fetish character of the commodity world has its origin in the peculiar social character of the labor that produces commodities ... It is only the particular social relation between people that here assumes, in the eyes of these people, the phantasmagorical form of a relation between things."
>
> Walter Benjamin, *The Arcades Project*

18

## BECKFORD, PATER, PHANTASMAGORIA

Bracketing the period of art history's professional and institutional crystallization are two extraordinary examples of disciplinary renitence: William Beckford's *Biographical Memoirs of Extraordinary Painters* (1780) and Walter Pater's "A Prince of Court Painters" (1887). Through recourse to fantasy, both works sidestep art history's claims either to scientific objectivity or aesthetic transcendence. The use of a forthrightly fictional narrative form signals both authors' recognition – and rejection – of art history's conventional genres. At the same time, this gesture demystifies the discipline's unselfconscious role as a guarantor of art's value as commodity.

William Beckford (1760–1844) earned celebrity in his lifetime for his extravagant personal excesses as well as his Orientalist fiction. *Vathek* (1786), his most successful work, was rumored to record his own overindulgences as well as that of his eponymous protagonist. Beckford's name rarely appears in art historical studies. When mentioned, it is usually in reference to his extensive art collection or his neo-Gothic mansion, Fonthill Abbey. *Biographical Memoirs*, however, has not attracted the scholarly interest of art historians. This idiosyncratic contribution to art writing lampoons one of the most staid genres of the discipline: the artist's biography. This genre, codified in the sixteenth century by Vasari and embraced by subsequent generations of scholars as well as dilettantes, offers an orderly and seemingly dispassionate method for the classification and analysis of art. The artist's biography became, in the wake of Vasari's *Lives*, the standard format for discussions of technique, provenance, authenticity, and meaning. Beckford, however, uses the genre to recount the lives of seven *fictional* sixteenth-century painters. Broadly satirical, *Biographical Memoirs* describes the painstaking method of Aldrovandus Magnus, the dramatic careers of his apprentices Andrew Guelph and Og of Basan, their rivals Soorcrout and Sucrewasser of Vienna, the cultivated barbarian Blunderbussiana, and the fawning Watersouchy. Published when Beckford was just 20, the book foreshadows his endeavors as author of gothic tales and ambitious patron and collector.

The precise circumstances of the book's production and publication remain uncertain. According to Beckford's earliest biographers, he wrote the volume after overhearing the housekeeper expounding to visitors upon his family's picture gallery. When some visitors expressed skepticism at the housekeeper's extraordinary explanations – based on information supplied puckishly by Beckford himself – he promised to "prove" the veracity of these accounts by publishing them:

> My pen was quickly in hand composing the *Memoirs*. In the future the housekeeper had a printed guide in aid of her descriptions. She caught up my phrases and her descriptions became more picturesque, her language more graphic than ever! ... Mine was the textbook, whoever exhibited the paintings ... I used to listen unobserved until I was ready

to kill myself with laughing at the authorities quoted to the squires and the farmers of Wiltshire, who took it all for gospel. It was the most ridiculous thing in effect that you can conceive.[23]

Received by critics with puzzlement, *Biographical Memoirs* nonetheless went into second and third printings.[24]

Though Beckford's text may have confounded contemporary reviewers, it now carries historiographic import. *Biographical Memoirs* records an intriguing juncture in the history of art history as a professional, authoritative discourse. If the recorded explanation of the volume's playful origins is to be believed – and I see no reason the gist of it should not – Beckford's "guidebook" served to detach his family's picture collection from the apparatus normally used to assign commercial value to art. Mocking the paintings' attributions, the circumstances of their production, and their aesthetic merit, Beckford's gesture undermines their status as commodities. His youthful, aristocratic disdain for his middle-class visitors' interest in the works' provenance challenges the commercial application of art historical method. Beckford's satire exposes the absurd reliance his visitors place on pedigree as a measure of aesthetic merit. Paintings, Beckford seems finally to say, are not the same as spaniels or Herefords. With *Biographical Memoirs*, Beckford seeks to shield works of art from the debasement threatened by the growing professionalization of art history.

By satirizing art historical convention, *Biographical Memoirs* marks an instance of aristocratic resistance to incipient capitalism and its concomitant commodity fetishism. "A Prince of Court Painters," the second chapter of Pater's *Imaginary Portraits*, registers a decidedly different moment. By the time Pater wrote *Imaginary Portraits*, commodity fetishism had attained maturity. For this reason, I believe "A Prince of Court Painters" – indeed the whole of *Imaginary Portraits* – is a gesture of belated rhetorical resistance to culture's complicity with capitalism. Like Beckford, Pater employs a genre that imparts a "reality effect" to his text. Written as a series of diary entries, "A Prince of Court Painters" documents the life of Antoine Watteau as perceived by a life-long female friend. The diaristic mode gives the text an authentic flavor: each entry is dated and events are documented with scrupulous detail.

Pater's *Imaginary Portraits* participates in a broader strategy to defy the encroachment of capitalism on culture and scholarship. Aestheticism, Benjamin observes, seeks to undercut the hold of capitalism. He outlines this struggle in "Paris, Capital of the Nineteenth Century":

> The non-conformists rebel against consigning art to the marketplace. They rally round the banner of *l'art pour l'art*. From this watchword derives the conception of the "total work of art" – the *Gesamtkunstwerk* – which would seal art off from the developments of technology. The solemn rite with which it is celebrated is the pendant to the distraction that transfigures the commodity.[25]

Aesthetic reverie and phantasmagoria, then, rest on opposite sides of the same coin. Both respond to capitalism and the commodification of culture. While reverie seeks to evade the cultural consequences of capitalism, phantasmagoria obscures its traces. Benjamin describes phantasmagoria as the illusive (and elusive) play of cultural symbols that serves to obscure the debasing effects of capitalism. Like the magic-lantern spectacle from which it takes its name, phantasmagoria produces an illusion so convincing that a shadow becomes a material body. Phantasmagoria seduces through artifice, severing psychic awareness from physical sensation. Aesthetic reverie or imagination, on the other hand, promises self-conscious escape. Of course, as Benjamin makes clear, "both abstract from the social existence of human beings."[26] In other words, neither reverie nor phantasmagoria challenges or even asserts reality. Though Beckford and Pater may refuse to participate in the commodification of art, their gesture does nothing to prevent the encroachment of the phantasmagorical.[27]

\*\*\*

It will be found, in fact, that the ingenious are always fanciful, and the truly imaginative never otherwise than analytic.
Edgar Allan Poe, "Murders in the Rue Morgue"

## MORELLI IN THE RUE MORGUE

The 1841 publication of Poe's "Murders in the Rue Morgue" introduced a new literary genre. Detective stories represent, for Benjamin, a consummately modern literary form. At once emotionally detached and compellingly visceral, the detective story vacillates between antithetical impulses. This new genre, Benjamin points out, fulfilled Baudelaire's prediction of a literature "in brotherly accord with science and philosophy."[28] In this way, detective fiction offers an analog to art history.[29] Inherently poised between positivist and idealist impetuses, art history seeks a similar accord between scientific and philosophic methods.

Further correspondences between art history and detective stories emerge in Benjamin's explanation of the structure of the genre. Detective stories comprise four components: the victim and the crime scene, the murderer, the masses, and finally an "intellect" that "break[s] through this emotion-laden atmosphere."[30] This formula may easily be transposed to art history. First, investigation is provoked by a work of art. Like the crime story victim, the work of art mutely offers itself as testimony to a hidden motive. The site of the artwork's discovery – whether an artist's studio, a collector's cabinet, a museum's galleries, or a dealer's vault – may offer information about the work's production or reception. Second, art historical investigation usually subjects the artist to lengthy interrogation and ultimately to judgment. Third, an artwork's audience functions like Benjamin's crowd: attentive viewers may help to anchor it in social discourse while apathetic viewers contribute to an artwork's cultural

invisibility.[31] Finally, art history struggles to balance an objective, truth-seeking purpose with a biased, aesthetic intuition. In other words, art history similarly seeks to use "intellect" to "break through [the] emotion-laden atmosphere" generated by the art object.

In "Murders in the Rue Morgue," Poe establishes the "method" by which his protagonist, the chevalier Auguste Dupin, "resolves" or "disentangles" complex and contradictory evidence. Outlined by Poe's anonymous narrator, Dupin's astonishing analytic abilities are "brought about by the very soul and essence of method" though they have "the whole air of intuition."[32] Thus, Poe introduces an approach that seems to disguise objective reasoning with subjective whim. This method involves two main operations. First, the analyst must simply "observe attentively."[33] No detail is too small for consideration, no action too commonplace for notice. The second step in the method refines the sweeping directive of the first: the analyst must know "*what* to observe."[34] This knowledge determines the "quality of the observation."[35] It is at this second stage that the guidance of intuition seems to hold greater sway. Poe's narrator never explains *how* Dupin determines what to observe.

Poe's narrator may just as easily be describing the method of connoisseurship advocated by Giovanni Morelli (1816–1891). Though trained in medicine and an ardent student of Cuvierian theories of comparative anatomy, Morelli rejected a career in science to become first a playwright then a politician.[36] Art history and connoisseurship were lifelong avocations to which he applied his skills both in anatomy and rhetoric. Like Poe, Morelli invented an infallible sleuth who outsmarts conventional authorities through his steadfast observance of method. Morelli's alter ego, the worldly-wise connoisseur Count Iwan Lermolieff,[37] shares Dupin's aristocratic status as well as his deductive approach. Lermolieff made his pseudonymous debut in 1874 as the author of "Die Galerie Roms: ein kritischer Versuch" in the venerable *Zeitschrift für bildende Kunst*.[38] Additional articles and even books followed, though Lermolieff's opinions were soon recognized as Morelli's. Regardless, Morelli used Lermolieff to gibe at the techniques of prominent professional art historians.[39] In these derisive passages, Lermolieff seems to echo Dupin's disdain for ineffectual police procedure. For example, Dupin opines "The Parisian police, so much extolled for acumen, are cunning, but no more. There is no method in their proceedings,"[40] while Lermolieff similarly complains that "art historians ... do not see ... at all. Preferring, as their practice is, mere abstract theories to practical examination."[41]

To redress his colleagues' misguided approach, Morelli–Lermolieff recommends a system of "art morphology" in which works of art are examined according to their constituent parts. Analysis is directed toward three major categories. First, a general impression may be ascertained from pose, drapery, movement, and expression. The second category encompasses anatomical details, background landscapes, and color or tonal harmony. Here, analysis focuses on discrete, irreducible components – or morphemes – of an artwork in order to effect a taxonomic comparison with other works. Finally, stylistic affini-

ties may be sought between or among works believed to be by the same artist, the latter observations arising from the highly subjective experiences and judgments of the connoisseur. Moving between empirical and intuitive positions, this method recalls Poe's description of Dupin: "His results, brought about by the very soul and essence of method, have, in truth, the whole air of intuition."[42]

Once setting to work, Morelli–Lermolieff's analysis again accords with Dupin's. For example, Morelli describes an encounter between Lermolieff and a new disciple in the galleries of the Uffizi Palace. Asking the young man to examine Botticelli's *Calumny of Apelles* before standing before a panel depicting *St. Augustine* attributed to Filippo Lippi, Lermolieff explains:

> Among Sandro Botticelli's characteristic forms I will mention the hand, with bony fingers – not beautiful, but always full of life; the nails, which, as you perceive in the thumb here, are square with black outlines, and the short nose with dilated nostrils, which you see exemplified in Botticelli's celebrated and undisputed work hanging close by – *The Calumny of Apelles* ... I think you will be forced to acknowledge that the painter of the *Calumny* ... must also have been the author of this *St. Augustine*.[43]

Thus, through a minute comparison of fingernails and nostrils, Lermolieff reattributes the painting without recourse to dubious observations about quality or debatable assertions regarding iconography. Dupin similarly solves the mystery of the Rue Morgue murders by first instructing his companion to

> 'glance at the little sketch I have traced here upon this paper. It is a facsimile drawing of what has been described ... as "dark bruises and deep indentations of finger nails" upon the throat of [the victim] ... You will perceive ... that this drawing gives the idea of a firm and fixed hold. There is no *slipping* apparent. Each finger has retained – possibly until the death of the victim – the fearful grasp by which it originally imbedded itself. Attempt, now, to place all your fingers, at the same time, in the respective impressions ... '

Dupin's companion, the narrator, complies:

> I did so; but the difficulty was even more obvious than before. "This," I said, "is the mark of no human hand." "Now read this passage from Cuvier." It was a minute anatomical and generally descriptive account of the large fulvous Orang-Outang ...[44]

Thus, Cuvier's theories are successfully deployed to identify a homicidal orangutan as well as a painting by Botticelli. In a typically modern juncture, comparative anatomy provides both a rational explanation for an act of

depravity as well as a standard for aesthetic discrimination. Blending fantasy with fact, intuition with science, Morelli joins Pater and Beckford in demonstrating art history's alliance with modernism.

Of course, the discipline's delicate balance between objective and intuitive strains is as often interrupted as it is fostered by institutional discourse. In the famous *Whistler vs. Ruskin* case, for example, civil law cut the Gordion knot so carefully tied by aesthetic debate. This would not, of course, be the last time a law court would adjudicate matters of aesthetic meaning or merit. As trials ranging from *Constantin Brancusi vs. United States* to *State of Ohio vs. Contemporary Arts Center* show, art itself is subject to legal definition. Similar institutional containment can be observed around the efforts of art historians who attempted to infuse their scholarly interests with political activism during the early stages of art history's professionalization. Both Gottfried Kinkel and Emilia Dilke, for example, sought to bring a socialist or Marxist perspective to their art historical scholarship. These works, however, were either suppressed or ignored by the discipline's crystallizing establishment.[45] The purview of the art historian, then, is subject to political, legal, and commercial circumscription in addition to the pedagogical, intellectual, aesthetic, and other cultural pressures brought to bear on traditional humanistic fields.

If, as I have argued, the history of art history remains bound to that of modernism and its institutions, have we then reached the end of art history? Once again to recoin Clark's query: if something of modernism has died, has art history died along with it? I believe it has not. As Susan Buck-Morss concludes in *The Dialectics of Seeing*:

> The *Passagen-Werk* suggests that it makes no sense to divide the era of capitalism into formalist "modernism" and historically eclectic "postmodernism," as these tendencies have been there since the start of industrial culture. The paradoxical dynamics of novelty and repetition simply repeat themselves anew.
>
> Modernism and Postmodernism are not chronological eras, but political positions in the century-long struggle between art and technology. If modernism expresses utopian longing by anticipating the reconciliation of social function and aesthetic form, postmodernism acknowledges their nonidentity and keeps fantasy alive. Each position thus represents a partial truth; each will recur "anew," so long as the contradictions of commodity society are not overcome.[46]

Neither modernism nor art history requires last rites. In fact, its modernist inception permits art history to lay claim to a self-conscious and critically aware epistemological legacy that maintains the discipline's vitality. Art history has been subject to competing professional and philosophical goals since its inception. The often-repeated declaration that art history is "a discipline in crisis" becomes, therefore, superfluous. Art history's modernist legacy endows its

practitioners with a zeal for disciplinary self-reflection as well as a facility for methodological recalibration. These inclinations may prevent art historians from enjoying sustained periods of intellectual self-assurance, but such impulses nevertheless maintain the tension required by a discipline codified during modernism's ascendance.

## NOTES

I wish to thank Susan Dackerman, Rob Bork, Sally Mills, John Grammer, and Woody Register for reading critically and responding supportively to earlier drafts of this chapter. Also, without David Joselit's advice and encouragement, *Art History and Its Institutions* would not have been realized.

1 My description – and insistence upon a mensurable institutional life – more or less accords with the definition given in the *Oxford English Dictionary*: "An *established* law, custom, usage, practice, organization, or other element in the political or social life of a people" [emphasis mine]. *OED Online*, "institution," section 6a.

2 L. Althusser, "Ideology and Ideological State Apparatuses (Notes towards an Investigation)," in *Lenin and Philosophy and Other Essays*, New York, Monthly Review Press, 1971 [essay orig. pub. 1969], pp. 127–86.

3 H. Belting, *The End of the History of Art? Reflections on Contemporary Art and Contemporary Art History*, trans. C.S. Wood, Chicago, University of Chicago Press, 1987.

4 T.J. Clark, *Farewell to an Idea: Episodes from a History of Modernism*, New Haven, Yale University Press, 1999, p. 8.

5 Hugo von Hofmannsthal, cited in J. McFarlane, makes this obsevation in 1893. McFarlane elaborates upon this definition of modernism in "The Mind of Modernism," in M. Bradbury and J. McFarlane, eds, *Modernism, 1890–1930*, London, Penguin Books, 1976, pp. 71–93.

6 Clark, p. 7.

7 Heinrich Dilly addresses art history's awkward disciplinary relationship to philosophy and science in *Kunstgeschichte als Institution: Studien zur Geschichte einer Disziplin*, Frankfurt, Suhrkamp, 1979. See especially part I, chapter 3, "Kunstgeschichte als Institution."

8 On the origins and development of the art museum, see D. Crimp, *On the Museum's Ruins*, Cambridge, MA, MIT Press, 1993; C. Duncan and A. Wallach, "The Universal Survey Museum," *Art History*, 1980, vol. 3, pp. 448–69; A. McClellan, *Inventing the Louvre*, Berkeley, University of California Press, 1994; as well as the special issue devoted to "The Formation of National Collections of Art and Archaeology" of *Studies in the History of Art*, 1994, vol. 47.

9 On the origins and development of museums of zoology and natural history as well as their points of intersection with art museums, see P. Findlen, *Possessing Nature: Museums, Collecting, and Scientific Culture in Early Modern Italy*, Berkeley, Los Angeles, and London, University of California Press, 1994; and C. Yanni, *Nature's Museums: Victorian Science and the Architecture of Display*, London, The Athlone Press, 1999. Findlen persuasively traces the origins of natural science museums to the sixteenth century whereas Yanni argues for a more recent nascence in the first decades of the nineteenth century. Both acknowledge the influences of natural history museums upon the development of art museums and vice versa.

10 W. Benjamin, *The Arcades Project*, trans. H. Eiland and K. McLaughlin, Cambridge, Harvard University Press, 1999, p. 406.

11 For an overview of these debates, see B.R. Collins, ed., "Rethinking the Art History Introductory Survey," special issue of *Art Journal*, fall 1995, vol. 54; C. Detels, "History, Philosophy, and the Canons of the Arts," *Journal of Aesthetic Education*, 1998, vol. 32, pp. 33–51; and S. Heller, "What Are They Doing to Art History in American Academia?" *Art News*, 1997, vol. 96, p. 102–5.

12 R. Fry, *Art-History as an Academic Study*, address delivered 18 October 1933, Cambridge, Cambridge University Press, 1933, p. 8.

13 Fry, *Art-History*, p. 10.

14 Fry, *Art-History*, pp. 37–8.

15 Fry, *Art-History*, p. 48.

16 R. Fry, "Art and Life," in *Vision and Design*, New York, Meridian, 1974 [orig. 1920], pp. 14–15.

17 Similarly, Heinrich Dilly explores the ramifications of art history *as* an institution, but not as a subject *of* institutions in *Kunstgeschichte als Institution*.

18 Althusser, "Ideology and Ideological State Apparatuses," pp. 142–3.

19 O.K. Werckmeister has recommended using the *Arcades Project* as a model for art history in "Walter Benjamins Passagenwerk als Modell für eine kunstgeschichtliche Synthese," in A. Berndt, ed., *Frankfurter Schule und Kunstgeschichte*, Berlin, Reimer, 1992.

20 *The Arcades Project*, "Translators' Foreword," p. xi.

21 Benjamin completed two versions of this text dating from 1935 and 1939, and both appear in *The Arcades Project*, pp. 3–26. My remarks are applicable to either, but my citations refer to the 1935 version.

22 S. Buck-Morss, *The Dialectics of Seeing: Walter Benjamin and the Arcades Project*, Cambridge, MA, and London, MIT Press, 1989, pp. 210–12.

23 C. Redding, Beckford's first biographer, reports these as his words. Cited in R.J. Gemmett, *William Beckford*, Boston, G.K. Hall, 1977, p. 54. See also the editor's introduction to William Beckford, *Biographical Memoirs*, ed. R.J. Gemmett, Cranbury, NJ, Associated University Presses, 1969, pp. 12–15.

24 Gemmett, "Introduction," *Biographical Memoirs*, pp. 22–31.

25 *The Arcades Project*, p. 11.

26 *The Arcades Project*, p. 11.

27 The struggle of art history mirrors the ambivalence charted in Benjamin's essay on "Art in an Age of Mechanical Reproduction," in *Reflections: Essays, Aphorisms, and Autobiographical Writings*, trans. E. Jephcott, ed. P. Demetz, New York, Harcourt, Brace, Jovanovich, 1978. One of the threads leading from the *Arcades Project*, this essay defines "auratic" objects as those that derive their value from their history, uniqueness, and authenticity. Benjamin imparts a paradoxical status to auratic works, however. At once resistant and acquiescent to commodification under capitalism, the status of auratic works vacillates between that of a vehicle for social emancipation and a device for political debasement (the commodity fetish).

28 W. Benjamin, "The Paris of the Second Empire in Baudelaire," in *Charles Baudelaire: A Lyric Poet in the Era of High Capitalism*, trans. H. Zohn, London, New Left Books, 1973, p. 43.

29 Donald Preziosi remarks on the connections between Arthur Conan Doyle's "The Cardboard Box" and Morelli's method in *Rethinking Art History: Meditations on a Coy Science*, New Haven, Yale University Press, 1989, p. 93. See also, C. Ginzburg, "Clues," in *The Sign of Three: Dupin, Holmes, Peirce*, Bloomington, Indiana University Press, 1983.

30 "Paris of the Second Empire," *The Arcades Project*, p. 43.

31 See Benjamin's discussion of the crowd in the "Flâneur" section of "Paris of the Second Empire," *The Arcades Project*, pp. 35–66.

32 Edgar Allan Poe, *The Collected Works of Edgar Allan Poe*, vol. II, ed. T. Ollive Mabbott, Cambridge, MA, and London, The Belknap Press of Harvard University Press, 1978, p. 528.

33 Poe, p. 529.

34 Poe, p. 530.

35 Poe, p. 530.

36 For biographical information on Morelli, see H. Zerner, "Giovanni Morelli et la Science de l'Art," in *Écrire L'Histoire de l'Art*, Paris, Gallimard, 1997, pp. 15–30; and J. Turner *et al.*, *Grove Dictionary of Art*, "Giovanni Morelli."

37 Morelli spelled the name alternately Ivan and Iwan.

38 Iwan Lermolieff, "Die Galerie Roms: ein kritischer Versuch," *Zeitschrift für bildende Kunst*, 1874, pp. 1–11, 73–81, 171–8, 249–53.

39 Among the eminent art historians Morelli takes to task in print are Charles Blanc, Wilhelm Bode, Giovanni Battista Cavalcaselle, Joseph Crowe, Otto Mündler, and Johann David Passavant.

40 Poe, p. 545.

41 G. Morelli (Ivan Lermolieff), "Principles and Methods," *Italian Painters. Critical Studies of Their Works: The Borghese and Doria-Pamfili Galleries in Rome*, trans. C.J. Ffoulkes, London, John Murray, 1892, p. 23.

42 Poe, p. 528. On Morelli's use of scientific and intuitive principles – and the failure of later art historians to understand correctly Morelli's approach – see Zerner.

43 Morelli, "Principles and Methods," *Italian Painters*, p. 35.

44 Poe, pp. 558–9.

45 See A. Berg, *Gottfried Kinkel: Kunstgeschichte und soziales Engagement*, Bonn, Ludwig Röhrscheid Verlag, 1985; and my "The Victorian *Grand Siècle*: Ideology as Art History," *Victorian Literature and Culture*, spring 2000, pp. 133–47.

46 Buck-Morss, p. 359.

# 2

# HEARING THE UNSAID

## Art history, museology, and the composition of the self[*]

### *Donald Preziosi*

Certainly we must be attentive to the "un-said" that lies in the holes of discourse, but this does *not* mean that we must listen as if to someone knocking on the other side of the wall.

<div align="right">

J. Lacan, *Écrits*

</div>

It's to provide knowledge and allow people to get access and education about modern arts and culture and also to be able to purchase related products. It will be rich in content and it will also have a community component and a commerce and merchandising component.

<div align="right">

Liz Addison, project manager for a new e-business joint venture
of New York's Metropolitan Museum of Art and London's
Tate Gallery (New York, Reuters, 17 April 2000)

</div>

After what is now more than a quarter of a century of disciplinary self-critique, why is it that we have been perennially unable to escape art historicism? Apart from the massive and growing commodifications of art history and museology as ancillary professions of a larger infotainment and edutainment industry in which all of us today are implicated, what most deeply supports and naturalizes our interest in the "history" of art, and motivates our abiding concern with "visual cultures"?

Certainly, these include assumptions about how the world of art or artifice sustains and legitimizes our individual and collective identities: how it is that our existence as subjects is permanently and essentially tied to the world of objects into which we are born and within which we always live as individuals and members of communities. Fundamental orientations on time, memory, history, and identity have underlain and made possible the art historical and museological practices we know today. These in turn rest upon very particular dialogic or dialectical relationships imagined to exist between ourselves as social subjects and the object-worlds we build ourselves into.

The idealist dualisms enabling art historical and museological practice in modern times are particular forms of a largely uninvestigated secular theologism

whose quintessential expression is aesthetics. This paper examines one facet of this problem as it relates to one of modernity's paradigmatic institutions, the museum, and it takes the principles of museology as the central armature upon which have been elaborated the modern discursive practices of art history.

## (1)

In 1936 Walter Benjamin published an essay entitled "The Storyteller" (*"Der Erzähler"*), which he had been working on for about a decade, and about which he'd said on several occasions that it was in fact the centerpiece of a whole series of projects he had been engaged with for quite some time. Those included his more famous *Theses on the Concept of History*, and his monumental *Arcades Project* (*Passagenwerk*).

In the essay, he observed that "the time is past when time didn't matter" ("Die Zeit ist vorbei, in der es auf Zeit nicht ankam"). This was his translation of a phrase by the French poet Paul Valéry ("le temps est passé où le temps ne comptait pas"). Valéry was writing on the passing of patient, time-consuming handicrafts (miniatures, ivory carving, lacquering, etc). Benjamin understood that Valéry had exposed a deep paradox at the heart of the modern sense of time and history; it was in fact this paradox that had preoccupied Benjamin for much of his career. It is, in short, that a time when time itself didn't seem to pass could *itself* pass – and that in its passing, not only would a particular time (an epoch) have passed, but time itself was at stake, passing away. Time itself, in other words, was temporary, or temporal. Another dimension of this paradox of the mortality of time is that while one can never truly leave the present, at the same time one can never truly occupy the present – because, in effect, our awareness of the present is always by hindsight; the recognition of the present is always a re-cognition; a re-thinking.

Today, the past, and the present that we are "present at" only as a past, are supremely museological phenomena. The invention of the museum as we know it today entailed a profound realignment of European time and space, and it was this realignment that is the cornerstone of what we now have come to call modernity.

For Benjamin the key characteristic of modernity was its contingency – the idea that modernity is fundamentally bound up with change and its measure. Life in modernity is lived in a stream of measured changes and transformations, of ever-unfolding stories always branching (like streets in a city) into more story lines; every moment an episode in an unfolding narrative to be continued just around the next corner. Who and what we are is linked inexorably to our where and when – which renders every thing we see and touch as intensely time-factored; marked by its age. Every object, humanly made or not, is understood to bear within itself the legible traces of its time and place. In modernity, every artifact is staged and framed as a text to be read, telling us the story of its origins, like a geological specimen in which can be read the history of thousands of centuries of climatic variation and atmospheric forces.

Every object is thus what can be called *funeous* – a term coined by the histo-rian of science Cyril Smith to refer to the sedimented traces of previous states of things in what can be observed of them at present. He coined the term after the character in Jorge Luis Borges' tale "Funes the Memorious," about a man who was cursed with the inability to forget anything he ever experienced. Everything complex, Smith noted, must have a history, and its internal structure might thereby be termed funeous. Our ability to read historical change and transfor-mation in the *funicity* of things – the very bedrock of our socialization – is a socio-semiotic skill we begin to acquire in infancy, and is refined throughout our lives. Consider how many of our modern disciplines are founded upon a belief in the funicity of things. Consider how our very being as creatures is understood as the epitome and the evolved summation of all of our parts – visible and microscopic – that preserve a memory trace of all that life has been on this planet. This is all deeply ingrained in all aspects of modern life; but it was also built upon, and transformed, a very rich tradition of pre-modern European practices, beliefs, and epistemological technologies – practices which themselves figure in the background to modern institutions such as art history and museology.

(2)

In 1812 the prominent London architect John Soane, who was to become famous for designing the massive Bank of England complex, wrote a sixty-four page manuscript entitled *Crude Hints towards an History of My House in L(incoln's) I(nn) Fields*. Assuming the role of an imaginary antiquarian of the future, and discovering his London house-museum in ruins, he offered various hypotheses as to the structure's original function, since there were no traces remaining of "the Artist who inhabited the place." Until his death in 1837, Soane continually rebuilt and remodelled his house (Figure 2.1), to paraphrase his imaginary antiquarian, as a great assemblage of ancient fragments which must have been placed there for the advancement and knowledge of ancient Art. Soane's remarkable text fabricated a "history" of his museum, but from a vantage point in the future, when it would have stood in ruin. *Soane spent the next quarter-century reconstructing the building in the image of what its ruins in the future might suggest it had been.*

How could he do this? On the face of it, there are insurmountable difficul-ties. The ruined state of a building would seem especially unpredictable: a product of pure chance. Destruction will have proceeded in random ways that could neither be predicted nor controlled, nor yet easily described. Yet Soane would have wished not only to predict the state of his museum's ruins in detail; he would also have had to "design" those (future) fragments in such a way that they might be *legible* enough to reconstruct their prior completeness, and, through that backward-projected, reconstituted fullness, the purposes of the building. In his words, this will have been "an assemblage ... placed there for

*Figure 2.1* Sir John Soane's Museum, London: The Dome, looking east.

*Source*: Author photo.

the advancement and knowledge of ancient Art" – so that, through the latter, the motivations and intentions of Soane himself – "the Artist who inhabited the place" – might be themselves reconstituted.

This would put Soane the Artist in the position of a visionary, a person of very special foresight, able to see without sight what others with sight cannot see. The museum's designer would have to circumscribe its subjection to another's desire and design – in this case, the whims of Nature. Think of just what kind of design problem this could be. How could a designer or builder predict the morphology of a ruin? What can be made of the Artist's intentions in such a project: in what sense can we say that they are really *prior* to their imagined material effects? And just what kind of "history" does all this extraordinary projection presuppose?

If his museum were to be a work of Fine Art in its own right, then such works must, in the words of Derrida, somehow "resemble effects of natural action at the very moment when they, most purely, are works of artistic confection." The building should appear to have constructed itself. Yet Soane's project

would have to go even further, for what is being fabricated as the effect of natural action is a state beyond that which could be in any Artist's control: how the ruined fragments of its future condition might be especially legible as to lead any future antiquarian to correctly reconstruct both the building's original purpose as well as the originating Artist's intentions for the institution. In short, the building should appear not only to construct itself, or to "decay" in some aesthetically pleasing and predictable way, but it would have to encode clues or instructions both as to how it might reconstruct or resurrect itself after its death, and how its future fragments might encode the intentions or desires of the original Artist. And those clues, to be safe, must be encrypted in every conceivable fragment that might remain in and as "the museum's ruins."

Soane's project, articulated in the very years when the modern disciplines of archaeology and art history were being professionally founded, recalls in a curious way some of the first experiments in photography then, in which artists of the new medium produced conundrum-photos depicting the photographer as a corpse. Soane's Artist – Soane himself – must imaginatively approximate the situation of a divinity, an artist-god, if this whole enterprise is to succeed both for the museum visitor in the present, and for the antiquarian in the future. In the implicit insistence here on a homology between the creativity of the Artist and that of God, the Artist is not imitating God's *effects* – Nature – as much as he is imitating Nature's God's *modus operandi*: how God works. Soane's mimetic labor must simulate *an activity which circumscribes or even circumnavigates time itself – it is outside of time, yet equally a product of time.*

As the existence, nature, and Will of God might be taken as "legible" in and through God's effects – the divine Artificer's artifacts, which is in fact the intensely *funeous* Book of Nature – so too must the existence and will of Soane the Artist be legible, in a two-step process of reconstructive reading, which itself might resemble the reconstructive reading of the collection's fragments themselves: their re-collection. Soane *gives himself to be seen* by giving his future public tangible symptoms of his creative activity – traces and relics by which the creativity and the intentions of this "Artist who inhabited the place" could be reconstructed clearly and unambiguously. Now this Artist of the future ruin – Soane himself – was a very complex, and seemingly very elusive character, in a number of important ways. In contrast to the founders of virtually all other great collections open to the public, whose busts, statues, and dedicatory inscriptions grace thresholds and entryways, John Soane was figured in his museum ambiguously, in fragments, and anonymously, as an unlabeled bust among other objects in the collection.

For example, in both his house-museum in Lincoln's Inn Fields and in his earlier residence in Ealing, Pitzhanger Manor, he erected a basement "monk's apartment" or Monk's Parlour. In his writings, John Soane often alluded to a fictional monk ("Padre Giovanni" – Father John) who wandered like a ghost among the basement ruins. That he strongly identified with this monastic specter emerges in a number of his letters and notebooks alluding to the

creation of the "Monk's Cell" in the London house in 1815–16 – a section of the building he increasingly haunted, redecorated, and rebuilt.

In 1830 he began to publish his *Description of the Residence of John Soane, Architect*, a general account of the building and its contents as they would have been seen by an ordinary visitor. Such a public audience did not yet exist at that time; two months after his death records indicate that some sixty visitors were admitted, by ticket, each day. The book went through several revised editions before Soane's death seven years later in 1837. In the 1835 edition of the *Description*, he described the tomb of the imaginary Giovanni amidst medieval and classical fragments, and adjacent to machinery of the new central heating system he designed and built.

The entire collection surrounds a large, three-storied, skylit space known as "the Dome," on whose eastern side is centrally fixed a bust of Soane himself, finished and put in place in 1829. The bust, by Sir Francis Chantrey, was said to be inscribed "John Soane Esq RA," but in fact the bust had and has *no label*. It stands directly opposite an *Apollo Belvedere*, on the western side of the atrium. In his book Soane recorded Chantrey's comments upon presenting it to him: Chantrey said that he himself could no longer tell whether he had made a bust of John Soane or of Julius Caesar. The hair and clothing resemble prototypes common in ancient Roman iconography, and are thus compatible in style with other busts and bas-reliefs in the Dome area. All these busts are overshadowed by a cast of the life size nude *Apollo Belvedere* in the Museo Pio Clementino in the Vatican, presented to Soane in 1811. Soane's own anonymously classical bust stands opposite the Apollo, on a pedestal of his own design, incorporating on its back an eighteenth-century imitation of an ancient mosaic image of Genius in a triumphal chariot.

Soane is thus figured in his museum ambiguously, and he is situated, in his writings about the building, both *anterior* to its present state (in the guise of that medieval Father John who wanders about down in the basement) and *posterior* to its falling into ruin – where the protagonist is the imaginary antiquarian of the future. This artist-god exists only in his absence and occlusion, only as a sculptural *object* in the present time of the visitor, and only by double-remove in the masquerade of an ancient monk or of an antiquarian yet to be born. By yet a third remove, in what might be taken as meta-commentary, his own image does not confront the visitor at the entrance to the building, but rather stands in relative anonymity as one fragment amongst several in the Dome area, dramatically overshadowed by the fine figure of the *Apollo Belvedere*, at the time widely considered to be not only the paragon of ancient male beauty, but also a canon to teach oneself how to recognize beauty in the ideal proportions of parts to whole.

Soane is thus seen on the temporal margins or frame of the museum *and* as one member of the cast of characters that make up that "great assemblage of ancient fragments that must have been placed there for the knowledge and

advancement of ancient Art." He gives himself to encounter us – so that we may constitute him as subject. But where exactly is he?

This can best be described by paraphrasing Jacques Lacan: he is not simply the "past definite of what he was" (John Soane, Architect, after 20 January, 1837 deceased), nor only the "present perfect of what has been in what he is" (Father John, his medieval alter ego, ruminating on ruins and mortality in the basement), but he is also as the "future anterior of what he shall have been for what he is in the process of becoming" – the antiquarian student of the museum's *own* ruins and fragments. This John Soane is at the same time the *alter ego* of the visitor of the (pre-destruction and yet intact) museum of the near future, whose imaginative powers are put to the test to resurrect from ruined fragments now in the museum a knowledge of antiquity that simulates what John Soane, Architect, would have embodied, had he been present to guide our journeys and meditations, failing possessing his *Description*, which was not a systematic catalogue of contents but rather a guidebook to the experience of visiting the collections.

Astonishingly, Soane deployed and disseminated himself across the spectrum of verbal tenses, serving as the *frame* of his museum, while being the *product of* any such framing: *he is the framer and what the museum frames.* He is both narrator and protagonist of the tale; both inside and outside the story; both stage-set and member of the cast. His life history is designed and constructed as a simulacrum of the principles of design and construction exemplified in the objects of the collection. He was, in short, a prototype of what will become the professional art historian.

Soane was both a subject and an object in this Museum. The Museum was made up of a mass of objects which were themselves archaeological fragments, or simulations of such relics, displayed in ways that they might be legible as examples of artistic and design principles which should be both understood and appreciated by visitors in the present, and emulated by students of art, design, and architecture in their task of creating a humane modern environment. Soane's life work was dedicated to rescuing the possibility of a humane environment from the massive disruptions being caused in his time by the Industrial Revolution, which so completely disoriented every facet of traditional space and time in Europe and America. The exemplary nature of the displayed items of the collection resonated with the exemplary nature of Soane's design and decoration of those portions of the building used for his own residence.

He termed the displays (compositions, tableaux, and juxtapositions of fragments) his "studies," and they were intended to serve as set-pieces or puzzles to not only intrigue and entertain the visitor or student, but to evoke, challenge, and elicit understanding. Soane's Museum seems to be a memory-machine or a modern *florilegium* – a garden of aphorisms, fragments of wisdom, and an exhibition of objects of *vertu* generating ethical knowledge through aesthetic example. Its aim was to foster the development of a humane environment based on exemplary fragments providing ancient precedents for the "union of archi-

tecture, painting and sculpture." In *projecting the entire edifice as a mass of future fragments*, he aimed to have the fragments *of* the building serve functions identical to those served by the fragments residing *in* the building.

There is no little irony in the fact that the Museum was donated to the state with the stipulation, confirmed by an Act (of Parliament, in 1833) "for the settling and preserving of Sir John Soane's Museum," that it remain in perpetuity in its then-current condition, after Soane's death, which was four years later. This stipulation has been remarkably well met, despite the vicissitudes of war (some minor damage during bombing raids on London during World War II, since repaired), electrification, some remodeling, and modern provisions for the study of archival materials relating to the architectural history of the period, once part of Soane's extensive library of books, drawings, and prints.

So – what possible relevance could this extraordinary museum have for the historiography of art and museology today, not to speak of the more fundamental issues of time, memory, history, and identity of which modern art history and museology are themselves the effects? Looking at Soane's Museum will certainly make it clear to us not only that museums as we know them today are different from the institution that Soane created, but that they are *radically and profoundly* different in form and function. I'd like to spend the rest of this paper talking about those differences, and their implications for contemporary discipline. The differences concern how the nature of relationships between subjects and objects comes to be conceived, articulated, and elaborated in practice.

## (3)

The American academic philosopher and occasional New York art critic Arthur Danto once remarked, at the conclusion of a *Nation* magazine review of the 1997 biennale of the Whitney Museum of Art, "You may not like the art, but it is probably closer to the heart of our period than other art we might prefer." He then added: "*Not knowing what we are looking at is the artistic counterpart of not altogether knowing who we are.*"

One could modify this rather telling and supremely modernist desire for an ideal correspondence between style and value, ethics and aesthetics, by saying that not knowing what we're looking at is, equally, the equivalent of not knowing *when* we are. We live in a world defined by corporate nation-states committed above all to prescribing disciplined and predictable linkages between individuals and their object-worlds. In this world, you are made desirous of being convinced that you are your stuff, so that you will become even more desirous of becoming that which even better stuff can say even more clearly to others and to yourselves about your continually evolving truth – what you shall have been (to recall Lacan for a moment) for what you are in the process of becoming. This linkage of psychology, physiognomy, genealogy, and teleology is no mere accident of modernity, but its very essence. To sin in modernity is to

be untrue to your "style," as every teenager on the planet knows perfectly well, without having to read Proust.

Four years earlier, in 1993, there was an article in the *New York Times* newspaper entitled "In France, It's How You Cross the t's." It concerned the case of a former sales manager of a Parisian furniture company who, after being unemployed for six months, decided to have his handwriting analyzed by an "expert." After several attempts to find a job, he'd begun to fear that his handwriting was somehow "suspect." The article went on about the increasing use by French corporations of "graphological tests" in narrowing the field of applicants, particularly for managerial positions. As one corporate representative stated: "You may suddenly find that a person you are about to hire as an accountant has a tendency toward deviousness," a personality trait, the article went on to say, that might be clearly evidenced in the loops, slants, margins, and flourishes of the applicant's handwriting. Almost all ads for jobs in France today, the article claimed, require a handwritten letter for, as one recruiter was quoted as saying, "it would be very badly viewed if a job applicant sent a typewritten letter." Commenting on this whole phenomenon, a Parisian newspaper (*Le Nouvel Observateur*) concluded: "Americans use figures … while we prefer impressions. We like grace, emotion, approximation, instinct. We are probably not made for the modern world."

But in fact it has been precisely this belief in a close and telling linkage between individuals and their products, the idea that the form of your work is the succinct and honest figure of your truth, that *is* central to the modernity we've built ourselves into over the past two centuries. But these have been more than just telling linkages; they are linkages which can be delineated by others outside of the consciousness of the producing person or people, and even beyond their own capacities to articulate such connections. In other words, identity and individuality in modernity are closely linked to the disciplinary order of external prostheses. Of such prostheses, the central and key technology is that astonishing invention of the European Enlightenment, that psycho-semiotic fiction, that we call "*art*."

Such beliefs have been essential to the modern professions of museology, art history, art criticism, and connoisseurship, not to speak of the graphology that achieved its modern synthesis in the work of the nineteenth-century French priest Jean-Hippolyte Michon, who in fact coined the term *graphologie* to refer to his systematic method for determining individual character through the study of handwriting. This modern "science" had early precedents in the theses of the seventeenth-century Italian author Camillo Baldi, who may have been one of the first to articulate a correspondence not only between a writer's identity and her style of penmanship, but more importantly between a person's writing and her moral character. Graphological science developed further in the eighteenth century, notably in the work of the Swiss physiognomist Caspar Lavater, who at the end of that century further concluded that there were indeed intimate and demonstrable homologies between handwriting, speech, and gesture. The idea,

in short, was that each person and people, each nation and race, each class or gender, had a distinct and distinguishable "style": a quality that was imagined to permeate everything palpable about a person or people.

Lavater was the contemporary of the Enlightenment philosophers, historians, philologists, collectors, and connoisseurs who were fashioning the systematic foundations of art history and museology as we know them today. For example, for the most influential eighteenth-century progenitor of modern art history and archaeology, J.J. Winckelmann, the glory of classical Greek art was a *direct consequence and effect* of the ancient Greek diet, climate, moral character, homosocial appetites, and (male) physical beauty, traits that he argued could be read clearly and concretely in all their best works. For subsequent art historians and critics, the scientific task became that of *rendering the visible legible* – so starkly and fully legible that objects could assume a physiognomic, even "graphological," relationship to their makers, and to the times and places of their production and reception. Virtually all of what art history has been since the end of the eighteenth century follows from this basic set of premises.

In imagining the uniqueness and private inner truths of the individual subject, modern disciplinary institutions have constructed that singularity as most truly (scientifically) knowable (even by those to whom it refers) through its invasion, by rendering it public, and hence susceptible to classification, comparison, and thus control. As the secular descendent of religious confession, this came to be achieved in modernity by the creation of a new optical or perspectival technology; a new system of topological and chronological relations amongst individuals, environments, and communities, designed to both echo and enable the performance of individuals' inner truths; a new technology for articulating and factualizing individualities. The museum was precisely such a technology; in certain respects the most paradigmatic means of knowledge production.

Museums today are part of a network of eclectic modern institutions designed explicitly to illuminate and illustrate important "truths" about individuals, peoples, nations, genders, classes, and races – in short, about precisely those things that museums are simultaneously complicit in fabricating and factualizing. The artifacts – the modernist fictions – *of* race, gender, nationality, ethnicity, identity, etc. These phantasms have for two centuries been key instruments of power and control in the massive enterprises of nationalism and imperial and global capitalization.

In point of fact the history of the institution effectively ended, and the museum itself was frozen in its final, unsurpassably evolved modern state, on 15 October 1851, at 4:30 in the afternoon. There has been nothing substantively new in museum and exhibitionary practice for a century and a half, except perhaps for the very recent admission that the evolution of museology may well be cyclical rather than linear, and that the self-described "post"-modernisms we may have avidly imagined ourselves to be desirous of a couple of decades ago (and that still survive in a dreary and hectoring half-life in our mostly moribund

art journals) have been little more than our modernity's own preservationist shell game. Such an admission could lead, belatedly, to a rather more nuanced and realistic understanding of the history and prospects of the institution than has been the case in the past couple of decades, where museology has been argued in the predictable accents of fashion, economics, politics, information management, marketing, or infotainment and edutainment.

Museology, art history, art criticism, aesthetic philosophy, connoisseurship, curatorship, commodification, and art making – we might refer to this matrix of practices under the common rubric of "museography" – are performative *genres* in the theatre of modernist nationalism and hypermodernist globalization. Common to them is the project of the modern corporate state in defining and prescribing disciplined and predictable linkages between citizen-subjects and their object-worlds. This causal linkage of psychology and physiognomy is no mere accident of modernity, but its very essence – and it is connected to the necessity of discovering, delineating, and articulating the individual citizen-consumer as a marked site; as the *locus* on and upon which meaning and purpose are constructed and inscribed. The citizen-consumer is thus both the product of, and productive of, this experiential world.

Some argue that changes in our social conditions require that the nature of museums must change. Others continue to argue, with equally partial cogency, that museological institutions should not be linked immediately or directly to external conditions, but should take a more preservative or archivally neutral role in society. Yet both positions are only opposed insofar as the two sides of the same coin are in conflict, since both take it as given that museums *really are* representational artifacts, and should be organized as "faithful" microcosms, as symbolizations, of particular worlds, histories, or peoples.

Underlying such presumptions are more fundamental attitudes toward objects themselves, and about our relationships to the world of objects as human subjects. Such attitudes in modern times have crystallized around the problem of "art" itself. I don't mean problems *with* art – whether someone thinks this or that art is good or bad, or politically correct or incorrect, or should or should not be displayed or debated or analyzed, or does or does not get to the heart of our current historical condition, to echo Arthur Danto's rather unfortunate if nonetheless telling words – but rather the problem that *is* "art" as such; its inherently paradoxical and ambiguous status. Modern conceptions of art are linked to our unquenchable desire to imagine art as a universal, pan-human phenomenon; the essential mode of symbolization; the (one might say purely graphological) idea that every distinguishable people "has" its own "art." The idea, in effect, that art is a universal language, exemplified (and legible) *in* the artifacts of every people.

We've been living in an age when virtually anything can properly be displayed (as "art" or as "history") *in* a museum, and when virtually anything can cogently be designated and serve *as* a museum. Trying to understand just what kind of world *that* is brings us closer to seeing what is more deeply at

stake today in attempting to deal with history, art history, culture, and politics. If virtually anything can be museological in intention and function, then we need to find ways of dealing with and talking about the institution – and, equally, about the "history" of visual cultures – in ways that depart from many of our received ideas. One possible beginning would be an investigation of the paradoxical complementarities between historiography and psychoanalysis, the two paradigmatic modernist modes of structuring memory, so poignantly illustrated some time ago by the late Michel de Certeau. Such an investigation would at the same time be an inquiry into the nature of our modern and hyper-modern subjectivities.

<div align="center">(4)</div>

I said earlier that the historical evolution of the modern museum effectively came to an end on 15 October 1851, the implication being that what we have seen since that time is an ongoing oscillation between what I'll call the two anamorphic states or facets of museological practice. One is the *temple of art*, which is to say the *shrine of and for the self*, intended to "cure" (i.e. discipline) individuals, and transform them into citizen-subjects of the nation-state or members of the Folk by imagining individuality, citizenship, as that which can be self-fabricated through optical and kinesthetic experience in museum space. The other is the *exposition* or expo, the *shrine of the object*, the sacred fetish, which was intended to transform citizen-subjects into consumers; to induce individuals to conceive of their lives with the fantasy-language of capitalism; to imagine oneself and others as commodities in every possible sense of the term. These are not opposites but rather anamorphoses of each other. That is, the relation between the two is that from the position or perspective of the one, the connections with the other are hidden or invisible.

Illustrated in Figure 2.2 is the Crystal Palace, the "universal exposition of the arts and manufactures of all nations," which opened on May Day 1851, and was closed by Queen Victoria at 4:30 pm on 15 October of that year, and which I argue in a forthcoming book was where the enterprises of capitalism, orientalism, aestheticism, fetishism, and patriarchy were stunningly and power-fully put in their full and proper perspective and interwoven for all to see, for the first time. That momentary, six month exposition was like a brief and blinding flash at mid-century that revealed, as would the quick shine of a torch in the night, an unexpected and uncanny landscape. The real landscape, as Walter Benjamin observed in 1937 speaking of that year's Paris exposition, of capitalism: "that catastrophic dream-sleep; that nightmare, that fell over nineteenth century Europe." What the Crystal Palace also revealed with unpar-alleled lucidity was the massive European imperial co-construction of aestheticism and orientalism in its de-othering or domestication of Others. In this extraordinary building, the largest in the world up to that time, and one which could have been extended indefinitely, the products of virtually all

<div align="center">39</div>

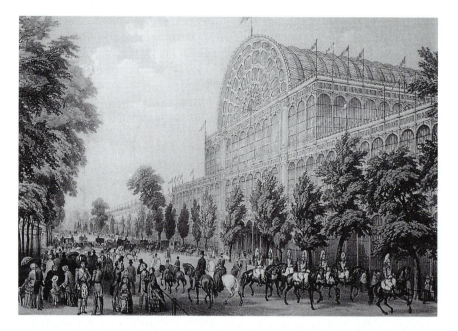

*Figure 2.2* The Crystal Palace, London, 1851. Color lithograph of exterior.

*Source*: Author photo.

nations on earth were displayed in pavilions defined by temporary screens, all within a grid of support columns, none of which was thicker than 20 cm in diameter. The building – in fact a vast greenhouse – was a blank, styleless grid or matrix, a three-dimensional model of an abstract system of classification, capable of absorbing, exhibiting, juxtaposing, and comparing anything with anything.

*I would claim that we have never in fact left this crystalline building.* We continue to wander amongst the topological and rhetorical machinery of its exhibits in the innumerable institutional and discursive simulacra we have built ourselves into, and transformed the planet into, since then. The Crystal Palace presents us with the most lucid and encyclopedic organization of our modernity – modernity's Unconscious, sketched out in glass and iron. (Only the contemporary Internet presents us with an even more extensively labyrinthine and efficient conception of the modernist concentration camp. But that's another chapter.)

(5)

Let me start to conclude by considering what the massive success of the Crystal Palace has caused us to *forget*. The first thing we have forgotten is that the invention of the modern museum as an instrument of individual and social transformation was, as we can now articulate more clearly, a specifically *Masonic*

idea. Virtually every single founder and director of the new museums in Europe and America in the late eighteenth and early nineteenth centuries was a Freemason, and the idea of shaping spatial experience as a key agent of the shaping of character was central to the museological mission from the beginning. The museum was also a Masonic realization of a new form of fraternization not dependent upon political, religious, or kinship alliances – that is to say, citizenship. They provided subjects with the means for recognizing themselves as citizens of communities and nations.

Sir John Soane's Museum in London is virtually unique (because of its actual physical preservation, mandated in Soane's bequest of it to the nation) in retaining today some flavor of the articulation of the Masonic program that it shared with the Freemasons who founded the Louvre (very explicitly organized for the political task of creating republican citizens out of former monarchical subjects), the original Ashmolean and, in part, the British Museum during its Montague House period, prior to the opening of the core of the present neoclassical temple of 1847. Of all these Masonic foundations, only Soane's retains the character that all these others (where they still exist) have lost.

In the summer of 1851 in London, then, you could have seen the two purest forms of this uncanny phenomenon we call the museum. Soane's Museum retained its final form upon his death in 1837, and the Crystal Palace was the final evolved state, the complete summation of the expositionary practices that had begun earlier in the century in a smaller and more fragmented fashion with the arcades of London and Paris, here orchestrating together the whole world of peoples and their products, of objects and their subjects. Replacing the ubiquitous prostitutes found in and around all the arcades was the ubiquitous figure of Queen Victoria, whose arrival in the Crystal Palace (Prince Albert's project) virtually every other day galvanized thousands, and whose gaze encatalyzed the desires of the multitudes (Figure 2.3). In seeing Victoria seeing, an Empire – a whole world – learned how and what to desire. One might compare the gaze of Victoria with that of Soane in their respective institutions.

The dazzling effects of the Crystal Palace have blinded us to seeing Soane's Museum in a way different from how it was intended to be seen, rendering the latter, by contrast, quaint, disordered, idiosyncratic – like the *Wunderkammern* of an earlier age might have come to be seen in the nineteenth century – in fact, *obscuring its function as a critical instrument whose own artifice was its subject matter*. Soane's Museum provided its visitors with a set of tools and instruments, derived from Masonic practice, for imagining a humane modern world – a world that reintegrated the lost social and artistic ideals being rent asunder by the early Industrial Revolution. It did *not* portray or present or "illustrate" what we might imagine or desire as "the" history of art or architecture. Art history as we know it today was the offspring of the marriage of Hegel and the Crystal Palace, whose midwife was Queen Victoria.

There is a sense in which the projects of John Soane and of Albert Einstein three-quarters of a century later can mutually illuminate each other. Much as

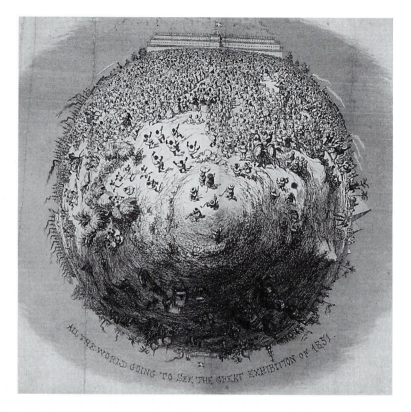

*Figure 2.3* George Cruikshank, *All the World Going to the Crystal Palace*, 1851.
Lithograph.
*Source*: Photo courtesy University of Colorado at Boulder Art Gallery.

Einstein did, Soane made legible the *processes* of fabricating histories – the very activity of constructing frames of understanding – the focus of his work. In the Museum, Soane made visible the practical labor of how artistic and architectural wholes might be imagined; he made legible how frames of understanding are set up, and how they are a complex function of the point of view of the observer. As did Einstein later in physics, Soane made visible the idea of a relativity of perception that avoided relativism and extreme individualism.

Soane's Museum was neither a "historical" museum nor a "private collection" in their more familiar later nineteenth- or twentieth-century senses. It was among other things an institution for understanding how histories – both individual and collective – might be fashioned: an instrument of social change and cultural transformation. As a result, unlike the object-commodities in the Crystal Palace – and unlike those in the modern domains of art history and museology which are descended from them – the objects in Soane's Museum did not "have" "meanings" that are fixed or final; they are, to use a linguistic or semiotic analogy, more phonemic than morphemic, being indirectly or differen-

tially meaningful rather than directly significative. Their significance lay in their potential abilities to be recombined and recollected by the visitor to form directly meaningful units – what Soane himself referred to as a "union" of all the arts. They are thus not strictly "objects" at all in the common (modern museological) sense of the term; and still less are they "historical" in any simple or historicist sense. They were not "museum objects" in the more recent sense of entities complete in their substance and significance – that is, as independent and distinct works of "fine art."

The museum today is a social phenomenon precisely of the order of an optical illusion, perpetually oscillating between one or another protocol of relating together objects and the subjects that seem to *haunt* them; subjects and the objects that appear to *represent* them. Artifacts or artworks have themselves for 150 years had a similarly anamorphic character, alternating between the two modes of modern fetishism – the aesthetic artifact ('art') and the commodity.

The objects of our art historical or museological attention – works of art – also oscillate between historically grounded documents and timeless fine art, between specimens in a class of like objects whose significance is a function of their place in time and space, and unique and mysterious and irreducible aesthetic entities. The objects of our art historical and critical attention oscillate between being understood as historical documents and sacred or magical relics. Our greatest challenge today is surely to understand what sustains this system of anamorphisms – even if it means that to take up such a challenge may entail a radically new orientation on the world of objects and their subjects. If the subject–object dichotomy that sustains our work is the effect of an aesthetic ideology grounded in a secularized theology, then we need to understand in greater depth what brought this about historically in the sixteenth and seventeenth centuries. In this regard, greater critical attention by art historians to the metamorphoses wrought by the Reformation and Counter-Reformation would be in order.

One thing that Soane's Museum may teach us is that our commonplace historiography of museums, which has claimed a progressive evolution of forms of display from earlier idiosyncratic or unsystematic practices to the more rational, systematic, and more historically "accurate" and encyclopedic practices of today, is not merely reductive, but false, being itself an artifact of the kinds of museology (and art historicism) that triumphed in the second half of the nineteenth century as indispensable instruments of national and imperial politics and capitalization. To imagine that museums have evolved in a linear, progressive manner would be to participate in and perpetuate the museums' own avant-gardist and historicist fictions. The modern museum (and its ancillary and complementary technologies such as history and art history) are heirs to an ancient European tradition of using things to reckon with, and of using them to fabricate and factualize the realities that in our modernity they so coyly and convincingly present themselves as simply re-presenting. Museums are

modernity's paradigmatic artifice, and the active, mediating, enabling instrument of all that we have learned to desire we might become. Modern experience is above all museological in nature: it is necessary to begin to understand exactly what we see when we see ourselves seeing museums imagining us.

(6)

So also do we need to attend to what museums present to us as objects, which provide us with the opportunity to attend to their ability to give back to us ideal images of ourselves as subjects; as possible identities, possible worlds, possible lives; possible ways of being. That mode of attending to what each of us might learn about ourselves as subjects from the museum's objects is what the modern (re)invention of the museum afforded – as for example in Soane's Museum, that remarkable astrolabe of the Masonic Enlightenment, intended to provide us with the means of learning how to ask questions; the raw materials for imagining a humane modern world in which the difference and otherness of individuals, and their internal complexity and heterogeneity, can be imagined and maintained, a world in which perception was imagined as active and constructive, rather than passive and consumptive. That world was submerged by the massive success of the Crystal Palace and its multiple progeny. Juxtaposing them – as I hope to have suggested here – can be a critical act, a first step to extricating ourselves from the deadly habits of modernist historicism and its teleological phantasms.

What, then, of our relationships with objects and object-worlds? It is when we imagine that we hear voices behind the silences of the wall, or within or behind or prior to an object; when we listen as passive readers or consumers to what the work of art "says" – letting "the work of art speak directly to us with a minimum of distraction or interference," as one ubiquitous museum guidebook puts it – that we paradoxically abandon our active subject positions and adopt a mode of agency dependent upon an imaginary consistency and wholeness as the autonomous authors of our actions – a statuesque fiction. It is in this way that we claim to reconstitute what objects "really meant" in their historical realities, and to hear the voices of an absent author (society, mentality, race, nation, class, gender, etc.) "speaking" through the "medium" of the object, revealing to us or to all time some authentic nature, mentality, or intention. Such secular theologism is completely consistent with that which claims that the world must only make sense as the artifact of a divine Artificer.

Visitors to the Crystal Palace (which continues to *pursue* us relentlessly through all its institutional and professional progeny) learned precisely to "read" in each object the "true" character of a person, people, race, or nation. This astonishing institution simultaneously fixed individuals in place as subjects for certain meanings, and provided them with a subjectivity, in effect subjecting them to the imaginary structure of society with its existing but occluded contradictory powers and relations. It is no exaggeration to say that the Crystal

Palace taught the world how to practice an art historicism and a historiography which, in bonding together fetishism, aestheticism, orientalism, capitalism, and patriarchy, fictionalized any possible escapes. A people or nation was therein convincingly conflated with its products, and products became emblems or simulacra of individual and national differences. Differences between peoples and persons could be convincingly reduced to stylistic qualities: you are what you make, *art history as graphology.*

Leaving this – finally exiting the world of the Crystal Palace with which we have been mesmerized for so long, and which is the ideological and conceptual *Unconscious* of our art histories and museologies today – may in fact entail more than finally seeing our own practices in their historical and cultural contingency. It may entail more than finally seeing what lies historically and conceptually prior to museology and art historicism.

Nonetheless, these are necessary first steps. I've suggested here that one of the things that can be glimpsed beneath the commodity fetishisms of the Crystal Palace is an earlier, more relational, interactive, and critical form of subject–object relations represented by an institution like Soane's Museum – itself the heir to pre-Enlightenment practices since forgotten. Such a critical historiography would mean coming to terms with the real artifice of art historicism. We need to learn to see what the perfect clarity and dazzling visibility of the Crystal Palace – not to speak of our own "history of art" – actually blinds us to and in fact renders obscure. In the end, we need to un-learn the domestications, the de-otherings of otherness that art history since Hegel and museology since the Crystal Palace have naturalized to the point of appearing to erase alternatives. In coming to appreciate the historical *contingency* of art history and museology, we may be in a better position to appreciate the contingencies of historiography, critique, and interpretation themselves.

The method of accomplishing this effectively may in the end be circumstantial, opportunistic, and individual. The juxtaposition of odd and uncanny quotations and of simultaneously true contradictions, as this essay has suggested, might provide one avenue, useful for some, perhaps not for others. But of course each of us must find our own way to hear the unsaid in what art history says it is saying.

### NOTE

* An earlier version of this chapter was read as the keynote address to the Nordic Conference on the Historiography of Art, Uppsala, Sweden, 17 June 2000.

# 3

# FROM BOULLÉE TO BILBAO

## The museum as utopian space

*Andrew McClellan*

We have grown accustomed to associating the rise of the museum with the decline of organized religion as a source of individual meaning and social cohesion. Art and culture have become new sources of spirituality in the West, the argument goes; art museums are the cathedrals of our time. Over two hundred years ago the young Goethe made the connection when he described his first visit to the Dresden museum as an experience which "opened a new prospect to me, and one that has had its effect on my whole life. With what delight, nay intoxication, did I wander through the sanctuary of that gallery!" From that moment "the love of art ... stayed with me like a guardian angel."[1] Goethe's testimony notwithstanding, recent critics have drawn only negative conclusions from the analogy, identifying the sort of uplift Goethe describes as bourgeois mystification masking the denaturing of art and the interests of the museum's sponsors. In this account, museum rituals have replaced rituals of the church and serve to enforce social hierarchies, political agendas, nationalistic myths, and art's commodification. The loss of original function inflicted on art transferred to the silent, eternal resting place of the museum gave rise to a second metaphor: the museum as tomb – and lately to a third: the museum as a shopping mall.

The force of these analyses is undeniable and a museum visit may indeed be construed as a ritualized lesson in societal values (though arguably no more so than a football game), but I would suggest that the metaphors of church, tomb, and mall fall short in their failure to account for the remarkable and enduring success of museums across time, space and significant cultural divides. These critical metaphors, born of avant-garde impulses in the arts and academia, obscure the fundamentally positive goals of museums which motivate governments, philanthropists, and corporations in the first place. Insofar as museums are social institutions dedicated to producing a better life here on earth (rather than an afterlife in heaven) and have proven themselves adaptable to contingent historical circumstances and shifting visions of what constitutes a better future, we should think of them also as utopian institutions. As a paradigm, the museum as a utopian space not only accommodates the social aspirations and future-driven ameliorative dimension of museums, but it also has powerful

46

explanatory reach, for the idea of utopia accompanies and overlaps the evolution of museums from their joint conception in early modern Europe, through Goethe and the Enlightenment, to the present. In his account of Dresden, Goethe himself went beyond his inner experience to describe the museum as "an eternal spring of pure knowledge to the youth; a strengthener of sensibility and good principles to the man, and wholesome for everyone." Not surprisingly, museum-like structures dot the landscape of the "pedagogic utopia" at the heart of Goethe's late novel *Wilhelm Meister's Travels*.

While the composition and purpose of Europe's first museums in the form of the *Kunst- und Wunderkammer* is by now well enough known, the connection between these spaces and the idealized collections and institutions of knowledge which figure prominently in early modern utopias bears closer scrutiny. If we may characterize the *Wunderkammer* as a microcosm of the universe, an attempt to contain and render visible the phenomena of the world, the desire for universality was fulfilled not in actual collections, where perfection remains forever an unreachable goal, but in the imaginary spaces opened up by utopian texts and architectural treatises. Three of the most famous early modern utopias, J.V. Andreae's *Christianopolis* (1619), Tomasso Campanella's *City of the Sun* (1623), and Sir Francis Bacon's *New Atlantis* (1627), all feature institutions of knowledge at the core of their imaginary communities. These three books, written by men of different nationalities, professions, and religions, mark the spread of a utopian museum ideal across Europe in step with the culture of curiosity.

Bacon's ideal city on the island of Bensalem was built around a college "dedicated to the study of the ... true nature of all things ... [the] enlarging of the bounds of human empire, ... the effecting of all things possible."[2] Much of the *New Atlantis* is given over to a detailed description of the college, its facilities and goals, as if it were the true subject of the text. Andreae's *Christianopolis* is similarly dominated by a college embracing institutions representing all knowledge: a library containing "the offspring of infinite minds ... everything that is by us believed to have been lost;" a pharmacy in which could be found "a compendium of all nature;" a museum "about which the most wonderful things can be said, for the whole of natural history is to be seen depicted on the walls," and so on.[3] In Campanella's *City of the Sun* knowledge is represented not in dedicated buildings but inscribed on the city's seven concentric walls, making learning an integral, everyday activity.[4] To the extent that the three books (especially Bacon's) went beyond fantasy to become a pattern for later educational institutions, they exemplify the status of utopias as "a state of impossible perfection which nevertheless is in some sense not beyond the reach of humanity."[5] Put another way, it is precisely through such institutions of knowledge that Western society has sought to better conditions on earth, and it is this utopian outlook that underpins the growth of museums.

But if these visions anticipated future academies and museums, they did so by looking back to classical antiquity, to the fabled *mouseion* at Alexandria and

the academies of Plato and Aristotle, which floated like a mirage across the sands of time. Memories of those institutions haunted the Renaissance imagination, and the dream of recuperating and even surpassing lost knowledge underpinned all collecting activity and related study.[6] Witness Andreae's traveler in the library at Christianopolis "dumbfounded to find there very nearly everything that is by us believed to have been lost."

Even as knowledge began to progress beyond what was inherited from the ancients, antiquity provided the means to represent the noble quest for knowledge through architecture. Beyond providing a physical space for the gathering and study of books and objects, museums, libraries, and academies were expressive in and of themselves of the idea of universal knowledge. At first, however, when the curiosity cabinets of Europe were housed within previously existing structures, the ideal of the public institution took shape in paper projects and utopian texts. As Marcin Fabianski has shown, an iconography of the museum, derived from various classical sources including the Pantheon, the Temple of Solomon, and temples of Apollo and the Muses, stabilized in architectural texts and images around a domed rotunda or octagon often decorated with allegories of the intellectual virtues and arts.[7] As notional architectural spaces symmetrical in plan and perfect in form, these ideal museums and temples embodied a terrestrial reflection of the abstract harmony of the heavens above. In this they shared marked affinities with ideal city plans of the Renaissance, whose symmetry and regularity constituted, in the words of Lewis Mumford, "a symbolic representation of the universe itself ... lowered down from heaven and cut to a heavenly pattern."[8] Eventually becoming an essential component of the ideal city, the museum bears dual allegiance to polis and cosmos through its rational arrangement and timeless form. In the three utopias mentioned above, spaces of knowledge are located at the "very heart" (Andreae) or "very eye" (Bacon) of the ideal community or, in Campanella's *citta del sol*, are mapped onto the circular city walls, each named after a planet, enclosing a domed temple.

Related to these fictive sites of learning is Raphael's great fresco of the *School of Athens* in the Vatican (Figure 3.1).[9] One of four frescoes decorating the library of Julius II – a space likened by contemporaries to the libraries at Pergamon and Alexandria – it shows an imaginary gathering of history's great minds led by Plato and Aristotle, who stride forward engaged in metaphysical *conversazione*. The two men point to heaven and earth respectively, representing an ideal fusion of speculative and empirical philosophy contributing to "causarum cognito," the knowledge of things, inscribed in the vault above. The scene is utopian in its suggestion of a purposeful march toward ultimate knowledge through the efforts of past, present, and future genius. The painted architecture in the *School of Athens* functions in an appropriately symbolic manner; as in other ideal *musea*, books and specimens are replaced by statues of Apollo and Minerva while the impressive barrel-vaulted space, a domed Greek cross whose scale is enhanced through perspective, signals the worth of scholarly enterprise and the grandeur of knowledge.

48

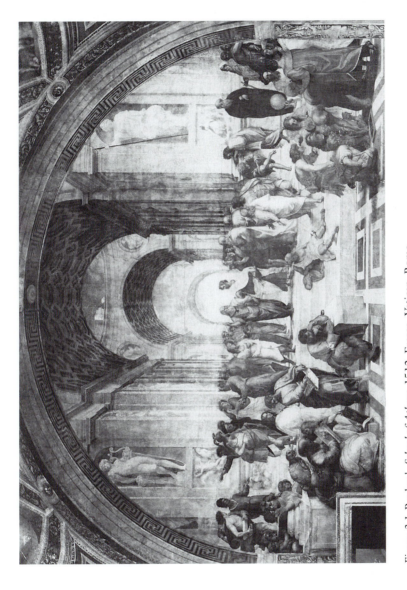

*Figure 3.1* Raphael, *School of Athens*, 1512. Fresco, Vatican, Rome.

*Source:* Photo: Alinari/Art Resources, New York.

These early modern representations prepared the way for the full flowering of the ideal museum during the eighteenth century, when Enlightenment attempts to reduce the distance between an imaginary utopia and the actual world through philosophy and pragmatic reform lent architecture and social institutions a special responsibility. In the words of Bronislaw Baczko, the Enlightenment effected a shift from "cities in utopia to the utopia of the city, from power and government in the utopia to the power and government envisaged as the agent of the utopia and the executor of social dreams."[10] A spirit of improvement, fostered by government schemes, fueled architectural treatises by Laugier, Blondel, Patte, and Peyre which combined blueprints for building types with specific ideas for the improvement of Paris. All the while students at the academies of Paris and Rome, free from the constraints of building in the real world, indulged their imaginations in the design of perfect museums, monuments, and a variety of other useful institutions.[11] It was on the level of imaginary design that the architecture and utopian writing of the Enlightenment converged, cross-fertilizing each other to produce literary and visual urban schemes and monuments of fantastic proportions.

In the realm of utopian fiction, Sebastian Mercier's novel *The Year 2440*, published in 1771, is particularly important. Traveling into the future instead of a distant land, Mercier's protagonist found himself at the center of Paris standing before a vast temple of knowledge labeled "Microcosm of the Universe." Entering the building, he found "four wings of immense proportions ... surmounted by the largest dome I had ever seen" and on display he found every specimen of nature and human culture laid out with judgement and wisdom.[12] He confessed to feeling overwhelmed by the spectacle: "I felt oppressed by the weight of so many miracles. My eye embraced nature in all its bounty. How at that moment I felt compelled to admire her author!" Everywhere he turned he found students and members of the public studying in an atmosphere of cooperation and freedom so different from what he had known in the eighteenth century. As in earlier utopias, Mercier's museum functioned as both a working site of knowledge and symbol of society's values.

Like other Enlightenment utopias, Mercier's novel was a polemical text which disguised as fiction directions for actual reform. Strictly speaking *The Year 2440* is a *uchronia* not a utopia, and the familiar setting transformed through civic action aimed to spur the government to realize the future now. As if in direct response to Mercier's challenge, the government of Louis XVI, guided by Count d'Angiviller, minister of the arts, made the Louvre museum a top priority after 1774. D'Angiviller was a friend and fellow minister of the physiocrat economist Baron Turgot, champion of the Enlightenment belief in human progress.[13] Turgot's belief in the power of knowledge and institutions to bring about continuous societal advancement underlies all that d'Angiviller did for the arts, from patronage of moralizing history painting to the creation of the museum.

In 1778, when the Royal Academy of Architecture staged a competition to design an ideal museum under d'Angiviller's watchful eye, Mercier's description

would seem to have inspired the winning entries by Gisors, Delannoy, and Durand (Figure 3.2). Of course, it might equally be said that Mercier had been inspired by the many earlier imaginary designs issuing from the academies of Paris and Rome, but the important point is that by the middle of the eighteenth century a centrally planned building with a dominant, usually domed room in the middle of four wings had become the standard format for public buildings devoted to knowledge and the arts.

This also holds true for the most compelling and influential of Enlightenment paper projects by Etienne Boullée, the great visionary architect whose sway over the generation of Durand and academy competitions of the late eighteenth century is well known. Boullée's own museum designs represent

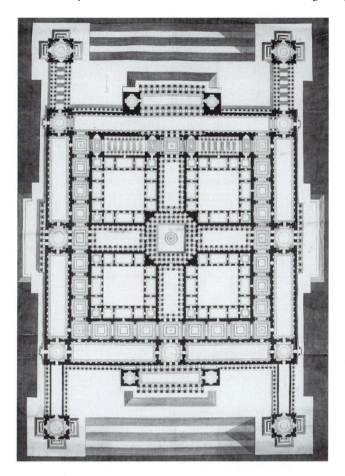

*Figure 3.2* Jacques Pierre Gisors, *Museum Design*, 1779. Drawing with watercolor.

*Source*: Courtesy of École nationale supérieure des Beaux-Arts, Paris. Photo: ENSBA.

a synthesis of earlier ideas and, though not published until 1783, most probably stand behind the student submissions of 1778 (Figures 3.3 and 3.4).[14] Where Boullée surpassed the younger architects is in his ability to achieve dramatic effect on the page through his handling of space and light, scale and perspective; though working with the same structural elements and within the established parameters of the building type, his vision is grander, more transcendent and sublime. Some have called it megalomaniac, but it would be more accurate to say that Boullée has more successfully articulated the utopian *character* of the museum.

The concept of "character" was at the heart of all that Boullée and other late eighteenth-century architects designed. Indebted to the sensationalist philosophy of Locke and Condillac, the theory of character held that buildings must

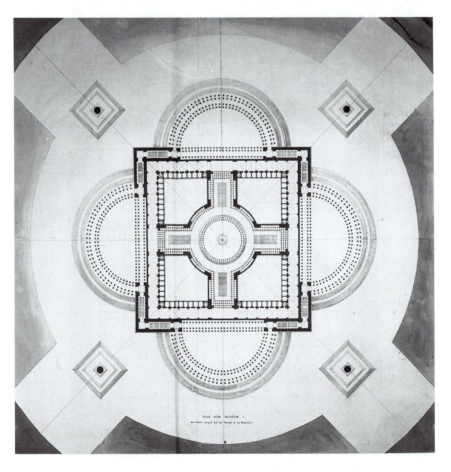

*Figure 3.3* Etienne-Louis Boullée, *Plan of a Museum*, 1783. Drawing with watercolor.

*Source*: Courtesy Bibliothèque Nationale, Paris. Photo: cliché Bibliothèque Nationale de France.

*Figure 3.4* Etienne-Louis Boullée, *Interior View of a Museum*, 1783. Drawing with watercolor.

*Source:* Courtesy Bibliothèque Nationale, Paris. Photo: cliché Bibliothèque Nationale de France.

be expressive of their use, and that a mere glimpse of a building would reveal its significance. Insisting that the idea must precede and determine the design, Boullée began by pondering a building's purpose:

> To give character to one's work, it is necessary to study the subject in depth, to rise to the level of the ideas it is destined to put into effect and to imbue oneself with them to such an extent that they are ... one's sole inspiration and guide.[15]

The effect, communicated through the senses, must be immediate and clear. In the case of buildings useful to society, which were always Boullée's primary concern, the architect must strive for magnificence and grandeur. Temples of knowledge, tombs of great men, the palace of a benign sovereign – all play a key role in their form as well as function in the public life and education of a people.

Leaning heavily on Burke's idea of the sublime, the *architecture parlante* of Boullée and his colleagues relied on certain forms, spatial relations, and effects of light and shade to trigger predictable and consistent responses in the beholder, which explains why there is a good deal of formal similarity among their elevated building types. Interrelated in purpose, they shared much in design and visual effect. Following Burke, and anticipating Kant, Schiller and other adherents of the sublime, Boullée was much preoccupied with the effect of immensity and infinity on the subjective mind. Achieved through visual means, immensity transcended the initial feelings of fear and vulnerability it aroused to evoke a sense of profound wonder at the bounty of the universe and man's ability to fathom it. Like Burke before him, Boullée used effects of nature to explain the sublime but his achievement lay in articulating an architectural equivalent to the feelings of awe we experience in the face of boundless oceans and mighty mountains. Transferred from nature to the built environment, immensity elevates the mind to a plane of abstract concepts, such as eternity, genius, and space. In his designs for noble public monuments, dizzying perspectives of columns, cavernous vaults, and glowing parabolas of light form a common vocabulary of the architectural sublime intended to dazzle and impress the beholder.

Boullée came close to realizing one of his schemes in the mid-1780s when he was asked to convert the *Palais Mazarin* into a royal library. Central to his plan was the massive, luminous barrel-vaulted reading room, given a thrilling and awesome aspect in a perspective view that anticipates a visitor's first *coup d'oeil* upon entering the space (Figure 3.5). The combination of spatial recession, suffused light, and figures dwarfed by knowledge justifies his description of the project as "sublime." Piranesi never seems far from Boullée's mind in such designs but in this case he acknowledged another inspiration: "I was deeply impressed by Raphael's sublime design for the *School of Athens* and I have tried to execute it."[16] Though his plans were shelved, they were well known through publication and an exhibited scale model and would seem to have influenced another royal project that did reach fruition during his life, namely the museum

*Figure 3.5*  Etienne-Louis Boullée, *Design for the Royal Library*, 1785. Drawing with watercolor.

*Source:* Courtesy Bibliothèque Nationale, Paris. Photo: cliché Bibliothèque Nationale de France.

in the Grand Gallery of the Louvre. Boullée's involvement with this project brings utopian discourse and an emphasis on architectural effect into the realm of museum design and the visitor's experience, where they remain to this day.

With instructions from d'Angiviller to transform the Grand Gallery into a "monument unique in Europe," the Royal Academy of Architecture met in 1785 to select nine architects, including Boullée, to determine how to maximize the potential of the existing space.[17] At this very moment Boullée was also working on the conversion of the royal library and the two projects, linked in purpose, bear more than a passing resemblance. I would like to focus on the architects' final report, submitted to the Crown in 1787. Though signed by all nine architects, the document reveals the clear mark of Boullée's approach to design in its treatment of detail and, more important, the effect of space and light in the mind and eye of the beholder.

The report opened with the matter of whether the long gallery should be divided with columns or partitions or decorated in some way. The answer was a firm no on both counts.

Decoration was to be limited to the vault, cornice, and two end doors, and even here restraint was recommended in order to attain an "expression of noble simplicity appropriate to the grand character of the place." The question of divisions required closer study and the architects found themselves pitting *a priori* reasoning against direct sensory experience of the space itself. In the end, to their surprise and delight, visual effect defied rational calculations:

> When we first saw the gallery plans at the Academy, we were virtually all agreed that some division of the space would be necessary. We differed only on the number of divisions that would be needed to create compartments comparable in size to existing picture galleries …. But once we set foot inside the monument and saw it with our own eyes a unanimous cry went up from all those involved against altering in any way the *spectacle of immensity that first meets the eye.* None of us was left with any doubt that the gallery should be left alone despite its seemingly disproportionate length; reason would easily fault this finding, and yet the senses, which must be the judge of such matters, find the proportions sublime. It is possible that theory could justify this impression; on the other hand its cause may remain obscure; in any event it would be impossible for any sensible man to remain unmoved by the effect.[18]

Immense spectacles, obscure causes, and the senses as supreme arbiter of judgment are the hallmarks of the Burkean sublime assimilated by Boullée.

An equal reliance on the eye and experiment bolstered their conclusions on lighting. After numerous visits to the top-lighted spaces of Paris, the architects came away convinced that "all those in the habit of using their eyes … will decide in favor of lighting [the gallery] from the summit of the vault." As for

the glass to be used in the skylights, they settled on a variety from Alsace which, left unpolished on the outside, would absorb the rays of the sun and create a "magical," even diffusion of light within. In conclusion, "we agreed that the size and placement of the openings will create an extraordinary and unique effect taken together with the extent and proportion of the gallery and the riches on view." Before a picture or statue had been displayed, the architects resolved to create a wondrous monument in its own right.

All of the effects anticipated by the panel would appear to be perfectly captured in Hubert Robert's famous paintings of the Grand Gallery (Figure 3.6). Robert was no stranger to the Louvre project as he had been named a curator of the museum in 1784. The first of his imaginary views in particular, dating from the mid-1780s, shows a diffused light penetrating from above and the "spectacle of immensity" caused by an infinite recession of space to a distant point on the horizon. While this painting captures the spirit of the architects' report, it is also remarkably similar to Boullée's contemporary project drawing for the royal library, right down to the coffered vault (which the Louvre gallery

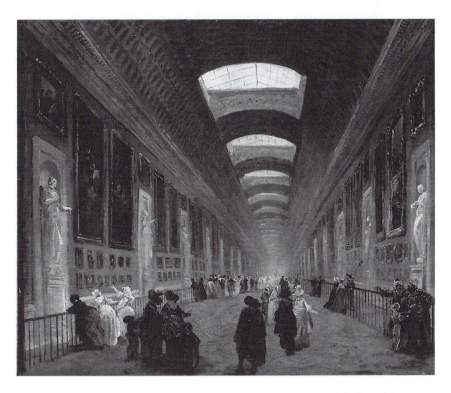

*Figure 3.6* Hubert Robert, *Project for the Arrangement of the Grand Gallery of the Louvre*, ca. 1784. Oil on canvas.

*Source*: Courtesy Louvre Museum, Paris. Photo: R.M.N.

never had) and shape of the skylights. The marked similarities speak to a pervasive fascination with the evocative, sublime potential of space and light and the importance of spectacle in grand public monuments.

By means of the widely disseminated engravings of his pupil J.-N.-L. Durand, Boullée exerted great influence on art museum design through the nineteenth and into the twentieth century.[19] The combination of uplifting domed spaces and perspective views, suffused light, rational plans, and classical style passed through Schinkel's Altes Museum in Berlin (1823–30; Figure 3.7), commonly regarded as the prototypical art museum, to John Russell Pope's National Gallery in Washington DC (1937–41), and beyond to the modernist refinements of Louis Kahn and his followers. Though the inception of the Louvre as an art museum signals a typological split of the encyclopedic storehouse of knowledge into museums and libraries of different disciplines, the universal aspirations and noble sentiments associated with the museum idea follow the architecture of knowledge and inspiration along its various trajectories.

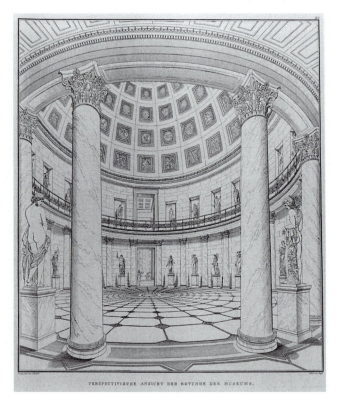

PERSPECTIVISCHE ANSICHT DER ROTUNDE DES MUSEUMS.

*Figure 3.7* Karl Friedrich Schinkel, *Altes Museum*, Berlin, 1823–30. View of the rotunda. Engraving.

*Source*: Author photo.

58

Along the way, and in step with unfolding utopian visions, the museum has evolved to accommodate new social ambitions. The continued success of the museum as an institution has depended to a large degree on its ability to nourish new dreams while remaining palpably tied to timeless values. The unquestioned benefits of accumulated knowledge and culture legitimize new goals and make the museum a magnet for still other desires. In short, the museum as a socio-political institution revolves around its shifting but always celebratory utopian potential. The Louvre of the French Revolution identified art as national patrimony and the museum as an open, public space, setting an example for nation states thereafter. Midway through the nineteenth century, against the backdrop of rapid urbanization and the industrial revolution, the art museum came to be seen as a refuge from the city and a wholesome recreational alternative to procreation and the pub for the working classes. As Charles Kingsley put it in 1848, "picture-galleries should be the townsman's paradise of refreshment ... beyond the grim city world of stone and iron, smoky chimneys, and roaring wheels."[20] The challenges of the new industrial age were met head on, and with great idealism, by the Victoria and Albert Museum in London and its progeny across Europe and the United States. Motivated by the prospect of superior design in manufacture, improved taste and trade, and meaningful work for the craftsman, the new utilitarian museum nurtured fanciful visions of a future in which the needs of society and the individual, the industrialist, the workman, and the consumer, could be reconciled.[21]

The brave new world of industry and capital fueled the resurgence of aestheticism and gave art a new compensatory value as the sign of human creativity and individual worth. In the early twentieth century, a new generation of art museums, often located in salubrious parkland on the edge of the city, underlined their removal from everyday life and the museum visit became a "liminal" experience restoring the beholder's faith in the family of man. Inspiration from art's transcendent message replaced utility in the museum's mission. "Art is our precious heritage from the past," asserted the director of the Toledo Museum in the 1920s: "It is the best of all man knew and thought and dreamed."[22] Or as DeWitt Parker put it in a lecture at the Metropolitan Museum of Art in 1926:

> Art puts us in touch with the desires of other classes, races, nations ... .
> The understanding of other nations, which by any other path would be
> long and difficult, is immediate through art ... Even as love creates an
> instant bond between diverse men and women, so does art between
> alien cultures.[23]

The historicizing Beaux-Arts style of the new art museums at Toledo and elsewhere, inspired by Durand, deliberately ignored currents of modern architecture; but when avant-garde architects turned their attention to museums, their designs were no less utopian in spirit. In the late 1920s Le

Corbusier designed a "Museum of World Culture" as part of his Mundaneum project for the League of Nations on the outskirts of Geneva. Universal in scope and embracing human history from prehistoric times, the *Musée Mondial* was to be a square ziggurat in form, whose plan recalled the symmetrical layout of Andreae's Christianopolis.[24] Clarence Stein's "Museum of Tomorrow" of 1930 took the form of an octagonal skyscraper embracing diverse art forms, cultures, and types of visitor.[25] Best known of all, of course, is Frank Lloyd Wright's Guggenheim Museum (1942–60; Figure 3.8). Guided by his advisor Hilla Rebay, the museum's founder, Solomon Guggenheim, believed that his "non-objective" (abstract) art was a universal language that, made accessible, could lead to a "brotherhood of mankind" and a "more rhythmic creative life and so to peace."[26] As Rebay put it to Wright, the new art would usher in "a bright millennium of cooperation and spirituality ... understanding and consideration of

*Figure 3.8* Frank Lloyd Wright, Solomon Guggenheim Museum, New York, 1943–59. View of the rotunda.

*Source*: Author photo.

others ... Educating humanity to respect and appreciate spiritual worth will unite nations more firmly than any league of nations." "Educating everyone ... may seem to be Utopia, but Utopias come true."[27] For Rebay and Guggenheim "art's utopian social values were primary," as Neil Levine has written, and Wright responded by creating an exhilarating dome of spirit, at once utterly modern and indebted to a tradition of inspirational museum architecture. Adding to the iconography of dome and circle, Wright conceived the Guggenheim as an "optimistic ziggurat," an inverted Tower of Babel whose form heralds community and shared experience in place of human dispersal and miscommunication.

In the wake of Wright's bold gesture, museums have become the most dynamic building type of our time, eliciting extraordinary work from the world's most distinguished architects. Frank Gehry's Guggenheim in Bilbao (Figure 3.9), dubbed the most important building of the twentieth century, is only the best known of the new breed of museums. What motivates these architects, and the governments and donors who support them, is the undying

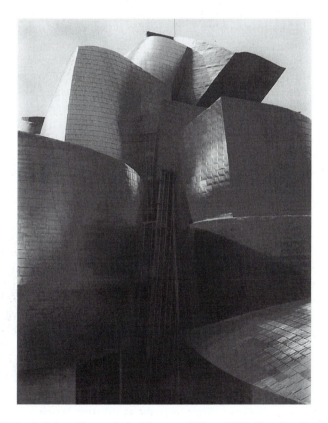

*Figure 3.9* Frank Gehry, Guggenheim Museum, Bilbao, 1997. Exterior view.
*Source*: Author photo.

utopian potential of the museum itself. In an age of media overload and "amnesia," to borrow Andreas Huyssen's expression, museums have become more important than ever as a space apart and assertion of core human values.[28] Gehry's museum may exemplify the technological sublime, but it is the architect's genius and the harnessing of technology to serve art and society that makes his building so compelling. Furthermore, the miracle of Bilbao demonstrates that culture may be the answer to urban decay, blight of the industrialized world. From the ruins of one utopian dream, the museum at the center of revitalized cities gives rise to another.

If respite from the modern world and engine of urban renewal are new ideals projected onto our museums, they continue to be a source of nourishment for the dream of a unified, harmonious society, which has acquired added urgency in recent decades in step with increased multicultural awareness. Witness, for example, the mission statement for the new de Young Museum in San Francisco, to be designed by Herzog and de Meuron. Not only does the museum promise to be an "urban oasis" contributing to "the City's crusade for urban renewal," but it will serve as "a common ground where – through art – the usual boundaries that separate us from each other: culture, creed, race and all the others, become bridges that connect us."[29] According to the architects, the building will itself articulate "the distinctiveness of different cultures" but also the "hidden kinships between divergent cultural forms."[30] Whatever differences of inflection we find in the mission statements and architecure of the new museums, they share a commitment as buildings to signaling their value as a place of meeting and dialogue, contemplation and beauty.

Since Wright and the Guggenheim, critics and curators have begrudged the new museum architecture, arguing that it interferes with the viewing of art as the primary purpose of the museum visit. For many in the art world, it seems, Bilbao represents nothing less than "the annihilation of the museum as we know it."[31] But such reactions are as historically shortsighted as they are hysterical. On the one hand, recent architects have learned from the mistake Wright made in not separating out spaces of display from the symbolic spaces of inspiration. What is overlooked in the rush to condemn the excesses of Gehry's museum, for example, is that the soaring atrium spaces are but the thrilling prelude to the adjoining, much quieter and quite conventional "white cube" galleries for the display of modern art. In fact Gehry has improved the static white cube format of earlier museums by subtly varying the shapes and sizes of his galleries in the interests of sharpening the beholder's attention to new art as one moves from room to room. On the other hand, critics nostalgic for the pre-blockbuster era of seemingly neutral installations and discerning viewers see architecture as a symptom of a new pandering to the public and in the process disregard the important role architecture has always played in marking the special place museums occupy in society. (They also disregard any benefits of the new populism, but that is another matter.) A function of our cultural amnesia – and the museum's forward-looking idealism – is that we forget that Schinkel's Altes

Museum was a striking building in its time, as the Guggenheim in Bilbao is today; that the Louvre when it first opened was a dazzling tourist attraction no less popular than the Pompidou Center has been in the last twenty years. To be sure, the public for art has swelled to levels disconcerting to art world insiders, and museums must now accommodate entertainment functions seemingly at odds with serious consumption of art, but these developments have not fundamentally altered, nor should they blind us to, the museum's quest for self-expression through built form, or what Boullée called its "character." Character was central to the Beaux-Arts tradition which produced so many now virtually invisible temple museums, while the spirit of Boullée may surely be felt in a broad range of great buildings from Schinkel and Soane in the early nineteenth century to I.M. Pei's Louvre pyramid, the vaults of Louis Kahn's Kimball Museum, James Polshek's dazzling Planetarium in New York, and Gehry's new Guggenheims. Through the medium of the museum and a common vocabulary of space, light, and form, the "speaking architecture" of Boullée speaks to us still.

To the extent that we expect art museums to float above the messy contingencies of the real world and affirm the eternal principle of beauty, they remain utopian spaces, and we rely on architecture to communicate this function to us. Such values are distasteful and naive to the postmodern ear, but there is perhaps no surer sign of the will to transcend the somber verities of postmodernism than the recent boom in celebratory museum architecture. If some years ago postmodernism decreed the obsolescence of the museum, the museums of the new millennium declare the irrelevance of postmodernism by embracing the legacy of Boullée and the utopian optimism of the Enlightenment. But of course much of the postmodern critique of museums is itself utopian in spirit, for what are charges of elitism, racism, and commercialism if not a call for the museum to live up to the full promise of its utopian rhetoric?

## NOTES

1 *Goethe on Art*, edited and translated by J. Gage, London, Scolar Press, 1980, p. 41.
2 Sir Francis Bacon, *Essays, Advancement of Learning, New Atlantis*, Franklin Center, PA, Franklin Library, 1982, pp. 372, 382.
3 J.V. Andreae, *Christianopolis*, trans. E.H. Thompson, Dordrecht, Kluwer Academic Publishers, 1999, pp. 203ff.
4 T. Campanella, *The City of the Sun*, trans. D.J. Donno, Berkeley, University of California Press, 1981.
5 K. Kumar, *Utopianism*, Minneapolis, University of Minnesota Press, 1991, p. 3.
6 See, most recently, P. Young Lee, "The Musaeum of Alexandria and the Formation of the Muséum in Eighteenth-Century France," *Art Bulletin*, 1997, vol. 79, pp. 385–412.
7 M. Fabianski, "Iconography of the Architecture of Ideal *Musaea* in the Fifteenth to Eighteenth Centuries," *Journal of the History of Collections*, 1990, vol. 2, pp. 95–134.
8 L. Mumford, "Utopia, the City and the Machine," in F. Manuel (ed.) *Utopias and Utopian Thought*, Boston, Beacon Press, 1965, p. 14; also Kumar, *Utopianism*, pp. 12–16; H. Rosenau, *The Ideal City in its Architectural Evolution*, Boston, Book and Art Shop, 1959.

9 See M. Hall (ed.) *Raphael's School of Athens*, New York, Cambridge University Press, 1997, especially R.E. Lieberman, "The Architectural Background," pp. 64–84.

10 B. Baczko, *Utopian Lights: The Evolution of the Idea of Social Progress*, trans. J.L. Greenberg, New York, Paragon, 1989, pp. 319–20.

11 J.-M. Pérouse de Montclos, *"Les Prix de Rome." Concours de l'Académie royale d'architecture au XVIIIe siècle*, Paris, École nationale supérieure des Beaux-Arts, 1984.

12 [Louis-Sebastien Mercier], *L'An deux mille quatre cent quarante*, 1786, vol. 2, pp. 25–6ff. All translations mine unless otherwise noted.

13 On Turgot, see F.E. and F.P. Manuel, *Utopian Thought in the Western World*, Cambridge, Belknap Press, 1979, pp. 461ff.

14 On Boullée, see J.-M. Pérouse de Montclos, *Etienne-Louis Boullée (1728–1799): Theoretician of Revolutionary Architecture*, trans. J. Emmons, New York, George Braziller, 1974.

15 E.-L. Boullée, *Architecture, Essay on Art*, in H. Rosenau, *Boullée and Visionary Architecture*, London, Academy Editions, 1976, p. 90. On character also see N. Camus de Mazières, *The Genius of Architecture; or, the analogy of that art with our sensations* (1780), trans. D. Britt, Santa Monica, Getty Center, 1992; and S. Lavin, *Quatremère de Quincy and the Invention of a Modern Language of Architecture*, Cambridge, MIT Press, 1992.

16 Boullée, *Architecture, Essay on Art* (as in note 15), p. 104.

17 For further discussion of the museum's architecture, see A. McClellan, *Inventing the Louvre: Art, Politics, and the Origins of the Modern Museum in Eighteenth-Century Paris*, Berkeley and London, University of California Press, 1999, chapter 2.

18 C.-A. Guillaumot, *Mémoire sur la manière d'éclairer la galerie du Louvre*, Paris, 1797, pp. 21–3 (my emphasis).

19 On Durand and his influence, see W. Szambien, *Jean-Nicolas-Louis Durand 1760–1834*, Paris, Picard, 1984; H. Searing, *New American Art Museums*, New York, Whitney Museum of Art, 1982.

20 Quoted by C. Klonk, "Mounting Vision: Charles Eastlake and the National Gallery of London," *Art Bulletin*, 2000, vol. 82, p. 331.

21 T. Bennett, "The Multiplication of Culture's Utility," *Critical Inquiry*, 1995, vol. 21, pp. 861–89.

22 B.-M. Godwin, "What the Small Museum Can Do," *The American Magazine of Art*, October 1927, p. 528.

23 D.H. Parker, *The Analysis of Art*, New Haven, Yale University Press, 1926, p. 181. Also Lewis Mumford, *The Story of Utopias*, New York, Viking, 1962, p. 293: "Pure art" brings "people together on a common emotional plane, as men."

24 Le Corbusier and P. Jeanneret, *Oeuvre complète de 1910–1929*, 4th ed., Zurich, 1946, pp. 190–3.

25 C.S. Stein, "The Art Museum of Tomorrow," *Architectural Record*, 1930, vol. 64, pp. 5–12.

26 On the Guggenheim Museum, see N. Levine, *The Architecture of Frank Lloyd Wright*, Princeton, Princeton University Press, 1996, pp. 299–363.

27 Ibid., pp. 315, 335.

28 A. Huyssen, *Twilight Memories: Marking Time in a Culture of Amnesia*, London and New York, Routledge, 1995.

29 H.S. Parker III, "Vision for the New de Young" [cited 29 February 2000], http://www.thinker.org/deyoung/newdeyoung/release-6.html.

30 "Artist Statement" [cited 29 February 2000], http://www.thinker.org/deyoung/newdeyoung/index.html.

31 J. Perl, "Welcome to the Funhouse: Tate Modern and the Crisis of the Museum," *The New Republic*, 19 June 2000, p. 31.

# 4

# MARBURG, HARVARD, AND PURPOSE-BUILT ARCHITECTURE FOR ART HISTORY, 1927

## *Kathryn Brush*

The year 1927 marked two extraordinary events within the history of art history and its institutions: the opening of two new, purpose-built structures for the study and teaching of art history at Marburg and Harvard Universities (Figures 4.1, 4.2). These large and comprehensive buildings, both of which integrated, under a single roof, classrooms, art museums, research libraries and the technical resources specific to the discipline, were unprecedented at European and American universities.

The Fogg Art Museum at Harvard and the Jubiläums-Kunstinstitut in Marburg opened within about a month of each other in 1927.[1] This contemporaneity, however, was fortuitous. Although the archives show that professors and students at Marburg and Harvard were in routine contact during the 1920s, it appears that these building programs were developed independently.[2] They gave, in short, architectural shape to the particular needs and practices of *Kunstwissenschaft*, on the one hand, and its developing North American counterpart, on the other.

The simultaneous invention of these specialized working plants for art history in Germany and America during the mid-1920s was significant, for this was the decade when the institutionalization of art history at American universities was accelerating, largely following the disciplinary and academic models developed in the German-speaking countries during the 1880s and 1890s. Viewed together from this perspective, the buildings at Marburg and Harvard can be recognized as landmarks within the international development of art history – ones that documented an early point of intersection, and perhaps even a growing equivalence, between the Old and New World branches of the discipline. But each of these projects of the mid-1920s responded in the first instance to a particular set of local conditions and imperatives. Thus, while the Kunstinstitut and the Fogg Art Museum had a great deal in common, they also displayed a number of unique features. As combined teaching facilities and public museums located within university communities, for example, they were

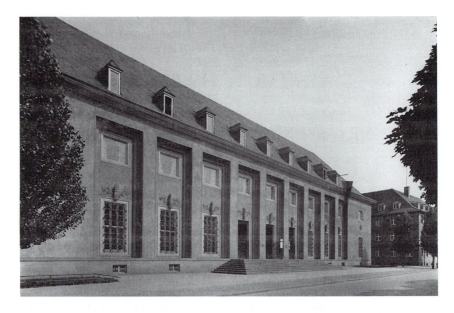

*Figure 4.1* Jubiläums-Kunstinstitut, University of Marburg, ca. 1930.

*Source*: Photo: Bildarchiv Foto Marburg.

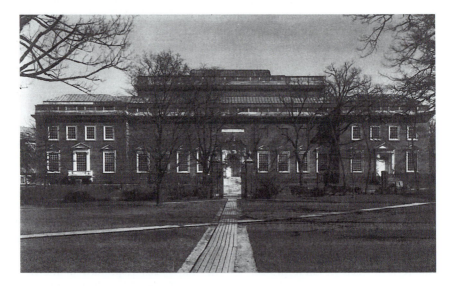

*Figure 4.2* Fogg Art Museum, Harvard University, ca. 1930.

*Source*: Photo: Courtesy of the Harvard University Art Museums, © President and Fellows of Harvard College. Photo credit: Katya Kallsen.

designed to serve a wide variety of functions and constituencies. Moreover, they participated, within their respective countries, in larger debates of the era, from museum reform to the role of universities as communicators of culture.

This chapter examines the conception of these two buildings within these various contexts, comparing their physical characteristics and resources as well as the research and pedagogical goals which they served and expressed. The histories and planning of these two institutions illuminate similarities and differences in the conditions under which art historical scholarship took shape on either side of the Atlantic during the 1920s.

The responsibility for the realization of these projects can be assigned to specific individuals. At Marburg the *spiritus rector* was Richard Hamann (1879–1961), who assumed the first professorial chair in art history at the Hessian University in 1913.[3] Although art history had been taught at Marburg on an intermittent basis during the nineteenth century, a permanent professorial chair for the discipline had never been established. Its foundation in 1913 was late in comparison to its equivalents in other German universities, and probably the absence of tradition allowed Hamann a freer hand when he began to plan the Marburg art history institute shortly after his arrival. Although his plans were hampered by the First World War, and subsequently by the disastrous economic conditions of the Weimar Republic, Hamann was an enterprising individual who had grand ambitions for his institute. In the early 1920s, when preparations to celebrate the four-hundredth anniversary of the university's founding (1527) were initiated, he proposed that this monumental event could be appropriately commemorated by the construction of a building to house the artistic disciplines and a museum that would also serve the public and act as a cultural center for the province of Hesse. This concept had immense local and patriotic appeal at a time when a newly democratic Germany was rebuilding itself and its traditions of *Kultur*.[4] The Jubiläums-Kunstinstitut was the largest and architecturally most distinctive of several new buildings inaugurated during the course of the anniversary festivities in July 1927.

Virtually overnight Marburg became the only university in Germany – and, it seems, within Europe as a whole – to dedicate a purpose-built structure to the relatively young discipline of art history. While other, more venerable, institutes, such as those at the universities in Berlin, Bonn and Leipzig, were randomly accommodated in inherited or pre-existent spaces, Marburg by 1926 could be described as a "model institute" (*Musterinstitut*),[5] which was also, on a techno-logical level, among the best-equipped in Germany. From the outset Hamann promoted his institute as a kind of *Zentralinstitut*, and shortly after the building opened he arranged for it to be designated as the Prussian Research Institute in Art History.[6]

Although it is clear that Hamann's ideas were reflected in many elements of this innovative structure, he was a scholar and not the architect of the building. He had studied philosophy, aesthetics and art history at the University of Berlin under Wilhelm Dilthey (1833–1911), Adolph Goldschmidt (1863–1944) and

Heinrich Wölfflin (1864–1945). His primary area of expertise was medieval architecture and sculpture in France and Germany, and this accordingly became a focal point of teaching and research at Marburg. Like many other German-speaking intellectuals of his day, Hamann was also attentive to the relationships linking art-making of the medieval and modern eras, and this caused him to forge close personal links with contemporary "masters." Indeed, he held remarkably liberal views on art of all eras as a form of social expression. Because medieval art was then still a relatively uncharted area of study, his publications on the Middle Ages tended to be largely formalist and concerned with establishing affiliations between individual sites and works on the basis of a comparative stylistic "science." When he arrived in Marburg in 1913, he embarked upon a large-scale campaign to document medieval works of art and architecture via photography, then a high-tech and scientific research instrument. Photography in the service of art history was to figure largely in the conception, function and economics of the new institute.

The architect of the building, Hubert Lütcke (1887–1963), had been trained at the Technische Hochschule in Berlin before the war, and from 1925 to 1933 he served as the Prussian government architect (*Regierungsbaurat*) for Marburg and the surrounding region.[7] In that capacity he was responsible for a wide range of public commissions, which included the design of several academic buildings in Marburg.[8] The Kunstinstitut is widely acknowledged as his most important work. During the 1920s, when a modernist and purely functionalist architectural aesthetic was being championed by his Bauhaus colleagues, Lütcke represented a relatively conservative branch of the German architectural profession. Nevertheless, the formal vocabulary employed by Lütcke for the art building at Marburg manifested a progressive kind of conservatism, for it meshed traditional elements (e.g., classicizing references, the incorporation of local building materials and styles) with expressionist detailing, which reflected contemporary medievalizing trends within German modernism.

On the street façade, the public side of the building which faced the city and provided entrance to the art museum, Lütcke conveyed an impression of monumentality through a series of "piers" that were created by rectangular two-storey niches set into the front wall at regular intervals. Yet, unlike the colonnades of traditional neoclassicizing "temples of art," these pier-like supports – in actuality the plastered front wall of the building – were completely unarticulated and surmounted by a steep-pitched roof of slate, typical of the region, rather than by anything resembling a classical entablature. Most striking was Lütcke's incorporation of indigenous materials and medievalizing decorative elements into the building in a way that not only reflected Marburg's medieval urban landscape, dominated by the castle of the Hessian Landgraves and the Gothic church of Saint Elizabeth, but also proclaimed – whether by coincidence or by intention – the medieval thrust of the research activities of the Kunstinstitut and the museum collections inside. Although a growing rift separated Lütcke and Hamann as the building was underway,[9] the decoration of

the structure and its iconography reflected their shared concern with the reciprocity between medieval and modern artistry and art patronage.

The monumental bronze doors commissioned for the central portal, for example, clearly recalled medieval prototypes in their genre and craftsmanship, thereby emphasizing the value of *Handwerk* in the twentieth century.[10] Furthermore, following the donor imagery of medieval cathedrals, the doors paid tribute to their patrons – in this case, the manual laborers and administrative officers of the university from whose salaries "tithes" had been withdrawn in order to pay for the doors.[11] In a similar fashion, the contributions of other major corporate and ecclesiastical donors of the region were symbolically recorded in the imagery of the keystones above the ground-floor windows.[12] In short, the building announced and celebrated, in emulation of medieval models, the broad public support which made the realization of the project possible at a time of economic deprivation. The continuing vitality of the Middle Ages in Marburg was made explicit in countless other decorative elements, ranging from the angular patterning of the metal window grilles to the design of the brickwork, light fixtures, and door handles. The bronze doors were particularly significant, however, for they also expressed a remarkable concordance between the building and the scholarly activities it housed. During the mid-1920s Hamann collaborated with other German scholars on a corpus of medieval bronze doors, the first volume of which was published in 1926 by the newly founded press of Marburg's art history institute.[13]

In Cambridge, Massachusetts, very different historical, intellectual, and sociological circumstances prevailed. A professorial chair for fine arts had been established at Harvard much earlier than at Marburg – in fact, during the 1870s – but at that point the study of art history was not envisioned as a profession as it was in Germany, but rather as an area of cultural study that could lend polish to a gentleman's education.[14] The collections of the first Fogg Art Museum, which opened in 1895 to house the Department (then Division) of Fine Arts and to support its teaching, were conceived in this spirit, and consisted largely of plaster casts, photographs and various artifacts which had been donated to the university.[15] The move to assemble a collection of original works of art for pedagogical and research purposes began shortly thereafter, and by the First World War significant examples of late medieval Italian panel painting had been acquired at the instigation of Edward W. Forbes (1873–1969), scion of an aristocratic New England family, who had become director of the Fogg in 1909. With the appointment, in 1915, of Paul J. Sachs (1878–1965) as assistant director, the scholarly ambitions for Harvard's Department of Fine Arts grew rapidly.[16] Sachs, a member of a prominent investment banking family in New York (Goldman Sachs), was a cosmopolitan man of action who, like Forbes, had the private means as well as the business skills and influential social connections necessary to raise art history to a serious area of study at Harvard. In the years around World War I, when Sachs moved to Cambridge – and coincidentally when Hamann arrived in Marburg – art history began to professionalize in the

United States. Harvard and Princeton took the lead in creating the conditions for advanced research in the field, and it is notable that those responsible for creating these conditions came from a variety of backgrounds, which were not always scholarly.[17]

The academic ambitions and collecting zeal of Forbes and Sachs far exceeded the facilities afforded by the first Fogg Art Museum, and immediately following Sachs' arrival they began to campaign together for a new building. In 1916 Sachs articulated his vision of the aims, functions and scope of such a comprehensive facility,[18] but the project was postponed by the war, as in the case of Marburg. Although the United States experienced a post-war economic boom – hence funds were available, unlike in Germany – Sachs and Forbes, in contrast to their Old World colleague Hamann, had to campaign vigorously on another, equally crucial front: for the recognition of art history as an independent area of inquiry that would add new and vital cultural dimensions to the educational environment of the university, and also enrich the quality of American society as a whole in a manner akin to the products of science and industry. It was telling in this regard that the funds for the new Fogg were raised between 1923 and 1925 as part of a university endowment campaign in which Harvard's Department of Chemistry and the Business School were the principal beneficiaries.[19] The need to justify the study of art as a scientific endeavor equal to chemistry, physics, or business is clear from the campaign rhetoric developed by Forbes and Sachs, who chose from the outset to promote the new Fogg as a "Laboratory of the Fine Arts."[20] The Rockefeller Foundation, as well as the German-born Felix Warburg (1871–1937), a banker in New York and one of the brothers of the Hamburg art historian Aby Warburg (1866–1929), provided the major funding for the project.[21]

The Boston architectural firm of Coolidge, Shepley, Bulfinch, and Abbott – a firm favored by Harvard University during the 1920s – drew up plans for the new building in close consultation with Forbes, Sachs and other members of the Department of Fine Arts.[22] Like the Kunstinstitut at Marburg, the exterior of the Fogg was designed to harmonize with its local environment, which in this case was not a medieval city but a highly artificial construct, a New England campus that was being revamped at the time in a modified Georgian style.[23] In a manner consistent with other university buildings located in proximity to it, the main façade which, like Marburg's, provided entrance to the art museum, was of unpretentious red brick and aimed for "serviceability" rather than monumentality and architectural display.[24] Harvard's own architectural traditions determined the style and massing of the exterior, which, somewhat ironically, produced a more conservative "Old World"-flavor building than its contemporary counterpart in Old World Marburg.

The special strength of the art history complexes at Marburg and Harvard was the interconnection between lecture rooms, art museums, and research facilities. The ground plans (Figures 4.3, 4.4) demonstrate that the spatial arrangements and functions of these buildings were envisioned in quite

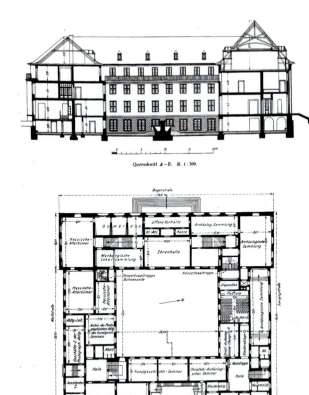

*Figure 4.3* Plan of the main floor (from the garden side) and elevation of the east-west section, Jubiläums-Kunstinstitut.

*Source*: Photo: Bildarchiv Foto Marburg.

similar ways. In both cases two-storey museums occupied the front, or public, side of the buildings, while the research libraries, classrooms, technical resources and professorial and administrative offices were located on multiple levels at the back. Moreover, the two buildings were organized around courtyards.

In the case of Marburg, a large open-air *claustrum* offered sanctuary from the intellectual labors carried out in the seminar rooms, libraries and offices adjoining it (Figure 4.5). The medievalizing decorative aesthetic of the building's exterior was continued in the zigzag shapes of the window panes as well as in the patterning of the brickwork and Meissen tiles that decorated the lower sections of the walls. A fountain in the center of the courtyard, which was inspired in material and in design by the *Backsteingotik* of northern Germany,

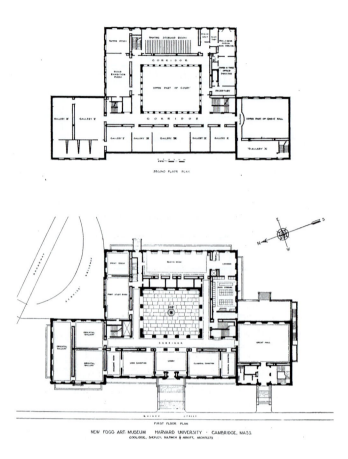

*Figure 4.4* Plan of the main and second floors, Fogg Art Museum.

*Source*: Photo: After Richard F. Bach, "The Fogg Museum of Art, Harvard University."

completed the ensemble. The courtyard at the Fogg took the form of a Renaissance *cortile* (Figure 4.6) in contrast to the Georgian exterior of the building.[25] Because the courtyard was covered it not only provided an area for rest and contemplation, as in the case of Marburg, but also served as the nucleus of circulation, for it was necessary to pass through the court in order to reach the art collections, research library and classrooms that were disposed around it. This was a deliberate feature of the design, for Forbes, Sachs and their colleagues believed that even the most casual contact with the works of art installed around the courtyard had the potential to arouse interest in the visual arts "by means of contagion."[26]

The Kunstinstitut and the Fogg also accommodated lecture halls as well as small seminar rooms, specialized libraries, large photographic archives, lantern slide collections, reading rooms, and study spaces. Furthermore, both art

history programs incorporated studio practice. At Marburg this consisted of drawing and painting, and at Harvard of a hands-on exploration of historical styles and techniques, which included the replication of frescoes as well as paintings in tempera and oil.[27] The German and American buildings thus gave novel architectural definition to the notion that learning and research in art history were ideally shaped by the interactive study of objects, images, techniques, and texts in a single, unified space.

But there were also differences in conception. The Kunstinstitut was considerably larger than the Fogg, and although the art history facilities and museum directed by Hamann occupied the lion's share of the space, the building was designed to accommodate the departments of classical archaeology, Christian archaeology, prehistory (*Vorgeschichte*), and music as well.[28] The goal was to foster dialogue between the study of artistic culture and adjacent *Kulturwissenschaften*. This attempt to situate the study of art in physical and conceptual proximity to other areas of cultural study was determined in part by practical and personal circumstances unique to Marburg in the mid-1920s.[29]

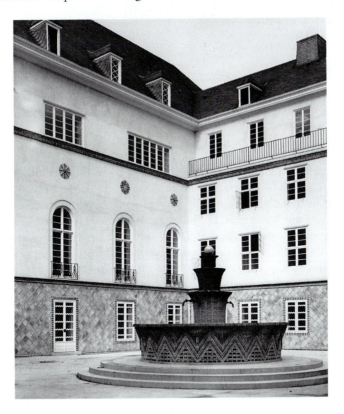

*Figure 4.5* Courtyard of the Jubiläums-Kunstinstitut, ca. 1930.

*Source*: Photo: Bildarchiv Foto Marburg.

*Figure 4.6* Courtyard of the Fogg Art Museum, ca. 1930.

*Source*: Photo: Courtesy of the Harvard University Art Museums, © President and Fellows of Harvard College.

It was possible to give architectural definition to an interdisciplinary model at Marburg because the battle for the academic legitimacy of art history had already been won in German-speaking Europe several decades earlier. This kind of dialogue was not featured in the building at Harvard, for Forbes, Sachs and their colleagues, by contrast, were still busy campaigning during the mid-1920s for recognition of the fine arts as an autonomous and intellectually valid area of academic inquiry. The construction of the Fogg as a "laboratory" dedicated exclusively to the production of scholars and critics of art as well as to the education of museum personnel was part of a strategy to professionalize the discipline in the United States. A multidisciplinary building, as at Marburg, would have impeded that cause.

But in addition to embodying distinct academic moments and positions, these exactly contemporary buildings and their contents registered what might be termed "differences in opportunities," which were conditioned not only by their German and American university cultures, but also by the historical circumstances of their respective societies during the 1920s. Some of these differences can be clarified by comparing the character and functions of the academic art collections at Marburg and Harvard and their technical resources.

The art museums, which allowed students and professors to have direct and sustained contact with the objects of their study, were central to the educational missions of both institutions. The collection in Marburg was largely local and German, for the Kunstinstitut had the opportunity to find its works and research subjects in the regional soil. Medieval art was particularly well represented by high-quality materials drawn from monuments of international significance in the area, most notably the Carolingian abbey at Fulda and the thirteenth-century church of Saint Elizabeth in Marburg.[30] But in addition to serving as a teaching resource, the museum had another, distinctly community-oriented function: it served as the regional cultural historical museum for the province of Hesse. Indeed from the outset the Kunstinstitut was intended to house and display a sizeable public collection of local antiquities that had been formed from the 1870s onward.[31] Thus, in addition to works of "fine art" and a collection of plaster casts belonging to the university's archaeological institute, the other objects installed in the museum ranged from cast-iron stoves to shields, tableware, historical dress, and furniture.

The economic difficulties of the Weimar Republic necessarily meant that Hamann's ambitions for the museum's permanent collection of painting and sculpture had to be modest. Nevertheless, he was a person of creative solutions, and he initiated a loan arrangement with the *Gemäldegalerien* in Kassel and Berlin whereby selected paintings in those collections were sent periodically to Marburg for exhibition.[32] Moreover, his ties to modern artists, among them the sculptor Georg Kolbe (1877–1947) and a number of German painters, had practical results, for he encouraged them to donate works to the museum on the occasion of its opening – these continue to form the foundation of the collection today – and also to loan others for purposes of exhibition and publication.[33] In this way Hamann strove to overcome his university's severe financial constraints in order to make a wide range of historical and contemporary art available to both the academic community and the larger public. The aesthetic character of the spaces in which the museum was housed – it occupied almost half of the Kunstinstitut – responded to contemporary reformist ideals in German museum design, which rejected longstanding traditions of palatial or historicizing environments for the display of objects.[34] The galleries at Marburg were thus largely unadorned, with Lütcke's muted expressionist ornament continuing on certain functional items like radiator covers and the light fixtures of the main staircases.

But the aesthetic character of the new Fogg was even simpler; it was not the kind of building where the visitor might stop to examine a door handle or a radiator cover. The galleries of Harvard's art museum were planned to offer a straightforward, dignified, and stylistically minimalist setting that did not overwhelm the works of art or the visitor. Except for the Renaissance-inspired courtyard and two-storey Great Hall on the ground floor, which was loosely reminiscent of medieval prototypes – this was used for the display of medieval art – the galleries of the Fogg made no specific historical references.[35]

Moreover, there was no monumental entranceway or grand staircase. This unpretentious and neutral approach reflected principles of museum planning then being formulated in the United States – principles which approximated those of the German museum reform movement. Museum design was an issue of great concern in the United States during the mid- and late 1920s, the "golden age" of American museum growth. The financial clout of American collectors and museums in the European art market during the post-war era encouraged the establishment and expansion of large and small museums all over the country, and especially on the East coast and in the Midwest.[36]

The ability of Americans to build collections during the 1920s contrasted with the Weimar Republic's lack of purchasing power, and this situation was reflected in the character of the art collections in Marburg and at Harvard. In contrast to the German museum, the Fogg could not find its works and research subjects in the local soil. Furthermore, it did not need to provide a cultural historical museum for its region (New England) because the Museum of Fine Arts in Boston had long been established for that role. The Fogg's collection thus responded to different opportunities, which included wealthier patrons, loyal alumni, and the possibility to purchase examples of art from all historical eras internationally for teaching and research. This resulted in a collection of wider scope, which included French and Spanish medieval sculpture and Italian panel painting as well as outstanding examples of Islamic, pre-Columbian, and Asian art.[37] The extraordinary commitment of Forbes and Sachs to making the Fogg a leading professional museum rapidly propelled its collections into the international arena. Their insistence on purchasing works of the finest quality derived from their shared consciousness of Harvard's pioneering role in formulating standards for the new discipline in America. Indeed, at a time of museum expansion in the United States, they recognized that the most effective way to foster the critical abilities of persons who could later become discriminating curators and museum directors was by presenting them with paradigmatic works in many fields. No other academic institution at the time, for instance, could have offered students the opportunity to study works by Simone Martini and Ambrogio and Pietro Lorenzetti side by side. This emphasis on the training of future museum professionals – also through the organization of exhibitions and first-hand experience of the technical dimensions of art-making – became central to the mission of Harvard's graduate curriculum. This same need did not exist at Marburg, for Germany already had many museums of international stature where several generations of curators had been trained. Moreover, the German-speaking world had a long tradition of joint appointments between universities and museums, and of easy movement between them.

But while Harvard could afford to assemble a collection of first-quality works from all eras and cultures in a way that Marburg could not, there was a further way in which the Germans took advantage of what they could do locally. Richard Hamann and his students, being based in Europe in immediate

proximity to the monuments, had the opportunity to photograph them in a way that the Americans did not. Hamann had recognized the importance of photography for the discipline long before he arrived in Marburg, and during the 1920s he launched a pioneering campaign to produce and collect detailed photographic documentation of works of art – especially medieval sculpture and architecture – all over Europe. Marburg's photographic archive, which Hamann envisioned as an internationally important research tool of his art historical *Zentralinstitut*,[38] made it possible for scholars to compare works at geographically distant sites and to construct chronologies and sequences. In an age of mechanical reproduction, this central image bank – images were manufactured upon demand – afforded a modern approach to the study of art history. Provisions for the storage of the glass negatives, for darkrooms and other requisite technical facilities were incorporated into the design of the Kunstinstitut, and a permanent lectureship (*Lektorat*) for photographic instruction, a concept novel for European and American art history programs at the time, was established when the building opened in 1927.[39] But in addition to serving strictly scholarly needs, Hamann's comprehensive photographic archive (now the "Bildarchiv Foto Marburg – Deutsches Dokumentationszentrum für Kunstgeschichte") served a practical, economic purpose: it was in fact an image factory which helped to fund research and teaching activities. Indeed the Fogg, like many other North American institutions, purchased much material for its own photographic archive and for purposes of publication from Marburg.[40]

While Harvard did not need to generate income this way – nor did it specialize, like Marburg, in the active production of new photography – it shared the German institute's concern with technology. The Fogg's distinctive and original contribution in this area was the scientific examination and conservation of art within an academic environment. During the early 1920s, when increasing numbers of European works of art were entering American collections, Forbes and Sachs recognized the need for their technical study, which embraced not only the chemical analysis of pigments and other materials, but also the restoration of damaged works and the detection of repainting and forgeries. The decision to mount and support such an initiative at Harvard was farsighted, for this was the first comprehensive conservation program developed in the United States and among the earliest internationally. By 1924 the Fogg was collaborating with such institutions as the National Gallery in London, the Louvre, and the Kunsthistorisches Museum in order to pioneer radiography, and to generate and construct a novel image bank of its own.[41] A research post for X-ray technology, analogous to Marburg's lectureship in photography, was created in 1926.[42] Conservation work became integral to the curriculum at Harvard, and by 1928, when the Department of Technical Studies, which occupied the upper floor of the building, was officially inaugurated, the hitherto metaphorical description of the Fogg Art Museum as a "Laboratory of the Fine Arts" was given concrete form.

Each of these imaginative and coherently integrated buildings for the study of art in Marburg and in Cambridge, Massachusetts, met with immediate response after they opened in the summer of 1927. Although the buildings were conceived independently, many of the responses had much in common. At the local level, for example, these specialized working environments sparked significant increases in the number of art history students, especially those engaged in doctoral work, and the following years saw a pronounced growth in the production and dissemination of research. The recruitment of additional faculty members, the expansion of professionalized museum, library and technical facilities, and the development of comparable publication programs contributed to this surge in production, although the onset of the Great Depression in late 1929 was to affect the pace of growth at both institutions.[43]

During these same years the German and American institutes left distinctive marks in the larger, international forum of art history when others launched equally high-minded projects to develop university centers for research and teaching in art history. The case of the Courtauld Institute of Art at the University of London, which was officially inaugurated in 1931, but for which planning began in 1928–9, is particularly illuminating in this regard.[44] Although a building was ultimately not a possibility at the University of London owing to deteriorating economic conditions,[45] the documents show that those responsible for devising the research goals, standards, and functions of the Courtauld Institute regarded the new art history complexes at Marburg and Harvard as important models. Efforts were made to establish ties with Sachs and Forbes as well as with Hamann, and to visit and study their facilities at first hand.[46] The London institute followed British educational traditions by offering a single-subject degree in art history at both the undergraduate and graduate levels, yet it also embraced certain ideas of the American and German institutions. While it was perhaps more directly inspired by the museological, pedagogical and especially technological aims of the Fogg,[47] it aspired like Marburg to play a much larger role as a "central institute" for Britain.

## NOTES

The research for this article was supported by the Social Sciences and Humanities Research Council of Canada.

1 The Fogg Art Museum was officially opened on 20 June 1927; the inauguration of the Jubiläums-Kunstinstitut took place on 30 July 1927.

2 For the personal and professional links between German and American art historians during the 1920s, see K. Brush, "German *Kunstwissenschaft* and the Practice of Art History in America after World War I: Interrelationships, Exchanges, Contexts," *Marburger Jahrbuch für Kunstwissenschaft*, 1999, vol. 26, pp. 7–36.

3 For the history and conception of the building project at Marburg, see M. Warnke, "Richard Hamann," *Marburger Jahrbuch für Kunstwissenschaft*, 1981, vol. 20, pp. 11–20; T. Jahn, "Das Kunstinstitut (Ernst von Hülsen-Haus) der Philipps-Universität Marburg," in J.J. Berns, ed., *Marburg-Bilder. Eine Ansichtssache. Zeugnisse aus fünf Jahrhunderten*, vol. 2 (= Marburger Stadtschriften zur Geschichte und

Kultur, 53), Marburg, Magistrat der Stadt Marburg, 1996, pp. 321–56; K. Krause, "Ein Kunstinstitut für Marburg. Konzeptionen und ihr architektonischer Ausdruck," in *alma mater philippina*, Marburger Universitätsbund (ed.), winter semester 1998–1999, pp. 12–18. For Hamann, director from 1913 to 1949, see G. André, "Richard Hamann (1879–1961), Kunsthistoriker," in I. Schnack, ed., *Marburger Gelehrte in der ersten Hälfte des 20. Jahrhunderts*, Marburg, Elwert, pp. 121–41, and the information compiled in "Richard Hamann und seine Schüler. Eine Chronik des kunstgeschichtlichen Seminars der Philipps-Universität Marburg" (typescript, Kunsthistorisches Institut der Philipps-Universität Marburg, March 1990).

4  Emphasized in the official university publication *Die Vierhundertjahrfeier der Philipps-Universität Marburg 1927*, Marburg, Elwert, 1928, pp. 67–9.

5  Jahn, "Das Kunstinstitut," p. 321, for the documentation. The fact that the Marburg institute was without parallel at German universities was emphasized in *Die Vierhundertjahrfeier der Philipps-Universität Marburg 1927*, p. 68.

6  Hamann's institute officially became the "Preussisches Forschungsinstitut für Kunstgeschichte" in 1929 (Marburg was located within the province of Hesse-Nassau, which from 1866 onward had formed part of the kingdom, then state, of Prussia). Hamann's papers [Nachlass Professor Dr. Richard Hamann, Universitätsbibliothek Marburg/Lahn; hereafter Nachlass Hamann] record his efforts to elevate the Marburg art history *Seminar* to the status of a research institute; in March 1926, as the building was underway, he argued, in a five-page typescript entitled "Ueber ein photographisches Zentralarchiv," for the creation of "an international photographic archive for art history and neighboring disciplines." Soon thereafter he published a twelve-page brochure "Entwurf zu einer Denkschrift über die Umwandlung des Kunstgeschichtlichen Seminars der Universität Marburg in ein Forschungsinstitut der Kaiser-Wilhelm-Gesellschaft zur Förderung der Wissenschaften," in which he named the special research areas of the institute: the investigation of the relationships linking French and German art of the Middle Ages, and the creation of a photographic central archive for art history. By 1929 the state of Prussia agreed to support the institute's operating costs, but the onset of the Depression that same year and the rise of Hitler in 1933 meant that some research programs were frustrated.

7  Jahn, "Das Kunstinstitut," pp. 350–2. For the architect's own account of his planning of the Kunstinstitut (with photographs), see H. Lütcke, "Der Jubiläumsbau der Universität Marburg," *Zeitschrift für Bauwesen*, 1930, vol. 80, pp. 1–20 (also distributed separately as a "Festgabe des Universitätsbundes Marburg aus Anlass seines zehnjährigen Bestehens," Marburg, 1930).

8  Lütcke renovated and extended several university buildings in these years and also designed various government buildings in the region. Around 1930 he restored the two most prominent medieval monuments in Marburg: the castle of the Hessian Landgraves and the thirteenth-century church of Saint Elizabeth. See Jahn, "Das Kunstinstitut," p. 350.

9  Jahn, "Das Kunstinstitut," pp. 332–3.

10  Lütcke designed the doors; they were executed by the Berlin artist Walter E. Lemcke, who specialized in sculpture for architectural contexts.

11  A half of one percent of each worker's and staff member's salary was withheld for a period of two years in order to fund the doors. These "forced donations" were commemorated in the imagery of the doors (figures of a laborer on the left door and an office worker on the right are identifiable by their attributes) and by the accompanying inscription, which reads: "Als Zeichen ihrer Anhänglichkeit stifteten diese Türe die Arbeiter und Angestellten der Philipps-Universität 1527–1927" ("The workers and administrators of the Philipps-Universität donated these doors as a sign of their devotion, 1527–1927").

12 These fifteen symbolic keystones (nine were located on the main façade) were designed by Lütcke; they showed the coats of arms and principal landmarks of the cities in the province of Hesse-Nassau which had contributed to the Kunstinstitut. The keystones, of local red sandstone, were also executed by Walter Lemcke of Berlin. According to Lütcke, "Der Jubiläumsbau," p. 10, the keystones documented the contributions of the "entire populace of Hesse-Nassau" to the project.

13 A. Goldschmidt, *Die Bronzetüren des frühen Mittelalters*, Marburg, Verlag des Kunstgeschichtlichen Seminars, 1926. This was the first volume in a corpus of medieval bronze doors sponsored by the Deutscher Verein für Kunstwissenschaft and coordinated by Hamann, who also produced the photographs. A further volume by Goldschmidt appeared in 1932 (*Die Bronzetüren von Nowgorod und Gnesen*), while A. Boeckler produced volumes on doors in medieval Italy (*Die Bronzetür von Verona; Die Bronzetüren des Bonanus von Pisa und des Barisanus von Trani*, Marburg, 1931 and 1953 respectively) The press established by Hamann in 1922 was guided by a philosophy unique for its day, for in addition to producing scholarly publications (including the *Marburger Jahrbuch für Kunstwissenschaft* launched in 1924), it aimed to make art history accessible to the general public through the production of popular, well-illustrated handbooks.

14 Charles Eliot Norton, an American literary scholar, historian and moralist, who was closely associated with John Ruskin, became the first Professor of Fine Arts at Harvard in 1875. See K. McClintock, "The Classroom and the Courtyard: Medievalism in American Highbrow Culture," in E. Bradford Smith, ed., *Medieval Art in America: Patterns of Collecting, 1800–1940*, University Park, Penn., Palmer Museum of Art, 1996, pp. 41–53.

15 Most recently J. Cuno, M.B. Cohn, I. Gaskell, D. Martin Kao, D. Gordon Mitten, R.D. Mowry, P. Nisbet, W.W. Robinson, S. Cary Welch, *Harvard's Art Museums: 100 Years of Collecting*, New York, Abrams, 1996.

16 J. Cuno, "Edward W. Forbes, Paul J. Sachs, and the Origins of the Harvard University Art Museums," in J. Cuno *et al.*, *Harvard's Art Museums*, pp. 11–35; Edward W. Forbes, "History of the Fogg Art Museum," 2 vols, typescript, Harvard University Art Museum Archives [hereafter HUAM Archives], n.d. (late 1940s/1950s).

17 For the formative roles played by Harvard and Princeton to ca. 1933, see Brush, "German *Kunstwissenschaft* and the Practice of Art History in America"; C. Hugh Smyth and P.M. Lukehart, eds, *The Early Years of Art History in the United States: Notes and Essays on Departments, Teaching, and Scholars*, Princeton, Princeton University Press, 1993. The social backgrounds and formal training of those who promoted the professionalization of art history at Harvard contrasted greatly with the situation at Marburg; Hamann had risen to a prominent academic position from humble origins. It is also noteworthy that at the time Harvard was a private institution for men (women studied at the closely affiliated Radcliffe College, also a private institution) while Marburg was a public university open to male and female students.

18 P.J. Sachs, "Fogg Art Museum," *The Harvard Graduates' Magazine*, March 1916, vol. 24, pp. 420–5.

19 The endowment campaign raised ten million dollars, of which the smallest amount (two million dollars) was destined for the building and endowment of the new Fogg Art Museum. Originally the campaign was directed exclusively toward the Department of Chemistry and the Business School; Forbes and Sachs had to argue for the inclusion of the Fogg project.

20 For example, Sachs, "Fogg Art Museum," p. 420. A seventeen-page promotional booklet entitled *The Fine Arts in a Laboratory* was issued in conjunction with the endowment campaign (Cambridge, Mass., Harvard University, The Division of the Fine Arts, Fogg Art Museum, March 1924; the authors were likely Forbes and Sachs).

21  The General Education Board of the Rockefeller Foundation and Felix Warburg each donated $500,000 toward the campaign goal of two million dollars; hence Warburg was the largest individual (i.e., non-corporate) patron. His older brother Aby was certainly informed about the Fogg project, as Sachs' correspondence shows (Brush, "German *Kunstwissenschaft* and the Practice of Art History in America").

22  For the chronology of the firm, see J. Heskel, *Shepley, Bulfinch, Richardson and Abbott: Past to Present*, Boston, Shepley, Bulfinch, Richardson and Abbott, 1999. Harvard had ties to this firm that dated back to the time of Henry Hobson Richardson, the firm's founder, who had designed Sever Hall (1880), a building that stood across Quincy Street from the site of the new Fogg. In keeping with this tradition, Richardson's grandson Henry Richardson Shepley was one of the two principal architects involved in the design of the Fogg. The other was Charles A. Coolidge, who served on Harvard's Board of Overseers during the 1920s. During these same years the Boston firm was also responsible for designing a number of medical and campus facilities on the East coast and in the Midwest.

23  The neo-Georgian style of the Fogg was shared by many of the Harvard dormitories constructed during the 1920s (e.g., McKinlock Dormitory, 1925; Lowell and Dunster Houses, 1930), for which the same architectural firm was responsible.

24  Contemporary analyses of the design and functions of the new Fogg Art Museum include R.F. Bach, "Museum Service in the University: The New Fogg Building at Harvard," *Bulletin of the Metropolitan Museum of Art*, 1927, vol. 22, pp. 175–7; *idem*, "The Fogg Museum of Art, Harvard University," *Architectural Record*, 1927, vol. 61, pp. 465–77; M.R. Rogers, "Modern Museum Design as Illustrated by the New Fogg Art Museum, Harvard University," *Architectural Forum*, 1927, vol. 47, pp. 601–8; W.H. Siple, "The New Fogg Art Museum," *The Harvard Graduates' Magazine*, September 1927, vol. 36, pp. 36–41; *Fogg Art Museum, Harvard University: Handbook*, Cambridge, Mass., Harvard University Press, 1927, esp. pp. vi-xvii; E.S. Siple, "The Fogg Museum of Art at Harvard," *The Burlington Magazine*, June 1927, vol. 50, no. 291, pp. 309–15; *The Arts*, July 1927, vol. 12, no. 1, was dedicated entirely to the new Fogg.

25  The courtyard was inspired by the two-storey façade of the canon's house of the church of San Biagio in Montepulciano, which was designed by Antonio da Sangallo the Elder; at the Fogg the façade was reproduced four times (and on a slightly reduced scale) in order to form the courtyard and a third storey was added above. Henry R. Shepley had measured the façade during a trip to Italy and suggested it as a model. See Forbes, "History of the Fogg," vol. 1, pp. 279–80. The American *cortile* was built of Italian travertine. A fountain was planned for the Fogg courtyard, as at Marburg, and the plumbing for it was completed. It seems, however, that this furnishing was accorded low priority at the time of construction; it did not come to fruition.

26  W.H. Siple, "The New Fogg Art Museum," p. 37.

27  Studio spaces were located in the top storey of the Marburg institute; see Lütcke, "Der Jubiläumsbau," p. 8; for Harvard's instruction in artistic techniques, see S. Gordon Kantor, "The Beginnings of Art History at Harvard and the 'Fogg Method'," in Smyth and Lukehart, *The Early Years of Art History*, pp. 161–74, esp. pp. 167–8.

28  Spaces for a lectureship in *Vortragskunst* (the art of rhetoric) were also accommodated in the Marburg building. For the interdisciplinary conception of the structure, see *Die Vierhundertjahrfeier der Philipps-Universität Marburg 1927*, pp. 110–11; Lütcke, "Der Jubiläumsbau," pp. 6–8. Each department had its own specialized library, classrooms, and offices and was joined physically to the other institutes through shared doorways, hallways, and staircases. A central reading room served all departments. The overall dimensions of the Marburg Kunstinstitut (it formed a

block, which was approximately 60 m wide and 55 m deep; the courtyard measured 28 × 23.4 m) were larger than those of the new Fogg Art Museum (it measured 70 m at its point of greatest width [the front] and 37 m in depth; the courtyard was 17 × 12.8 m).

29 These departments, many of which were relatively young disciplines at Marburg, had been housed in very cramped quarters in the Alte Universität. Thus, Hamann's proposal that they move cooperatively into new, purpose-built spaces (i.e., under his leadership) promised long-term advantages for each department. Moreover, the fact that art history did not have an established tradition at Marburg prior to Hamann's arrival permitted greater flexibility with regard to its positioning within humanistic study at that institution. See Krause, "Ein Kunstinstitut für Marburg," pp. 14–15, for the local situation.

30 A. Kippenberger, "Hauptwerke des Museums im Jubiläumsbau der Universität Marburg," *Marburger Jahrbuch für Kunstwissenschaft*, 1927, vol. 3, pp. 273–304.

31 The museum incorporated the collection of the Verein für hessische Geschichte und Landeskunde, an organization founded in 1834, which in 1875 assumed responsibility for a cultural historical collection begun by the lawyer Ludwig Bickell. The collection was merged with that of the Marburg Kunst- und Altertumsverein in 1917. A satisfactory solution for the display of the objects (most were kept in storage in the castle of the Hessian Landgraves) did not exist until Hamann suggested that these cultural historical collections could be accommodated within the Kunstinstitut project. See Kippenberger, "Hauptwerke des Museums im Jubiläumsbau," pp. 273–4, for the educational philosophies guiding this alliance of local historical collections and *Volkskunst* with a "scientific" university art institute. For a more recent account, see S. Becker, C. Herrmann, A. Höck, G. Junghans, and J. Wittstock, *Marburger Universitätsmuseum für Kunst und Kulturgeschichte*, Braunschweig, Westermann, 1989, esp. pp. 18–23.

32 For example, *Die Vierhundertjahrfeier der Philipps-Universität Marburg 1927*, p. 111.

33 S. Becker *et al.*, *Marburger Universitätsmuseum*, pp. 114–25. The sculptor Kolbe gave a bronze "Sitting Girl" (1907) to the museum in 1927; in the same year the university purchased another of his bronzes ("Adagio" of 1923) for the new museum while the Deutscher Beamtenbund (Marburg branch) donated his "Eva" (1923), also of bronze. Kolbe was commissioned to produce a large-scale sculpture ("Crouching Woman") for the garden of the Kunstinstitut, and Hamann arranged for the artist to receive an honorary doctorate on 30 July 1927, the opening day of the new building. Hamann also encouraged other artists, among them painters of the "Neue Sachlichkeit" movement, to offer gifts to the university collection in 1927. Furthermore, four German artists, among them Paul Baum and Ewald Mataré, contributed original lithographs and woodcuts to the inaugural volume of the *Marburger Jahrbuch für Kunstwissenschaft* (1924). Hamann was thus remarkably concerned to encourage dialogue between scholarly and artistic forms of production.

34 Lütcke, "Der Jubiläumsbau," p. 3; Krause, "Ein Kunstinstitut für Marburg," p. 13.

35 The two-storey Great Hall (later renamed "Warburg Hall" to commemorate the generosity and many years of service of Felix Warburg to the Fogg) featured a sixteenth-century carved oak ceiling from Dijon. The Fogg's collection of Romanesque sculpture, most of which was assembled during the early 1920s, was exhibited in the room (*Fogg Art Museum, Harvard University: Handbook*, 1927, p. xvi).

36 This was reflected in the increasing number of articles on museum design that were featured in major American architectural journals (including *The Architectural Forum* and *The Architectural Record*) during the second half of the 1920s; reviews of the new Fogg often appeared within these larger discussions. The December 1927 issue of *The Architectural Forum* (vol. 47), for example, was entirely devoted to museum

planning at various institutions on the East coast and in the Midwest (pp. 559, 601–3 and plate 121 for the Fogg).

37  The museum handbook published in 1927 (*Fogg Art Museum, Harvard University: Handbook*) gives an overview of the scope of the collection at that time; see also J. Cuno *et al.*, *Harvard's Art Museums*.

38  Hamann's papers [Nachlass Hamann] show that during the 1920s he often referred to his photographic archive as the central research instrument of his "world institute" (*Weltinstitut*); indeed he expected that scholars from around the globe would need to consult the image bank he was constructing. Thus, from its inception, Hamann's new institute incorporated guest quarters for visiting professors (these were located on the top floor).

39  Dr. Arthur Schlegel assumed the new lectureship in photography in the summer semester of 1927, and from that point onward he and others offered a variety of introductory and advanced courses tailored to the needs of art history students; most of these courses involved excursions to artistic monuments. Other classes focused on optics, and on the technical aspects of photographic production (e.g., development, enlargement, copying). See "Richard Hamann und seine Schüler," pp. 137–8. Movie equipment was purchased in 1929, and courses in this branch of photography were offered at least through the early 1930s. The large lecture hall in the basement of the Fogg Art Museum was also outfitted with movie equipment during these same years; courses in photography for art historical purposes, however, were not offered by Harvard's Department of Fine Arts.

40  During the 1920s a number of German art historians endeavored to sell photographs to the rapidly expanding museums and art history departments in the United States. The motivating factor was not simply scholarly cooperation but also genuine financial need: only the Americans could afford large-scale purchases of photographs and books in the postwar years.

41  Alan Burroughs was responsible for introducing and developing radiography at the Fogg during the 1920s; see R. Spronk, "The Early Years of Conservation at the Fogg Art Museum: Four Pioneers," *Harvard University Art Museums Review*, Fall 1996, vol. 6, no. 1.

42  J. Cuno *et al.*, *Harvard's Art Museums*, p. 37.

43  Harvard's Department of Fine Arts had the funds to expand its faculty in anticipation of the new building; in 1920, for example, Sachs and Forbes made a successful attempt to win the well-known medievalist Arthur Kingsley Porter of Yale University for Harvard. He subsequently helped to build the Fogg's art collection, and several of his students, among them the architectural historian Kenneth Conant, also joined the Harvard faculty in the 1920s. Limited financial circumstances at Marburg meant that new faculty members could be added only after the building was opened and the funding of the Prussian Research Institute for Art History was more or less assured; Richard Krautheimer and Otto Homburger joined the Marburg institute in 1928 and 1930 respectively (following the rise of Hitler, however, both were removed from their positions owing to their Jewish ancestry). The Americans could also afford to invite leading German scholars to their side of the Atlantic, and Adolph Goldschmidt of the University of Berlin was a guest professor at Harvard during the academic year 1927–8 (i.e., immediately after the new Fogg Art Museum opened). The Marburg institute had established a press in 1922; in a similar fashion, Harvard and Princeton collaborated to found the scholarly journal *Art Studies* in 1923 (after 1931 *Art Studies* was merged with the *Art Bulletin*). At Harvard a monograph series in art history (The Harvard-Radcliffe Fine Arts Series) was established in 1935.

44 For a recent overview of the early history and benefactors of the Courtauld Institute, see J. Murdoch, "Introduction," *The Courtauld Gallery at Somerset House*, London, Thames and Hudson, 1998, pp. 7–13.

45 Yet a building was part of the original plan for the new Courtauld Institute, as the announcement of the University of London's resolution to establish the institute shows; see Lord Lee of Fareham, "Art and the Expert: A New Institute in London," *The Times*, October 1930, vol. 27, pp. 13–14. Arthur Lee, Viscount Lee of Fareham, was the primary campaigner for the foundation of an art history institute at a British university; his efforts intensified from 1928–9 onward, when he enlisted the contributions of many others, including Samuel Courtauld, Sir Robert Witt, and Sir Martin Conway.

46 The ties between the Fogg, the Courtauld, and Marburg will be fully documented in an exhibition and publication which I am currently preparing for the Fogg Art Museum (2003).

47 In his article of October 1930 in *The Times* (see note 45 above), Lee emphasized the need in Britain for specialized facilities for the education of scholars, art critics, and museum personnel, which would be comparable to the "*Kunst-Historische* Institutes" [his italics] of universities in the German-speaking countries and the Fogg Art Museum at Harvard. The latter, he argued, p. 14, "is worthy of the closest study and most nearly provides the ideal to which the promoters of the Courtauld Institute of Art have sought to attain."

# 5

# VIOLLET-LE-DUC AND TAINE AT THE ÉCOLE DES BEAUX-ARTS

## On the first professorship of art history in France

*Philip Hotchkiss Walsh*

*In Memoriam D. R. W., 1927–1994*

On the afternoon of Friday 29 January 1864, in the grand hemicycle of the École des Beaux-Arts, a standing-room-only audience of more than four hundred students assembled. Seated in the front rows of the auditorium, admitted by special advance tickets, were members of the artistic and cultural elite of the Second Empire: Le Comte de Nieuwerkerke, Surintendant des Beaux-Arts of the Maison de l'Empereur, was prominent among them. Eugène-Emmanuel Viollet-le-Duc, architect, courtier, restorer, and scholar of medieval monuments, theorist, polemicist, and since 18 November 1863, the holder of the first chair in art history and aesthetics created in a French institution of higher learning, approached the podium, laid out his notes, and began to lecture on "De l'influence des idées religieuses dans les arts chez les indiens et les grecs." Instead of the docile silence accorded a professor in the exercise of his duties, Viollet-le-Duc's voice was drowned out by a surge of noisemaking by his students, later described in student slang by Maxime du Camp as a "*chahut baby-lonien.*"[1] Shouts and howls were soon followed by a shower of apples, wads of paper, small coins, and eggs. The uproar intensified. Ultimately the professor abandoned his platform and exited the hall, retinue of notables in tow. The students, not satisfied with merely shouting down the lecture, chased Nieuwerkerke back across the Seine to the secure precincts of the Louvre. In part because of du Camp's witty account of the event, it has become a favorite anec-dote in histories of nineteenth-century French cultural politics. The fact that this represented the first lecture in the discipline of the history of art taught by the first professor of art history in France has drawn relatively little attention.[2]

The reaction, as Viollet-le-Duc well knew, was not to the newly introduced discipline per se but to himself as professor. The students had ample reason to be hostile to him. The rioters may have been unaware of the ideological

program that motivated the creation of a chair in art history, which was by no means innocent of broader governmental interest in the role of the visual arts in a liberal capitalist economy and an empire in search of cultural legitimacy. With hindsight, however, it is evident that the introduction of this new discipline into the curriculum of the École marked a sea change in the way in which art was thenceforth to be apprehended. The coherence of the art world that the students were preparing for was permanently altered.

In 1863 institutionalized art history was launched as a counter-discourse intended to articulate the identity of France and its pre-eminence in the production of visual culture. At bottom, the goal was not simply to reinforce France's influence in the more or less autonomous arts of painting, sculpture, and architecture, but also to reinvigorate its art-industry production through design-oriented visual education. World markets were at stake. France was threatened by Great Britain's and Prussia's rapid expansion in textiles, ceramics, and other spheres of art-industry design. The task of art history in mid-nineteenth-century France was to identify, organize, and render comprehensible a heterodox and deplotted past, and to create a serviceable narrative, a discourse capable of distinguishing the French from the Other. In so doing, art history fabricated a hierarchy within which the identity of the nation could be privileged within the diverse and conflicting visual cultures present in Western Europe. Art history also defined the European and French against the non-European and non-French, and was thus informed by and participating in the same cultural discourse that supported French colonial expansion and the further analysis of non-industrial cultures that this required. Art history in France was a project of self-definition motivated by the desire for domination. Its hierarchies and racialism were not innocent or incidental, but purposive and utilitarian. This was the context that made institutionalized art history in 1863 an ideologically charged discourse.

Of course, art history, in France and elsewhere, existed long before 1863. Yet when we speak of an intellectual discipline, we perforce describe a practice within a set of institutions, possessed of certain tacit and explicit operating principles embodied in statutes, practices, and a panoply of obligations and privileges. In France, the creation of the chair "de l'ésthetique et de l'histoire de l'art" (alternatively referred to as "de l'histoire de l'art et de l'ésthetique") at the École des Beaux-Arts marks the birth of such a discipline.

The inauguration of a discipline poses a number of problems. In the first instance, in the absence of "art history" as an institutionalized practice, who possesses the authority to produce "art history"? How is this individual recognized? This dilemma has returned now that art history is practiced, often more fruitfully than otherwise, by many scholars trained in fields outside the defined limits of the discipline and its now well-established institutions.

Secondly, what is the significance of the fact that the first chair in art history is established at an art school and not within the university itself? With the exception of the program in architecture, the École des Beaux-Arts did not

grant degrees or diplomas, and made no claim to train art historians. Other institutions of higher learning in France were slow to recognize the discipline. The Collège de France inaugurated its first chair in art history in 1878; the Sorbonne did not admit the discipline until 1893.[3] To whom was the discipline directed? What ends did it serve in this first formation?

Finally, why did institutionalized art history in France come into being at this particular juncture? What factors were at play in the creation of the position at the École? 1863 is more commonly marked as the year of the Salon des Refusés, an event that reflected Napoléon III's willingness to question the authority of the Académie des Beaux-Arts in matters of artistic value and indulge the press and the public in their own judgments. Did the introduction of art history to the École change the character of the art produced by its students?

The first chair in art history in France – as distinct from archaeology and classical studies – was created as part of the reform of the École des Beaux-Arts putatively directed by the Comte de Nieuwerkerke. The uproar following the imposition of these reforms generated intense conflict and controversy among the cultural elites of the Second Empire. The significance of the reform effort has drawn the attention of numerous scholars, beginning with Albert Boime in the 1970s, followed by Jeanne Laurent in the 1980s, and continuing with the work of Alain Bonnet and Monique Segré in the 1990s, to name only the most prominent.[4] 13 November 1863, the date on which the reform decree was published in the *Moniteur universel,* is a key moment in the administration of cultural politics in nineteenth-century France. In official circles it remained a reference point for the remainder of the century. Because the reform of 1863 was sweeping in nature, however, few writers have focused on the fact that institutionalized art history was part and parcel of the project, and that this new intellectual endeavor was far from disinterested in the management of the visual arts contemporary to its enactment.

A reform of the École had been discussed for decades. As early as 1831 official inquiries were undertaken to redefine the institution as it had been established in 1819 under the Restoration.[5] The Revolution of 1848 prompted fresh discussion of the need for reform, and many of the elements that entered into the 1863 reforms were debated at this earlier time.[6] Both Prosper Mérimée and Gustave Planche published articles on the teaching of the fine arts in the *Revue des deux mondes.*[7] Among other things, Mérimée argued for the establishment of a library at the École and the creation of a chair in medieval architecture; Planche called for the teaching of art history itself. The brief life of the Second Republic ensured that these calls to action led nowhere, but the same issues re-emerged in artistic circles intimately linked to Napoléon III during the Second Empire.

A sense of mounting economic pressure motivated increasing attention to art education under the Second Empire. Following the 1851 Great Exhibition in London, Comte Léon de Laborde prepared a voluminous report entitled *De l'union des arts et de l'industrie,* which appeared in 1856.[8] The exhibition in London, and de Laborde's analysis of it, coincided with a period of anxiety about

France's artistic and economic hegemony. As the century continued, de Laborde's text was to have a major impact on the theorization of fine arts instruction in France as a whole.[9] As Boime has pointed out, de Laborde exercised a direct influence on Viollet-le-Duc and Mérimée, to whom he was close, as well as on Nieuwerkerke and Maréchal Vaillant, the official executors of the 1863 reform.[10]

Boime emphasizes the romanticism of de Laborde's arguments in favor of democratizing art instruction and reads into de Laborde a *plaidoyer* for origi- nality and individuality in art. Yet the bottom line in de Laborde's report is economic and nationalistic: educating the average worker's aesthetic sense and elevating her taste, de Laborde claimed, would increase the quality and desir- ability of French goods on the international market. De Laborde formulated a complex historical argument in favor of the instrumental approach to art instruction. In England the followers of the Utilitarian philosophers Bentham and Mill in Parliament had put into effect such a program, which established the Schools of Design and led to the foundation of the museum at South Kensington, the shadow of which served as an emblem of British resolve to achieve dominance in the "fancy trade" manufactures that had long been central to France's export economy.[11]

Utilitarian theories about the value of the visual arts in the national economy gained influence under the reign of Napoléon III. Mérimée assumed a promi- nent position within the cultural bureaucracy of the Second Empire. He was a frequent guest at the Imperial residence of Compiègne, where he was especially appreciated for his talent for writing amateur theatricals. In addition, Mérimée regularly attended the salon of the Princesse Mathilde, cousin and at one point nearly wife of the Emperor. Mathilde's role as patron and behind-the-scenes cultural administrator is fascinating and it bears deeper investigation than I can give it here. Suffice it to say that Mathilde cherished the company of a group of intellectual and artistic figures that included Flaubert, Sainte-Beuve, Renan, Taine, Littré, and the Goncourts, among others. Sainte-Beuve dubbed her "Notre Dame des Arts." Her salon was one of the gathering points of a self- conscious intellectual elite within the Second Empire, one which was determined to shape the culture within which they lived. Nieuwerkerke himself, a sculptor of minor reputation, owed his administrative career to his romantic liaison with Mathilde.[12] Mérimée had also been acquainted with the Empress Eugénie since before her marriage to Napoléon III, and was thus connected to two axes of power within the court.[13] Mérimée had known Viollet-le-Duc since the latter's childhood, and Viollet-le-Duc's work as restorer of medieval monu- ments under Imperial patronage stems from this connection.[14]

Under the Second Empire, Mérimée and his protégé Viollet-le-Duc were sufficiently well placed at court to advance the reform project that each had long contemplated. Alain Bonnet has observed that, although Nieuwerkerke was the official instigator of the reforms of 1863, he is better described as the instrument of Mérimée and Viollet-le-Duc's proposals rather than their inspira- tion.[15] Discussion of the reform project began in court circles in March 1862.[16]

Viollet-le-Duc publicly called for the reform of the École in a four-part article with the provocative title "L'Enseignement des beaux-arts: Il y a quelque chose à faire" that appeared in the *Gazette des Beaux-Arts* in four installments between May and September of 1862.[17] In the summer of 1863 he was openly gloating at court about the upcoming reform, designed in large part by his own thinking and politically engineered by Mérimée.[18]

By November 1863 Viollet-le-Duc had done everything he could to push for the reform of the École and to ensure that the art world was aware of his opinions. Moreover, his association with the revival of Gothic architecture and his own career path – he had himself refused to study at the École and thus attacked the school as an outsider – meant that his critique of the École and the Académie could not have been more offensive to the established order. His appointment to the seemingly minor position of *Professeur de l'histoire de l'art et de l'ésthetique* (not, indeed, one of the three professorships of architecture created by the reform decree) was as bold as a signature. The ideology associated with the economically oriented art-industry reforms projected by de Laborde and embraced by Mérimée, Nieuwerkerke, and Maréchal Vaillant was thus introduced at the top of the hierarchy of France's art education institutions.

The decree of 13 November 1863 and the new policies it inaugurated could hardly have gone further to arouse the antagonism of both the Académie des Beaux-Arts and the students enrolled in the École. A brief review of the major elements of the decree makes this clear. The decree transferred control of both the École itself and the Prix de Rome, the *sine qua non* of academic training, to the Ministre de l'Instruction Publique, effectively ending the Académie's ability to disseminate its doctrines. Moreover, the age for which students could compete for the Prix de Rome was reduced to 25 from 30, and the rota of *concours d'émulation* were suppressed. The intent of the reform was ostensibly to stimulate originality and to liberate the students from the stifling embrace of the Académie; the effect was to expel a large percentage of students overnight and to deprive those remaining of the myriad extra-artistic benefits of the minor competitions, which included cash prizes and the chance to win reductions in the mandatory military service period of three years. Small wonder that the reactions of both the Académie des Beaux-Arts and the students of the École were immediate and hostile.

Despite the many claims of the irrelevance of the École and the Académie made both by vanguard artists and critics in the nineteenth century and by modernist art historians of the twentieth, the École, the Prix de Rome, and the Villa Medicis were of central importance to the artists and students who were within the orbit of that system. As the students pointed out in their petitions, they learned from the *Moniteur* that from one day to the next the school into which many of them had invested years of their lives was abolished.[19] Given the factors at play, it is hard to believe that Nieuwerkerke, Mérimée, and Viollet-le-Duc could have seriously thought that their *coup d'état* (as it was often described) would succeed. And in the end it did not.

But that is another story. When Viollet-le-Duc appeared at the École to assume his responsibilities as the new professor of art history, the students, doubtless primed by their Academician professors, channeled their fury against him with a vengeance that has reminded later commentators of the events of May 1968.[20] After the seventh lesson, each held under conditions of utter disorder, Viollet-le-Duc resigned. Both Mérimée and Henri de Courmont, the Directeur des Beaux-Arts, were profoundly disappointed, feeling that this dealt a further blow to the reform effort.[21]

Given the intense provocation of the major elements of the reform, it is not surprising that institutionalized art history of itself did not attract much attention at the time. Indeed it was considered even by opponents of the reform to be a reasonable addition to the courses of instruction offered at the École. Louis Vitet, in his rebuttal to the vitriolic pamphlet Viollet-le-Duc wrote after his resignation, only objected to the person named to the position, not to the position itself.[22] Yet art history at the École represented a profound restructuring of the meaning of art as previously defined by the Académie, and this shift became even more apparent with the appointment of Viollet-le-Duc's successor.

Originality, as Albert Boime has pointed out, was the watchword of the reform effort. This stood in contrast to the concept of emulation central to academic doctrine. The artist is formed through the imitation of the correct models of the past, and through emulation learns, at last, to equal her predecessors. The Académie des Beaux-Arts was established to produce a clearly articulated canon of masters and practices to codify this process, to manage the past in the interests of perpetuating an unchanging standard of artistic achievement. The art of classical antiquity, of the Italian High Renaissance, and of Poussin were the absolute standard. These achievements cannot be exceeded, and can only be emulated. And since the ideals of art do not change, art has no history; only criticism is relevant. Art was defined as a transhistorical constant: that which is good is that which conforms to the canon; that which does not conform to the canon is either insignificant or bad.

This model of academic doctrine was still in place in 1863, but numerous fissures had appeared in the academic edifice. The complexity of the situation is made manifest in one of the most prominent décors of the École itself: the hemicycle, the principal assembly space, decorated by Paul Delaroche and a team of assistants between 1837 and 1841. In his sprawling mural, Delaroche erased what were once heated debates between line versus color and Northern versus Southern schools of painting into one massive assembly of the seventy-four greatest painters, sculptors, and architects of all time. Delaroche did not provide a reading of the history of art according to the precepts of emulation that privileged line over color and history painting over genre. The historical tradition he constructed was inclusive and therefore polysemic. Old hierarchies were reworked into a new relativist paradigm. Students reading the mural would find no trace of the Ingriste disdain for Rubens, for example, nor a clear indication of what made the art of Poussin more important than that of Terborch.

Alain Bonnet has pointed out that the mural itself is an affront to the vision of the past officially endorsed by the Académie, yet it occupies the most symbolically charged space in the École, the room in which the annual awards ceremony was held.[23] Paradoxically it received universal critical acclaim: no one seemed to notice its tacit subversion of accepted academic doctrine. In the place of a clearly articulated hierarchy and canon, Delaroche offered a deplotted past. The reform merely confirmed this state of affairs. The professorship of the history of art emerged at the École to provide a new narrative of the past. Although a seemingly minor complement to otherwise radical reforms, art history was inserted into the École's curriculum to supplant one model of the past with another. In place of the static model of the Académie, art history was to provide what Lyotard has termed a *grand récit* that generated a dynamic and usable past.[24]

Although Viollet-le-Duc's lectures were largely inaudible to their audience, they were published in the *Revue des cours littéraires* between 27 February and 10 October 1864.[25] Their content is quite distinct from the *Entretiens sur l'architecture* and his other writings. The seven lectures that Viollet-le-Duc prepared treated art history from the arrival of the Aryan race in the Himalayan Plateau to the Greco-Roman era. He avoided any mention of medieval architecture, the work with which he was most closely associated and precisely the area most likely to affront academic sensibilities. He rejected a doctrinaire approach to the study of the past, and compared his work to that of an anatomist dissecting a cadaver to discover the secrets of life itself. The biological metaphor associated his methodology with the natural sciences rather than the humanities, a turn Hippolyte Taine would later pursue with a vengeance.

Viollet-le-Duc's lectures were also explicitly grounded in a racist construction of human civilization, in which the European race, the most recent branch of the Aryans, occupied the highest position.[26] During his first lecture he attempted to relate the development of Hinduism and its complex pantheon to the emergence of classical Greek civilization. One can only imagine what the students would have made of this, had they been able to hear. Mérimée, in a sympathetic letter written from Cannes, suggested that Viollet-le-Duc had offered too much "quintessence" for the *crapauds*.[27]

Viollet-le-Duc's lectures are characterized by a high degree of abstraction. He endeavored to relate artistic production to the social and historical environment principally through the religious ideas of each culture. He also engaged in complex cross-cultural comparison between ancient civilizations and their arts, from time to time introducing a concrete example to illustrate his point. The lectures were not easy to assimilate into daily artistic practice as experienced by his students. And in contrast to the principles of the Académie, Viollet-le-Duc embraced the necessity of progress in the visual arts.

Viollet-le-Duc's resignation in the spring of 1864 left the professorship vacant for the remainder of the academic year. On 26 October 1864 Taine was named his successor. Taine was, like Viollet-le-Duc and Mérimée, a member of the circle of Princesse Mathilde, and thus was privy to the goals of the reform

effort. He had earlier applied for a position at the École as professor of history and archaeology. His name was put forward for the art history position by Victor Duruy, Ministre de l'Instruction publique and an old acquaintance of Taine's.[28] Taine could be counted on to provide instruction that countered the hegemony of academic discourse, which had proven itself capable of resisting the imperatives of the new economically motivated cultural policy. While Viollet-le-Duc served as the scapegoat for the poorly orchestrated reform of the École, Taine would reintroduce the rhetoric of progress and capitalist individualism into the school's curriculum.

Taine's qualifications as an art historian were substantially less secure than Viollet-le-Duc's. His academic training was in philosophy and history. His career to that point had been characterized by repeated rejection by the academic establishment.[29] Despite widespread recognition of his brilliance from his days at the École normale supérieure onward, he had spent much of his academic career to that point in minor positions in the provinces. Patrizia Lombardo and more recently Christophe Charle have analyzed the dynamics of Taine's vexed relationship with academia, then in the embrace of Victor Cousin's metaphysics.[30] Taine's work, grounded in eighteenth-century empiricism and the natural sciences of Cuvier and Lamarck, as well as his persistent anglophilia, courted rejection. At the time of his appointment to the École des Beaux-Arts he occupied a position as examiner in History and German at the military academy of St. Cyr, a minor post for a scholar of his abilities.

Taine published profusely despite his marginal position within the academic world. In addition to journalism, his major means of support, he published works of literary criticism, notably his *Histoire de la littérature anglaise*, and volumes of travel writing.[31] Consciously following the precedent established by Stendhal, Taine's travel works compile specific observation of local values and customs in an attempt to account for the cultural production of the different peoples under investigation. Taine's art history is rooted in his travel writing and the direct experience of cultural alterity.

Mérimée and de Courmont expressed some concern that Taine would meet with the same hostility that Viollet-le-Duc had encountered.[32] He was a known associate of the authors of the hated reform decree. His appointment has been seen as a final provocation of the academic establishment, a "*bonne petite revanche*" for Viollet-le-Duc's expulsion.[33] Yet his opening lecture, held on 25 January 1865, met with an overwhelmingly positive response from the students in attendance.[34] Doubtless this was in part due to the fact that in the year that separated Taine's lectures from Viollet-le-Duc's, the harshest provisions of the decree of 13 November 1863 had been modified by a decree of 13 January 1864. The new decree returned the age limit for the Prix de Rome competition back to 30 and re-established the *concours d'émulation*. Notwithstanding this softening of elements of the 1863 decree, other factors came into play as well.

Like Viollet-le-Duc, Taine was an outsider to the École, but an outsider without the manifest hostility to the institution that Viollet-le-Duc had made

transparent to the students he attempted to teach. Taine was also a charismatic and lucid lecturer. In place of Viollet-le-Duc's abstruse "quintessence," Taine articulated his critical platform at the outset and proceeded in a logical progression through the course of lectures he set out to deliver. His success was such that he remained at the post until his death in 1893.[35]

Indeed, Taine's methodology was the root of his appeal to his students and to the many listeners and readers who responded favorably to his work. The core concepts with which he is associated – the catchphrase of "race, milieu, and moment" – emerged in his work prior to the École lectures, but they are also central to his art historical method. Most importantly, Taine insisted that his historical approach was scientific, stating in his opening lecture:

> The modern method which I will follow, and which is beginning to introduce itself into all of the moral sciences, consists in considering human works, and in particular works of art, as facts and products of which it is necessary to indicate the character and search for the causes; nothing further. Thus understood, science neither proscribes nor pardons; it observes and explains.[36]

To underscore this point, in the following passage Taine ridiculed academic injunctions against Dutch or Gothic art: these biases have no basis in science.

At the outset of his teaching at the École, Taine established his rejection of the aesthetic discourse of the Académie and the new character of his method to his students, as Morton has emphasized: "Casting his method of instruction as tolerant and progressive, he insinuated a transfer of power from the authority of the academy to the individual student."[37] But above all, Taine's claim to science made his dictates resonant. Those elements of his lectures that now provoke a negative reaction – their cookie-cutter determinism, sweeping generalizations and oversimplifications – nevertheless had a boldness that appealed to his audience. Taine's method was not universally admired, even by his own peers: the de Goncourts, Flaubert, and Théophile Gautier privately expressed their reservations.[38] Nevertheless, Taine's thought was broadly influential during the Third Republic and well afterwards.

The shift in emphasis from academic canon to supposedly scientific method did not pass unnoticed in the artistic press. Louvrier de Lajolais, writing in the *Gazette des architects et du bâtiment*, commented:

> These ideas, frankly presented, clearly expressed, warmly welcomed, inaugurate at the École des Beaux-Arts an entirely new system. Instruction will no longer be methodologically doctrinaire: no more unity, no more organization of the whole. [...] [W]e ask ourselves if this eclecticism, so close to indifference, which today enters the École under the mantle of liberty and with the support of M. Taine, does not run the risk, by leaving individuals the choice of a direction in

conformity with their sympathies, of encouraging in the minds of men still quite young the value of individuality before that of principle, of personal sentiment before the tradition of beauty. The École will no longer be the École, but simply a school.[39]

Indeed this was Taine's explicit program. In his opening lecture he declared: "The modern critical method leaves the individual the freedom to follow his particular sympathies, to prefer that which is in accord with his own temperament and to study with the greatest care that which will contribute the most to the development of his own mind."[40] The idea recurs frequently in Taine's writing. The Académie's "tradition of beauty," with its longstanding philosophical connections to concepts of authoritarian power, legitimacy, and civilization, is supplanted by the autonomy of the individual, henceforth liberated from the constraints of received values and beholden only to the market. Taine's teaching was fully in accord with the deeper principles of the reform of 1863: the formation of cultural producers oriented to the new realities of capitalist individualism.

Other commentators, however, critiqued Taine's teaching from a different perspective. Paul Gout, writing in 1914, found that, in contrast to Viollet-le-Duc, Taine, "whose teaching was brilliant but not in the least technical, was infinitely more appropriate for the training of humanist scholars than architects. One could scarcely imagine a more elegant way of burying the very principle of the reform."[41] Taine's art history paid scant attention to the techniques of art itself to the extent that his sensitivity to visual experience is open to question. Indeed, Taine himself was aware of the non-visual character of his thinking.[42]

Strong arguments have been advanced with regard to Taine's influence on the visual arts in France after 1864. It is not known how many École students actually attended his lectures. Pierre Vaisse has argued that the majority of his listeners were *auditeurs libres*, members of the general public or students from other schools taking advantage of the opportunity to listen to a prominent thinker.[43] The architect Charles Garnier is reported to have remarked: "Everyone goes to the lectures ... except the students."[44] There is little to suggest in the work of the students who emerged from the École after 1863 that a paradigm shift had occurred after Taine's appointment. Henri Regnault, first winner of the Prix de Rome after the reform of 1863, might be taken as typical. He made pointed efforts to demonstrate the new liberties granted to him by the reform: he traveled to Spain as well as to Rome, and sent back, as his required exercise in full-scale copying, a rendition of Velázquez' *Surrender at Breda*. Yet in his own short career his work differs little from his academic contemporaries.

Yet Taine's lessons did have a significant impact on the visual arts in the later part of the century. Paradoxically his greatest influence was felt outside the École itself. Mary Morton has argued for Taine's direct influence on the painters of the Impressionist generation, as well as on Cézanne and Eakins.[45] Zola found in Taine a major inspiration for his own criticism, although, as

Morton observes, it may well be that Taine's "most radical presence was in the pages of Zola's criticism."[46] Richard Shiff has deftly analyzed the ways in which Taine's thinking, along with that of Littré, filtered through critical debates on the "new painting" that emerged in the 1860s and 1870s and the formation of a Symbolist discourse on Impressionism.[47] Although Zola initiates what might be called a Tainean line of criticism in the 1860s under the direct influence of Taine's École lectures, Shiff locates the most salient of Taine's ideas with regard to the discourse on Impressionism in one of Taine's most abstruse and certainly his most enduring text, *De l'intelligence*.[48] This book was written during the late 1860s, concurrent with his École lectures, and published in 1870. Thus Shiff suggests that Taine's art history was of secondary importance when compared to his work on mental process and psychology.

Taine said very little about the art of his own times. This is particularly striking in that he was working in what is now widely recognized as one of the most dynamic moments in European art. Yet he was unaware, for example, of the importance of Manet and the Impressionist movement. It is characteristic that Taine's portrait was painted by the Academician Léon Bonnat, his colleague at the École, and not by any of the younger artists who were influenced by him, as Cézanne claimed to be, or whose critical supporters drew on him, as was the case with Zola. The deterministic character of his art historical method suggested that surrounding social conditions, the character of the climate, and the tenor of the age would automatically produce an art.

Taine specifically addressed the condition of the visual arts in Paris in an essay commissioned by his publisher Hachette for a volume entitled *Paris Guide*, published at the occasion of the 1867 Exposition universelle. Entitled "L'École des Beaux-Arts et les Beaux-Arts en France," it also appeared in the *Journal des débats* on 2 April 1867.[49] Here Taine returns to the travel writing genre but in reverse, as an insider interpreting that world of the capital for a foreign visitor. It is a deeply pessimistic view of the art world at a moment of official celebration. In the text Taine plays his own persona against that of a fictive Italian count who collects only the art of the Renaissance. The ruse is similar to his use of the British alter-ego Thomas Graindorge in *Notes sur Paris*, also published in 1867.[50] Faced with the ironic observations of his interlocutor, Taine describes the art world as fragmented and feeble, unable to synthesize the many influences active within it. For the art student "the public is a second school more powerful than the École itself," and this public, lacking in education, attends the Salon with the same desire for distraction that it seeks in a street fair.[51] The restless search for sensation creates a demand for overwrought novelty, as "art models itself on taste as a bronze on its mold."[52] The elite exceptions, according to Taine, were Ingres, Delacroix, and Decamps. Only the last is mentioned by name, and Taine reserves for him his highest praise: "the most lively and most original of our times."[53] Taine's critical opinion took no risks: all three painters had been specially honored at the 1855 Exposition universelle and by 1867 all three were dead.[54]

Taine's inability to identify those of his contemporaries who corresponded with his own positivist aesthetics may stem from the type of "science" he constructed for himself. Taine anchored his thought in the biological sciences of his age, in particular zoology. As Cuvier would reconstruct an entire animal from the evidence of a single bone and Lamarck read in the structures of an organism the imprint of its environment, Taine sought to analyze entire cultures through the evidence of discrete works of art. Cuvier and Lamarck both posited, however, a static world in which no new species emerged, and vanished species disappeared only through cataclysm. Although Taine soon accepted Darwin's concept of evolution, the closed system of a taxonomically oriented science remained central to his thinking. In consequence, the idea of an avant-garde, even as it unfolded in his own time, was an impossibility for Taine. To borrow one of his own metaphors, for Taine the idea of a work of art coming into existence in advance of its racial, social, and physical milieu was as impossible as a tropical plant flourishing under the winter skies of Paris. The avant-garde art of the 1860s and 1870s, which emerged in advance of a public capable of supporting it, was inconceivable within his methodological framework. It is ironic that Taine's writing was taken as a source of legitimization for the very work he was unable to theorize. In his aesthetics as in his politics Taine was in no sense a progressive.

\*\*\*

In the twentieth century the reputations of France's first institutionally constituted art historians have fluctuated widely, and the history of their vicissitudes is more complex than needs to be recounted here. It is compelling to note, however, that both Viollet-le-Duc and Taine have been claimed by a variety of scholars as the precursors of structuralism. As early as 1964 Hubert Damisch argued that Viollet-le-Duc's writings offered "the singularly precocious and decided manifesto, at least in sketch form, of the method and ideology of structuralist thought such as it is seen today in linguistics and anthropology."[55] In 1978, writing with Philippe Bourdon and Philippe Deshayes, Damisch extended this argument in a book-length study.[56] At the same time Hans Aarsleff argued that Saussure's linguistics was rooted in his study of Taine's writings.[57] Aarsleff expanded this argument in his 1982 book *From Locke to Saussure*, and both Donald Preziosi and Mary G. Morton have adopted his position.[58] Further, Patrizia Lombardo has seen in Taine a prefiguration of Barthes, the structuralist renegade to the academic establishment.[59] Although at first reading both Viollet-le-Duc and Taine laid the groundwork for social art history, a consensus of scholars has sought to place them at the origins of structuralist thought, and thus, by extension, structuralist art history. The implications of this consensus raise a number of questions, none of which can be adequately addressed within the scope of the present chapter. But a few questions might be posed for future analysis. If structuralism's origins lie at least partly within the work of Viollet-le-

Duc and Taine, how does this relate to the larger node of thinkers associated with the Princesse Mathilde and the intellectual elite of the late Second Empire? Does structuralist thought, normally associated with the left wing of intellectual practice, equally bear the trace of the clearly Utilitarian and liberal capitalist values that undergirded the 1863 reform of the École des Beaux-arts and the creation of an institutional position in the history of art? Twenty-first century art history surveys bear an unsettlingly deep resemblance to the courses offered by Viollet-le-Duc and Taine, but as yet no body of students has risen to protest them. To repose the question in terms borrowed from Lyotard, we might wish to ask of structuralism – and of art history – not "is it true?" but again "what exactly does it serve?"[60]

## NOTES

I would like to acknowledge the kind assistance of Mme. Michèle Le Pavec in the Département des Manuscrits at the Bibliothèque Nationale, Paris, in making available uncatalogued materials from Taine's papers, and the perceptive critique of this text generously provided by Gonzalo J. Sánchez, Associate Professor of Social Sciences at Boston University.

1 M. du Camp, *Souvenirs d'un demi-siècle*, Paris, Hachette, 1949, p. 221.
2 L. Therrien treats Viollet-le-Duc's and Taine's roles in *L'Histoire de l'art en France*, Paris, Éditions du Comité des travaux historiques et scientifiques, 1998, pp. 83–112. A. Bonnet details Viollet-le-Duc's appointment in "La Réforme de l'École des Beaux-Arts de 1863: Problèmes de l'enseignement artistique en France au XIXe siècle," unpublished Ph.D. dissertation, Nanterre, Université de Paris X, 1993, vol. 1, pp. 277–287.
3 See Therrien, *L'Histoire de l'art en France*, pp. 599–600.
4 A. Boime, *The Academy and French Painting in the Nineteenth Century*, London, Phaidon, 1971; Boime, "The Teaching Reforms of 1863 and the Origins of Modernism in France," *Art Quarterly*, Autumn 1977, pp. 1–39; J. Laurent, *À propos de l'École des Beaux-Arts*, Paris, École nationale supérieure des Beaux-Arts, 1987; Bonnet, "La Réforme," 1993; M. Segré, *L'École des Beaux-Arts XIXe et XXe siècles*, Paris, L'Harmattan, 1998.
5 See P.H. Walsh, "The Atelier of Gustave Moreau at the École des Beaux-Arts," unpublished Ph.D. dissertation, Cambridge, MA, Harvard University, 1995, pp. 29–36, for a summary of these discussions.
6 Walsh, "The Atelier of Gustave Moreau," pp. 37–42.
7 P. Mérimée, "De l'enseignement des beaux-arts," *Revue des deux mondes*, 1848, vol. 22, pp. 634–48; G. Planche, "De l'éducation et de l'avenir des artistes en France," *Revue des deux mondes*, 1848, vol. 24, pp. 608–29.
8 L. de Laborde, *De l'union des arts et de l'industrie*, 2 vols, Paris, Imprimerie Impériale, 1856.
9 On de Laborde and his report see N. Pevsner, *Academies of Art: Past and Present*, New York, NY, Da Capo Press, 1973, pp. 249–51; and Boime, "The Teaching Reforms of 1863," pp. 4–6.
10 Boime, "The Teaching Reforms of 1863," p. 6.
11 See Q. Bell, *The Schools of Design*, London, Routledge and Kegan Paul, 1963, pp. 38–63. On English design theory and its Utilitarian bias see J.G. Rhodes' fascinating study "Ornament and Ideology: A Study in Mid-Nineteenth Century Design Theory," unpublished Ph.D. dissertation, Cambridge, MA, Harvard University,

1983. Somewhat earlier Utilitarian thinking on the visual arts is examined in A. Hemingway, "Genius, Gender and Progress: Benthamism and the Arts in the 1820s," *Art History*, 1993, vol. 16, pp. 619–46.

12 See F. Goldschmidt, *Nieuwerkerke, le bel Émilien: Prestigieux directeur du Louvre sous Napoléon III*, Paris, Art International Publishers, 1997.

13 P. Gout, *Viollet-le-Duc, sa vie, son oeuvre, sa doctrine*, Paris, Édouard Champion, 1914, p. 51.

14 Bonnet, *La Réforme*, pp. 277–87.

15 Ibid., p. 269.

16 Gout, *Viollet-le-Duc*, p. 52.

17 *Gazette des Beaux-Arts*, 1862, vol. 12, pp. 393–402, pp. 525–34; vol. 13, pp. 71–82, pp. 249–55. Reprinted in B. Foucart, ed., *À propos de l'enseignement des arts du dessin*, Paris, École nationale supérieure des Beaux-Arts, 1984, pp. 101–43.

18 Foucart, ed., *À propos de l'enseignement des arts du dessin*, p. 14.

19 *Réclamations des élèves de l'École des Beaux-Arts au sujet de la réorganisation de leur école*, Paris, Ad. Lainé et J. Havard, 1864, p. 8.

20 G. Viollet-le-Duc, "Viollet-le-Duc et l'École des Beaux-Arts: La bataille de 1863–64," in E. Viollet-le-Duc, *Esthétique appliquée à l'histoire de l'art*, Paris, École nationale supérieure des Beaux-Arts, 1994, p. 153.

21 See P. Mérimée, *Correspondance générale*, Toulouse, Édouard Privat, 1948, vol. 12, pp. 100–102. Maurice Parturier, editor of the Mérimée correspondence, notes that although Maxime du Camp placed Mérimée at the École on the fateful day of Viollet-le-Duc's first lesson, he was in fact in Cannes. See also G. Viollet-le-Duc, "Viollet-le-Duc et l'École des Beaux-Arts," pp. 138–45.

22 L. Vitet, "De l'enseignement des arts du dessin," reprinted in Foucart, ed., *À propos de l'enseignement des arts du dessin*, p. 51.

23 A. Bonnet, "Une histoire de l'art illustrée: L'hémicycle de l'École des Beaux-Arts par Paul Delaroche," *Histoire de l'art*, 1996, no. 33/34, pp. 17–30. I advance a similar argument in "Gustave Moreau, *Professor Chef d'Atelier*," in *Gustave Moreau y su legado*, Mexico D.F., Centro Cultural/Arte Contemporaneo, 1994, pp. 272–6.

24 J.-F. Lyotard, *La Condition postmoderne: Rapport sur le savoir*, Paris, Les Éditions de Minuit, 1979, pp. 54–62.

25 The lectures were reprinted as Eugène Viollet-le-Duc, *Esthétique appliquée à l'histoire de l'art*, Paris, École nationale supérieure des Beaux-Arts, 1994. My citations are to this edition.

26 Viollet-le-Duc's racism is both frank and entirely typical of his era. For example: "The races of mankind are not equal, and, to speak only of the two extremes, it is evident that the white races that have occupied Europe for three thousand years are infinitely superior to the Negro races that have inhabited a large area of Africa since time immemorial. The first have a regular history, a series of more or less perfected civilizations, and moments of astonishing splendor; the others are today what they were twenty centuries ago, and their contact with the civilization of European peoples has had the sole result of transmitting to them cravings and vices of which they were unaware, without leading them to the path of true progress." Ibid., p. 15. It scarcely needs to be pointed out that in this way art history directly served as part of the ideological infrastructure for paternalistic colonialism.

27 Mérimée, *Correspondance générale*, vol. 12, p. 20.

28 Taine's papers in the Bibliothèque nationale, Paris, include letters from Duruy dating back to 1855. See also Therrien, *L'Histoire de l'art en France*, pp. 100–1.

29 Editor's note: see Mary G. Morton's chapter in this volume.

30 P. Lombardo, "Hippolyte Taine Between Art and Science," *Yale French Studies*, 1990, vol. 77, pp. 117–33; Christophe Charle, *Paris fin de siècle*, Paris, Éditions du Seuil, 1998, pp. 97–123.

31 Taine, *Histoire de la littérature anglaise*, 4 vols, Paris, Hachette, 1863–1864, republished in 5 vols in 1866 and frequently reprinted thereafter; Taine's reputation as an art historian was established by his *Voyage en Italie*, 2 vols, Paris, Hachette, 1866, which republished travel essays that had appeared earlier in the 1860s.

32 Mérimée, *Correspondance générale*, vol. 12, p. 313.

33 F. Leger, *La Jeunesse d'Hippolyte Taine*, Paris, Éditions Albatros, 1980, p. 324.

34 Mérimée, *Correspondance générale*, vol. 12, p. 313; Leger, *La Jeunesse d'Hippolyte Taine*, p. 328.

35 Taine's long tenure at the École was interrupted by several absences, notably between 1884 and 1893, when Eugène Müntz substituted for him. See Therrien, *L'Histoire de l'art en France*, p. 110. On Taine's teaching method at the École, see Mary G. Morton "Naturalism and Nostalgia: Hippolyte Taine's Lectures on Art History at the École des Beaux-Arts, 1865–1869," unpublished Ph.D. dissertation, Providence, Brown University, 1998. Editor's note: see also Morton's contribution to the present volume.

36 Taine, *Philosophie de l'art*, 10th ed., Paris, Hachette, 1903, p. 12. Unless otherwise indicated, all translations are mine.

37 Morton, "Naturalism and Nostalgia," p. 40.

38 See T.H. Goetz, *Taine and the Fine Arts*, Madrid, Playor S.A., 1973, p. 21.

39 Bonnet, *La Réforme*, vol. 2, p. 149.

40 Taine papers, Bibliothèque nationale, Paris, folder for first lesson, as of this writing uncatalogued.

41 Gout, *Viollet-le-Duc*, p. 55.

42 Taine, *Vie et correspondance*, vol. 2, Paris, Hachette, 1905, p. 334.

43 P. Vaisse, *La Troisième République et les peintres*, Paris, Flammarion, 1995, p. 82.

44 Therrien, *L'Histoire de l'art en France*, p. 109.

45 Morton, "Naturalism and Nostalgia," pp. 155–60.

46 Ibid., p. 161.

47 Shiff, *Cézanne and the End of Impressionism*, Chicago, University of Chicago Press, 1984, pp. 29–36.

48 Taine, *De l'intelligence*, 2 vols, Paris, Hachette, 1870.

49 Reprinted in Taine, *Derniers essais de critique et d'histoire*, 4th ed., Paris, Hachette, 1909, pp. 49–66.

50 Taine, *Notes sur Paris; vie et opinions de M. Frédéric-Thomas Graindorge ... recueillies et publiées par H. Taine, son exécuteur testamentaire*, Paris, Hachette, 1867.

51 Taine, *Derniers essais*, p. 54.

52 Ibid., p. 55.

53 Ibid., p. 66.

54 Nordmann, *Taine et la critique scientifique*, Paris, Presses Universitaires de France, 1992, p. 75.

55 H. Damisch, Introduction to Viollet-le-Duc, *L'Architecture raisonnée: Extraits du dictionnaire de l'architecture française*, Paris, Hermann, 1964, p. 14.

56 P. Bourdon, H. Damisch, and P. Deshayes, *Analyse du dictionnaire de l'architecture française du XIe au XVIe siècle par E. Viollet-le-Duc, architecte*, Paris, A.R.E.A., 1978.

57 H. Aarsleff, "Taine and Saussure," *The Yale Review*, 1968, vol. 68, pp. 71–81.

58 H. Aarsleff, *From Locke to Saussure*, Minneapolis, University of Minnesota Press, 1982; D. Preziosi, *Rethinking Art History*, New Haven, Yale University Press, 1989, p. 88; Morton, "Naturalism and Nostalgia," pp. 63–4.

59 Lombardo, "Hippolyte Taine Between Art and Science," pp. 123, 130–1.

60 Lyotard, *La Condition postmoderne*, p. 84.

# 6

# COLONIZING CULTURE

## The origins of art history in Australia

*Jacqueline Strecker*

Over the last three decades there has been an unprecedented growth of writing on the institutional origins of art history in Australia. The tendency has been to construct art history's history in Australia as an essentially twentieth-century phenomenon which originated with the establishment of art history departments at Australian universities in the first half of the twentieth century.[1] If one accepts, however, a definition of art history as research in the history of art, then the institutional origins of art history in Australia lie in the nineteenth century, which saw the emergence of a range of cultural institutions and endeavors devoted to broadening public knowledge about the history of art.

From the 1830s to the 1880s art institutes, artists' societies and public art museums flourished in four of the six Australian colonies. This chapter explores the history of Australia's earliest cultural institutions, which emerged in Hobart, Sydney, Adelaide, and Melbourne in the early to mid-nineteenth century following European settlement of Australia in 1788. From a postcolonial perspective it is easy to dismiss these early cultural institutions as a form of cultural imperialism which developed in what were then British colonies situated on the periphery of the empire. But what Australian art historiographies have not sufficiently taken into account is the significance of these institutions as the first manifestations of antipodean culture combining imperial models with the unique local situation of colonial culture.

It is surprising that the colonial origins of art history have largely been overlooked compared to the period after 1880, which has been exhaustively studied and is usually assumed to mark the beginning of a uniquely Australian sense of culture and identity. The study and promotion of fine arts through lectures and the establishment of public art institutions were placed high on the cultural agendas of each of the colonies during the middle of the nineteenth century. By the 1880s all four colonies had established a publicly funded art gallery.[2] The fact that Australia's first cultural institutions originated within a context of colonial regionalism is important for this set a pattern of fierce regional competition between cultural institutions which survives to the present day.

The Eurocentric nature of colonial culture is revealed in the earliest comments relating to the fine arts in Australia. Reports on Sydney's emerging

local art scene in the late 1820s optimistically refer to cultural developments in the colony of New South Wales, which had been established as Australia's first penal colony in 1788. The anticipatory tone of John McGarvie's 1829 article on the state of the fine arts in New South Wales is typical:

> The fine arts may seem a misnomer for foul arts, when applied to this Colony. Nevertheless, it gives us pleasure to undeceive the patrons of so preposterous a sentiment. Forty years is a period in which Britons can work wonders. The Muses and Graces are not inimical to our southern climes; and we have no doubt that they will take up their residence amongst us.[3]

The cultural ideals and aspirations expressed by this Scottish Presbyterian minister for what was then believed by white settlers to be a culturally barren land now seem rather high-minded and overstated. Other contemporary writers such as John Lhotsky, in an 1839 article entitled "Australia, in its Historical Evolution,"[4] measured in a similar way the development of art and taste in colonial society against the quality of imported works.[5] This predominantly Eurocentric view of art history remained largely unchanged in Australia until well into the second half of the twentieth century, when the history of Australian art – including Aboriginal art – began to be taught at Australian universities and became the subject of independent scholarly research.

The rise of the Mechanics' Institute movement in the colonies from the late 1820s to the 1850s was by far the most significant development in the history of Australia's earliest cultural institutions. The first Australian Mechanics' Institute was founded in Hobart in 1827, just four years after George Birkbeck had initiated the movement by establishing the first Mechanics' Institute in Glasgow and three years after the founding of the first London Mechanics' Institute.[6] This was a substantial achievement for such a young and remote colony as Van Diemen's Land (now known as Tasmania), considering that it had only been settled in 1803 as a penal colony. The Mechanics' Institutes were established in theory to help artisans and skilled working men "improve themselves in their leisure hours through the gaining of useful knowledge which would be made available through a library and lectures given by experts."[7] But within a short period of time the Institutes had been taken over by the professional and middle classes, who were eager for knowledge and culture as a means of furthering their own interests.[8]

The declared aim of the Van Diemen's Land Mechanics' School of Arts was to offer instruction primarily in the liberal arts rather than the fine arts, but gradually the Institute included in its programs lectures on a range of aesthetic issues. Benjamin Duterrau was one of the first newly arrived artists from England to deliver a lecture at the Institute on the importance of cultivating the fine arts in the development of colonial society. An established artist who had exhibited portraits at the Royal Academy, Duterrau emphasized that only

through education and culture could the colony overcome its depraved convict origins. In his 1849 lecture entitled "The School of Athens, as it assimilates with the Mechanics' Institution" Duterrau compared Plato's Academy as represented by Raphael in *The School of Athens* with the Mechanics' Institute in Hobart. Nowhere was a greater sense of hope expressed for the higher purpose of Australia's earliest cultural institution than in Duterrau's claim that "... the School of Hobart Town may do as much in proportion for our little happy community, as the School of Athens has done for the wide world."[9] Though this comparison may now seem ludicrously optimistic there was a genuine belief that the arts would thrive in the colony. In a similar spirit of inspired optimism Governor Sir John Franklin and Lady Franklin had a Greek-style temple built at Acanthe, New Town, for the support of the arts and sciences. Yet, in spite of these high-minded ideals, Hobart's cultural institutions went into decline in the 1840s following the departure of Sir John and Lady Franklin from Hobart in 1843 and the onset of economic recession.

A second institute was established in Van Diemen's Land at Launceston in 1842 with the aim of "promoting the intellectual culture of the operative classes, mechanics and workmen."[10] For at least two decades the Launceston Mechanics' Institute conducted lectures, organized exhibitions and built up its library, art gallery and museum collections. In 1848 John West, a congregational minister and one of the founders of the Launceston Mechanics' Institute, delivered a lecture on "The Fine Arts in their Intellectual and Social Relations" to mark the occasion of the first loan art exhibition in Launceston. His exploration of the role of art in the history of human evolution served to demonstrate what he described as "the intellectual and moral power of art."[11] West justified the role of art within colonial society on moral grounds and, like many of his contemporaries, judged its development in relation to the history of European art. While this didactic view of art was hardly surprising in an evolving penal colony, it is interesting to note that the Mechanics' Institute lectures rarely promoted a utilitarian view of the fine arts as a way of improving the standard of manufacturing and trade in the colonies.

The Mechanics' Institute movement rapidly spread to other colonies such as New South Wales, where Institutes were established in Sydney in 1833 and in regional areas including Newcastle in 1835 and Maitland in 1839. A Melbourne Mechanics' Institute was set up in 1839 in the recently established Port Phillip District (soon to become Victoria), which had not been tainted by a convict past but was settled by pastoralists from New South Wales and Van Diemen's Land. Ballarat, Geelong, and Bendigo followed in establishing Institutes, as did virtually every other country town in Australia. The emphasis was again upon lectures as the preferred method of instruction, with the fine arts assigned varying degrees of importance. At the Sydney Mechanics' School of Arts, for example, of the forty-three lectures delivered in 1841 three were on "Principles of Drawing" by John Skinner Prout, four on "Principles of Taste" by John Rae, and one on "Printing" by Mr. J. Kemp.[12] In addition to organizing lectures on

art and drawing classes, the Institutes sometimes collected and displayed art as an adjunct to their instructional programs. The collections, of course, varied enormously but among the finest art objects to be collected by the Sydney Mechanics' School of Arts was a set of etchings by Albrecht Dürer. These works had been sent to the colony by John Ruskin, who took a keen interest in the early development of the Institute.[13] Despite the strong presence of the Mechanics' Institutes in early colonial culture, their significance was restricted to the nineteenth century. By the early twentieth century, as art historian Bernard Smith has suggested, "country folk absorbed the Institutes as dance halls and snooker pools; in the cities they were forgotten."[14] In some rare instances these Institutes have survived in their original form to the present day, as in the case of the 167-year-old Sydney Mechanics' School of Arts which remains committed to its initial aim of delivering cultural and educational programs to the public.

In the small colonial settlement of South Australia, which had been established in 1834 through private capital and settled entirely by voluntary immigrants, there was not the same impetus to set up institutions designed to educate the working classes. Rather the early founders hoped that the most desirable aspects of middle-class English society and culture would be transplanted to the colony.[15] In Adelaide, the first reflections on the study of art were made by Thomas Wilson, an English solicitor and art collector who arrived in Australia in 1838 and became the mayor of Adelaide in 1842.[16] In 1843, at the first lecture ever given on art in the new colony, Wilson spoke about engraving in the sixteenth century. An informed collector who had published a scholarly catalogue in 1828 on his splendid collection of prints – many of which are now held in public art collections – Wilson was one of the earliest specialists in the fine arts to organize local art exhibitions and to deplore the lack of a public art gallery in colonial society. He was an important early advocate of the British Museum as the preferred type of model for a public cultural institution, and his articles on the fine arts in the *Adelaide Magazine* (1843–6) included a lecture on "The Print Room of the British Museum."

The founding of the Society for the Promotion of Fine Arts in Sydney in 1847 marked the beginning of a new era of emerging art societies in each of the colonial states. The art societies – unlike the Mechanics' Institutes and Schools of Arts – were devoted exclusively to promoting the fine arts in the colonies by sponsoring painting and sculpture for their intrinsic worth. Based upon similar English models, the art societies organized lectures, conversazione, and annual exhibitions. The three exhibitions organized by Sydney's Fine Arts Society, consisting mostly of loan works by local artists such as Conrad Martens, John Skinner Prout, George French Angas, Frederick Garling, Samuel Thomas Gill, and Marshall Claxton, were held at the Australian Library in Bent Street in 1847, at the Barrack Square in 1849 and at the Mechanics' School of Arts in 1857.[17] By contrast, the recently established South Australian Society of Arts included imported works of art rather than local works in its first exhibition in

1857 at the Legislative Council Chamber, North Terrace, Adelaide. The Fine Arts Society in Sydney was eventually superseded by professional artists' associations, as was the Society of Arts in Adelaide which continued to hold annual exhibitions until the 1880s.

By far the most dramatic transformation in colonial culture occurred in Victoria in the 1850s. After an initially slow and uncertain beginning, the art scene in Melbourne thrived as a result of the gold rushes which began in Victoria in 1851. The sharp increase in the production of art, the growth of art exhibitions, and the diversity of art criticism all reflected the colony's growing interest in the fine arts, which was itself a response to the creation of new gold-generated wealth. Art became an important sign of the colony's progress towards a civilized society and a matter of national pride.[18] A section of fine arts exhibits was included in the exhibitions organized by the Victorian Industrial Society during the years 1851–8. In addition, two quite distinct art societies were formed in Melbourne. The Victorian Fine Arts Society was founded in 1853 and held an exhibition the same year at the Mechanics' Institute, but within a few months it had disbanded. In 1856 the Victorian Society of Fine Arts was formed with the aim "to advance the cause of the Fine Arts in Australia."[19] Many of the committee members were British and European artists who had been lured to Australia by the gold rushes; they included Charles Summers, William Strutt, and Nicholas Chevalier from London, Ludwig Becker from Darmstadt, Eugene von Guérard from Vienna, and John Alexander Gilfillan from Scotland.[20] The Society's objectives were to hold annual exhibitions, organize an art union and form a collection of pictures and a library. However, the Society dissolved within a year after holding only one exhibition at Melbourne's first Exhibition building in 1857.

Though it did not survive as an institution, it was within the context of the inaugural conversazione of the Victorian Society of Fine Arts that James Smith, a leading art critic and committee member, proposed the idea of forming a National Art Gallery. In 1858 plans were made by the Victorian government to build an extension on to the rear of the recently established Melbourne Public Library to house a Museum of Art. Three years later, in 1861, Australia's first public art museum was opened. As well as forming an art collection and organizing exhibitions it was hoped that the National Gallery would become the center for the study of art.[21] The imperial models for this type of public institution were the British Museum and the National Gallery in London.[22] One of the prime movers responsible for establishing in Melbourne this type of early Victorian Library–Museum–Art Gallery complex was Redmond Barry. An Anglo-Irish Supreme Court judge who arrived in Melbourne in 1839, Barry had advocated for at least a decade his vision of creating free cultural institutions that could be accessed by the general public. In two lectures on the fine arts delivered at the Mechanics' Institute in 1847 Barry talked about the universal qualities of the fine arts and their centrality to the development of a civilized community. He argued for the widest possible base for community

participation in cultural activities.[23] Barry's firm belief in the educational purpose of public cultural institutions demonstrated his commitment to progressive nineteenth-century ideas about collective urban idealism.[24]

As President of the Board of Trustees, Barry, to a large extent, determined the early collecting policy of the National Gallery. A grant of £2,000 made by the government in 1859 was used upon his recommendation to purchase "statues, busts, ... coins, medals and gems ... and photography."[25] This group of works reflected not only the nineteenth century's fascination with copies but also Barry's interest in forming a large, non-specialized collection similar to that of the British Museum. But soon a far greater emphasis was placed on forming a collection of original works of art based on the model of London's National Gallery. A Fine Arts Commission was set up in 1863 and, in a progress report published two years later, stated that the objectives of the Gallery's collecting policy were twofold: "one in the acquisition of choice works of contemporary artists for the pleasure, improvement, variety and contrast which they afford, another [i.e. the copies] in the illustration of the History of Art."[26] Sir Charles Eastlake, Director of the National Gallery in London and President of the Royal Academy, was asked by the Gallery's Trustees to make a selection of paintings for the collection by contemporary British, European, and American artists. Eleven paintings depicting historical subjects by artists such as George Folingsby, Guillame Koller, Jehan-Georges Vibert, and Charles West Cope were purchased upon Eastlake's recommendation through an additional government grant of £1,000. In 1864 the National Gallery's first picture exhibition was opened in a wing of the Melbourne Public Library. This was the first of many highly successful exhibitions organized by the Gallery throughout the 1860s that led to the formal establishment of the National Gallery of Victoria in 1869 and the National Gallery School of Art in 1870.

The international and intercolonial exhibitions held during the mid- to late nineteenth century were an important contributing factor in the formation of the first public art collections and created a real public interest in the visual arts. Designed by Europe's nation states to stimulate trade and industry on a global scale, the exhibitions became an important tool in the imperializing process.[27] In the Australian colonies, as in other parts of the British Empire, the exhibitions took as their model the Great Exhibition of London held in 1851 at the Crystal Palace. Australia's first Exhibition building was completed in 1854 within Melbourne's prosperous and flourishing gold rush culture for a preliminary showing of the Victorian exhibits being sent overseas to the Paris Universal Exhibition in 1855. A small section of art – including works by von Guérard, Becker, Strutt, and Summers – was displayed together with a wide range of industrial, agricultural, and manufactured material, and this marked the first occasion on which Australian art was officially shown in Europe.[28] Australian art continued to be exhibited overseas at London's International Exhibition in 1862, Chicago's International Exhibition in 1866, Paris's Universal Exhibition in 1867, and Philadelphia's Centennial Exhibition in 1876.

The international exhibitions also brought European art to Australia, and it was here that many works of art were purchased for the first national collections. Austro-Hungary, Belgium, France, Italy, Germany, and the United Kingdom all sent art to Melbourne's International Exhibition in 1880. The National Gallery subsequently represented works by all of the participating nations in its collection. By 1880, of the ninety-five original works owned by the Gallery, nearly a third were contemporary narrative and anecdotal paintings by Italian, Austrian, German, Belgian, and French artists, less than a third were by Australian artists and the remainder were British.[29] Twenty-two paintings were also purchased by the newly established art museum in South Australia. Since 1875 private endowments had been provided to form a public art collection in Adelaide, and these donations were supplemented by a government grant of £2,000 in 1879 to purchase works at Melbourne's International Exhibition. The National Gallery of South Australia opened on 18 June 1881 in two rooms of the Public Library and, like Melbourne's National Gallery, was presided over by a Board of Trustees administering the Public Library, Museum and Art Gallery until the 1940s. In Adelaide, as in Melbourne, the Fine Arts Galleries were by far the most popular section of these all-in-one complexes by the late nineteenth century.

At the beginning of the 1870s, Sydney had no national art gallery, no professional artists' association, and no art school. But the situation changed after 1870 when Sydney's art scene gradually came to rival that of Melbourne as a cultural center. The New South Wales Academy of Art was formed in 1871 through private patronage with the purpose of promoting "the study of various departments of the Fine Arts, and for an annual exhibition of works in Sydney."[30] Like its Melbourne counterpart – the Victorian Academy of Art established in 1870 – Sydney's Academy of Art emerged to become an important venue for the exhibition and sale of work by local artists during the 1870s. Interestingly, the colonial academies were formed only a few years before the aesthetic dominance of the academies in Europe was to be challenged by the emergence of modernism in Paris. Modeling themselves on the much older academies in Britain and Europe, the colonial art academies held conversaziones, bestowed distinctions, and promoted the study of art, though the development of the New South Wales Academy of Art as a teaching institution remained a precarious enterprise.[31] The Academy held exhibitions annually from 1872 to 1879, but dissolved in 1880 due to a lack of secure funding.

The most lasting and significant contribution made by the New South Wales Academy of Art to Sydney's colonial art scene was the seminal role it played in establishing the National Art Gallery of New South Wales. In 1874 five members from the Academy's Council – Sir Alfred Stephen, Edward Combes, Eliezer Levi Montefiore, Eccleston du Faur, and James Reading Fairfax – were elected to a committee of trustees responsible for administering a state government grant of £500 "towards the formation of a gallery of art."[32] They acquired plaster casts taken from the antique, contemporary British art, and a

small group of local works, and these early collections were on temporary display at Clarke's Assembly Rooms from 1876. It was, however, the success of the Fine Arts section of Sydney's International Exhibition in 1879 that greatly enlarged the Gallery's prospects. Following an additional government grant of £5,000, the Trustees purchased works shown in the Exhibition from each of the major collections represented by Britain, France, Belgium, Austria, Germany, and New South Wales.[33] The grant was also used to construct a separate annex for the Fine Arts Section of the Exhibition near the main Garden Palace building in the Domain. The Gallery's collections were moved into the annex after the Exhibition closed and, in September 1880, the Art Gallery of New South Wales opened to the public. After only three years, however, the building was declared unsuitable because, as noted by one commentator, "the heat from the iron roof plays sad havoc with the pictures."[34] The complete destruction of the Garden Palace by fire in 1882 increased concerns about the inadequacy of the Exhibition buildings as temporary exhibition spaces. A permanent building was erected on the present site at Art Gallery Road and the renamed National Art Gallery of New South Wales was finally opened in 1885.

By the 1880s, four of Australia's six colonies had established public art museums. The pressure to form a permanent art gallery came last of all in Hobart, even though the colony had been the site of Australia's earliest cultural institution and art exhibition.[35] Though the idea of forming a public art gallery in Hobart was proposed as early as 1838, it was only in the 1860s that Tasmania's Art Gallery was established as an adjunct to the Museum. In 1889 the Gallery was officially opened in an extension of the Museum building (on the site of the current Tasmanian Museum and Art Gallery). By the end of the nineteenth century, public art galleries had also been founded in Launceston, Queensland, and Western Australia. The problem of prefixing the titles of the state galleries with the word 'national' became apparent after Federation in 1901, though many public galleries did not drop the word 'national' from their titles until the second half of the twentieth century.[36] In Australia today, there are still two national galleries: the National Gallery of Victoria, which has retained its original title, and the National Gallery of Australia, established in Canberra in 1973.

The history of cultural institutions during the colonial period demonstrates that art history in Australia had its origins in the nineteenth century, long before art history was established as an independent discipline in Australian universities. For it was within the context of these early art institutes, artists' associations, art exhibitions, and art museums that the study of the history of art was promoted. The establishment of cultural institutions represented a powerful form of cultural imperialism through which the cultural values and aesthetic universalities of British culture were imposed upon the colonized culture. In reviewing the emergence and development of these institutions, this chapter has shown that the foundations for a Eurocentric view of art history were laid down in the nineteenth century. By developing a critical awareness of

this view of art history, it is hoped that the institutional origins of art history in Australia can be understood within a broader historical context which includes the colonial period.

In the final section of this chapter I will be dealing with more recent reflections upon the history of art history in Australia, where the focus has been on the modern period. Indeed, art history departments were established at Australian universities much later than other disciplines in the humanities. The University of Western Australia was the first to offer in the late 1920s "a comprehensive fine arts course, supplemented by a large collection of reproductions in color of works ranging from Giotto to the cubists."[37] Mr. W.A. Laidlaw, a lecturer in Greek art and aesthetics, taught the earliest known fine arts course and founded the University Art Club in 1928. It was, however, only during the post-World War II period that the first Department of Fine Arts was established at the University of Melbourne. In 1947 the Herald Chair of Fine Arts was created through an endowment by Sir Keith Murdoch "for teaching the understanding and appreciation of the Fine Arts and the application of their principles and practice to the life of the community."[38] Professor Joseph Burke, a specialist in eighteenth-century English art, was the first appointment to the position, and he soon selected other professional art historians to join the new Melbourne department.

Franz Philipp, a European art historian who had studied under Julius von Schlosser at the Vienna School, was chosen by Burke to head the art history department. Philipp established a course in Renaissance art history that was characterized by high standards of scholarship, and this area of specialization remains a feature of the Department's teaching. Dr. Ursula Hoff, who had been a pupil of Erwin Panofsky and had worked at the Warburg Institute in Hamburg, joined Philipp in teaching art history at Melbourne, while working as Curator of Prints and later Assistant Director of the National Gallery of Victoria. The strong influence of both the Vienna School and the Warburg Institute upon the development of art history as an academic discipline at Melbourne is evident in the early emphasis placed upon the analysis of iconography and iconology as well as subject matter.[39] Professor Jaynie Anderson, who is the current appointment to the Herald Chair of Fine Arts at the University of Melbourne, is one of the few art historians to have explored in depth the range of methods introduced to the study of art history in Australia by scholars and artists from postwar Europe.[40]

The emphasis on what were essentially late nineteenth-century modes of analysis remained in place until the discipline of art history expanded with the establishment of fine arts departments at most major Australian universities in the 1960s and 1970s.[41] The Power Institute of Fine Arts was founded through private patronage at the University of Sydney in 1966. Bernard Smith was the first Australian art historian to be appointed Professor of Contemporary Art and, in accordance with the terms of the Power bequest, placed special emphasis upon the study of contemporary international art.[42] The teaching of

European art remained the main focus of the Power Department of Fine Arts, though Smith's own writings reflected the growing interest in Australian art history.[43] General fine arts courses were expanded in the late 1970s to include the study of Australian art, Asian art, and film, with Aboriginal art being taught relatively recently in the 1980s and 1990s. The emergence of these subjects coincided with the development of a wider trend in art history to offer differing theoretical approaches to the study of art.

This necessarily brief history of the emergence of Australia's first two art history departments illustrates that, in contrast to Europe and the United States, the teaching of fine arts at Australian universities was essentially a postwar development. This chapter, however, has demonstrated that art history in Australia has a much longer history, originating in the nineteenth century with the establishment of a range of cultural institutions committed to broadening public knowledge about the history of art. In keynote lectures delivered at two recent annual conferences of the Art Association of Australia, Professor Jaynie Anderson and Professor Emeritus Bernard Smith addressed the issue of art history's history and future in Australia.[44] That two of Australia's leading art historians chose to discuss the institutional origins and future directions of art history is a strong indication of the continuing interest in the history of art history as an important area of scholarly research.

## NOTES

1  I refer here to the following review essays on art history's history in Australia: J. Stewart, "Bibliographical Essay on Art Historical Studies in Australia since 1958," *Australian Academy of the Humanities Proceedings*, 1974, pp. 65–96; B. Smith, "The Teaching of Fine Arts in Australian Universities: The Present Situation," *The Australian University*, May 1975, vol. 13, no. 1, pp. 8–18; T. Smith, "Writing the History of Australian Art: Its Past, Present and Possible Future," *Australian Journal of Art*, 1983, vol. 3, pp. 10–29; U. Hoff, "Observations on Art History in Melbourne 1946–1964," *Australian Journal of Art*, 1983, vol. 3, pp. 5–9; B. Smith, "Art Historical Studies in Australia with comments on Research and Publications since 1974," *Australian Academy of the Humanities Proceedings*, 1982–3, 1984, pp. 43–73; A. Sayers, "Art History," *Oxford Companion to Australian History*, Melbourne, Oxford University Press, 1998, pp. 38–40.

2  A. Galbally, "The Development of Public Museums, Libraries and Art Galleries in Colonial Australia," in A. Galbally and A. Inglis, eds, *The First Collections: The Public Library and the National Gallery of Victoria in the 1850s and 1860s*, exh. cat., University Gallery, University of Melbourne Museum of Art, 14 May–15 July 1992, pp. 8–29.

3  J. McGarvie, "On the State of the Fine Arts in New South Wales," *Sydney Gazette*, 20 July 1829, reprinted in B. Smith, ed., *Documents on Art and Taste in Australia: The Colonial Period 1770–1914*, Melbourne, Oxford University Press, 1975, p. 65.

4  J. Lhotsky, "Australia, in its Historical Evolution," *The Art Union*, July 1839, pp. 99–100, reprinted in B. Smith, *Documents on Art and Taste in Australia*, pp. 71–6.

5  Sayers, "Art History," pp. 38–9.

6  Smith, *Documents on Art and Taste in Australia*, p. 95.

7  A. Galbally, *Redmond Barry: An Anglo-Irish Australian*, Carlton, Melbourne University Press, 1995, p. 46.

8 Galbally, *Redmond Barry*, p. 46, and Galbally, "The Development of Public Museums," p. 11.

9 B. Duterrau, "The School of Athens, as it assimilates with the Mechanics' Institution," lecture delivered at the Hobart Town Mechanics' Institute, 29 June 1849, reprinted in Smith, *Documents on Art and Taste in Australia*, pp. 88–96.

10 E. Whitfield, "History of the Launceston Mechanics' Institute and Public Library," Launceston, n.d., reprinted in Galbally, "The Development of Public Museums," p. 13.

11 J. West, "The Fine Arts in their Intellectual and Social Relations," lecture delivered at the Launceston Mechanics' Institute, 1848, reprinted in Smith, *Documents on Art and Taste in Australia*, pp. 77–85.

12 J. Riley, "The Movement's Contribution to the Visual Arts: Three New South Wales Case Studies," in P. Candy and J. Laurent, eds, *Pioneering Culture: Mechanics' Institutes and Schools of Art in Australia*, Adelaide, Auslib Press, 1994, p. 213.

13 E. Elzey, "A Brief History of the Sydney Mechanics' School of Arts," lecture delivered at the Sydney Mechanics' School of Arts, 19 June 2000.

14 Smith, *Documents on Art and Taste in Australia*, p. 62.

15 Galbally, "The Development of Public Museums," p. 17.

16 S.C. Wilson and K.T. Borrow, *The Bridge over the Ocean: Thomas Wilson (1787–1863) Art Collector and Mayor of Adelaide*, Adelaide, S.C. Wilson and K.T. Borrow, 1973.

17 The author gratefully acknowledges the assistance of Professor Joan Kerr at the Center for Cross-Cultural Research at the Australian National University for making available her copies of catalogues and reviews on the early colonial exhibitions. See also J. Kerr, ed., "Major Exhibitions to 1870," *The Dictionary of Artists: Painters, Sketchers, Photographers and Engravers to 1870*, Melbourne, Oxford University Press, 1992, pp. xix-xx.

18 C. Bruce, "Art and Australia Felix: Art Criticism, Taste and Nostalgia in mid-nineteenth century Victoria," Ph.D. thesis, Department of English, Faculty of Arts, University of Sydney, 1997, p. 47.

19 Galbally, *Redmond Barry*, p. 142.

20 W. Moore, "Societies," in W. Moore, *The Story of Australian Art: From the Earliest Known Art of the Continent to the Art of To-day*, vol. 1, Sydney, Angus and Robertson, 1934, p. 155.

21 F. Philipp, "History of Art," in A. Grenfell Price, ed., *The Humanities in Australia*, Sydney, Angus and Robertson, 1959, p. 163.

22 Galbally, "The Development of Public Museums," p. 10.

23 Galbally, *Redmond Barry*, p. 87.

24 Galbally, *Redmond Barry*, p. 86.

25 Galbally, *Redmond Barry*, p. 111.

26 Galbally, "The Development of Public Museums," p. 24.

27 B. Smith, *Modernism's History: A Study in Twentieth-Century Thought and Ideas*, Sydney, University of New South Wales Press, 1998, p. 43.

28 A. McCulloch, *Encyclopedia of Australian Art*, vol. 2, Victoria, Hutchinson Group, 1984, p. 612.

29 D. Thomas, *Australian Art in the 1870s*, exh. cat., Art Gallery of New South Wales, Sydney, 25 June–2 August 1976, p. 9.

30 *First Annual Report of the New South Wales Academy of Art*, April 1872.

31 Galbally, "The Development of Public Museums," p. 16.

32 M. Germaine, *Artists and Galleries of Australia*, Brisbane, Boolarong Publications, 1984, p. 16.

33 P. McDonald, "Art at the Garden Palace," *Sydney International Exhibition 1879*, exh. cat., Museum of Applied Arts and Sciences, Sydney, 24 September–24 November 1979, pp. 24–9.

34  A. Greenwood and H. Stephen, "Art in Sydney," *Catalogue of the Art Gallery with Art Notes*, Sydney, 1883, p. 8.

35  Galbally, "The Development of Public Museums," p. 13. Australia's first art exhibition was held at George Peck's Argyle Rooms in Hobart in 1837, when two hundred and sixteen works were shown.

36  McCulloch, *Encyclopedia of Australian Art*, vol. 2, p. 392.

37  Moore, *The Story of Australian Art*, vol. 1, p. 178.

38  Hoff, "Observations on Art History in Melbourne 1946–1964," p. 5.

39  Hoff, "Observations on Art History in Melbourne 1946–1964," p. 6.

40  J. Anderson, "Art History's History in Melbourne: Franz Philipp in correspondence with Arthur Boyd," Franz Philipp memorial lecture delivered at the annual conference of the Art Association of Australia, Art Gallery of South Australia, Adelaide, 3–4 October 1998. See also Hoff, "Observations on Art History in Melbourne 1946–1964," pp. 5–9, and Smith, "The Teaching of Fine Arts in Australian Universities," pp. 8–15, and "Art Historical Studies in Australia," pp. 43–73.

41  Art history departments were established at the following universities during the 1960s and 1970s: Sydney University (1966), Flinders University (1966), Queensland University (1971), La Trobe University (1973), Monash University (1974), and the Australian National University (1977).

42  Smith, "The Teaching of Fine Arts in Australian Universities," p. 10.

43  B. Smith, *Place, Taste and Tradition: A Study of Australian Art since 1788*, Sydney, Ure Smith, 1945; *European Vision and the South Pacific 1768–1850: A Study in the History of Art and Ideas*, Oxford, Clarendon Press, 1960; *Australian Painting 1788 to 1960*, Melbourne, Oxford University Press, 1962.

44  J. Anderson, "Art History's History in Melbourne," and B. Smith, "In Defence of Art History after Listening to Jacques Derrida," Franz Philipp memorial lecture delivered at the annual conference of the Art Association of Australia and New Zealand, Department of Art History, Victoria University, Wellington, 6–9 December 1999.

# Part II

# INSTITUTING A CANON
## Placing the center and margins
## of art history

# 7

# DEEP INNOVATION AND MERE ECCENTRICITY

## Six case studies of innovation in art history

### David Carrier

> Being known is essential – your texts, your actions – something –
> has to appear. Otherwise you haven't made a difference.
> Alexander Nehamas, Interview with
> David Carrier, *Bomb*, 1998, no. 65

To be taken seriously and responded to by your colleagues, you must accept the standards of the community to which they belong. Like all professional groups of any size, the academic world contains various communities, each with its own standards. We all know which submissions are more likely to be accepted in *October* and which in *The New Criterion*. However, there are ideas that lie beyond the pale of any existing academic community. If you express such ideas you will be considered an eccentric. But if standards change, you may not remain an eccentric forever.

Galileo was eccentric when he said that the earth moves, and John Stuart Mill when he argued that women are not inferior intellectually to men. Several twentieth-century art writers made claims, initially considered eccentric, which now are generally accepted. Panofsky's reading of the van Eyck *Arnolfini Marriage* as an allegory was eccentric when it was first advanced. So was Leo Steinberg's argument that Caravaggio was not a simple naturalist and Clement Greenberg's assertion that Pollock was a great painter. Within a short time, these unorthodox opinions came to be taken seriously by most scholars. Even critics and historians who reject these claims find them worth discussing. Panofsky, Steinberg and Greenberg are exceptional. Most eccentric interpretation is not taken seriously. Nevertheless, the fact that radical innovation is sometimes successful gives some reason to take eccentric arguments seriously.

My book *Principles of Art History Writing* examines the changing styles of argumentation within art history.[1] I seek to identify the implicit assumptions defining reasonable discussion within art history. The book deals only with art historians of established reputation – with insider art history. This chapter supplements that analysis by looking at outsider art history. I look at the work of some scholars who are eccentric. And I compare successful and failed

attempts at radical innovation. When a community defines standards of reasoning, it takes seriously publications that accept these standards. Ideas that violate such basic principles are not taken seriously. Yet, we all know that the standards of any community change. How then can we reconcile our awareness that the grounds for our judgments can change with the need for truth as a foundation for those judgments? I give six case studies, the first worked out in detail, the five others presented more briefly. Then I answer that question.

In art history, as in art itself, the greatest recognition and highest professional esteem go to those capable of deep originality. To become an art historian, a student is expected to learn the skills of professors. Of the graduate students who become professors, only a few attempt significant innovation. To write showing skilled mastery of the established methodologies, extending these familiar approaches to new materials, is a significant achievement. But at the highest levels of academic life, more is expected. Our admiration for deep innovation reflects the demands of the intellectual market place. A discipline unable to innovate would be unlikely to attract good students or adequate financial support. Demand for innovation is a natural expectation of a culture where change of all kinds in everyday life comes so quickly.

A younger student may think of the demands of the profession as merely externally imposed when, for example, her professors tell her what thesis topic is acceptable. But the more senior scholar becomes aware of the way in which the standards are both imposed upon her, and have an authority which depends, in part, upon her willingness to validate them. Scholars have learned the accepted standards. The system of peer reviewing practiced by academic publishers means that several scholars are willing to testify to the value of an academic book. Self-taught scholars who self-publish their books are effectively outside the academic system. They are the art historical equivalent of doctors practicing without a license.

Outsiders look eccentric to the professionals. They argue in strange ways, discussing the 'wrong' questions. Louis Richard Velazquez's *Rembrandt: the Man in the Golden Helmet* (1994) attributes this painting to Rembrandt by using a self-portrait hidden in the picture. The book tells of the author's career in law enforcement; reproduces a mural made by the author at the age of seventeen; and provides a form letter for the reader to send to the director of the Berlin Gallery, protesting the recent deattribution of this painting.[2] The minimal condition necessary for engaging your colleagues is that you learn enough about their rules to get them to take your claims seriously. Velazquez fails to do that. And so, the professional art historian who reads Velazquez will likely feel frustrated.

Professors of art history know how to argue in ways their colleagues find convincing. This appeal to shared standards does not in itself say anything about what particular professional standards are adopted. Analytic philosophers are distressed by the standards of cultural studies; most art historians write very differently from art critics. And non-academics, like astrologers, have their own

standards. None of these groups is monolithic. When in 1872 Friedrich Nietzsche published his first book, *The Birth of Tragedy*, he hoped to change the standards of academic philologists. He failed completely – Ulrich von Wilamowitz-Möllendorff, who became the most significant German classical philologist, persuaded his colleagues that Nietzsche's work did not deserve serious consideration. But Nietzsche attracted a different, much larger audience.[3] This wider public, not competent to judge Nietzsche's philology, found his diagnosis of modernist culture of great interest. "The art world is a fairly savage social zone where values are always in doubt and often in conflict," the critic Peter Schjeldahl writes in his account of that community, "that's a function and part of the fun of the art world."[4] Similar remarks apply to communities in the art history world.[5]

To talk about standards for evaluating creativity is thus to talk about how communities validate opinions and make it possible to have constrained debates. Authority within an interpretative community is the product of an implicit consensus within at least some subgroup. "We who know are the possessors of an institutionalised competence."[6] This 'we' may be a small group, but its shared standards define a community. Not everyone agrees which innovations are worth discussion, but unless a critical mass of scholars takes interest in a new interpretation, soon it will be forgotten. What, by contrast, makes a genuine outsider eccentric is his inability to enter into debate. An influential original account may be full of errors or conceptually confused. What matters is that it be thought a productive starting point worthy of further investigation. Better suggestive error than an unproblematic truth – for suggestive error may sometimes inspire more interesting research than unproblematic truths. Even downright error is not necessarily an obstacle to fame. Michel Foucault's account of *Las Meninas* is untrue to the facts, for it depends upon a straightforward miscalculation of the perspective. But many writers (myself included) think it deserves discussion.

When a writer breaks with the accepted standards, how are we to judge that accomplishment? Insofar as a writer is genuinely original, the existing criteria are not adequate for evaluation of his work. But what other criteria then are appropriate? Following Thomas Kuhn, philosophers of science have had much to say about paradigm shifts. "The normal-scientific tradition that emerges from a scientific revolution is not only incompatible but often actually incommensurable with that which has gone before."[7] The same perhaps is true in the visual arts when we are evaluating a radically novel interpretation. After being described by a deeply original historian, a well known painting may momentarily seem unfamiliar. That experience can be exciting, but it is also disconcerting. Innovation attracts attention when it provides scholars with techniques they can borrow. An original analysis is susceptible to being popularized. This is why the history of innovation is hard to reconstruct. When an interpretation becomes renowned, then it is imitated. Soon it is hard to reconstruct that moment when this novel account was genuinely unsettling. Few innovations succeed. What

professor is not familiar with those once exciting seeming volumes which gather dust in her study? If a novel interpretation is not taken seriously, soon no one reads it.

## CASE STUDY ONE: NICOLAS POUSSIN AS POLITICAL PAINTER

Orthodox accounts of Nicolas Poussin's *The Arcadian Shepherds* focus on iconography. Panofsky, drawing attention to the ambiguity of the words on the tomb, argues that Poussin's earlier version of this scene, the painting in Chatsworth, expresses a different meaning than the later one in the Louvre. Pierre Rosenberg's catalogue entry for the 1994 retrospective, citing the elaborate recent literature, sets the debate within this now well-defined paradigm.[8] Although a landscape occupies the largest part of the painting, it is not implicated in the iconographical interpretation. Not so in the eccentric interpretation that I will now discuss at some length.

Henry Lincoln's *The Holy Place* discusses Poussin's *Arcadian Shepherds* in the context of his earlier writing about the medieval sect known as Catharism.[9] He builds on his book *Holy Blood, Holy Grail*, co-authored with Michael Baigent and Richard Leigh.[10] According to Lincoln, the tomb depicted in Poussin's painting is located in the village of Rennes-le-Château, in the South of France, where a crusade against the Cathars took place in the thirteenth century. The top image shows the tomb; at the bottom we see the landscape after that tomb was removed. In the late nineteenth-century the parish priest became rich because he found the treasure left behind by the Cathars. The painting is a visual encoding of a secret of the Cathars. Poussin learned the secret from the brother of Nicolas Fouquet, his patron. Fouquet was the finance minister of France under Louis XIV until the king had him deposed and arrested in 1661. This is usually interpreted as an act of jealousy on the part of Louis XIV. Fouquet built a chateau that was grander than the king's own palace. Lincoln has a different explanation.

Louis XIV, Lincoln explains, wanted Poussin's painting because it recorded a secret about the Cathars. The secret that Lincoln reveals was known only to a sequence of wise men, Poussin and Jean Cocteau among them. What the Bible does not tell is that Christ married Mary Magdalene, and that their child, who is not named by Lincoln, founded a dynasty that later became a rival to the French monarchy. Christ, contrary to Catholic teaching, did not die on the cross. He staged the crucifixion to establish his political position. He and his family went to Marseilles, where his descendants thrived. By 1100 they were prominent in European politics. That is why the Pope sought to exterminate the Cathars. The secret history of Europe is the struggle between Christ's descendants and the Church.

This story is taken further in Lincoln's more recent books, *The Holy Place* and *Key to the Sacred Pattern*. A cryptic inscription on a headstone in the town

church of Rennes-le-Château yields a coded reference to Mary Magdalene; the grave slab refers to a king and treasure, and to the words on the tomb in Poussin's painting, *et in Arcadia ego*. The painting's geometry reveals a pentagon. Lincoln calls our attention to a pentagon which he says was hidden in the composition by Poussin, to be copied by Cocteau in his 1960 depiction of the crucifixion in Notre Dame de France, near Leicester Square, London. Lincoln finds in the picture "coherent and precise geometric patterns." A " 'structured landscape' " is revealed "when we superimpose a map of the local countryside over Poussin's composition."[11] The background landscape in Poussin's painting is an actual landscape in Southern France. And the composition of his painting presents an aerial view of that landscape. Poussin showed the tomb in the landscape and structured his painting following the geography to make a visual memorial to the Cathars' secret.

Lincoln's claims have generally been dismissed. Anthony Blunt told him that there is no documentary evidence showing Poussin to have visited this area, which is not on the usual route between Rome and Paris. Poussin's landscape may look like a real landscape, but he could easily have invented such a scene. With ingenuity, any landscape can be mapped onto such a pattern. Nevertheless, *Holy Blood, Holy Grail* does fit together much evidence. A non-historian would need to do a great deal of reading to disprove Lincoln's account. Lincoln probably would advise him not to read history books, since the published histories of Christianity and Europe are all wrong. The true history of Christianity has been hidden. According to Lincoln, Louis XIV desired Poussin's painting because it revealed this secret.

Lincoln employs visual demonstrations of a kind not practiced in mainline art history. No matter how visually convincing his analysis may be, it will therefore be considered irrelevant. His interpretation of Poussin's painting is not taken seriously. In itself, there is nothing scandalous about this. All of us rely, at some point, on division of intellectual labor. Unable to check all the evidence and rethink all the theories, we depend upon our colleagues. In doing so, we gravitate toward like-minded scholars and avoid those whose ways of thinking appear alien to us. Conservatives do not trust Marxists; positivists dislike continental philosophers. We trust our community. Art writers often appeal to Derrida, Foucault and Lacan, though few of us are prepared to evaluate their claims. Few art writers can discuss Foucault's evidence about the history of madness or critique Lacan's argumentation about what he calls the mirror stage. Once Foucault and Lacan were taken by the community to be authorities, their followers did not question their claims.

Lincoln, by contrast, does not belong to a scholarly community. Neither do his followers. The pamphlet *Poussin's Secret*, which supplements his account, is by David Wood and Ian Campbell, British mystery writers. Their analysis is also unlikely to impress the scholarly community. Comparing the first and second versions of *The Arcadian Shepherds*, they write: "Considering the state of undress exhibited by the shepherds and the shepherdess, the pregnancy in the

Louvre version is hardly surprising."[12] But even if Wood and Campbell made less outrageous claims, they would have a hard time winning support from academics. Catharism and its devotees are outside the academic world. Many art historians expect a picture to reveal social history. Lincoln's analysis reveals too much. So far as I know, this theory is taken seriously in the Poussin literature only by Christopher Wright, who says that the landscape near Carcassonne "bears some resemblance to the Poussin landscape background. These similarities are undeniable and are unlikely to have been coincidental."[13] But he does not develop this analysis, beyond suggesting that other Poussins also may show specific localities.[14]

## CASE STUDY TWO: HIDDEN IMAGES

The search for hidden images is typical eccentric art history. János Plesch writes: "The quality that distinguishes Rembrandt from all his artistic contemporaries is that he not merely brings his subjects to life with colour, likeness and expression as they did too, but that he breathes a soul into them."[15] According to Plesch, Rembrandt's paintings, drawings, and engravings are filled with subordinate figures which "because they arise unnoticeably out of their surroundings and unnoticeably merge into them … represent an integral part of the work as a whole." Plesch asks that we look for these figures "with half-closed eyes and from a certain distance … the observer should put himself into a kind of trance." For example, in the etching *The Descent from the Cross* Plesch sees a veiled woman climbing and, turning the picture to look at another angle, a high priest in prayer robes and Christ hanging on the cross. No one else recognized these figures because they are set in unusual positions.

The problems with Plesch's analysis seem obvious. The suggestible viewer will project such unintended images into any picture. There is no reason to believe that Rembrandt intended that his images be scanned in this odd way. Plesch is an eccentric within art history. But recently writers who are taken seriously by art historians have taken up the search for hidden images.

Mieke Bal argues that the Rembrandt etching *Joseph and Potiphar's Wife* contains two phalli – the one identified with the father, that is the bedpost, and another associated with the son which is "hidden yet conspicuous for whoever has eyes to see."[16] And she considers also the navel of Potiphar. "We can also erase it. Erasing the navel turns the woman around … " And then we see not the woman facing outward, but a figure with her back turned. "This dream of pleasure takes place inside, within the gigantic female body formed by the curtain." Bal deals with much discussed concerns – feminist art history, literary theory, and semiotics. Published by a distinguished academic press, her book on Rembrandt is taken seriously by art historians.

Sidney Geist finds hundreds of revealing hidden images in Paul Cézanne's paintings and works on paper.[17] Thus, to take one typical example, in *Still-life with Bread* (1879–82), the bread (in Provençal, *pan*) "is an excellent effigy of a

donkey head ... On the left of the loaf, the tablecloth is arranged in a vaginal fold; further to the left are apples symbolic of Hontense" (the artist's wife).[18] My review of his account was highly critical.[19] I can imagine a surrealist creating such hidden images, but I do not believe that Cézanne worked in this way. Even when I see the images Geist identifies, I do not believe that these hidden images are significant. But here we come to interpretative disagreements which are not easy to resolve. Geist's book, published by Harvard University Press, was supported by peer reviewers. His analysis is original and suggestive. It gathers much information not found in the literature, builds upon Freud's famous account of Leonardo da Vinci, and it could be applied also to other artists. Geist's analysis is not too eccentric to be discussed by art historians.

## CASE STUDY THREE: RECENT MANET-STUDIES

The traditional view of Manet was that he was a spontaneous, essentially unreflective artist. In 1975 George Mauner described him as a highly complex painter. And in 1985 Tim Clark also said that Manet was not a straightforward artist. Both historians argued that *A Bar at the Folies-Bergère* (1882), traditionally treated as an exercise in failed perspective, was a picture whose visual structure deserves close attention. The interesting shared assumption of Mauner and Clark is that the failure of the mirror to be consistent is seriously meaningful:[20]

> There is a direct opposition between the "two" barmaids who are, nevertheless, undeniably the same person. The actual girl is conceived much in the manner of the early portraits ... The brilliance of the setting ... identify this looking-glass as the mirror of the vanities. Only part of the girl belongs to it, and Manet has dissociated that part of her nature from the other part ... [Two women are] used to illustrate the duality of human nature ... (Mauner)

> Little by little we lose our imagined location and because of that ... our first imaginary exchange of glances with the person in the picture is made to appear the peculiar thing it is ... inconsistencies so carefully contrived must have been felt to be somehow appropriate to the social forms the painter had chosen to show ... The mirror must ... be frontal and plain, and the things that appear in it be laid out in a measured rhythm. And yet it is clear that some of these things will not be allowed to appear too safely attached to the objects and persons whose likenesses they are. I think that this happens ... as a result of Manet's attitude ... towards modern life in Paris ... (Clark)

In neither case can even these extended quotations do justice to the well developed arguments, which set this painting in the context of book-length

interpretations. Mauner says that Manet is painting modernist versions of visual allegories found in late medieval art by Mauner's teacher, Meyer Schapiro. According to Clark, Manet, acutely sensitive to the political currents of the day, anticipates Clark's own awareness of the events of the late 1960s. Mauner's traditional-seeming Manet attracted much less attention than Clark's proto-leftist painter, whose concern with popular entertainments, civil unrest, and gender politics speaks to many of us. Clark's analysis inspired imitation and crit-icism because it politicized Manet's painting in suggestive terms, and suggested ways of looking at other modernists. Both books are speculative. Mauner's speculations did not attract much attention. Clark's social history of art inspired many other scholars.

## CASE STUDY FOUR: SEMIOTIC THEORIZING AND ART HISTORY

In the 1980s, there was the felt desire for art history to explore and exploit the rich array of theorizing developed within literary studies of narrative. Roland Barthes, Michel Foucault, Gerard Gennette and the other French figures and their American commentators were much discussed. How was semiotic analysis relevant to visual art? Richard Brilliant's *Visual Narratives: Storytelling in Etruscan and Roman Art* gave a clear analysis, developed in lucid detail. He shows how Roman art can be described in a semiotic vocabulary.[21]

> The Column of Trajan embodies three distinct, but interrelated codes of varying degrees of narrrativity: the annalistic, the iconic, and the imagistic. The annalistic informs the helix as a primary whole ... The iconic code shapes the ceremonial structure through individual scenes ... whereby Trajan's powerful effect on affairs is manifested in com-prehensible, framed patterns ... The imagistic code relies on the tableau as the principal form of immediate visual communication ... The artist who invented Trajan's Column integrated these three systems or codes to an unusual degree.

This account attracted less attention than another semiotic analysis. Rejecting Ernst Gombrich's claim that naturalistic painting is "a copy of the world," Norman Bryson offered an alternative, a semiotic account of pictures. Gombrich, he complains, has "dehistoricised the relation of the viewer to the painting; history is the term that has been bracketed out ... "[22] Bryson's semi-otic account emphasizes "the immanently social character of the painterly sign ... all the codes of recognition flow through the image ... they interact at every point with the economic and political domains."

Bryson's analysis is not easy to evaluate.[23] His claim that Gombrich fails to deal with the social dimension of Constable's achievement is belied by some explicit claims in *Art and Illusion*:[24]

> In a case such as Constable's it should indeed be possible to recon-
> struct some of the motivations, social, historical, and psychological,
> which determined his choice ... No one whose youth coincided with
> the French Revolution could remain unaffected by its challenge to the
> old hierarchy of values. The "humble style" had always been associated
> with truth unadorned.

Gombrich seeks to understand what he calls the "framework of the social situa-
tion" in his analysis of Constable's style. He says a great deal about the political
preconditions for an art showing English country houses. He certainly does not
claim, as Bryson asserts, that "no cultural training will be required for the viewer
to 'recognise' Wivenhoe Park – all he need do is consult his own visual experi-
ence ... ."[25] On the contrary, Gombrich explicitly says: "I consider it a heresy
to think that any painting as such records a sense impression or a feeling. All human
communication is through symbols ... " Bryson's real complaint is not that
Gombrich is apolitical, but that he has the wrong politics. Gombrich is a liberal.
Bryson wanted to associate his semiotic theorizing with the leftist politics of Roland
Barthes. Much of the appeal of the semiotic theory to feminists relies upon the
claim that defending realism means taking a conservative view of gender politics.

Bryson's constructive arguments are not convincing. Rejecting the realist
theory of art history, which would imply that Giotto's *Betrayal of Christ* is more
realistic than Duccio's earlier version, Bryson claims that his semiotic analysis
provides an alternative explanation of realism. "The Giotto *Betrayal* conveys far
more information than the Duccio ... None of this information is required for
the purpose of recognising the scene as a *Betrayal* ... "[26] This is incorrect.
Giotto provides different information than Duccio, but the semiotic theory
gives no warrant to assume that the Duccio provides less information. Here
Bryson appeals illicitly to a realist analysis.

Bryson's book offered a suggestive, novel interpretative framework, and so
art historians borrowed from him. Gombrich's account had been much
discussed; art historians felt a need for a novel approach, and Bryson, more than
anyone else, provided a suggestive appropriation of the structuralist literature.
Aestheticians had better arguments about the nature of representation, but
these philosophers' concerns were distant from the practice of art history. *Visual
Narratives* provided more reliable theorizing, but without suggesting how to
extend the analysis beyond Etruscan and Roman Art; *Vision and Painting*, for
all of its obvious problems, promised more.

## CASE STUDY FIVE: AN HEGELIAN THEORY OF THE END OF ART HISTORY

Arthur Danto's "The Artworld" (1964) must have seemed eccentric when orig-
inally published in *The Journal of Philosophy*.[27] After beginning with an epigraph
from Hamlet, Danto asks whether art is mirror-like. Discussing theories of art

and the identification of artworks, he closes with an interpretation of a puzzling sculpture exhibited that year by the then little known Andy Warhol. Danto argues that Warhol's *Brillo Box* suggests how to develop a structuralist theory of art, in which the style of every kind of painting would be identified in relation to the array of possible artistic styles. In 1964 this was a genuinely eccentric argument. Apart from the assigned commentator in *The Journal of Philosophy*, who found Danto's account very puzzling, no one responded until the 1980s, when Danto became a famous aesthetician and art critic.

Today, after Danto's account of Andy Warhol's *Brillo Box* has been presented in many books, including his 1995 A.W. Mellon Lectures at the National Gallery, and much commented on, it is hard to reconstruct the original context of its presentation. In 1964 Warhol had only started to be discussed by art critics. Danto's claims surely were very hard to understand. A Columbia professor, Danto was an editor of *The Journal of Philosophy*, where this essay appeared. But had he himself not taken up the ideas presented in "The Artworld," then probably this article would have disappeared from sight. For deep innovation to have an impact, a commentator must work out his analysis in sufficient detail to make borrowing from him possible. Danto himself presented his thesis repeatedly until it became well known. When Warhol became famous and was much written about, he was described as a political painter, or a gay artist. Such commentary was relatively predictable. No other writer developed anything like Danto's analysis. In order for innovation to succeed, it may be necessary to be extremely persistent.

## CASE STUDY SIX: EMILIA DILKE'S LATE VICTORIAN ART WRITING

Emily Francis Strong (1840–1904), an important figure in the history of feminism, published two books on art history under her first married name, E.F.S. Pattison, and five more volumes under the name of her second husband, as E.F.S. Dilke. Writing in both English and French, reviewing very widely, this erudite self-educated woman was the leading expert on French art from the Renaissance to the nineteenth-century.[28] Her discussion of French art in relation to political institutions anticipates the most important recent approaches. Like some of the most influential present-day modernist historians, she sought to link art history to political activism. She is a reliably suggestive narrator, as when comparing Watteau with Chardin she writes:[29]

> When one meets the full strength of that perfect workman, Chardin, his masterly whites impose themselves by their forceful quality, but Chardin ranks apart – a reigning prince, but of another royal house,

or when she calls Claude Lorrain the greatest landscape painter of his century:[30]

> Sa passion pour la lumière et pour l'air aurait suffi pour donner à sa oeuvre un accent de poésie, même sans la tendance qui l'a toujours porteé à chercher dans l'image de la nature les vibrations de l'âme humain.

Today she is mostly forgotten among art historians. Her name does not appear in the bibliography of Anthony Blunt's history of French art 1500–1700, nor in Thomas Crow's study of the institutional contexts of French eighteenth century painting.[31] In the thirty-six volume *Dictionary of Art* (1996), only one brief paragraph is devoted to her.[32]

In part, Dilke's present obscurity reflects the weakness of late nineteenth century English art history compared with German academic art writing of that era.[33] Some English-language writers of that era are still read. Crowe and Cavalcaselle play a role in the development of connoisseurship; John Ruskin is a personality who fascinates, even now when much of his style of argumentation ceases to inspire conviction; Walter Pater interests modern academics who admire the literary distinction of his writing, and his subtle synthesis of German philosophizing about aesthetics. But compared with their German contemporaries, these writers all seem eccentric art historians. Dilke writes more like a typical present day art historian than Ruskin or Pater, but she has dropped out of the literature, without influencing present day debate. Emilia Dilke was unlucky, working in England before the rise of professional art history in that country. Her writing and life are fascinating to modern feminists, and to historians of art history. But it is hard to imagine her writing influencing present day art historians.

We may like to imagine the development of art history as a collaborative process in which every scholar can play a part. But that sense of things is not obviously true to the realities of the process. In its competitiveness, and its "stars," present day academic life mirrors the larger capitalist culture. Why indeed should it not when art history is so dependent upon those relatively few writers who successfully innovate? These innovators are rewarded appropriately. But relentless competition perhaps is not the whole story. Describing the institutional structure of philosophy, Thomas Nagel suggests that perhaps[34]

> we are engaged in a collective enterprise whose results can't always be easily traced. Some kind of marketplace of arguments and ideas may generate developments of value that wouldn't have been produced just by the greatest thinkers working individually and responding to each other.

As he indicates, whether this is a good description of academic philosophy remains an open question. But he does provide a suggestive vision of art history. Innovation in art history requires an interpretative community.

An interpretation does not simply exist, waiting to be found. It is a creation of the interpreter, who gathers information with the aim of getting us to see the work of art in a certain way. Highly complex interpretations require an elaborate support system. Were there not support for highly detailed commentary on individual artists, writers would not take the trouble to write out such accounts. Were publishers not able to provide many good quality illustrations, academic books would not discuss pictures in great detail. Were museums not able to organize large retrospectives, no one would have reason to gather the information found in catalogues of such exhibitions.

An interpreter's claims cannot be judged merely as abstract arguments, but must be understood in historical and political context. In identifying the importance of such concerns for the reception of novel interpretations, my six case studies surely show that the conflict of interpretations does not take place entirely apart from the political events outside of the academic world. But acknowledgment of the sociological influences on art historical interpretation is not at all incompatible with the achievement of objectivity. My analysis gives no support to the hope that ahistorical interpretative standards are possible. But that does not imply that we should become relativists. Interpretation is objective relative to the institutions which make interpretation possible. Given the goals and purposes art and its interpretation serve, it is not arbitrary that one interpretation attracts many scholars.

Such an appeal to interpretative communities leaves aside, it might seem, questions of truth. That there are shared beliefs about how to argue does not show that the arguments of a community lead to truth – otherwise Christians, Jews and Muslims all could legitimately conclude that the religious beliefs of their community all were true. But once we understand the way in which interpretations are constructed, then appealing to an ideal of abstract, ahistorical truth will seem less satisfactory. Art history writing has intersubjective validity when a community of historians takes it seriously. Each interpretation must be judged relative to the interests of an interpretative community. The art world is constituted by many such communities, with overlapping interests and disagreements.

The history of art history thus is like history in general – for it is history writ small. The historian seeks to understand why certain interpretations have triumphed over their rivals. The struggles of interpretations teach us about both art's history and our culture. Politics certainly often is involved. Tim Clark's triumph shows the desire of academic art historians for a leftist conception of early modernism, a way of projecting back into Manet's era the concerns of 1960s progressive politics. Norman Bryson's success demonstrates the felt need for conceptual innovation in art history. Like historical struggles, these battles amongst interpreters have unpredictable outcomes. Who would have expected that Clark's leftist views would have found so friendly a reception in a profession not traditionally politically radical, in a country which, unlike Europe, lacks prominent leftist parties? Who might have imagined that Bryson, a wonderfully imaginative literary scholar, would have such an influence within art history?

Who could have predicted that Arthur Danto's work, essential for aestheticians, would become important for art critics?

I have argued as if the distinction between professional and eccentric art history writing were absolute. But one consequence of my analysis is to deconstruct that distinction. Danto has argued that there is no important visual difference between Warhol's *Brillo Box* and the nearly identical box in the grocery. What makes Warhol's *Brillo Box* an artwork, he claims, is that an artist placed it in an art gallery. The mere appearance of *Brillo Box* does not reveal its nature. In order to be able to identify it as an artwork you must know its history. Danto is offering a very general philosophical argument. For Descartes there is no intrinsic difference between dreaming and waking experience. The intrinsic qualities of waking experience or of *Brillo Box* are not sufficient to reveal their true nature. Identifying the nature of waking experience or of art requires a philosophical argument. Let us apply Danto's analysis to art history writing.

There is no intrinsic difference between normal and eccentric art history. One and the same text would be read closely if published by an art historian and ignored if written by an outsider. Were Henry Lincoln published in *The Art Bulletin*, then the profession would come to grips with him. The difference between normal and eccentric art history is contextual. A serious art historian is a member of the community – an eccentric is not.

My Danto example is an ideal case, but within the recent Poussin literature consider four partial approximations to such an example.

Sheila McTighe claims that *Landscape with Orpheus* does not merely show its ostensive subject, but is a political allegory.[35] The picture depicts a classical landscape with mythical figures, but really is about French politics of Poussin's time. The ship stands for government by subterfuge; and so it is no accident that just before the painting arrived in Paris, Cardinal Mazarin staged the opera *Orfeo*, whose hero links cities with marriage. This allegorical interpretation supposes that the real meaning of the picture is something other than its literal significance. Part of McTighe's background evidence is an argument from silence. If Poussin's painting had this political meaning, then that could not be said in 1650. Poussin took an interest in politics, but nowhere did he ever suggest that any of his paintings were commentaries on contemporary events. McTighe's claim may seem eccentric, but she works within an established academic tradition. No less an authority than Anthony Blunt argued that Poussin often worked for a group of secretive heterodox initiates.[36] Blunt's Poussin, like Blunt himself, is both a member of the establishment and a secret subversive. But the revelations about Blunt's spying have not destroyed his reputation as an art historian. His way of thinking about Poussin has been taken up by other scholars who do not share his political interests.

The catalogue of Konrad Oberhuber's important 1988 exhibition of early Poussin is based in part upon theosophical readings. Many reviewers praised this exhibition.[37] Following Rudolf Steiner, Oberhuber discovered "that we rhythmically pass through various attitudes toward space in the course of our lives."[38]

The theory of Poussin's development which Oberhuber worked out independently "remained valid," he adds, "once I applied my new, more theoretical and abstract method."

In his 1984 Mellon lectures, Richard Wollheim presents an account of Poussin based in part upon the psycho-analytic doctrines of Melanie Klein.[39]

> In *The Garden of Eden* (1660s) that God turns his back upon Eve

> can be seen not just as an expression of His, but as a projection of her, unwillingness to know. In all this there is no evil: just the distempering, the disorientating, the blinding, effect of richness and abundance.

And in *The Flood* (also 1660s), the snake and water

> presses upon ... our unconscious memories ... of infantile sadism. For snake and water commemorate ... the two resources of destruction, of terror, that the infant once had at his disposal for the phantasized attacks upon the parental bodies ... biting gums or teeth, and burning urine.

Denis Mahon, in one uncharacteristic "note of pure fantasy" as he describes it, argues that *Poussin's Rebekah quenching the thirst of Eliezer at the Well* (1627) is autobiographical. Eliezer may be a stand-in for Poussin and his relationship with his patron, Cassiano dal Pozzo:[40]

> We see ... a youngish man, fatigued by his travels and exertions in the head of a Mediterranean summer's day, at length attaining his goal and receiving solace and refreshment from the well (pozzo) at the hands of a dignified and statuesque figure worthy of typifying the eternal city – in a setting which indeed evokes the environs of Rome.

McTighe, Oberhuber, Wollheim, and Mahon make eccentric observations within the bounds of academic discourse. They set their interpretations within the literature, and so open up the possibility for debate. Even scholars who reject Steiner's and Klein's ways of thinking may find that Oberhuber and Wollheim make claims worth debating; even those who doubt that Poussin alluded to politics of the day, or was an autobiographical painter, can think the arguments developed by McTighe and Mahon of interest. These interpretations enter into professional dialogue. Lincoln's analysis does not.

I have repeatedly spoken of some commentaries as "eccentric." That word deserves some discussion. I once said to the historian Stephen Bann, "I admire your writing, but it is eccentric." "Fine," he replied, "but where is the center?" His question is a legitimate one, and so deserves an answer. The center is defined by the standards of your community, for truth in art historical interpre-

tation is, in part, based upon convention. But such centers can move. As Jack Miles noted to me in discussion, in response to this argument:

> In general, a center is a midpoint with spokes outward to a group. On occasion, however, an individual of great ability may, in effect, assign himself the center spot and from there deign to define an eccentric into the circle thus defined.

That gives us reason to take seriously eccentric interpretations. But there is also another reason.

Even those unconventional accounts judged unconvincing are revealing for the historian of art. Just as Freud found abnormal mental experiences worth study in part because these experiences helped reveal the nature of normal mental activity, so something can be learned about the nature of art historical reasoning by scrutiny of the arguments of outsiders to the academic world. Foucault also adopts this procedure, as Michael Roth has observed:[41]

> I learned from Foucault that often to understand a phenomenon, it's extremely useful to look at its opposite. In writing on madness, Foucault is really interested in the Enlightenment.

Interpretations in an alien style reveal the difficulty of stepping, even momentarily, entirely outside of our own ways of thinking. If a historian's style be too alien, following the details of his reasoning seems a waste of time. Genuine dialogue with him is probably impossible. Art history would have to change a great deal for Lincoln's account to be accepted. Compared with him, Panofsky, Steinberg and Greenberg are but modest conceptual revolutionaries.

After the fact, it is relatively easy to trace the development of art history, as I have done in these six case studies. The more difficult task is doing something new. And yet, unless we art writers have the courage to try new approaches, we will be doomed to repeat ourselves endlessly. Truth in art history is grounded in the consensus of the community of scholars. But it is not easy to imagine very radical changes in the conventions which make this dialogue possible.[42]

## NOTES

1 University Park and London, Pennsylvania State Press, 1991.
2 San Diego, Vela Press, 1994. I owe my knowledge of this example to Gary Schwartz. The literature of connoisseurship provides further examples of such 'outsider' art writing; see, for example, H. Hahn, *The Rape of LaBelle*, Kansas City, Frank Glenn Publishing Co., 1946.
3 See R. Geuss, "Introduction," Friedrich Nietzsche, *The Birth of Tragedy and Other Writings*, trans. Ronald Speirs, Cambridge, Cambridge University Press, 1999, p. xxviii.
4 P. Schjeldahl, *Columns & Catalogues*, Great Barrington, Mass., The Figures, 1994, p. 121.

5 Much is to be learned about this problem from study of the reception of Leo Steinberg's work which, as well defended as it is by his erudition and persistence, often is responded to highly critically because it does not fit the existing paradigms. He has described this process instructively in "Animadversions: Michelangelo's Florentine Pietà: The Missing Leg Twenty Years After," *Art Bulletin*, 1989, vol. LXXI, no. 3, pp. 480–505. My earlier discussion of his work, and these issues, is "Panofsky, Leo Steinberg, David Carrier. The Problem of Objectivity in Art History," *The Journal of Aesthetics and Art Criticism*, 1989, vol. 47, no. 4, pp. 333–47.

6 F. Kermode, *The Art of Telling: Essays on Fiction*, Cambridge, Mass., Harvard University Press, 1983, p. 158.

7 T.S. Kuhn, *The Structure of Scientific Revolutions*, Chicago and London, University of Chicago Press, 1970 (second edition), p. 103.

8 P. Rosenberg with L.-A. Prat, *Nicolas Poussin: 1594–1665*, Paris, Réunion des musées nationaux, 1994, pp. 283–5, summarizes Panofsky's interpretation and responses to it.

9 H. Lincoln, *The Holy Place: The Mystery of Rennes-le-Château–Discovering the Eighth Wonder of the Ancient World*, London, Jonathan Cape, 1991.

10 M. Biagnenet, R. Leigh, H. Lincoln, *Holy Blood, Holy Grail*, New York, Dell, 1983.

11 Henry Lincoln, *Key to the Sacred Pattern: The Untold Story of Rennes-le-Château*, New York, St. Martins Press, 1998, p. 174.

12 Wentwood, North Farm Road, High Brooms, Tunbridge Wells, Kent, England, Genisis Trading Co. Ltd, 1995, p. 24.

13 C. Wright, *Poussin: Paintings. A Catalogue Raisonné*, London, Harlequin Books, 1985, p. 189.

14 I told James Elkins about Lincoln. And so, since chapter eight of his *Why Are Our Pictures Puzzles?: On the Modern Origins of Pictorial Complexity*, New York and London, Routledge, 1998, briefly discusses Lincoln's work, perhaps now Catharism will be discussed by other art historians.

15 J. Plesch, *Rembrandts within Rembrandts*, trans. E. Fitzgerald, London, Simpkin Marshall, 1953, pp. 16, 19, 21.

16 M. Bal, *Reading "Rembrandt": Beyond the Word–Image Opposition*, Cambridge, Cambridge University Press, 1991, pp. 312, 313.

17 Earlier Meyer Schapiro and Theodore Reff identified some hidden images in Cézanne's paintings.

18 S. Geist, *Interpreting Cézanne*, Cambridge, Mass., and London, Harvard University Press, 1988, pp. 58–9.

19 *Arts*, February 1989, pp. 111–12. See also the review by John Rewald, "Cryptomorphs and Rebuses: A Double Disaster befalls Cézanne," *Gazette des Beaux-Arts*, Mai–Juin 1989, pp. 249–56.

20 G. Mauner, *Manet: Peintre-Philosophe. A Study of the Painter's Themes*, University Park and London, Pennsylvania State Press, 1975, p. 161; T.J. Clark, *The Painting of Modern Life: Paris in the Art of Manet and His Followers*, New York, Alfred A. Knopf, 1985, pp. 251, 252, 253.

21 R. Brilliant, *Visual Narratives: Storytelling in Etruscan and Roman Art*, Ithaca and London, Cornell University Press, 1984, pp. 115–16.

22 N. Bryson, *Vision and Painting: The Logic of the Gaze*, New Haven and London, Yale University Press, 1983, pp. xii, xiii, 139.

23 My review of *Vision and Painting* appeared in *Art in America*, 1983, vol. 71, no. 11, pp. 12–15.

24 E.H. Gombrich, *Art and Illusion: A Study in the Psychology of Pictorial Representation*, Princeton, Princeton University Press, 1961, pp. 381, 382.

25 Bryson, p. 44; Gombrich, p. 385.

26 Bryson, pp. 56–7; see the critical account in my *Artwriting*, Amherst, University of Mass. Press, 1987, pp. 82–7.

27  *The Journal of Philosophy*, 15 October 1964, vol. LXI, no. 19, pp. 571–84.

28  See C. Eisler, "Lady Dilke (1840–1904): The Six Lives of an Art Historian," in C. Richter Sherman and A.M. Holcomb, ed., *Women as Interpreters of the Visual Arts, 1820–1979*, Westport, Connecticut, and London, Greenwood Press, 1981, ch. 6. The fullest recent study, K. Israel, *Names and Stories: Emilia Dilke and Victorian Culture*, New York and Oxford, Oxford University Press, 1999, has relatively little to say about her art history writing. Elizabeth Mansfield drew my attention to Dilke's relevance to my present argument.

29  Lady Dilke, *French Painters of the XVIIIth Century*, London, George Bell, 1899, p. 91.

30  Mme Mark Pattison, *Claude Lorrain. Sa via et des oeuvres*, Paris, Librairie de l'art, 1884, p. 183.

31  A. Blunt, *Art and Architecture in France 1500 to 1700*, Harmondsworth, Middlesex, Penguin, 1973 (second edition revised); T.E. Crow, *Painters and Public Life in Eighteenth-Century Paris*, New Haven and London, Yale University Press, 1985. But she is in the exhaustive bibliography of the exhibition catalogue by M. Morgan Grasselli and P. Rosenberg, *Watteau 1684–1721*, Washington, National Gallery of Art, 1984.

32  *The Dictionary of Art*, ed. J. Turner, London, Macmillan, 1996, vol. 8, pp. 895–6.

33  My account draws upon E. Mansfield, "The Victorian *Grand Siècle*: Ideology as Art History," *Victorian Literature and Culture*, Spring 2000, pp. 133–47.

34  T. Nagel, *Other Minds: Critical Essays 1969–1994*, New York and Oxford, Oxford University Press, 1995, p. 10.

35  S. McTighe, *Nicolas Poussin's Landscape Allegories*, Cambridge, New York, Melbourne, Cambridge University Press, 1996, pp. 65–6.

36  On Blunt's politics in relation to his art history writing see M. Kitson, "Anthony Blunt's Nicolas Poussin in context," in K. Scott and G. Warwick, eds, *Commemorating Poussin: Reception and Interpretation of the Artist*, Cambridge, Cambridge University Press, 1999, Ch. 8.

37  "Early Poussin in Rome: The Origins of French Classicism, Kimbell Art Museum, Fort Worth," *Arts*, March 1989, pp. 63–7.

38  Konrad Oberhuber, *Poussin: The Early Years in Rome. The Origins of French Classicism*, New York, Hudson Hills, 1988, p. 15.

39  R. Wollheim, *Painting as an Art*, Princeton, Princeton University Press, 1987, pp. 228, 230.

40  "The dossier of a picture: Nicolas Poussin's 'Rebecca al Pozzo'," *Apollo*, March 1965, vol. 81, pp. 202–3. See the discussion in the catalogue entry, G. Finaldi and M. Kitson, *Discovering the Italian Baroque: The Denis Mahon Collection*, London, National Gallery, 1997, pp. 150–1.

41  "Talking with Alexander Nehamas," *Bomb*, Fall 1998, no. 65, pp. 36–41.

42  I thank Marianne Novy, Paul Barolsky, Arthur Danto, Steven Marcus, Elizabeth Mansfield, Jack Miles, and Michael Roth for comments on earlier drafts. Gary Schwartz made very detailed critical suggestions on the portion of this chapter given in the session he organized at the CAA convention, February 2000. In 1989, when I was working on Poussin, Professor Nancy Brown, my wife Marianne Novy's teacher, gave me *Holy Blood, Holy Grail*. A few years later, Marianne and our daughter Liz went to the Cathar country. The food is great, the scenery magnificent, the climbing challenging. I dedicate this paper to Nancy and Gary, for her gift and his generous comments made it possible.

# 8

# THE TASTE OF ANGELS IN THE ART OF DARKNESS

## Fashioning the canon of African art

*Christopher B. Steiner*

> Since it is commonplace that every work of art requires both a
> creator and a spectator, it became evident that some exploratory
> inquiry was in order to determine the role of the patron and
> collector. Through the centuries he has held the balance between
> the artist and the layman and has handed down with courage and
> a spirit of adventure the tangible remnants of the history of civi-
> lization.
>
> Francis Henry Taylor, *The Taste of Angels*

Before every trip to Africa, I always pay a visit to one of the leading tropical
disease doctors in Manhattan. Although he practices out of a swank apartment
building on the upper eastside, the doctor's office itself is unassuming with a
starkly appointed waiting room stocked with a bare assortment of tattered
books and dated magazines. Among this odd array of reading materials laid out
for his patients' perusal, one book that always catches my eye is an autographed
copy of the 1971 exhibition catalogue *African Art: The deHavenon Collection*,
which was published by the Museum of African Art in Washington, D.C. Like
most African art exhibition catalogues of this period, the book contains surpris-
ingly little text – a half page of gratitude and praise for the collector written by
the museum's director; a half page of gratitude and praise for the museum's
director written by the collector; and two pages of introductions about the
history, function, and diversity of African art written by an unidentified author.
The catalogue's remaining two hundred or so pages contain mostly grainy,
black-and-white photographs of African masks and statues, all of which are shot
on white backgrounds so that they appear to float on the surface of the page.
Like the spartan waiting room in which it now resides, the catalogue contains
little extraneous matter: each object is identified plainly by a number, a "tribal"
affiliation, a short descriptive term (e.g., "ancestor figure" or "ritual head"),
and a single measurement taken in inches. In this particular copy of the cata-
logue, the inscription penned in black ink across the title page also includes
words of gratitude and praise by the collector for the good doctor.

Since there is hardly any other worthwhile literature in the waiting area, I am always leafing through the pages of this now dog-eared exhibit catalogue when the doctor suddenly emerges to call me into the examination room. "Are you familiar with deHavenon's collection?" he routinely asks. "Sort of," I reply, stumbling through some version or other of a noncommital answer. The doctor then interrupts to recount to me a story that I have by now heard well over a half-dozen times. Gaston deHavenon, the story goes, visited the doctor some time in the late 1970s before undertaking a trip to Zaire, where he was to receive a medal of recognition for his contributions to the collection and under-standing of African art. "He was incredibly nervous," the doctor recalls. " 'But surely,' he remembers asking his patient, 'aren't you far better off traveling to Africa today than in the '50s when you put together your collection?' 'But I've never been to Africa,' deHavenon reportedly replied, 'I bought everything in Paris.' " The doctor's laugh is timed precisely to the sting of his hyperdermic needle, which always sneaks up unexpectedly from behind.

The story of Gaston deHavenon is a familiar one not only because I have heard it so many times, but because it is a truism that almost every major collec-tion of African art in Europe and the United States was not acquired in Africa. Why have so many collectors chosen not to procure objects directly from their site of creation and use? Why is Africa perceived as the last place on earth from where to build a "serious" collection of African art? What is the special mystique of African art objects in Europe and the United States that distinguish them in the eyes of collectors from their material counterparts on the African continent? Fear of malaria, cholera, and dysentery may account for part of the answer, but I think it is a minor part or, as it were, only a smart punchline to the doctor's well-rehearsed anecdote. Rather, the answers to these questions, as I will suggest in this chapter, lie elsewhere – pointing us not into the logistics of international travel in the Tropics but into the trenches of some of the most fundamental art-historical debates about authenticity, the parameters of canon-ical ideals, and the subjective constructions of value and taste.

Perhaps more so than in any other field in the world of art, collectors have dominated the formation of taste and construction of aesthetic value in the study and exhibition of African art. Collectors have dealt a heavy hand in structuring research agendas and fashioning the content of exhibition catalogues and text-books alike; these publications in turn have become canonical models guiding the formation of subsequent collections, and thus creating an institutional cycle for the reproduction of aesthetic norms and ideals. Unlike some art genres, where scholarship has guided public desire, in African art it has often been the other way around. As art historian Susan Vogel once remarked, "More often than not it has been the collector who led the institution (museum or university) to become involved in African art. The institution in turn influenced the general public."[1] In this chapter, I approach the collector as one of the primary "insti-tutions" responsible for the formation of African art history. The collectors' cultural assumptions and aesthetic preferences are not only reflected in scholarly

and museological approaches to African art but are indeed woven into the very art-historical fabric that structures these fields of inquiry and exhibition.

## ENVISIONING AFRICA

One of the most common explanations for why collections of African art have been developed largely outside of Africa focuses on the collector's skewed and somewhat fragile vision of "Africa" itself. Like an antique glass lantern slide, the collector's image of Africa is said to be so delicate that even the slightest dose of historical reality threatens to shatter a collective fantasy about the idyllic qualities of art from the pre-colonial era. According to those who share this particular longing for an imagined past, "authentic" African art is thought to have existed only *before* the first European presence on the African continent. Thus, the arrival of missionaries, colonial officers, school teachers, and other agents of social change is said to have led inevitably to the demise of African creative genius and a decline in the overall quality of Africa's arts. A typical statement on this perspective comes, for example, from an early book on African sculpture by Paul Guillaume and Thomas Munro, who described the period immediately after 1907 in the following way: "The coming of the white man has meant the passing of the negro artist; behind him remains only an occasional uninspired craftsman dully imitating the art of his ancestors ... The art-producing negro, then, was the negro untouched by foreign influence."[2] A similar declaration was made just a decade later by Michael Sadler in his book on West African art: "Thus the conditions which fostered the older art are passing away, and will not return. With them is passing the art which was sustained by the ancient traditions of ritual and worship."[3] And, writing in 1957, Margaret Webster Plass introduced her catalogue on *The Classical Art of Negro Africa* by noting: "All of the sculpture collected for this exhibition is 'pure' in the sense that it derives from ancient African traditions, unaffected by non-African influences."[4] Operating under such assumptions, collectors who seek to mine this utopian past for desirable art have resorted to acquiring works from a fairly restricted pool of so-called authentic objects that have been in a state of nearly constant recirculation in Europe and America since they first departed Africa, riding, as it were, on the crest of a receding wave of foreign arrivals.

Again, we may turn to Susan Vogel who sheds some light on the logic behind these collecting practices:

> The feeling that the art they own comes from lost civilizations is reflected by the general agreement among collectors that it is not important or even necessarily enlightening to visit Africa. Collectors may be disconcerted by the idea that sculptures like those in their living rooms could be dancing today in Africa. The sweaty reality of use and sense of things recently removed from their origins affront

both aesthetic and ethical scruples. The elevation of African art to the status akin to that of antiquities ennobles and aestheticizes it, and also moves it further from a possibly questionable recent traffic in cultural property, with its sordid implications of theft or purchase at low prices from poor people.[5]

The perspective outlined above is also confirmed by the words of collector Brian Leyden, whose objects were included in Vogel's 1988 exhibition *The Art of Collecting African Art* at the Center (now Museum) for African Art. In an interview quoted in the exhibit catalogue, Leyden explains to Vogel why he has never traveled to Africa: "If Addidas [sic] sneakers and Sony Walkmen were absent from the Ivory Coast, I might reconsider my position, but, at present, my romantic vision of pre-colonial Ivory Coast is too fragile to tamper with."[6]

The irony in this and other statements of its kind is that African art collectors, perhaps more so than any other type of art collector, claim to have a deep, personal connection to the artists and cultures responsible for the creation of the objects they acquire. In contrasting his collecting practices to those who devote themselves solely to European or American painting, for instance, deHavenon notes in the forward to his exhibition catalogue:

Unlike the purchase of a western painting which is unavoidably influenced by the name of the artist, what is challenging and exciting for the collector who selects an African sculpture is that you are completely on your own. You may have the satisfaction of looking at the painting, but as you turn a fine object between your hands you experience an emotion which is heightened by your physical contact with its detailed form and the quality and patina of the wood. This experience gives you the feeling that you become closer and somehow part of the artist who has created such a miraculous work.[7]

Close encounters such as these are often accompanied by a deep incorporation of objects into the collector's home, where works of African art become seamlessly integrated into their new domestic environments. Under such conditions, an object's presence attests not so much to a reality that exists outside the collection and its particular decor, but rather, as Bourdieu might say, it speaks to the good taste of the collector herself.[8] As Matty Alperton noted in a column advising collectors on the appropriate placement and use of "primitive art" in interior design: "By decorating your home properly, you can make every acquisition more than just another addition to your collection. It can become an important part of the environment in which you live."[9]

Note, however, that the "closeness" to the artist that collectors of African art such as deHavenon and Alperton experience comes in a rather unusual way and at an odd price – namely, a marked physical and intellectual distance from the artists themselves. Unlike collectors of contemporary European or American art,

such as Robert Scull or Victor and Sally Ganz, for instance, who often came to appreciate and understand "difficult" art through direct contact and dialogue with the artists whose works they acquired, many collectors of African art appear to value (rather than lament) their distance from the artists and the cultural environments from where the art originates. There is, in fact, in many instances an assumption made that African art communicates so perfectly and effectively across cultural divides that knowledge of Africa is unnecessary and sometimes even an impediment to proper aesthetic appreciation and understanding.

## UNIVERSALISM'S BLACK HOLE

The capacity of African art to spark ubiquitous feelings of appreciation and universal transcultural aesthetic response has been noted again and again since the earliest moments of African art collecting and exhibition. One point that has often been stressed is the fact that African art can withstand public observation in the bright light of the gallery display case without the support of interpretive text or contextual information – i.e., any knowledge that might be derived from an art-historical perspective on Africa. In the early twentieth century, these claims were made out of necessity due to the massive gaps and deficits in the art-historical record on Africa. Witness, for example, Herbert Spinden's remarks from his 1937 catalogue to the Brooklyn Museum's exhibition of Frank Crowninshield's collection: "African sculptures have certain qualities which are absolutely esthetic, producing rhythms of beauty which drum inevitably upon sensitive nerves."[10] He then goes on to note that such works "are products of creative imagination and it is possible for us to *enjoy them as such without too much deference to ethnological fact*" (emphasis added).[11] Given that the field of African art history did not even exist when Spinden voiced these remarks, we might interpret his deference to the "innocent eye" as a practical solution to an information gap. However, even as we move ahead into the second half of the twentieth century, when the discipline of African art history developed and as art-historical knowledge about Africa began to expand and deepen, the argument for "pure" appreciation unencumbered by cultural data continued to be heard. As one critic noted in his review of the newly formed Museum of Primitive Art in 1962, the museum "judges its acquisitions and collections by modern esthetic standards. In other words – by what looks best to the best informed eyes. It does not attempt the impossible act of putting itself in the minds of the primitive artists nor does it try to revive a sense of the blood and magic which originally informed so many of its possessions."[12] And, writing in the early 1980s, in an essay intended for potential investors in African art, dealer Charles Bordogna emphasizes the potential of African art to stir the individual's imagination: "The emotional intensity of African art ignites the collector's passions. The sculptures and masks are thrilling to look at and exciting to touch. The stories behind the pieces of tribal rituals can inflame the imagination."[13] Finally, writing in 1990, collector Eric Sonner described his approach

to collecting in the preface to a catalogue of his works exhibited at the UBC Museum of Anthropology in Vancouver. "The observer of a piece of African art," he says,

> is not influenced by the possible importance or fame of the artist. The Western observer has in most cases no particular insight into the meaning of a piece in the tribal context. The only relationship of the Western observer to a piece is the visual impact in the context of his world, not the possible intent or purpose of the tribal world. The message of the piece is a direct confrontation with the spectator.[14]

One way, of course, to interpret the kind of pleasure that is achieved in this surprising context of blissful ignorance, or what William Fagg once referred to as the lure of an "uninformed *nègrerie*,"[15] is to take the position that Africa has been perceived by Westerners as somehow undeserving of the more serious scholarly attention devoted to other world art traditions. As Marcel Griaule argued years ago: "However much the Negro is esteemed, he is not thought worthy of the scrupulous attention reserved for the classics of our latitudes."[16] Yet, at the same time, this peculiar brand of artificial intellectual innocence is also open to a very different interpretation, and one that may be more germane to the point of this chapter. That is, African art since its earliest excursions through the studios of European modernist artists has always been perceived as a blank slate upon which to project one's own meanings and illusions – whatever those may be. This has been true in art as well as in literature. As literary historian Christopher Miller rightly points out in his critique of the history of Africanist discourse in texts:

> Favorable descriptions of Africa can be as detached from reality as negative ones: the axis between realism and fantasy does not run parallel to that of desire and loathing. Desire is the desire for realism, for the documented, reified presence of the object. The peculiarity of Africanist discourse has been the slight and constant tease between what the author proposes and what he can prove; for, as often as not, what he wishes to describe is the presence of an absence.[17]

The idea that African art, to borrow Miller's own phrase, is a "blank darkness" upon which individual interpretations, fears, and desires are projected might explain why some people believe that the arts of Africa are so easily approached and understood. While one might assume that cultural distance would present a difficult obstacle that must be surmounted before iconographic interpretation can begin, many have argued that African art transcends the interpretive boundaries of any aesthetic alterity. "The sensitive observer," Susan Vogel once remarked, "responds to unfamiliar works intuitively without knowing their cultural context."[18] In his introduction to the exhibition catalogue for *African*

*Negro Art* (an exhibition held in 1935 at the Museum for Modern Art in New York, which largely established the canon of accepted African sculptural forms to this day), James Johnson Sweeney acknowledges that African art had reached a "place of respect" in spite or, perhaps, because of the public's shallow depth of understanding. "We can never hope to plumb its expression fully," he admits. "For us its psychological content must always remain in greater part obscure."[19]

Reviews from some recent exhibitions of African art confirm the persistence of this perceived ignorance and the optimistic assertion of its impact on our understanding and appreciation of African art. "Few people entering the galleries," begins a review of the exhibit *Masterpieces from Central Africa* at the Art Institute of Chicago, "can be indifferent to the emanations of faith, fertility and enduring peoplehood that are rampant here."[20] Or, thinking along similar lines, an equally sanguine reviewer noted of the *Kilengi* exhibit at the Neuberger Museum of Art: "It is easy for many Americans to say that they understand African art after having seen just a few exhibitions."[21]

In 1946 Alain Locke began his essay for the catalogue to the Baltimore Museum of Art's first exhibition of African art by noting the ease with which such works could be understood by even the most unacquainted viewer. He refers not only to African art as the universal "revelations of the common denominators of mankind's creative urge toward self-expression and beauty," but also suggests that in contrast to the intellectual challenges posed by contemporary European or American art, interpretive access to African art by Western audiences should be quite effortless. "Its messages," Locke wrote, "should not be dark and cryptic to anyone who can understand and appreciate contemporary art, as any glance at our abstract painters and sculptors should make clear."[22] Some fifty years later, in a revealing commentary in *The Washington Post*, Baltimore Museum of Art director Doreen Bolger described the on-going efforts of the museum to make contemporary art more accessible to a wide public. She, like Locke writing for the same institution in 1946, contrasts contemporary art to the "more familiar" art forms that inhabit various corners in the museum building.

> Visitors entering our contemporary wing may have just viewed an 18th-century American period room, a Flemish Old Master painting or an African Baga mask in another part of the museum. The obvious craftsmanship, skill and historical or cultural significance of these works make them seem more familiar. But what's to be made of Carl Andre's "Zinc-Magnesium Plain" installed on the gallery's floor or Bruce Nauman's blinking neon work "Raw War"?[23]

What makes the meaning of an African "secret" society sculpture, such as a Baga initiation mask, more transparent to a Baltimore museum-goer than an installation piece by an American Minimalist or a neon sculpture by a conceptual artist born in the American heartland? The Baga mask or headdress, after

all, is not representational, in the sense that it can be identified with any recognizable animal or human form; even in its original cultural setting its spiritual references were oblique and shrouded in secrecy; and the type of mask to which the article probably refers fell out of use over a half century ago when such objects were torched by incoming Muslims or exported routinely to Western museums.[24] How then could such an elusive object be open to such straightforward, universal interpretation?

## SPIRIT POSSESSION

If part of the draw to the art of Africa has been its infinite possibilities of iconographic interpretation and the apparent ease with which its meanings and values cross cultural divides, another attraction that has been identified by some collectors at least is its spiritual magnetism. Just as African aesthetic appreciation is thought to be universal, so too are its metaphysical forces which putatively travel across the Atlantic, wielding their relentless seductive powers on audiences in museums, galleries, and living rooms across Europe and America. To return for a moment to deHavenon's remarks in his exhibition catalogue, it is instructive to look at the language he uses to describe his initial emotional pull to African art. "I became more and more *enchanted* with the diversity of tribal styles which taught me to understand and love the seemingly endless ingenuity of those African artists who worked such emotion and spirituality into their three-dimensional forms" (emphasis added).[25]

While it is arguable that art collectors in many fields are "enchanted" by the alluring spell cast on them by a work of art, and drawn inexplicably to acquire what they collect, the significance of an object's perceived "magical" force takes on a slightly different character in the context of African art collecting. After all, it is the "black" magic associated with certain African objects that first laid the groundwork for their removal by missionary zeal and later wholesale colonial conquest. Fetishes were prohibited or confiscated by the Christian church, and sacred arts were often seized as symbolic acts of colonial violence. Yet, following their arrival in Europe and America, many collectors, such as deHavenon, refer to the magical power of African art to seduce and draw them in. Sometimes this power is even described as being so forceful that it actually overcomes any initial distaste that the viewer might have had. Pablo Picasso, for example, when he first encountered African art in his famous visit to the Trocadéro in spring 1907 is reported to have felt immense disgust and an overwhelming desire to flee the museum. "I was alone," he recounted to his friend André Malraux, "I wanted to get away. But I didn't leave. I stayed. I understood that it was very important."[26] Decades later, Wactaw Korabiewicz described a similar process of what might be called the "reluctant attraction" experienced by European collectors more generally: "African art is spellbinding. It may perhaps not appeal at first glance, although it attracts and holds attention by its extraordinary power of vision."[27]

In some cases, it is a disinclined spouse who seems to be overtaken by the "magical" presence of African art. As one collector's wife noted after explaining her initial resistance to her husband's acquisitions: "But when Hans returned a month later with three dominating works carved by those same 'uncultivated' tribesmen, I took my first objective look – *and the spell was cast*" (emphasis added).[28] Or, consider what renowned collector Paul Tishman says in the preface to the catalogue of his collection: "Although my interest in collecting African art was at first not fully shared by my wife, who was absorbed in Western art, it was not long before the purity and force of the material *worked their spell on her*" (emphasis added).[29] Like the rhythmic drumming of African vodun, which possesses its devotees (sometimes even in spite of themselves), African art has often been described as hypnotic in its ability to captivate, sometimes unwittingly, the viewer's senses. "These ceremonies," says collector Nancy Nooter, "usually with masked dancing, are rich in color, motion, and the sound of contrapuntal music. We were *enchanted*" (emphasis added).[30] Or, like a forbidden fruit, African art is sometimes described as enticing its prospective audience in spite of obstacles pitched in their path. "I was strangely attracted to and fascinated by some strange figures I saw in the distance," collector Serge Brignoni reveals in an interview. "They had large heads, long arms and exaggerated genitals. Our teacher wouldn't let us look at them more closely, so, on arriving back home I asked my father to take me back."[31]

These lingering "magical" powers that have been attributed to African art parallel the kind of universal aesthetic appeal described in the section above. Just as it is claimed that anyone can understand the intentions of an African artist, so too it is argued anyone can become possessed by the universal spiritual forces that are sedimented in the core of every transplanted African religious object. Spiritual references are no longer taken to be specific to any particular African religion or belief system, but rather are described as transcultural in their exercise of power and spiritual jurisdiction. In an otherwise sophisticated and nuanced essay rebutting a recent attack by Patricia Penn Hilden on the ethnocentric and hegemonic agendas she associates with the Museum for African Art's exhibitions of decontextualized objects,[32] art historian Carol Thompson falls back on a rather naive argument about the "universal spirituality" of African art in order to rebuke Hilden's accusations. "Even removed from its original contexts," Thompson writes, "African art has the power to communicate socially therapeutic values cross-culturally to people of all ages, transcending differences of race, gender, and class, and uniting generations, living and deceased."[33]

## METAPHORS OF CONQUEST AND DISCOVERY

In his brief catalogue remarks, Gaston deHavenon acknowledges the help and participation of his wife by noting that "Anna Lou has been the most influential

companion during these years of the 'African hunts,' and it is through her generous advice and encouragement that our collection is now presented for you to share some of these great joys with us." It is ironic that a man who had never been to Africa before the award ceremony held for him in Zaire during the late 1970s should describe his collecting activities with a metaphor that conjures an image of the great white hunter exploring an uncharted African wilderness – Teddy Roosevelt shooting down a Black Rhinoceros on the wind-swept plains of the Serengeti. But the image of the hunt, which is a common metaphor in almost *all* fields of art collecting, takes on special significance in the context of African art.

Like John Hanning Speke setting out to discover the source of the Nile, collectors of African art have sometimes fancied themselves as intrepid explorers voyaging into the uncharted waters of the international art market. Consider, for example, Herbert Baker's description of his early adventures as a bargain hunter searching for African art: "As an 'explorer' seeking treasures in second-hand stores, attics and basements, I found that I could afford African and Oceanic 'curios' that looked like copies of a Picasso, Braque, Modigliani or Vlaminck."[34] More recently, a collector of my acquaintance in the Ivory Coast spent his weekends scouring through warehouses of African art in search of "authentic" materials. Before setting out on these little adventures, he would don his "African art clothes," rugged attire specially selected to withstand the dirt and dust generated from overturning piles of wooden sculptures and arti-facts. Unlike some collectors who collect objects for their aesthetic appeal, this African art enthusiast preferred to acquire works with little or no aesthetic value because, he claimed, there was less chance that such objects might have been faked for the market. As he once exclaimed when finding such a piece, "It's so ugly, it's gotta be real." Finally, the wife of a collector in New York told me once that her husband saw nearly every African "runner" that called him at his Manhattan office. "He keeps hoping to find that one masterpiece, like a real Fang reliquary figure or something, buried somewhere in the junk that the runners usually sell."[35]

## FASHIONING THE CANON

In the first decade of the twentieth century, American scientist Frederick Starr traveled to the Belgian Congo to collect specimens and artifacts for the American Museum of Natural History. In his carefully kept diaries, which have been analyzed recently by Enid Schildkrout (1998), Starr discusses some of his strategies to acquire "authentic" objects of art and material culture for the museum's burgeoning ethnographic collections. His remarks reveal not only his preferences for "old" and "used" objects, but more importantly the effect his desires had on local traders, and the messages that they in turn communicated to indigenous artists and craftsmen. In an entry from December 1905, Starr writes:

> Yesterday a well-carved wooden figure was offered. I refused it because
> it was rather new and empty [of medicine] in its stomach hole. Today
> it appeared again, this time with a fat round belly neatly sewed up and
> well smeared with cam and oil. I agreed to the price, getting it down
> to 1.50 francs.[36]

Eventually, Starr's sources became so familiar with his taste that they only
brought objects that fit the Western criteria of authenticity – at least, as they
perceived it. Starr, however, began to turn down these "manipulated" objects as
he came to realize the effect of his choices on the integrity of the collection. In
February 1906 he wrote:

> I felt really badly when four little fellows came from Ndombe loaded
> down with beautiful new figures which they had prepared with much
> care, painting them fresh and bright and sticking feathers in them ...
> Now we had to draw the line and refused most of them.[37]

Nearly a century after Starr's adventures in the African interior, Dutch collector
Harrie Heinemans recounts in the preface to his collection catalogue (1986) his
experiences in purchasing objects. His relationship with suppliers, and the
exchange of information that went on between the two parties, is strikingly
similar to the situation Starr described in the Congo during the early 1900s.
When Heinemans invited itinerant African traders into his home in Holland, he
says, they were not only concerned with selling their objects "but they were also
interested in books with pictures of masks and figures. In this way they could
find out what we considered beautiful and then they could have it made."[38] He
goes on to note, like Starr, that his choices and commentaries often influenced
the type of works he was later shown. "During those first visits I told them in all
innocence what was wrong with their figures and masks. As a result that defect
never occurred again. They take their time perfecting things and they have a
patience and stamina which is unknown to us."[39]

The influence that collectors such as Starr and Heinemans have had on the
body of collected works from Africa should not be underestimated. Although
few collectors have articulated their influence or impact as clearly as these two
men, the history of African art collecting is essentially characterized by an
ongoing mediation of knowledge between Africa and the West, in which objects
deemed canonical by collectors have either been reproduced or recirculated
along highly developed and specialized lines of trade. These collections, in turn,
have come to form the basic reference points for the canonical forms and ideals
of African art history. Unlike many fields of art, where collectors and the
academy have worked in step to develop and deepen knowledge of a particular
period or style, in the context of African art, scholarship and collecting have all
too often been at odds. Whether it is in the collector's uncritical appeal to
universal aesthetics, in their conviction of the lingering magical potency of

African material objects, or in their desire to recapture innocent virginal sensations of "discovery," collectors have often perpetuated (through the presentation of their collections in museum exhibitions and catalogues) a particular vision of African art that either eclipses the complexity and contradictions that exist within specific African social systems, or obscures the messy and unpleasant socio-political realities of modern Africa. Although African art history has made great strides in recent years to bring into the fold of the art historical canon modern African art and expressions of contemporary popular material cultures, collectors have generally resisted such "alien" intrusions into their watchfully guarded, carefully constructed object world. While it is true, as Francis Henry Taylor pointed out in *The Taste of Angels*, that collectors have provided art historians with the physical tools of their *métier* – "the tangible remnants of the history of civilization"[40] – the specific relationship between African art collecting and scholarship needs to be (re)viewed through a more skeptical lens.

In catalogues of African art, collectors have generally been extolled for having the vision, perseverance, and resources to collect and preserve Africa's "dying" heritage. "When universal appreciation of the significance of Africa's creative tradition is finally achieved," begins Warren Robbins prefatory remarks to deHavenon's exhibition catalogue, "the important role played by the private collector must be recognized. For it has been the efforts of the discerning collector to assemble examples of the many different tribal styles comprising that tradition that have contributed immeasurably to its preservation as a resource for posterity."[41] But not all references to collectors have been as favorable as Robbins's acknowledgment to deHavenon. With characteristic mordancy, William Fagg years ago warned of the impact "undisciplined" collecting might have on the field of African art history and the public perception of Africa's arts.

> Does my heart swell with Africanist pride when I see in the expensive magazines that So-and-so, the well-known film star, innocent alike of taste and of intellect, has had her home decorated on her behalf in the latest style by Such-and-such, the avant-garde interior decorators, and that the necessary note of surrealist incongruity ... has been provided by a fake Negro sculpture? No, these gentlemen are applying to the appreciation of African art a kind of hormone weed-killer which could well kill the plant by promoting excessive and weak growth. The activities of "collectors" who are not prepared to become genuine and critical connoisseurs are anything but praiseworthy, especially if they proceed to fix their defective taste upon the community by giving their collections to museums – all or nothing.[42]

While Fagg would probably not have lumped deHavenon into the category of collectors he describes in this passage, his remarks underscore the power of

material collections to shape art historical knowledge and the intellectual paradigms of the field.

NOTES

1 S. Vogel, ed., *The Art of Collecting African Art*, New York, The Center for African Art, 1988, p. 5.
2 P. Guillaume and T. Munro, *Primitive Negro Sculpture*, New York, Harcourt, Brace & Co., 1926, p. 13.
3 M.E. Sadler, ed., *Arts of West Africa*, London, Oxford University Press, 1935, p. 7.
4 M. Webster Plass, *The Classical Art of Negro Africa*, New York, Duveen-Graham Gallery, 1957, n.p.
5 Vogel, *The Art of Collecting African Art*, p. 4.
6 Leyden quoted in Vogel, *The Art of Collecting African Art*, p. 58
7 Quoted in Museum of African Art, *African Art: The deHavenon Collection*, Washington, D.C., Museum of African Art, 1971, n.p.
8 P. Bourdieu, *La distinction: critique sociale du jugement*, Paris, Les editions de minuit, 1979.
9 M. Alperton, "Decorating with Primitive Art," *Primitive Art Newsletter*, 1981, vol. 4, no. 3, p. 2.
10 H.J. Spinden, "Foreword," *African Negro Art from the Collection of Frank Crowninshield*, New York, Brooklyn Museum, 1937, n.p.
11 Ibid.
12 Quoted in S. Price, *Primitive Art in Civilized Places*, Chicago, University of Chicago Press, 1989, p. 85.
13 C. Bordogna, "The Lure of African Art: Accessible Masterpieces," *Collector–Investor*, September 1981, p. 36.
14 Quoted in M. Halpin, *Fragments: Reflections on Collecting*, Museum Note No. 31, Vancouver, Canada, UBC Museum of Anthropology, 1991, p. 2.
15 W. Fagg, "The Study of African Art," *Allen Memorial Art Museum Bulletin*, 1957, vol. 13, no. 2, pp. 44–62.
16 Marcel Griaule, *Arts of the African Native*, London, Thames & Hudson, 1950, p. 16.
17 C.L. Miller, *Blank Darkness: Africanist Discourse in French*, Chicago, University of Chicago Press, 1985, p. 248.
18 S. Vogel, "Collecting African Art at the Metropolitan Museum of Art," *Quaderni Poro*, 1981, vol. 3, pp. 76–7.
19 J. Johnson Sweeney, *African Negro Art*, New York, The Museum of Modern Art, 1935, p. 11.
20 J. Auer, "Exhibit of African Art Gets Extra Attention," *Milwaukee Journal Sentinel*, 24 February 1999, p. 2.
21 W. Zimmer, "Layers of Complexity in a Show of African Objects," *The New York Times* (Westchester County supplement), 12 December 1999, p. 18.
22 A. Locke, "The Significance of African Art," in *An Exhibition of African Art*, Baltimore, The Baltimore Museum of Art, 1946, p. 4.
23 D. Bolger, "A Look at … the Fuss Over Art; You Can Learn to Love It, Believe Me," *The Washington Post*, 12 December 1999, p. B03.
24 F. Lamp, *Art of the Baga: A Drama of Cultural Reinvention*, New York, Museum for African Art, 1996.
25 *African Art: The deHavenon Collection*, n.p.
26 A. Malraux, *Picasso's Mask*, New York, Holt, Rinehart, and Winston, 1976, p. 10.

27  W. Korabiewicz, *African Art in Polish Collections*, Warsaw, Polonia Publishing House, 1966, p. 10.

28  J. Hans Lehmann, "The Joys and Trials of Collecting African Art," in *The Poetry of Form: The Hans and Thelma Lehmann Collection of African Art*, Seattle, Henry Art Gallery, University of Washington, 1982, n.p.

29  Quoted in R. Sieber and A. Rubin, *Sculpture of Black Africa: The Paul Tishman Collection*, Los Angeles, Los Angeles County Museum of Art, 1968, p. 8.

30  W. M. Robbins, "Robert H. and Nancy Ingram Nooter: Collectors of Beauty and Grace," *Tribal Arts*, 1997, vol. 49, no. 1, p. 89.

31  Quoted in C. Gianinazzi and C. Giordano, *Extra-European Cultures: The Serge and Graziella Brignoni Collection*, Lugano, Edizioni Città di Lugano, 1989, p. 42.

32  P. Penn Hilden, "Race for Sale: Narratives of Possession in Two 'Ethnic' Museums," *The Drama Review*, vol. 44, no. 3, pp. 11–36.

33  C. Thompson, "Slaves to Sculpture: A Response to Patricia Penn Hilden," *The Drama Review*, 2000, vol. 44, no. 3, p. 41.

34  H. Baker, *The Herbert Baker Collection*, New York, The Museum of Primitive Art, 1969, p. 4.

35  Quoted in C. B. Steiner, *African Art in Transit*, Cambridge, Cambridge University Press, 1994, pp. 9–10.

36  Quoted in E. Schildkrout, "Personal Styles and Disciplinary Paradigms: Frederick Starr and Herbert Lang," pp. 169–92, in Enid Schildkrout and Curtis A. Keim, eds, *The Scramble for Art in Central Africa*, Cambridge, Cambridge University Press, 1998, p. 182.

37  Ibid., pp. 182–3.

38  H. Heinemans, *The Pleasure of Collecting African Art: The Harrie Heinemans Collection*, Eindhoven, The Netherlands, Private printing, 1986, p. 5.

39  Ibid.

40  F. Henry Taylor, *The Taste of Angels: A History of Art Collecting from Ramses to Napoleon*, Boston, Little, Brown and Company, 1948, p. xi.

41  *African Art: The deHavenon Collection*, n.p.

42  Fagg, "The Study of African Art," p. 44.

# 9

# TRADESMEN AS SCHOLARS

## Interdependencies in the study and exchange of art[1]

*Ivan Gaskell*

In today's art world scholars and dealers seem, on the face of it, to occupy spheres that scarcely intersect. Many scholars avoid contact with dealers and auction house staff, known collectively as "the trade." Some scholars feel ill at ease in what they perceive as the socially forbidding ambience of commercial old master galleries, preferring emulsion and denim to damask and pin stripes. Many feel far less exposed on a concrete campus than in Bond Street or the upper east side. Some give their unease a political explanation, seeing dealers and auction house specialists as commercial fetishists and the toadies of pluto-crats. Be this as it may, the interests of every participant in the art world, whether abstruse theorist or rank salesman, are intimately intertwined.[2]

The matter that concerns the trade most urgently is attribution, for a work that is supposed to be by a given artist, but is not, is worth infinitely less than a work that actually is by that artist. Who has the right to decide? Right has nothing to do with it, for this concerns the mechanisms of capitalism. Those who decide are those who can command confidence, irrespective of an often fugitive truth. Thus although there might well have been an oeuvre created firsthand by, for example, Rembrandt van Rijn, it remains in practice beyond our grasp, while each generation, by means of its own chosen scholarly means, defines for itself the Rembrandt oeuvre it deserves.

The structure of academic and museum scholarship, with its ostensibly disin-terested stance, is the supposed guarantor of probity and the honest search for that unattainable but much-to-be-desired truth. Yet that structure of scholar-ship is closely allied to the dictates of the publishing industry. Together they ensure that competition among scholars for oracular status with regard to attributions to any given artist is minimal. Repetition or mere refinement of an existing catalogue raisonné will neither launch nor sustain a scholarly career. Neither would a publisher see any advantage in offering a second, third or fourth catalogue raisonné of the works of all but those artists perceived as truly great, complex, or controversial, unless it promises to render its predecessors obsolete. Therefore individual scholars who have demonstrated a particularly thorough engagement with the works of a single artist can easily become the

recognized arbiter of attributions to that artist. Dealers seek their opinion. When that opinion is not yet published, dealers approach the scholar privately. Some scholars get reputations for being cooperative, others for remaining aloof. Cooperation varies. Some scholars give their opinions freely without the expectation of anything in return. They count being alerted by dealers to works which they might not otherwise know of as recompense enough, perhaps with a photograph thrown in. Others are keenly aware of the commercial value of their opinions and sell them dearly. This has given rise in the German speaking lands to the certificate or *expertise*: a document signed by the scholar stating unequivocally his opinion of the work in question which thenceforth accompanies it as a testimonial. Some German scholars have reportedly acquired Mediterranean summer homes, or works for their own art collections, on the strength of their certificates. In the English speaking world such documents are viewed askance, for the disinterestedness of the opinion they express is too readily open to doubt. Nonetheless, scholars who do not issue *expertises* can receive benefits in exchange for their attribution opinions, ranging from lobster lunches to large sums of money, without the overt public acknowledgment of a commercial relationship to cast the scholar's ideas in a questionable light.

While academics are perfectly free to accept the rewards of such consultations, museum scholars are not. Yet if museum scholars cannot gain material benefits for themselves, they can for their institutions. Just as wise academic scholars who take an interest in works of art cultivate good relationships with the trade, even if they never engage in business exchanges, so assiduous museum scholars do the same. This is not simply a question of being in the right place when the trade brings newly discovered works of art to light. It is also because dealers are often very knowledgeable in particular ways about the art they handle. Dealers and auction house specialists often have highly developed powers of discernment. They often enjoy great sensitivity not only to characteristics significant for hazarding questions of attribution, but concerning other matters, such as techniques of fabrication. Scholars can learn from the trade, just as the trade can learn from scholars.

A distrust of the way in which certain types of art history can be informed or even driven by the trade's commercial imperatives has consistently informed other kinds of art-historical and museological practice. What might be described as the Warburg tradition of iconological decipherment and cultural interpretation has long been at odds with those forms of art history more readily identifiable with the Courtauld Institute and Institute of Fine Arts traditions, which are far more compatible, in certain respects, with the art market. Social histories of art, whether loosely Marxist-inspired or not, or, more recently, motivated by feminist or queer theorizing, largely sidestep or explicitly repudiate concerns that appear to have direct art market application. The same can be said of those recently established theoretical orthodoxies based on linguistics or psychoanalysis. This hostility to issues immediately pertinent to the art market is in part a revulsion against a perceived hypocrisy in which the common

interests and mutual exploitation of those in the trade and scholarly institutions, both universities and museums, who address matters such as quality and attribution, were never openly acknowledged by the scholars concerned, or seen as factors that might affect decision making and choices in particular ways. Yet must interests common to scholars and the trade be discredited? How has this questionable sharing of interests arisen? Is it inevitable, or avoidable?

Scholarship is often represented by its publication. Let us look at some eighteenth- and nineteenth-century examples of how dealers' publications exemplified and helped to modify scholarly assumptions. I have chosen to discuss four dealers whose publications were either innovative or influential on subsequent art-historical scholarship more broadly, or both. All are well known individually, but I know of no attempt to sketch any aspect of their aggregate achievement. All worked either in Paris or London, which were the scarcely rivaled centers of taste in the visual arts during the eighteenth and for most of the nineteenth century.

Pierre-Jean Mariette (1694–1774) represented the fourth generation of his family's Paris print dealing business. Not only was he, with his father Jean Mariette (1660–1742), a leading compiler of print collections, but also reputedly one of the most sophisticated connoisseurs of drawings ever.[3] Mariette was one of the three persons responsible for one of the most innovative and influential art books of the eighteenth century, the *Recueil d'Estampes d'après les plus beaux Tableaux, et d'après les plus beaux dessins qui sont en France dans le Cabinet du Roy et dans celui du Duc d'Orléans, et dans autres Cabinets.* The *Recueil* appeared in two volumes, the first bearing the date 1723, although it was not in fact published until 1729, and the second, 1742. This enormously ambitious project was directed by Pierre Crozat (1665–1740), a banker and the treasurer of the Estates of Languedoc. Crozat was one of the great collectors of the eighteenth century, one of whose most notable achievements was the negotiation of the acquisition by the Duc d'Orléans of the art collection that the Odescalchi family had inherited indirectly from Queen Christina of Sweden. The paintings arrived in Paris in 1721.[4] The third collaborator was Anne-Claude-Philippe, Comte de Caylus (1692–1765), whose contribution principally concerned the illustrations, the preparation of which by many engravers, some in a novel technique combining etching and chiaroscuro woodcut, was a daunting task.

The text was largely Mariette's responsibility. One of its innovative features was a particular attention to provenance. For very good reason this aspect of art-historical scholarship has long been associated with dealing. Dealers and collectors habitually interpret and exploit the ownership of a work by a socially elevated person, or a respected collector, as an indication, or even guarantee, of its authenticity. Knowledge of ownership can, indeed, be important information, for, when considered in the light of its historical circumstances, it can help to clarify the likely status of an object or group of objects. This is most obviously the case when documentation of the commission or earlier purchase can

be traced as a consequence. However, dealers exploit the fact that some prospective buyers will be more likely to acquire objects once owned by an ostensibly illustrious person than by a nonentity. Parties to such transactions tend to assume that a certain social luster passes with that object to its new owner. Such social ambition can be leavened and complicated by a collector's genuine antiquarian or even historical interest in earlier owners. In short, a concern with provenance, fostered by dealers' scholarship as exemplified early by Mariette's contribution to Crozat's *Recueil*, cannot invariably be reduced to mere commercial interest. Provenance allows scholars to discern patterns of ownership, use, and taste. It must be the armature of any discussion of the fortunes of artworks subsequent to their initial making and use. Although ignored or denigrated by some art historians, tracing provenance remains one of the central tasks of the compiler of scholarly catalogues, whether of the works of individual artists or of collections. This is so for good reasons. Provenance is also one of the most intellectually demanding fields of inquiry.

Provenance was not the only important scholarly contribution made by Mariette to Crozat's *Recueil*. Most obviously, he assumed editorial responsibility for bringing out the second volume in 1742, two years after Crozat's death. More importantly, though, for the development of art history, Mariette's text places greater emphasis on the discussion of attribution and style than on the subject matter of paintings, notably portraits. Indeed, as Francis Haskell remarked: "[F]or Mariette, the figure or figures represented in a picture are of fascination chiefly for the light they can throw on the artist who painted them and on the nature of his style."[5] He cites Mariette's discussion of the portrait identified as being of Cardinal Reginald Pole, then believed to be by Raphael. Mariette reestablished the identification of the sitter by comparison with other contemporary portraits, but observed that Pole was only 20 years old at the time of Raphael's death, whereas the sitter in the purported "Raphael" is obviously older. On these grounds he disqualified Raphael. He then proposed Sebastiano del Piombo as the artist responsible for the painting (in the State Hermitage Museum, St. Petersburg), appealing to criteria of style. This attribution remains generally accepted. In Mariette's discussion, the identity of the sitter takes second place to that of the artist, exemplifying a change of focus from antiquarianism to connoisseurship which was to have enormous long-term consequences for art-historical scholarship. In the dealer's hands the artwork became a route principally to knowledge of its maker, rather than to information about what is depicted. Works of art in consequence began to lose some of their remaining transparency, and further attained the opacity of objecthood as attention shifted to consideration of the minutiae of their physical characteristics. They began to assume the character of reflective surfaces revelatory of the physical and mental processes of their makers. Dealers such as Mariette were among those who led the way in this development, for to be able to assign responsibility for the making of an artwork reliably was – and still is – in some sense to control it. That intellectual control had commercial consequences as

connoisseurs focused on the process of the conception and making of artworks. Krzysztof Pomian has argued persuasively that Parisian dealers' ability to propose and enforce the precedence of attribution over other concerns gave them the initiative at the expense of collectors during the course of the eighteenth century.[6] Given the attention to process in connoisseurship, it is no coincidence at all that Mariette was reputedly at his most sophisticated when dealing with drawings: those objects in chalk, charcoal, graphite, metalpoint or ink on paper most intimately connected with the very processes of inventing and making artworks in a vast variety of other media. This sensitivity to the peculiarities of artists' drawing styles is nowhere better demonstrated than in the catalogue Mariette prepared of Crozat's drawing collection prior to its dispersal following the latter's death, the *Description sommaire des desseins des grands maistres d'Italie, des Pays Bas et de France, du Cabinet de Feu M. Crozat. Avec des réflexions sur la manière de dessiner des principaux peintres* (1741). Drawings would always play a supporting role in the hierarchy of Western art, yet the nicety of connoisseurship, as it is applied to drawings, is unexceeded in any other field. Scholarship associated with the trade has contributed to this state of affairs since at least the time of Mariette, and continues to do so: one need only cite the career successively at the British Museum, London, and the auction house Sotheby's of one of the leading twentieth-century students of Italian Renaissance drawings, the late Philip Pouncey.[7]

My second example of a dealer whose practice helped to shape subsequent art-historical scholarship by means of publication is Jean-Baptiste-Pierre Le Brun (1743–1813). Le Brun became one of the most successful and innovative dealers to work under both the French *ancien régime* and the chaos that succeeded it. Aspects of his career have been carefully considered by Gilberte Émile-Mâle, Francis Haskell, and Andrew McClellan.[8] Before the revolution Le Brun dealt both in old master and contemporary art, and acted as advisor-cum-curator to King Louis XVI's cousin, Louis-Philippe, Duc d'Orléans, and the king's brother, Charles-Philippe, Comte d'Artois. Le Brun's wife, the portraitist Elisabeth Vigée-Le Brun, was one of the earliest emigrants following the outbreak of the revolution in 1789. Le Brun remained in Paris, adapting to new and ever-changing circumstances with alacrity, and taking advantage of the upheavals to play a role in the foundation of the museum in the Louvre, and the accelerated commercial exchange of artworks as old collections were dispersed and new ones formed. He wrote detailed catalogues of the collections he was charged with offering for sale, competing in this respect, as in others, with his exact contemporary, the other highly successful dealer in Paris, Alexandre-Joseph Paillet (1743–1814).[9] Le Brun's greatest publication, however, was his *Galerie des peintres flamands, hollandais et allemands*, in three volumes, two of which were published in 1792 and the third in 1796.

This grand project, realized in the most difficult political circumstances, was informed by personal commercial interest and scholarship in equal measure. Although certainly not without precedent – Crozat's *Recueil*, for instance – the

incorporation of a large number of reproductive engravings after the paintings discussed in the text stimulated and confirmed the expectation thereafter that ambitious works of art history should be lavishly illustrated. Engravings had long been important means whereby artists' inventions were published and made available for admiration and emulation. Their incorporation into large folios in which they played a role equal to a text, illustrating its arguments and inviting examination in its light, made word and image interdependent in a discursive manner. This was to become the mark of the nineteenth-century illustrated art book and is taken for granted as the normative publishing model for art historians today. Although the grounds for this development had been laid by the mid-seventeenth century – by Girolamo Teti's *Aedes Barberinae* of 1642, for example – it was consolidated by French dealers such as Mariette and Le Brun during the eighteenth century.

Le Brun's major innovation, as Émile-Mâle noted,[10] was to avoid arranging the artists whose works he discussed in the *Galerie* chronologically, as had been the case in earlier studies, but rather to group them in schools. He described the works of successive masters, but placed the works of pupils, followers and imitators of each master immediately thereafter, thereby proposing and expounding lines of artistic filiation, so that patterns of influence and emulation might emerge clearly. This mode of seeking to understand the transmission of formal, stylistic and thematic concerns among artists methodically has had, and continues to have, an immense impact on museological and art-historical method, beginning with the arrangement of paintings in the Louvre between 1798 and 1802 when Le Brun was "commissioner-expert."[11] It not only provided a model for understanding how artists make art by looking at other art – in particular that of their teachers – but also established a form of classification which encouraged the discernment of distinctions among the works of masters and their emulators so that the innovative works could reliably be accorded higher value. Attempts to understand the transmission of artistic techniques and ideas, and therefore to be able to identify innovation reliably, are scholarly concerns; but, once again, they intersect with commercial desiderata. Such knowledge readily translates into a hierarchy of commercial value. Once again, though, the scholarly cannot be merely reduced to commercial terms, for such relationships have a function as explanatory mechanisms quite independent of any commercial efficacy they also may enjoy.

Le Brun's second important contribution to art-historical scholarship consists of his embrace of the concepts of artistic originality and innovation, closely allied with the rediscovery of misidentified or forgotten artists. Once a sophisticated taxonomic system of masters, pupils and artistic filiation through influence and emulation was under development, the previous chronological and biographical model, ultimately derived from Giorgio Vasari's *Lives*, could no longer credibly account for the attribution of works among which viewers could perceive stylistic differences far more readily. Thus when Le Brun came across the work we know as the *Geographer* (now Städelsches Kunstinstitut,

Frankfurt-am-Main), he had it engraved by Louis Garreau in 1784 and subsequently included it in his *Galerie* correctly attributed to the then largely forgotten Delft artist Johannes Vermeer.[12] He took this course rather than try to account for the *Geographer* as the work of a readily recognizable artist, as had been the case when Vermeer's *Girl Reading a Letter at an Open Window* (now Gemäldegalerie Alte Meister, Staatliche Kunstsammlungen, Dresden) had been engraved as being by Govaert Flinck by Johan Anton Riedel just two years previously.[13] Le Brun went so far as to describe the then unknown Vermeer as a "très grand peintre," though without immediate consequence.[14] Nonetheless, as Francis Haskell observed, by drawing attention to previously unnoticed artists of unique character, such as Vermeer and the seventeenth-century Dutch church painter Pieter Jansz. Saenredam, Le Brun helped to initiate a new system of values. He used previously unfamiliar names to account for the authorship of paintings, asserting their claims to sympathetic attention.[15] This occurred in the precincts of a form of art – that of seventeenth-century Holland – which was already generally accepted by collectors and was held to have been accounted for, by and large, by existing scholarship. The proliferation of differentiation among artworks in the field was not merely a commercial matter, for it had profound intellectual consequences for future art-historical understanding of innovation, influence, and emulation. Once their works had become desirable commodities under their own makers' names, the newly dubbed artists of consequence entered the attribution system, rendering it much more complex and nuanced than it had been. The intellectual and commercial consequences of this enrichment were, and remain, utterly inseparable.

In his *Galerie* Le Brun had limited his attention to paintings that had passed through his hands, or in which he had had or retained a direct commercial interest. The greatest dealer-scholar of the next generation was John Smith (1781–1855) of London. Smith had many wealthy and discerning clients, including the Lancashire cotton magnate and politician Sir Robert Peel. While home secretary, Peel, who was to be prime minister between 1841 and 1847, had been instrumental in the founding of the National Gallery. Seventy-seven predominantly Dutch paintings from his collection, largely formed by Smith, were acquired by that institution in 1871. Smith's scholarly achievement was his consolidation of a new principle that still informs the compilation of catalogues raisonnés; that is, a self-imposed obligation to discuss as many works of any given artist as possible, irrespective of ownership. This was the principle that governed his nine volume work (the ninth being a Supplement) *A Catalogue Raisonné of the Works of the Most Eminent Dutch, Flemish, and French Painters* (1829–42), which Smith dedicated to Peel. Smith expressed his motivating principles in that dedication, in his introduction to the first volume, and in his preface to the Supplement. He was concerned above all to promote reliability and integrity in the art trade. Well aware that some dealers' ignorance and sharp practice could reflect badly on all, Smith articulated what has remained the art dealer's guiding principle: that in respect of any given artwork there should be

no discrepancy between what the dealer might propose it to be and what the well-informed collector with access to independent opinions might find credible. Within this nexus between dealer and collector, Smith recognized that a reputation for integrity was a dealer's most important single asset.

Smith held that the key to achieving and sustaining good practice by both dealers and collectors was the availability of good information about the works of art concerned. Thus he claimed of his book at the outset: "Its chief merit consists in the quantity of information, collected with a practical knowledge of the subject, and the persevering assiduity by which such knowledge was obtained."[16]

The key to ensuring the quality and reliability (within the bounds of human fallibility) of this information – information that had never before been assembled in such quantity – was the fact that Smith gathered it and presented it irrespective of whether or not he had a commercial interest in the works described. Indeed, such a personal commercial interest, whether past or present in any given instance, could only ever concern a minority of the works he discussed. This strategy helped to give the appearance, and even the substance, of a genuine immediate disinterestedness to Smith's judgments. However, Smith was very sensitive to the accusation that his judgments of artworks could have been made in anticipation of a potential future direct commercial interest in their status, or in the status of other artworks belonging to the same owner whose business Smith might hope to attract by making flattering attributions. The director of the Gemäldegalerie of the Königliche Museums, Berlin, Gustav Friedrich Waagen (1794–1868), accused Smith of just this fault in the preface to his *Kunstwerke und Künstler in England und Paris* (1837–9).[17] Indeed, Waagen's stated opinion of Smith's project, of which seven volumes had appeared when he penned it, exemplifies the patronizing attitude towards those in the trade found all too often among museum scholars and academics then and ever after:

> Though it is not without various errors and repetitions, the idea of giving *Catalogues raisonnés* of all the existing paintings of the greatest masters of those schools, is a very happy one, and extremely facilitates a knowledge of those masters. Every reasonable person will allow, that from the difficulty of such an enterprise, perfection is not to be attained at once, and that what is given, is to be gratefully received as a beginning, which may be improved and enlarged. Mr. Smith proves himself, in this book, to be a refined connoisseur.[18]

Yet it was Waagen's concluding sentence about his *Catalogue* that Smith sought urgently to rebut: "Many opinions on pictures, to which we cannot assent, proceed more from regard to their possessors, than from want of better judgment."[19] The insinuation that, as a dealer, Smith was seeking to flatter and benefit clients and potential clients with his attributions was one that he had to counter if his project were to retain any scholarly credibility. It is, of course, a charge that is hard to refute even if it is untrue. All Smith could do was to quote it and assert his innocence:

This charge, being of a personal nature, and coming from so respectable and highly gifted a writer, is much too serious to remain unnoticed; and the author therefore avails himself of this opportunity positively and unequivocally to disavow the insinuation, and to assure the doctor [Waagen] and his readers that no inducement of a personal consideration could ever influence him to forfeit that confidence which above all things *he most* highly values, and which alone can give interest and stability to his work.[20]

In a lengthy footnote Smith leveled accusations of his own against Waagen. Acknowledging the difficult circumstances in which Waagen must have worked when visiting collections (he was himself all too familiar with owners' manners) and, in footnotes to his footnote, citing specific examples, Smith berated Waagen:

But an author, however talented, should surely have paused before pronouncing opinions on works of art of the highest importance calculated to injure valuable property; – both the names of painters of high-class pictures are changed to those of inferior masters, and the state of preservation of many fine pictures is seriously misrepresented. Can lack of time or convenient means justify immatured opinions, so hastily and injudiciously pronounced, and so wholly uncalled for?[21]

Yet in spite of this strong attack, Smith carefully drew back from impugning Waagen's integrity, or imputing what he termed "sinister motives" to him.

A huge difference existed between the vantage points of the two men. The commodity status, whether active or dormant, of the artworks did not directly concern Waagen in the way it inevitably concerned Smith. Smith's reference to injury to valuable property makes explicit the concept – property – that informs his understanding of art and that constitutes his underlying concern. On the face of it this would seem to vindicate Waagen's accusation and encourage us to infer that museum scholars and academics can make disinterested judgments more readily than can dealers. Yet is the matter really so simple? Museum scholars and academics may well regard artworks as instantiations of ideas and ideologies before they think of them – if at all – as valuable property, but is that necessarily a superior conception? Artworks are complex objects. That complexity includes their character both as cultural expressions *and* as property. Any consideration of them ought to take that complexity fully into account. To be oblivious to the consequences of one's pronouncements – as was Waagen and as are many scholars today – hardly encourages responsible thought and action. Yet Smith would seem not to have been able to conceive of Waagen's downgrading of attributions as having been performed obliviously, for he pronounced it "*calculated* to injure valuable property." His horror at an assumed deliberate and knowing readiness to injure on Waagen's part indicates the depth of the gulf between them. It is a gulf that still exists between academics on the

one hand, and collectors and the trade on the other. Smith was quite right to draw attention to the possible gravity of the consequences of reattribution, and he was quite right to point out that making attributions prematurely, without due consideration, especially from a position of institutional authority, and unbidden, is irresponsible. One walks a fine line when making attributions, and the scholar doing so must respect the full complexity of the work concerned and its circumstances. This includes its status as property. The polarity often cited between commercial interest and academic disinterestedness simply does not account for the case. Neither is it a matter of the dealer simply reducing works of art to private property and articles of commerce. To him they are these things, but they are also, in Smith's words, "productions of genius" and, therefore, not solely a private matter: "Productions of genius," wrote Smith, "are a species of public property, entrusted to the care of the wealthy few for the benefit of the many" through public access and exhibitions.[22]

Although compiled explicitly to inform collectors, Smith's *Catalogue* had enormous scholarly consequences. Even though the choice of artists for inclusion in itself suggests judgments of artistic value, the structure of the catalogue of each artist's work as compiled by Smith has been followed ever since, as has his formula of title, description, bibliography, provenance, present whereabouts, dimensions, support, reproductions, and commentary. Most directly, Smith's publication was the acknowledged basis for the more comprehensive (in terms of Dutch artists addressed) catalogue by Cornelis Hofstede de Groot published between 1907 and 1928.[23] The documentation accumulated in the process of compiling and revising Hofstede de Groot's catalogue in turn formed the basis of the documentation archive at the Dutch state art history institute, the Rijksbureau voor Kunsthistorische Documentatie in the Hague. This forms a scarcely avoidable resource for most serious research on seventeenth-century Dutch art to this day. Among Flemish artists Smith addressed the works of Rubens, Van Dyck, and Teniers. All later scholars built on Smith's work, and the documentation archive based on the Rubens and Van Dyck material bequeathed by Ludwig Burchard (1886–1960) forms the core of the Rubenianum research institute in Antwerp. The catalogue raisonné of Rubens's works, entitled the *Corpus Rubenianum Ludwig Burchard* will comprise 27 parts, of which 17 have been published to date in 22 volumes by leading scholars in the field. These books are the great-grandchildren of Smith's Rubens volume (vol. 2, 1830), just as the volumes of the Rembrandt Research Project are of Smith's Rembrandt volume (vol. 7, 1836).

While Smith consolidated those matters that empirical art historians would continue to consider ever after, he remained, nonetheless, conservative in his choice of artists for investigation. In this respect he differed from Le Brun. Yet this is not to say that he lacked sensitivity to the claims on the attention of works by artists who remained as yet little known. For instance, he may have been the first to recognize Vermeer as the painter of *Girl Reading a Letter at an Open Window*, which we saw earlier attributed, first, to Govaert Flinck and

subsequently to Pieter de Hooch. He annotated his copy of the 1826 Dresden Royal Gallery catalogue to that effect.[24] The case of Vermeer illustrates the under-appreciated fact that without a continuous tradition of attribution, it is very difficult to identify the works of an artist, other than isolated examples, and to place them within a structure of influence and emulation. Smith dedicated half a page to Vermeer, whom he called "Vander Meer, of Delft," under "Scholars and Imitators of Gabriel Metsu."[25] It would be left to another scholar-dealer, the Frenchman Théophile Thoré, to try to define an oeuvre for Vermeer more or less from scratch. In doing so he established many of the procedures that remain common practice to this day.

Théophile Thoré is more usually described as an art and social critic rather than as a dealer, yet there is no doubt that he engaged in commerce, especially as a means of backing and promoting the works of those artists he championed as a critic and art historian.[26] While in political exile from Napoleon III's France in the 1850s, Thoré had adopted the pseudonym William Burger or Bürger.[27] In undertaking the enormous task of the recuperation and definition of Vermeer's work, Thoré-Bürger followed Smith's practice of traveling to see works of art firsthand. Dealers of Le Brun's generation had traveled extensively through much of Europe to gather stock from collections whose owners, whether private or ecclesiastical, found themselves in difficult circumstances. In this way Le Brun saw much art firsthand, but almost always with an eye to acquisition. Smith traveled too, but with the more ambitious motive of gathering material for his *Catalogue* as well as for commercial purposes. Smith fully realized the importance of reproductions in assembling information about artworks, and detailed them in his entries. He included modest numbers of extremely high quality reproductive lithographs, characterized by rich and fine tonal gradations, in his *Catalogue*. During the 1850s France was closed to Thoré-Bürger, so in the course of his search for works by Vermeer, paintings in that country were inaccessible to him. He examined paintings themselves in the Netherlands, Belgium, and Germany. In the Dresden gallery he studied the *Procuress* at the top of a ladder and found the Vermeer signature and date, 1656.[28] Occasionally he would accept the advice of others concerning a work that he had not been able to examine, as in the case of the *Art of Painting* (now Kunsthistorisches Museum, Vienna), then in the Czernin Collection, Vienna.[29] By at least 1860 he was aware that the paintings he was attributing to Vermeer exhibited an extreme variety of styles and techniques. "This devil of an artist without doubt had a diversity of styles," he wrote in the second volume of his *Musées de la Hollande*, published in 1860.[30] He therefore set great store by the form of signature for comparative purposes and he published facsimiles.[31]

The publication of his major study of Vermeer took the form of a series of three articles in the *Gazette des Beaux-Arts* published between October and December, 1866. It reveals a further means of comparative study: "To obtain a photograph of such and such a Vermeer, I have behaved madly."[32] If he had a photograph of a work he made a point of mentioning the fact in the relevant catalogue entry.[33]

There were two principal drawbacks to the use of photography in the study of paintings at this time. First, the considerable amounts of light required for early exposures meant that many works – especially large ones – simply could not be illuminated sufficiently. Secondly, emulsions were selectively sensitive across the light spectrum, resulting in a translation from hue to tone that was either obscuring or misleading. Because yellow produced a dark tone it was often impossible to acquire any photographic image whatsoever of a heavily varnished painting.[34] This characteristic only began to be overcome with the development of isochromatic emulsion in the 1890s, and panchromatic film in the 1920s. Nonetheless, Thoré-Bürger's determined gathering of photographs of ostensible Vermeers marks a move in the direction of a practice taken for granted today and facilitated by the great photographic archives of works of art, such as the Witt Library in London, the Rijksbureau voor Kunsthistorische Documentatie in The Hague, and the Frick Art Reference Library in New York. The comparison of paintings as represented by their photographic simulacra is an entrenched component of modern connoisseurship.[35]

Although Thoré-Bürger set great store by photography in the positivist art history he was pioneering in his *Gazette des Beaux-Arts* study of Vermeer's paintings, photomechanical reproduction for publication was not yet technically feasible. Between 1853 and 1854 Charles Blanc, editor of the *Gazette des Beaux-Arts*, had published a set of one hundred photographic reproductions after Rembrandt's etchings under the title *L'Œuvre de Rembrandt reproduit par la photographie*,[36] yet not only was a combination of letterpress and photographic printing impossible, but a great deal of prejudice had to be overcome before photographs of works of art could be accepted. Critics such as Philippe Burty argued that interpretation by a skilled engraver or lithographer was preferable to the supposedly impersonal, undiscerning quality of a photographic reproduction, and indeed essential if the character of the original were to be conveyed adequately.[37] Thoré-Bürger's 1866 publication was therefore illustrated by other means: four woodcuts (plus the title design in the same medium) set with the letterpress, one lithograph, and three full page etchings interleaved within the letterpress signatures.[38] Two of the woodcuts and two of the etchings reproduce paintings that were either then owned by Thoré-Bürger himself or, in one case, had recently been acquired from him.[39]

Thoré-Bürger published his *catalogue raisonné* of Vermeer's works in the *Gazette des Beaux-Arts* in the fall following a major loan exhibition in Paris of old master paintings held between May and July 1866. He had been closely involved in the organization of the exhibition and took advantage of the opportunity to introduce the artist whose oeuvre he was so painstakingly reconstructing. Eleven paintings that Thoré-Bürger attributed to Vermeer were included. Of these no fewer than six belonged to him at the time, two of the others had been acquired through him by their then owners, and one had recently been attributed by him to Vermeer.[40] Critical notices of the exhibition, and the impact of Thoré-Bürger's catalogue, ensured that Vermeer would never again lapse into obscurity.

This hard-won and carefully orchestrated success was not purely a commercial matter for Thoré-Bürger, for his advocacy of Vermeer, which followed upon his advocacy of Meindert Hobbema and was to be succeeded by his advocacy of Frans Hals, was ideologically motivated.[41] Thoré-Bürger's socialism was class-consensual, rather than class-conflictual. This led him to champion art which, in his view, depicted contemporary life rather than the oppressive mysteries of religion, mythology, and heroic history. He summarized his requirements in the slogan, "Art for man" (*"L'Art pour l'homme"*). Vermeer's art, as he was defining it, fitted his requirements perfectly. Ideological commitment, positivist art-historical scholarship, the manipulation of public art exhibitions, and determination to affect the art market directly, all combined seemingly seamlessly in Thoré-Bürger's case, as they have done in many others subsequently. Therefore we can see that the creation of the market for Vermeer's art was essential to the development of scholarship about it.

It is often assumed that the very structure of Thoré-Bürger's investigation in pursuit of both his disinterested curiosity and his socio-political agenda was determined by the needs of commerce, and that the consequence was the creation of a modern, positivist art-historical scholarship of oeuvre definition and biographical investigation. Might scholarship have developed along different, less reputedly tainted lines, had commerce not been involved? Yet in the consideration of art it is quite impossible for commerce not to be involved, whether directly or indirectly. Any substantial discussion of things that are traded in a capitalist market will both affect and be affected by that market. Art historians may try to confine or direct their discussions to intangibles in order to avoid contamination, but while the reality of objects in the world subtends ideas about them such avoidance is impossible. Many of the strongest, most persistent and complex ideas about such objects are articulated within the terms of that market. Furthermore, the contamination of commodification extends to ideas, however abstract or apparently subversive. Theodor Adorno observed that this condition affects all academics who provide saleable services, such as teaching and texts. He concludes witheringly: "He who offers for sale something unique that no-one wants to buy represents, even against his will, freedom from exchange."[42] Politics, aesthetics, and commerce are simply inextricable under capitalism for *anyone*. To admit as much is not to propose that everyone's motivations must be identical, nor that choices regarding conduct are not available, some of which may be ethically or politically preferable to others. It is, rather, to recognize that any inquirer must take the determining conditions fully into account, and, in the case of art, those determining conditions include the unavoidably pervasive existence of the market.

We should do our best to be aware of the determining structures within which inquiry takes place, and try to understand how that determination functions, how it might be resisted, and how it might be harnessed to desirable ends. One of the cornerstones of art's institutions, and hence of art history's, is the market in art. Scholar-dealers have contributed greatly to the shaping of the art world and of art history through their commercial activity and through their

often innovative publications. And just as dealers can bolster scholarship, so scholars bolster the market, for the interdependency of both parties is total. Even scholars whose writings lead one to believe that they might be inimical to the market can participate within it. For example, the theoretical scholar Norman Bryson participates, albeit indirectly, in the commercial art world through his contributions to contemporary art exhibition catalogues and books. Bryson complements with the authority of his own reputation those of contemporary artists whose products are actively part of the market. These include Mary Kelly, Cindy Sherman, Thomas Struth, Mark Dion, Robert Therrien, and a number of Chinese artists under the curatorial aegis of Gao Minglu.[43] His work in this field represents a thoroughly laudable engagement with current artistic activity. Yet it is part of the complex reticulation of the art world, in which the movement of any filament affects all the others.

One of the characteristics of the art market is the discretion – secrecy – that surrounds it. If scholars are too discreet about the nature of their involvement in the market, suspicions can understandably be aroused. There is nothing whatsoever secretive about Bryson's participation. Neither is the German *expertise* system secretive: it is well known that certificates are the result of a commercial transaction that benefits the scholar concerned. Thoré-Bürger presented his scholarly and commercial interests as openly interdependent. Yet Waagen's criticism of Smith is a common one, frequently repeated in more recent circumstances, and in anticipation of the accusation some scholars do their best to conceal the nature of their relationship with dealers. Most notorious in this respect, owing to the foundational nature of his work on Italian Renaissance art, is Bernard Berenson (1865–1959), who not only acted at times as a dealer or agent on his own account, but enjoyed a lucrative and highly secret arrangement with the great dealer Joseph Duveen, by which he benefited substantially from attributions he gave to paintings subsequently sold by Duveen.[44] To the client the discretion of this arrangement evidently borders on deception. Disclosure of interest in such cases may imply a taint that Berenson sought all his life to avoid, preferring the risk of the infinitely worse taint that would have been conferred by discovery. Yet there are scholars who remain capable of giving honest opinions, even when they are being paid for them, as academics with consultancies or who receive grants from commercial entities will readily attest. In the case of dealers, their commercial interests are already taken for granted, and although this lays them open to Waagen's charge and its oft repeated variants, contemporary catalogue raisonné projects sponsored by dealers, such as those compiled under the auspices of the Wildenstein Institute, are rarely accused of commercially inspired bias.[45] As the published work of dealers from the time of Mariette in the early eighteenth century to his contemporary successors demonstrates, scholarship has been a consistent ingredient of the art market (along with duplicity and ignorance), and that scholarship has in turn helped to shape art scholarship more generally. The institutions of art and art history would be a good deal poorer – in every sense – were this not the case.

## NOTES

1 Many dealers and auction house specialists have been generous to me by sharing their knowledge and enthusiasm over the years, none more so than Edward and Anthony Speelman whose enlightened endowment of the Speelman Fellowship of Wolfson College, Cambridge, has directly supported a number of scholars in the field of Dutch and Flemish art, myself among them (1983–7). I therefore dedicate this paper to the memory of Edward Speelman, scholar-dealer *par excellence*.

2 I argue this in detail, with examples, in "Magnanimity and Paranoia in the Big, Bad Art World," in C.W. Haxthausen, ed., *The Two Art Histories: The Academy and the Museum*, Williamstown, Clark Art Institute (2001).

3 *Le Cabinet d'un grand amateur, P.-J. Mariette, 1694–1774: dessins du Xve siècle au XVIIIe siècle*, exh. cat., Musée du Louvre, Paris, Réunion des musées nationaux, 1967; M.-T. Mandroux-França, "La collection d'estampes du Roi Jean V de Portugal: une relecture des notes manuscrites de Pierre-Jean Mariette," *Revue de l'Art*, 1986, vol. 73, pp. 49–54; F. Haskell, *The Painful Birth of the Art Book*, London, Thames and Hudson, 1988; M.B. Cohn, *A Noble Collection: The Spencer Albums of Old Master Prints*, exh. cat., Fogg Art Museum, Cambridge, Mass., Harvard University Art Museums, 1992, especially pp. 22–30.

4 On Crozat's collection of paintings see M. Stuffman, "Les Tableaux de la collection Pierre Crozat. Historique et destinée d'un ensemble célèbre établis en partant d'un inventaire après décès inédit (1740)," *Gazette des Beaux Arts*, 1968, 6ème per., vol. 72, pp. 29–32. See also J. Guerin, "Un Amateur d'art au XVIIIème siècle: Pierre Crozat, Toulousain," *Revue Historique et Littéraire du Languedoc*, 1949, vol. 19, pp. 237–52.

5 Haskell, *The Painful Birth of the Art Book*, p. 46.

6 K. Pomian, "Marchands, connaisseurs, curieux à Paris au XVIIIe siècle," *Revue de l'Art*, 1979, vol. 43, pp. 29–30: he attributed this success first to the fact that dealers had often begun as artists and therefore had firsthand experience of niceties of touch; and second, to dealers' extensive travels to view and obtain artworks which gave them cumulative firsthand experience as the basis for comparisons indispensable to connoisseurship.

7 See J. Stock and D. Scrase, *The Achievement of a Connoisseur, Philip Pouncey. Italian Old Master Drawings*, exh. cat., Fitwilliam Museum, Cambridge, 1985.

8 G. Émile-Mâle, "Jean-Baptise-Pierre Le Brun (1748–1813): son rôle dans l'histoire de la restauration des tableaux du Louvre," *Paris et Ile-de-France: Mémoires publiés par la Fédération des Sociétés historiques et archéologiques de Paris et de l'Ile-de-France*, 1965, vol. 8, pp. 371–417; F. Haskell, *Rediscoveries in Art: Some Aspects of Taste, Fashion and Collecting in England and France*, Oxford, Phaidon, 1976, pp. 17–23; A. McClellan, *Inventing the Louvre: Art, Politics, and the Origins of the Modern Museum in Eighteenth-Century Paris*, Cambridge and New York, Cambridge University Press, 1994, *passim*.

9 J. Edwards, *Expert et marchand de tableaux à la fin du XVIIIe siècle: Alexandre-Joseph Paillet*, Paris, Arthena, 1996.

10 Émile-Mâle, "Jean-Baptiste-Pierre Le Brun," p. 385.

11 McClellan, *Inventing the Louvre*, pp. 138–40.

12 J.-B.-P. Le Brun, *Galerie des peintres flamands, hollandais et allemands*, Paris, Le Brun, 1792–6, vol. 2, p. 49.

13 In 1826 the attribution was changed to Pieter de Hooch. In 1858 Gustav Waagen published it as a Vermeer: I. Gaskell, *Vermeer's Wager: Speculations on Art History, Theory, and Art Museums*, London, Reaktion, 2000, p. 118, with further references.

14 Haskell, *Rediscoveries in Art*, p. 21.

15 Haskell, *Rediscoveries in Art*, pp. 21–3.

16  J. Smith, *A Catalogue Raisonné of the Works of the Most Eminent Dutch, Flemish, and French Painters; In which is included a short Biographical Notice of the Artists, with a copious description of their principal pictures; a statement of the prices at which such pictures have been sold at public sales on the Continent and in England; a Reference to the Galleries and Private Collections, in which a large portion are at present; and the names of the artists by whom they have been engraved; to which is added, a brief notice of the scholars & imitators of the great masters of the above schools*, 9 vols, London, Smith and Son, 1829–42, vol. 1, p. ix.

17  G.F. Waagen, *Kunstwerke und Künstler in England und Paris*, 3 vols, Berlin, Nicolaischen Buchhandlung, 1837–9, vol. 1, p. vii.

18  G.F. Waagen, *Works of Art and Artists in England*, trans. H.E. Lloyd, 3 vols, London, John Murray, 1838, vol. 1, pp. xi-xii.

19  Ibid., p. xii.

20  Smith, *Catalogue Raisonné*, vol. 9, p. viii.

21  Ibid., p. vii, footnote.

22  Ibid., p. v.

23  C. Hofstede de Groot, *Beschreibendes und kritisches Verzeichnis der Werke der hervorragendsten holländischen Maler des XVII. Jahrhunderts*, 10 vols, Esslingen and Paris, P. Neff, 1907–28.

24  A. Blankert (with contributions by R. Ruurs and W. van de Watering), *Johannes Vermeer van Delft 1632–1675*, Utrecht and Antwerp, Spectrum, 1975, p. 157 no. 6, citing Smith's copy of the *Catalogue des tableaux de la Galerie Royale de Dresde*, 1826, p. 74 no. 486 in the Rijksbureau voor Kunsthistorische Documentatie, The Hague.

25  Smith, *Catalogue Raisonné*, vol. 4, p. 110.

26  In 1867 he was attacked in the *Figaro* as a "catalographe et agent commercial de vieux tableaux" by rival critic Théophile Sylvestre, a charge he sought to rebut: see F. Suzman Jowell, "Thoré-Bürger and Vermeer: Critical and Commercial Fortunes," in C.P. Schneider, W.W. Robinson, and A.I. Davies, eds., *Shop Talk: Studies in Honor of Seymour Slive Presented on His Seventy-Fifth Birthday*, Cambridge, Mass., Harvard University Art Museums, 1995, p. 125 with references.

27  In this discussion I shall use the now customary dual name Thoré-Bürger which signifies that Thoré's adoption of the pseudonym marked a break with his earlier predominantly political identity and, rather than being a mere expedient device, constituted a radical self-fashioning. In this discussion I draw on a more detailed account of Thoré-Bürger's work on Vermeer in my *Vermeer's Wager*, pp. 116–39.

28  W. Bürger [pseud. Théophile Thoré], *Musées de la Hollande. II. Musée Van der Hoop, à Amsterdam et Musée de Rotterdam*, Paris, J. Renouard, 1860, p. 79.

29  Bürger [pseud. Théophile Thoré], *Musées de la Hollande. II*, p. 70: "Nous ne l'avons pas vu non plus; mais, d'après des témoignages très-compétents, c'est un Delftsche incontestable."

30  Ibid., p. 68: "Ce diable d'artiste a eu sans doute des manières diverses."

31  For example, that on the *Portrait of a Young Woman*: W. Bürger [pseud. Théophile Thoré], *Études sur les peintres hollandais et flamands. Galérie d'Arenberg à Bruxelles, avec le catalogue complet de la collection*, Paris, Brussels and Leipzig, J. Renouard, 1859, p. 35.

32  W. Bürger [pseud. Théophile Thoré], "Van der Meer de Delft," *Gazette des Beaux-Arts*, 1866, vol. 21, p. 299: "[P]our obtenir une photographie de tel Vermeer, j'ai fait des folies."

33  Ibid.: he mentions having photographs of paintings catalogued as nos. 2, 3, 5, 6, 7, 8, 13, 28, 32, 34, 35, 49, and 50.

34  T. Fawcett, "Graphic versus Photographic in the Nineteenth-century Reproduction," *Art History*, 1986, vol. 9, pp. 201–2, quoting W. Lake Price, *Manual of Photographic*

*Manipulation*, 1868, pp. 215–16: "The effects of the colours, as seen in the picture, may probably be transposed in the photograph, and thus a light yellow drapery in the high light of the composition, and a deep blue in the dark portion will, in the photographic copy, produce startling and precisely opposite effects from those that they did in the original … " See also P. Burty, "Exposition de la Société française de photographie," *Gazette des Beaux-Arts*, 1859, vol. 2, p. 211: "Le jaune vient au noir, ainsi que le vert; le rouge, au contraire, et le bleu viennent en blanc."

35 For a detailed examination of the penetration of art-historical practice by photography and its epistemological consequences, see Gaskell, *Vermeer's Wager*, especially pp. 99–164 with further references.

36 P.t.D. Chu, *French Realism and the Dutch Masters: The Influence of Dutch Seventeenth-Century Painting on the Development of French Painting between 1830 and 1870*, Utrecht, 1974, Haentjens Dekker & Gumbert, p. 7.

37 Burty, "Exposition de la Société française de photographie," p. 211: "La photographie est impersonelle; elle n'interpète pas, elle copie; là est sa faiblesse comme sa force, car elle rend avec la même indifférence le détail oiseu et ce rien à peine visible, à peine sensible, qui donne l'âme et fait la ressemblance … mais elle s'arrête à l'idéalisation, et c'est là justement que commence le rôle du graveur et du lithographe de talent."

38 Gaskell, *Vermeer's Wager*, pp. 126–8.

39 The works then owned by Thoré-Bürger were a *Sleeping Maidservant* (whereabouts unknown), a *Self-Portrait* (whereabouts unknown), and the *Woman Standing at a Virginal* (National Gallery, London): Bürger [Thoré], "Van der Meer de Delft," pp. 563, 565, and opp. p. 326. The painting reproduced by etching (opp. p. 462), which had then recently been acquired by Léopold Double, is the *Soldier with a Laughing Girl* (Frick Collection, New York).

40 F. Suzman Jowell, "Thoré-Bürger – A Critical Role in the Art Market" (*Documents for the History of Collecting*, 21), *Burlington Magazine*, 1996, vol. 138, pp. 116, 118.

41 See Chu, *French Realism and the Dutch Masters*, pp. 9–14; also Haskell, *Rediscoveries in Art*, pp. 146–51, and Jowell, "Thoré-Bürger – A Critical Role in the Art Market," p. 115 n. 1, both with further references.

42 T. Adorno, *Minima Moralia: Reflections from Damaged Life*, trans. E.F.N. Jephcott, London, Verso, 1978, §41, pp. 66–8.

43 N. Bryson, "*Interim* and Identification," in *Mary Kelly. Interim*, exh. cat., The New Museum of Contemporary Art, New York, 1990, pp. 27–37 (also shown between 1990 and 1991 at the Vancouver Art Gallery, and The Power Plant, Toronto); *Cindy Sherman, 1979–1993*, text by R. Krauss, essay by N. Bryson, New York, Rizzoli, 1993; *Thomas Struth, Portraits*, texts by T. Weski, N. Bryson, and B.H.D. Buchloh, exh. cat., Sprengel Museum, Hanover, 1997–8, Munich, Schirmer/Mosel, 1997; *Mark Dion*, texts by L.G. Corrin, M. Kwon, and N. Bryson, London, Phaidon, 1997; L. Zelevansky, with contributions by T. Frick and N. Bryson, *Robert Therrien*, exh. cat., Los Angeles County Museum of Art, 2000; G. Minglu, ed., *Inside/out. Contemporary Chinese Art*, with essays by N. Bryson *et al.*, exh. cat., Asia Society Galleries, New York and San Francisco Museum of Modern Art, 1998–9.

44 C. Simpson, *Artful Partners: Bernard Berenson and Joseph Duveen*, New York, Macmillan, 1986, especially pp. 137–8.

45 Recent court cases in Paris against the Wildenstein Institute for not including works in catalogues raisonnés do not depend on the fact that the sponsoring institution is an art dealing firm.

# 10

# HOW CANONS DISAPPEAR
## The case of Henri Regnault

*Marc Gotlieb*

In recent years, new concerns have emerged regarding how canons in the visual arts are made. Rather than attending to questions of artistic judgment, to the historical genesis of masterpieces, or to variations in taste, we have come to think of canons as embodying values. And far from treating those values as neutral or impartial, we hold them to incorporate interests. To cite the case of French art of the late nineteenth century, new attention has fallen to the social instruments of canonicity – specifically, to the converging network of collecting, exhibition, and promotional forces that propelled and sustained the rise of Modernism. New attention, similarly, has fallen to our continuing complicity in that canon, specifically to the ideological, institutional, and gendered interests that seemingly nourished on the cultural capital Modernism supplies. For all the rewards of those new perspectives, we know rather less about the inverse condition – about how canons disappear. We have paid relatively little attention to the crumbling of reputations, to the process by which once famous works failed to compel conviction, to the gradual dismantling of institutional, economic, and other forms of support.[1]

If speed is any measure, the so-called *pompiers*, or academic masters of the late nineteenth century, offer a spectacular example of such decline. Within only a few decades, and after centuries of international leadership, an entire school of painting seemed almost to vanish from the horizon of European cultural accomplishment. The luminaries who once dominated the artistic landscape would be accused of perpetrating a gigantic aesthetic error, attributable in part to their very loyalty to the tradition and institutions they were charged with upholding. Of course, the ascendancy of Modernism forms part and parcel of this transformation, from the emergence of the artist-dealer system to the cementing of pictorial concerns that largely discarded longstanding academic protocols and the pedagogical routines that sustained them. It's worth adding, too, that in the present day the battle lines no longer appear so clearly drawn. Leading masters once swept aside have begun to attract new attention, not least of all as the genesis of Modernism has itself come under intensive scrutiny. Nevertheless, the *pompiers* remain in thorough disrepute. This is not the place to detail the reasons for their continuing disfavor, although it's tempting to speculate: in his

1939 essay "Avant Garde and Kitsch," Clement Greenberg suggested that the average Russian peasant, at bottom, would always prefer a Repin to a Picasso, mainly on account of the former's easy and seductive illusionism. Few today would admit to sharing such views, but when it comes to the *pompiers* it may well seem that little has changed. The anecdotalizing verisimilitude often said to characterize their paintings has been recast as bourgeois realism or naturalizing ideology, capable as it seems of mystifying the critical faculties of modern audiences. All of this is to say that, even today, the *pompiers* have been not so much rehabilitated as recuperated under the most rigorously controlled conditions.[2]

This chapter proposes to address such concerns, although from a necessarily limited perspective. Specifically, it focuses on the biographical, critical, and promotional texts that sustained those painters who once defined the accomplishment of the French school. How did such texts structure the careers of the artists they championed? What rhetorical figures did authors deploy in their efforts to advance a painter's canonicity? What opportunities were offered by new publishing formats, imaging technologies, and marketing practices? Finally, how was normative art criticism conducted under such circumstances? Did those texts, for example, engage in undifferentiated promotion, or do they betray signs of a break-down in consensus over the nature and aims of the French school? Rather than offer general reflections on such questions, the remarks that follow treat the reputation of a single representative artist whose painting and career seemed to dominate the cultural imagination of an entire nation. Before turning to his case in detail, however, let us consider a publishing venture that offers a convenient measure of the French school on the brink of collapse.

Around 1900 the publisher Pierre Lafite launched a new collection of illustrated monographic texts on the visual arts entitled *Les Peintres Illustres*. The seventy-odd volumes that made up the series were small in size but well illustrated and attractively designed. They also came bound. Traditionally, French books were bound by booksellers or purchasers themselves. By contrast, Lafite offered purchasers a ready-made collection, in effect reaching out to a new class of novice connoisseurs. Lafite's *artistique-bibliothèque en couleurs*, as it termed itself, also included eight color illustrations and a color plate pasted on the front cover. Not only was this the first major publishing venture in French art systematically to introduce color, that advance relied on new photo-mechanical technologies that largely eliminated from book production the traditional role played by wood engraving, lithography, and similar artisanal processes. In a similar spirit, the texts themselves were brief, introductory, and published without notes, bibliography, or clearly identified authors. On the other hand, the series was launched with the highest academic certification: the entire suite was published under the direction of Henry Roujon (1853–1914), a leading French belletrist and *secrétaire perpetuel* of the Academy of Fine Arts. Such prestigious auspices doubtless assured readers that their library comprised only the most esteemed and durable names in the history of art.

Roujon had connections to the Impressionists, although to this day the question of whether he truly promoted their interests remains the subject of debate.[3] At any rate, the series made little effort to flag new developments in painting. Among the dozen volumes dedicated to recent painters, all but one were French, and only three could be thought of as Modernist in even a general sense: Henri Fantin-Latour, Gustave Moreau, and James McNeil Whistler. By contrast, more conservative painters were well represented: Bastien-Lepage, for example, who promised to rescue Impressionism by (as Zola put it) actually realizing his impressions; Félix Ziem, another landscape painter credited with saving Impressionism from itself; Pierre Puvis de Chavannes, France's leading mural painter; Ernest Hébert, an academic figure painter deemed important enough to merit a one-man museum; Paul Baudry, whose decorations for the Paris Opera were held to be the most significant mural project since the Sistine ceiling; Ernest Meissonier, France's leading battle-painter; Jean-Léon Gérôme, professor at the École des Beaux-Arts and in his day the most famous painter in Europe; Jean-Jacques Henner, another figure painter who left behind a one-man museum; Jean-Joseph Benjamin-Constant, a leading Orientalist and fashionable portrait painter; and finally, in a volume authored by Roujon himself, Henri Regnault (1843–1871), perhaps the most talked-about French painter of the later nineteenth century. Regnault's portrait of *Salomé*, framed in black and set against a shimmering gold background, had electrified Paris audiences at the Salon of 1870 (Figure 10.1).

*Les Peintres Illustres* promoted a vision of the French school as at once stable and broadly based. That vision was misleading. Take the case of Regnault: Roujon's volume was no less than the sixth book-length text on the artist published since his death in 1871, not including abundant Salon and exhibition criticism devoted to Regnault's pictures. Of all those publications, Roujon's text has perhaps the least to offer in terms of original content or analysis, although its eight color plates doubtless helped familiarize readers with the works of a painter once hailed as a brilliant colorist. But in one respect Roujon's book is deeply revealing. This slim volume was the *last* significant text devoted to Regnault until the scholarly treatments of recent years.[4] As it happens, roughly the same is true for the titles on Baudry, Henner, Benjamin-Constant, Hébert, and Meissonier, among other luminaries Roujon privileged for inclusion. *Les Peintres Illustres*, then, stands on the edge of a precipice. Dedicated to sustaining the careers of France's most famous artists, this ambitious series was in fact the final stop before their descent into critical and popular oblivion.

Born in 1843, Henri was the son of Victor Regnault, director of the Sèvres porcelain manufactory and professor at the Collège de France. Connections aside, his talent and ambition promised for him a successful career. In 1866 Regnault won the Grand Prize at the École des Beaux-Arts, entitling him to five years of study at the French Academy in Rome. Over the next four years, and while still a student, he captivated audiences with a series of bold figure subjects. But Regnault was more than a promising student. He was also, for lack of a better

*Figure 10.1* After Henri Regnault, *Salomé*. Lithograph, ca. 1870.

*Source*: Courtesy of the author.

term, a celebrity, his fame and reputation nurtured by an international media apparatus that tracked his movements and circulated his pictures through a myriad of new duplication technologies. American museums, among others, competed for the opportunity to have one of Regnault's pictures anchor their emerging collections of modern art. In 1912 George F. Baker donated Regnault's *Salomé* to the Metropolitan Museum in New York – a sufficiently important gift to earn Baker the position of trustee.[5] The Metropolitan was merely catching up, however. In 1884 students at the Boston Art Institute led a subscription campaign to purchase Regnault's 1868 *Automedon and the Horses of Achilles*, an enormous canvas only recently conserved and rehung after languishing in storage for decades. This great work, wrote the *Daily Advertiser*, "is worth a ton of the 'icily regular' and 'splendidly null' " canvases usually placed before students of art.[6]

Regnault was only 28 when he was killed in action in the Franco-Prussian War. Already famous, death made him a martyr. A year later, following an 1872 retrospective at the École des Beaux-Arts, a wildly successful sale dispersed Regnault's works across the country. Dealers stayed on the sidelines as collectors bought everything in sight: "each wanted his own Regnault large or small, drawing or painting."[7] In the years that followed, Regnault emerged as a privileged icon of revanchist nationalism – this is not the place to detail the numerous portraits, orations, memoirs, civic memorials, musical works, as well as paintings and sculptures commemorating the fallen hero. Predictably, Regnault's battlefield death fundamentally shaped accounts of his life and career. Arthur Duparc, for example, in his widely circulated edition of Regnault's correspondence, opened his text with a reconstruction of Regnault's movements on the day he died. Jules Claretie, in a variation on this theme, began his essay by recounting how he had first learned of Regnault's demise. For Claretie and his contemporaries, so powerfully were they shaken by the event that the news of Regnault's death had branded itself on their memories.[8]

Patriotic death also shaped assessments of Regnault's artistic reputation. Indeed – and this is the principal claim of my chapter – Regnault's death served as a powerful, but ultimately equivocal, instrument of his canonicity. While any number of texts offer revealing testimony of such concerns, in the remainder of this chapter I want to confine my attention to three book-length studies of Regnault published in the fifty years after his death. All three, it is worth underlining, were released under prestigious rubrics designed to highlight and memorialize the accomplishments of the French school. All three, accordingly, sought to assign to Regnault his place in its future unfolding. Nevertheless, each of their authors stumbled over the question of just what it was Regnault promised to offer. Indeed, each struggled over a single picture by Regnault that seemingly compromised the leadership role their own texts assigned to him.

Roujon tackles Regnault's canonicity right at the outset, and specifically the problem presented by his death: "Three times since 1830 French art seemed to be on the brink of a splendid rejuvenation." "Three times," however, "fate" destroyed those "cherished hopes." Roujon mobilizes on Regnault's behalf a

privileged and illuminating genealogy. Three times the unfolding of the French school had been frustrated by the early deaths of its ostensible pioneers. The first pioneer was Géricault, who in fact died in 1824 and who complained of failing to paint even five major pictures. The second was Bastien-Lepage, who died in 1884 at the age of 36 and who promised to chart a middle course between Impressionism and ambitious figure painting. As for Regnault, had he not died so young his painting would surely have opened a "new direction" in modern art.[9] Regnault's death, Roujon suggests, was not just an individual but an artistic calamity, with fundamental consequences for a nationally based enterprise. The deaths of all three artists established a linked series, as if the French school, over the course of a century, had been plagued by a sequence of lost opportunities. This prestigious genealogy, it's worth noting, was not original to Roujon. He had borrowed the notion (along with much else) from a major book on Regnault published by Roger Marx in 1886. But the key point here is not the source of the phrase but the fact of its repetition.

I shall return to the comparison with Géricault and Bastien-Lepage, but right away let us recognize that Regnault's example differed from theirs in one key respect. At the time of his death Regnault's painting career had barely been launched. What is more, despite the artist's celebrity, his few completed pictures generated considerable controversy. His *Salomé* of 1870 had already provided cause for alarm. The painting commanded broad public attention, but its union of eroticism and barbarity seemed fundamentally to depart from the academic tradition of ambitious historical painting. This Salomé was a Roman girl, an artist's model whom Regnault met on the *piazza* and whom his friends described as a "bohemian," a "flirt," and a "fillette."[10] Critics were especially mystified by Regnault's last major figure painting, *Execution without Judgment under the Kings of Morocco*, completed in Tangier shortly before the outbreak of the Franco-Prussian War (Figure 10.2). Despite its lurid subject, strictly speaking the picture was a student assignment: under the terms of their fellowships, holders of the Rome Prize were obliged to complete a life-size single figure subject. Just this academic context made critics uncomfortable, suggesting as it did that Regnault had deliberately travestied the demands imposed on him. If Roujon's views are any measure, the painting continued to trouble critics four decades after the painter's death. Roujon claimed to admire its "virtuosic technique" and "resources of color," but he also reproached Regnault for undermining the ethical imperatives of *grande peinture*. Regnault, he complained, had engaged in a gratuitous rendition of horror without "emotion, anguish or pity." Thank goodness, Roujon added, that several other late works evinced greater "style" and "nobility."

It is hard to imagine that terms such as "style" and "nobility," as late as 1914, still possessed much critical purchase or explanatory power. But of course that is just the point. What is significant is less the meaningfulness of the characterization than the fact that Roujon felt entitled to offer it in the first place. Regnault, in his mind, was not simply a talented painter who had died young.

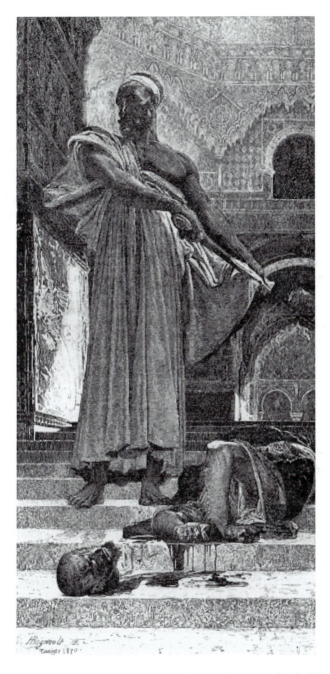

*Figure 10.2* After Henri Regnault, *Execution without Judgment under the Kings of Morocco*. Lithograph, ca. 1870.

*Source*: Courtesy of the author.

Rather, Roujon's vision of the French school rested on Regnault's shoulders. Hence the seeming imperative to measure Regnault's accomplishment accordingly, as if his pictures were destined to give terms such as "style" and "nobility" new and meaningful currency. All of this is to say that Regnault's example, by his own death, served as a natural touchstone for a broader discussion about the state of the French school. On the other hand, to judge by the manifest anachronism of Roujon's critical terminology, the same example also hinted at that school's expiration.

A second text, arising from another ambitious publishing venture, offers further evidence of such concerns. As in the case of *Les Peintres Illustres*, *Les Artistes Célèbres* promoted itself as a major contribution to the history of art (Figure 10.3). In this instance there was some truth to the claim. Published by Rouam over the course of the 1880s, the series displayed all the hallmarks of intellectual legitimacy: each volume was accompanied by a preliminary catalogue, extensive bibliography, detailed footnotes, and numerous wood engravings. The entire suite was edited by Eugène Müntz, librarian at the École des Beaux-Arts and the among the most distinguished art historians of his day. The series also targeted more upscale collectors. Beyond the general print run, each was published in a limited numbered edition, printed on Japan paper and accompanied by a volume of unbound lithographic plates. From Phidias and Polyclites to Veronese and Correggio, the range of the series was as catholic as its authorship learned: Müntz wrote on Donatello, André Michel on Boucher, Maxime Collignon on Phidias, and Marius Vachon on Jacques Callot. As for modern art, attention naturally fell to France, with promised volumes on Gros, Delacroix, Prud'hon, and Decamps. With the exception of Corot and Diaz, however, recently deceased figure painters were notably absent. Barye and Carpeaux had died in 1875, Fromentin in 1876, Courbet in 1878, Daumier, Préault and Couture in 1879, to cite only the losses of a single decade, but none were deemed fit for inclusion. The only truly young painters included in the series were Mariano Fortuny and Regnault. (Fortuny and Regnault were linked by more than their ephemeral celebrity: the two had worked together in Rome in the late 1860s).

The absence of so many modern artists makes Regnault's inclusion all the more striking. Here as elsewhere, new publishing instruments deployed emerging technologies to promote the French school across an expanded field. We might even say that those publishing ventures found in Regnault a dynamic new vehicle to extend their reach. For example, beyond the numbered editions on Japan paper, others versions were elegantly but inexpensively bound and distributed as school prizes – doubtless in an effort to assimilate a new generation of French youth to a republican culture of heroic citizenship. Such conditions might not seem to favor rigorous art criticism, but the volume on Regnault was an important text in its own right. Müntz had commissioned it from Roger Marx (1859–1913), a leading critic, collector, and arts administrator. A champion of the decorative arts and of new tendencies in painting, Marx was especially sensitive to the continuing impact of Regnault's death.

1886

LES

ARTISTES CÉLÈBRES

—

HENRI REGNAULT

PAR

ROGER MARX

OUVRAGE ACCOMPAGNÉ DE 40 GRAVURES

LIBRAIRIE DE L'ART

| PARIS | LONDON |
| J. ROUAM, ÉDITEUR | GILBERT WOOD & Cⁱᵉ |
| 29, CITÉ D'ANTIN | 175, STRAND |

*Figure 10.3  Les Artistes Célèbres*, Paris, Rouam, 1880s.
*Source*: Courtesy of the author.

"Three times since 1830," to return to the formula Roujon had borrowed from Marx, French art seemed to be on the threshold of a "splendid renewal." But "three times" fate crushed those flowers "just as they bloomed." As this prestigious genealogy of lost opportunities suggests, Regnault was charged with something more urgent than Roujon's "style" and "nobility." Marx speaks of a rebirth or return to youth, intimating that French painting was in crisis or had lost its way. Géricault, Bastien-Lepage, and Regnault, then, promised not only to lead the French school but to *reform* it, specifically by recasting ambitious figure painting in a naturalist key. Just that reform, it's worth adding, established a powerful unifying rubric for a rejuvenated French school. Marx envisions a national enterprise structured around a regular cycle of reform and organic rebirth. The deaths of all three artists at once certified that overarching vision but also threw the movement of the cycle into doubt. The fact that Bastien-Lepage died after Regnault underscored the ongoing and still urgent nature of Marx's concerns.[11]

As it turns out, the specifics of Regnault's promised reform proved hard to detail. Consider in this respect Marx's complaints about Regnault's *Execution without Judgment*, the same picture that troubled Roujon. Marx explained to readers that the Louvre was unable to hang the work due to lack of space. Just this absence, however, "serves Regnault's memory well." The picture was "mediocre" and its sight did the artist a disservice. For example, the painting betrayed Regnault's weak command of value. As for its subject, the chief protagonist evinced "neither emotion, nor anguish, nor sympathy, nor pity." Regnault, Marx speculated, must have chosen this horrifying subject specifically to pursue an unorthodox range of color combinations – a disjunction between means and ends that struck the critic as perverse. Regnault, Marx concluded, showed himself "as inflexible as the executioner."

The idea that viewers are better off not seeing one of the artist's last pictures may well appear startling. But Marx's complaints were not new. In Regnault's lifetime, critics often complained that Regnault betrayed an unbridled and potentially unhealthy enthusiasm for color, decor, and illusion – a complex of defects they grouped under the umbrella term "materialism." In fact, Regnault did put a heavy burden on strictly technical concerns – this is not the place to recount the singular measures he devised, in his *Execution without Judgment* as in other works, to scale down conventional modeling in favor of lustrous Orientalist surfaces. It may well be tempting, in the present day, even to link those strategies to contemporaneous experiments on the part of Edouard Manet and his followers.[12] Nevertheless, if it seems meaningful to speak of Regnault in such terms, just that possibility underscores the challenge critics faced in assimilating his paintings to their presumed legacy. For Marx, in the end, it was simpler to describe Regnault's *Execution* as a mediocre work better left unseen. Precisely by treating the picture as an error, as technically flawed, or as an aberration, he was able to marginalize it from Regnault's corpus.

A third text on Regnault sheds further light on these conflicting imperatives. In 1889 Gustave Larroumet (1852–1902), a prominent critic and arts administrator, published an oration on Regnault first delivered at an award ceremony at the Lycée Henri IV, where Regnault had graduated forty years earlier. Larroumet spoke mainly of Regnault's school years, although he also rehearsed the story of Regnault's patriotic death. Predictably, Larroumet offered Regnault as a model of heroic action, on a par with the heroes of Sparta and Athens. Consider in this context the frontispiece engraving designed by Joseph Blanc (1846–1904), a leading academic painter and student friend of Regnault (Figure 10.4). If the laurels placed around the head honor Regnault's artistic achievement, another detail is even more revealing: the bullet hole in Regnault's temple, a detail lifted from Regnault's death-mask. The detail is real, but the manner of its representation is pure invention: Blanc rotates the head to one side in order to highlight the entry wound without at the same time obviating the bust's traditional frontal view. Blanc's engraving, then, at once glorifies Regnault's artistic accomplishment *and* the patriotic forfeit of that accomplishment.

Such concerns naturally colored Larroumet's vision of what Regnault was supposed to accomplish: "After Ingres and Delacroix," Larroumet wrote, Regnault's "succession of masterpieces" would surely "have inaugurated a new

*Figure 10.4* Joseph Blanc, frontispiece to Gustave Larroumet's *Oration.*
Engraving, 1889.

*Source*: Courtesy of the author.

French school." Here was a rhetorical formula with even more powerful reso-
nance than Marx's tragic sequence of Géricault/Regnault/Bastien-Lepage.
Larroumet implies that the French school of painting had been adrift since the
deaths of both Ingres and Delacroix. No less than Marx before him, Larroumet
evinces an acute sense of loss, as if the passing of Ingres and Delacroix had left
French painting in a permanent state of confusion. Regnault's own death had
robbed the French school of one of the only lifelines still available to it – a painter
who seemed destined to forge a new consensus out of the prevailing chaos.

In contrast to Marx, Larroumet does not evoke an organic cycle of naturalist
reform. Rather, he mourns the loss of another kind of authority, expressed in the
great contest of schools associated with the leadership of Delacroix and Ingres.
What Larroumet evokes, we might say, is the continuing possibility of leadership –
leadership that by definition commanded sufficient authority to found and sustain
a genuine school. Certified by the nation's premier educational institutions,
blessed by his prestigious family connections, and adored by the public, Regnault
promised not just to sustain the great tradition of historical painting but to *revali-
date* the idea of a school organized on national grounds. That expectation, it is
worth adding, itself served to uphold the authority of those national educational
and artistic institutions alleged to have formed Regnault in the first place.[13]

Death on the battlefield put an end to that prospect. But in rhetorical terms,
patriotic death confirmed that prospect's possibility. It underscored the essential
Frenchness of Regnault's painting career, as if his art-making and his soldiering
were one and indistinguishable. Patriotic death, in other words, served the
cause it seemingly jeopardized. Sacrificing his art for the sake of his country,
Regnault offered reassuring evidence of the continuing relevance of the school
he was presumed destined to lead. Once again, what's significant here is less the
persuasiveness of such a characterization than the fact that Larroumet felt
compelled to make it. For Larroumet as for other critics, those canonizing
imperatives converged on Regnault with pressing force precisely in response to
urgent fears about the French school's apparent disintegration.

The published version of Larroumet's oration offers a clear demonstration of
such fears, which as I have suggested we should partly lay at Regnault's door.
Leaving the text of the oration untouched, Larroumet supplemented his remarks
with several important appendices. Testimony from Regnault's friend George
Clairin offered new details about the circumstances surrounding Regnault's
death and the recovery of his body. Larroumet also included testimonials and
recollections from half-a-dozen former professors and fellow students of
Regnault, each of whom offered further details regarding Regnault's student
accomplishments. Finally, Larroumet supplemented the text of his oration with a
series of explanatory notes. Most of them treated Regnault's student years, but
one in particular elaborated on Larroumet's passing assertion that Regnault
ignored traditional chiaroscuro in favor of unadulterated effects of light and
color. In the case of *Salomé*, Larroumet explains, Regnault seemed almost to have
pasted the figure of the dancer onto its background, an effect produced by the

picture's unusual layering of yellow on yellow. Regnault's *Execution without Judgment* betrayed similar faults. Specifically, the white gauze of the executioner's robe failed to define the mass of his legs. Regnault, Larroumet complained, seemed determined to sacrifice volume in favor of surface effects of color and texture. In a similar vein, Larroumet charged Regnault with ignoring sound technical procedures in favor of unnatural and unstable colors. Regnault, he complained, "found that commercially available colors were not bright enough." In France as in the Orient, Regnault searched "almost at random" for "colors that were more immediately brilliant." Here as elsewhere, then, Regnault's materialist predilection fostered a willful substitution of means over ends.

Patriotic death guaranteed for Regnault a massive institutional and public investment, certifying his presumed leadership of the French school. New imaging technologies, married to a new generation of inexpensive text formats, helped promote and expand that conception, at once bolstering the idea of a national school and revalidating those pedagogical and regulatory institutions that nourished on it. At the same time, Regnault's extraordinary posterity was nurtured by more than academic prestige. As his wide currency across these new popularizing instruments suggests, Regnault offers a powerful example of an emerging culture of celebrity in the visual arts, cemented in this instance by a nationalist discourse that had refashioned him into a revanchist icon. Just that combination, I have tried to suggest, assured that most discussions of Regnault routinely opened to broader reflections on the nature of the French school and the possibility of its survival. On the other hand, those same reflections betrayed the fragility of the edifice Regnault was charged with supporting. Critics, we have seen, as they fabricated for Regnault an imaginary place in the future unfolding of the enterprise, finished by negating its possibility. The more critics reflected on the significance of his art, the more it seemed he was at the forefront of the enterprise's dissolution. Indeed the sheer pressure to promote Regnault's canonicity partly nurtured its undoing, just such pressure serving to bring Regnault's accomplishment into sharp and lasting critical focus.

As for the nature of the critics' concerns, they seem at once unexpected and familiar. A thorough analysis of Regnault's art would have to argue that charges of materialism, of substituting means over ends, and of unbridled colorism, bear a family resemblance to charges made against other French painters in these years, notably those made against Manet and his Impressionist followers. Certainly I don't mean to claim that Regnault's painting has much in common with an emerging Modernist tradition. Rather, it makes more sense to propose that Regnault, no less than other academic masters from this era, was moved by pressures similar to those that moved his Modernist counterparts. We might even think of Regnault, along with some of his academic colleagues, as staking out a new direction for their art. For all kinds of reasons that effort proved unfertile or without posterity, but to this day its history remains to be written.

Perhaps no work better attests to such concerns than Regnault's *Execution without Judgment*, in other words the painting that seemed most openly to

challenge the tradition that Regnault, in death, was charged with sustaining. We don't have to agree with the critics to acknowledge their perspicacity. As they fashioned Regnault into an icon of the French school, they found themselves obliged to bracket and neutralize the most troubling aspects of his manner. The picture was not a mistake or an aberration, however. Its presumed defects were not only typical of Regnault's art but the source of its power and lasting importance. In fact, of all Regnault's pictures, it is precisely his *Execution* that speaks most powerfully to modern audiences, and for roughly the same reason: its startling union of horror and decor. Just what that union says about Regnault's project lies outside the compass of the present inquiry. Suffice to say that the picture's renewed ability to command our attention is itself revealing and deserves investigation. At the very least, that renewed ability offers still further evidence of the relentless, unpredictable, and unceasing process of canon formation.

## NOTES

1 For the notion of cultural capital (drawn from Bourdieu) in canon formation, see J. Guillory, *Cultural Capital: The Problem of Literary Canon Formation*, Chicago, University of Chicago Press, 1993. Also pertinent in this context is B. Hernstein Smith, *Contingencies of Value: Alternative Perspectives for Literary Theory*, Cambridge, Harvard University Press, 1988.

2 C. Greenberg, *The Collected Essays and Criticism*, vol. 1, pp 15–16. For an attempt to rescue academic painting as a form of bourgeois realism, still valuable is A. Celebonovic, *Some Call it Kitsch: Materspieces of Bourgeois Realism*, New York, Abrams, 1974. The notion of academic painting as a form of capitalist ideology and imperialist mystification remains central to many accounts of Modernism, notably those which credit Courbet, Manet, and their followers with a new, avant-garde critical consciousness. Without tracing the historiography of this (arguable, in my view) notion, it survives for example in S. Eisenman, *Nineteenth-century Art: A Critical History*, London, Thames and Hudson, 1994, pp. 225–37. Some recent accounts of French Modernism have sought to overturn the misleading distinction between advanced and conservative tendencies in painting, particular with respect to the 1860s and 1870s. See in this connection M. Fried, *Manet's Modernism, or the Face of Painting in the 1860s*, Chicago, University of Chicago Press, 1996; D. Pitman, *Bazille: Purity, Pose, and Painting in the 1860s*, University Park, Pennsylvania State University Press, 1998; M. Gotlieb, *The Plight of Emulation: Ernest Meissonier and French Salon Painting*, Princeton, Princeton University Press, 1996.

For an institutional perspective on the decline of academic painting, the best accounts are P. Mainardi, *The End of the Salon: Art and the State in the Early Third Republic*, New York, Cambridge University Press, 1993; P. Vaisse, *La Troisième république et les peintres*, Paris, Flammarion, 1995. For the problem of the *pompiers* in art historical scholarship, see C. Rosen and H. Zerner, *Romanticism and Realism: The Mythology of Nineteenth-century Art*, New York, Norton, 1984; and J. Thuillier, *Peut-on parler d'une peinture pompier?*, Paris, Presses Universitaires de France, 1984. In the field of museums and museum scholarship, new attention to the *pompiers* can be dated to the Musée des arts décoratifs' pioneering exhibition *Equivoques: Peintures françaises du XIXe siècle*, Paris, 1973.

3 Henry Roujon, *Les Peintres Illustres: Henri Regnault*, Paris, 1914. For Roujon's activities in this respect see J. Laurent, "The Caillebotte Affair: The Refusal of Twenty-nine

Impressionist Paintings," *October*, 1984, vol. 31, pp. 69–84, with a reply by P. Vaisse, "The Caillebotte Affair that Never Was," *October*, 1984, vol. 31, pp. 85–7.

4 *Correspondance de Henri Regnault*, ed. A. Duparc, Paris, Charpentier, 1872; T. Gautier, "Notice," in *Oeuvres de Henri Regnault exposées à l'École des beaux-arts*, Paris, École des beaux-arts, 1872; idem, "H. Regnault," in *Tableaux de siège: Paris, 1870–71*, Paris, Charpentier, 1880; H. Baillère, *Henri Regnault, 1843–1871*, Paris, Didier, 1872; H. Cazalis, *Henri Regnault: Sa vie et son oeuvre*, Paris, A. Lemerre, 1872; C. Blanc, "Henri Regnault," in *Les Artistes de mon temps*, Paris: Firmin-Didot, 1876; C. Timbal, "Henri Regnault," in *Notes et causeries sur l'art et les artistes*, P. Plon, 1881; R. Marx, *Henri Regnault*, Paris, Rouam, 1886. For further bibliography see *Henri Regnault: 1843–1871*, Saint-Cloud, Musée municipale, 1992.

5 Henry W. Kent to Charles R. Henschel, July 19, 1916. Archives of the Metropolitan Museum, dossier B173. Also see B.B. [Bryson Burroughs], "Regnault's *Salomé*," *Bulletin of the Metropolitan Museum of Art*, 1916, vol. 11, 164–6.

6 For details of the campaign see "Henri Regnault's *Automedon*," *Boston Daily Advertiser*, 15 February 1884. S. Burns tracks the new culture of artistic celebrity in her book *Inventing the Modern Artist: Art and Culture in Gilded Age America*, New Haven, Yale, 1996. While Burns treats chiefly American art, her analysis is no less relevant to the European scene. For the promotional efforts of dealers and related parties in the emergence of Modernism, see R. Jensen, *Marketing Modernism in Fin-de-Siècle Europe*, Princeton, Princeton University Press, 1994. For new exhibition practices of French Modernists, including new publicity instruments, see M. Ward, *Pissarro, Neo-Impressionism, and the Spaces of the Avant-Garde*, Chicago, University of Chicago Press, 1995.

7 R. Marx, *Henri Regnault*, p. 86.

8 J. Claretie, *Peintres français contemporains; première série*, Paris, Librairie des biblio-philes, 1882, pp. 1–2.

9 Roujon, *Regnault*, pp. 13, 80.

10 Baillère, *Henri Regnault*, p. 59. For the Salomé see M. Dottin-Orsini, "*Salomé* de Henri Regnault (1870): Genèse et reception d'un tableau légendaire," in *Textes, Images, Musique*, Toulouse, Presses Universitaires du Mirail-Toulouse, 1992, pp. 31–45; and C. Sterling and M.M. Salinger, *French Paintings: A Catalogue of the Metropolitan Museum of Art*, II, *Nineteenth Century*, New York, Metropolitan Museum of Art, 1955–67, pp. 201–2; as well as my "The Three Dances of Henri Regnault's Salomé," in C. Bernheimer and R. Kaye, eds, *Salomé: Queen of Decadence*, Chicago, University of Chicago Press, forthcoming.

11 For the topos of reform and innovation, see E.H. Gombrich, "The Renaissance Conception of Artistic Progress and its Consequences," in E.H. Gombrich, *Norm and Form, Studies in the Art of the Renaissance I*, London, Phaidon, 1966, pp. 1–10; for the nineteenth century, see N. Bryson, *Tradition and Desire: David to Delacroix*, Cambridge, Cambridge University Press, pp. 1–32; Gotlieb, *The Plight of Emulation*, pp. 96–154.

12 For Regnault's technical procedures see R. Shiff, *Cézanne and the End of Impressionism*, Chicago, University of Chicago Press, 1984, pp. 85–7; Pitman, *Bazille*, pp. 16–30. Pitman broadens her discussion of Regnault's technical proce-dures to include the artist's rendition of his model and its relation to the beholder. In this respect Regnault's practice should be linked to Manet's groundbreaking efforts to recast the relationship between painting and beholder, as discussed in Fried, *Manet's Modernism*.

13 For efforts by the state to reverse the decline of *grande peinture*, see Mainardi, *The End of the Salon*, passim.

# 11

# USING ART HISTORY

## The Louvre and its public persona, 1848–52

*Gabriel P. Weisberg*

Administrators of the French public museums, those who ascended to their positions at the time of the 1848 Revolution, were determined to reexamine earlier artists who might further their contention that art could be used for didactic purposes – to teach, to educate, to motivate the masses. These earlier artists, the ancestors of the realist tradition, were accordingly reinstated for many reasons.

Among those who had a very specific program to follow, based on his own radical inclinations, was Philippe-Auguste Jeanron (1809–77; Figure 11.1).[1] He became Director of the French National Museums in 1848 and set forth a program of change that had far reaching implications, not only for his own immediate period, but for the future of French museums. Coming to power during a moment of intense democratization of many political institutions, Jeanron made it his policy to study selected painters from the past so that their works could be placed on public display in the Louvre.[2] Among them were Chardin and the Le Nains, whose plebian themes were in clear opposition to the more aristocratic imagery of a Hyacinthe Rigaud or Vigée-Lebrun, for example. The former often used themes that were linked to the commonplace, to the nature of work, and would have been more easily grasped by the lower classes and the expanding middle class.

Recognizing the Louvre as the national palace for art, Jeanron was motivated by a keen awareness of art history, and by the need to reappreciate painters from the extensive tradition of French creativity who could compete with other European masters while firmly establishing the basis of a French national school.[3] Jeanron's philosophy, partially outlined in his writings published in the radical press of the late 1840s, must be carefully probed since these texts set forth an ideology that was decidedly populist. They reflect issues, also espoused by others at the time, revealing that Jeanron was one of many who were involved in expanding the role artworks could play in society and, in addition, in rethinking the function of museums in educating the public about the art of their own nation and even that of other schools. In identifying specific artists for new appreciation, and in rescuing others from the "dustbin" of the past, Jeanron, and his Republican colleagues, used their knowledge of art history and

*Figure 11.1* Félix Nadar, photo of Philippe Auguste Jeanron, undated.

*Source*: Courtesy: Caisse Nationale des Monuments Historique et des Sites.

of contemporary collections. The fact that Jeanron was himself a painter made him sympathetic to the work of others; it also helped his understanding of all artists, not only the well-known names, but all those who contributed to the richness of the French school. While Jeanron recognized the supremacy of the Louvre as the "palace of art," he also was determined to show – in every conceivable way – that this location had to become a far more welcoming site to those from all classes in society. The Louvre could not remain an enclave only for the privileged and the elite. It had to become a palace for the people. The means by which Jeanron put his beliefs into practice, and the reasons these reforms had such a far reaching effect on a national institution, provide the basis for our reconsideration of the importance of museums as institutions of learning. Jeanron's placement and utilization of critical paintings from the immediate past demonstrate a sensitivity toward contemporary society. They also demonstrate how some painters were deeply involved in the history and events of their own period.

## JEANRON'S ROLE AS CREATOR

As a painter and draughtsman, and as a political activist who had been involved in the Revolution of 1830, Jeanron knew much about the ways in which imagery could be used to promote a cause and enlist the spirits of the people. His early painting *Les Petits Patriotes* (Figure 11.2), rightfully compared with Delacroix's canvas *Liberty on the Barricades*, focused attention on the children of France, on what they would inherit, and on the ways in which the "petits

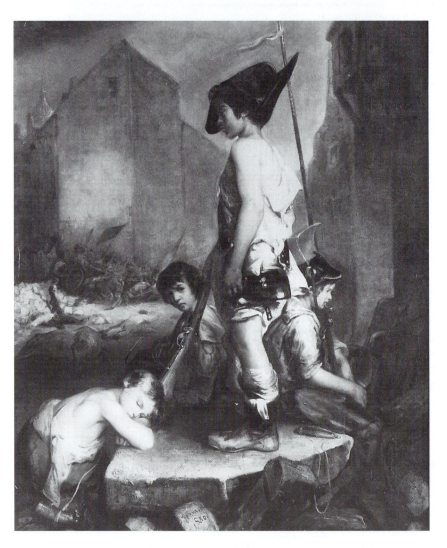

*Figure 11.2* Philippe Auguste Jeanron, *Les Petits Patriotes*. Oil on canvas, 1830.

*Source*: Musée des Beaux-Arts, Caen. Photo: Bulloz.

patriotes" had actually served the cause of democratization by fighting on the barricades in the streets of Paris.[4] Through a series of other works, many of them painted on a large scale, Jeanron advocated the rights of man; he was recognized as a spokesman for the populace, and as a defender of the glories of liberty and democracy.[5] He dreamed of completing a large cycle of works that would focus on various working class types; some of these images were actually created, leading Jeanron to be widely hailed as a spokesman for the rights of the people by republican art critics.[6]

Throughout the July Monarchy Jeanron maintained his realist allegiances, showing works at the public Salons while furthering his ideas through publications, speeches, contacts with the press and close associations with many artists.[7] Jeanron was, himself, a man of the people; he was also exceedingly well read, learned for his time, and deeply aware of the traditions of art history. He remained entirely receptive to an inclusiveness that was rare, as his ideas were grounded in republican beliefs that proposed to involve everyone in a pantheon of creativity that he hoped would be mirrored by similar reforms of French society. As the July Monarchy crumbled from within and as it became evident that the head of state was not interested in the middle and lower classes, Jeanron situated himself in a position of opposition to those in power.[8] At the moment of the 1848 Revolution, when new leaders were ushered into positions of importance, Jeanron was immediately recognized by his peers as an impassioned leader. Because of his background as a creator, his close ties to the artistic community, his understanding of the art of the past, and his long standing contacts with the republican cause, he was nominated by Ledru-Rollin, the head of the provisional republican government in 1848, to lead the National Museums and to become the Director of the Louvre.[9] Seizing the initiative, and recognizing that his was a mission of change, Jeanron projected a series of significant reforms. These need to be enumerated here, though we must note that many of these reforms were ideas whose time had not come, even though they were advocated in the press by some writers, including Clément de Ris and others. They remained visions of what would eventually be accomplished.

## THE PROJECTED REFORMS

Jeanron's administrative acumen was immediately tested when he came to power in the art world. The revolution in the streets of Paris, and the tenor of the time, made it clear that the collections that were housed in the Louvre were threatened by immediate destruction and potential total dispersal.[10] Jeanron's first task was to defend what was actually housed in the various rooms of the Louvre; he was determined that the building not be harmed nor the collections further pillaged. Jeanron was immediately recognized as a defender of the Louvre and as a key individual in preserving the past so that it could be used and made available for the future.[11] By hiring guards for the Louvre, and by

patroling the various rooms with his curatorial colleagues, Jeanron took an activist stance that was right during this period of total unrest. Jeanron also established a strong stand *vis-à-vis* the rebels, talking to them in order to calm them down. He reiterated that the Louvre was, now, the palace of the people and that it and its contents belonged to them.

In making the Louvre the central repository for the visual arts, Jeanron also wanted to initiate other significant changes. Since a number of key works had been sent away from the Louvre to be housed in the private homes and villas of the wealthy members of the court of Louis Philippe or the royal family, Jeanron became determined to remedy this deplorable situation.[12] The Louvre was a state collection; the works housed in it were not part of a lending collection destined to decorate the homes of the wealthy. He wanted as many objects as possible located and brought back to the Louvre itself, and a new and comprehensive inventory of the holdings of the museum to be initiated.[13] By following this particular reasoning Jeanron, once again, upheld the validity of the importance of a central national museum whose collections were to become inviolable. Jeanron also understood the value of a professional staff managing the museum. Along with his curator of collections Frédérick Villot, a figure of considerable importance in his own right, Jeanron further established the right of the museum director and his staff to initiate changes so that the institution could remain immune from the vagaries of political change and above personal influences.[14] The initiation of a publication program, including the preparation of a catalogue of the collections, was held to be most important since this was one way in which an existing collection could be presented and explained to the public.

While the maintenance of the collections and the relocation of objects that had once been in the collections became paramount, Jeanron moved on to other issues that were equally pressing. Exhibitions, especially the yearly Salons, were often held in the Louvre, necessitating the taking down of the permanent collections; Jeanron wanted this modified so that the public would not be deprived of the old master collection. The Louvre would no longer be the site where contemporary shows by living artists would be held. With this modification Jeanron demonstrated that the professional staff of the Louvre had a voice in the contemporary world, reshaping the collections and organizing exhibitions with a didactic role; he helped shift the focus from temporary exhibitions toward the examination and hanging of the permanent collection. Jeanron also wanted the National Library transferred to the Louvre and, while this did not happen, he helped initiate the organization of a separate curatorial library inside the Louvre (and the development and maintenance of internal archives) that made it possible for the staff of the Louvre to have access to documentation necessary to their work. With this type of documentation system in place, it became possible to keep track of all works of art in the permanent collection and to know their history, including how and when they had entered the collection. It also became a means to keep a record of contemporary works shown at the Salons that were either kept in the Luxembourg Museum or sent to provincial museums.[15]

As an advocate of the "worker" in society, Jeanron also tried to find appropriate ways in which a laborer could be involved in the world of the visual arts. He lobbied for the inclusion of workers in the completion of various sections of the Louvre; the grand plan – much in evidence in the last ten years – was actually initiated when Jeanron was Director. He recognized that more space was necessary if all the collections were to be properly exhibited. While this plan did not occur, Jeanron made it clear, in yet another way, that the mission of the arts, and the Louvre, was to find ways in which they could reach all members of society, even members of classes not conventionally considered museum-goers. By using common laborers to complete the Louvre, he hoped that they would help spread the message that a palace of the arts was all inclusive; they and their families were welcome. Jeanron, in effect, was a visionary as he considered the ways in which museums should open their doors to the disadvantaged and make themselves accessible and open to all in society.

At the same time as he was working on these aspects of reform, Jeanron remained extremely sympathetic to the case of some forlorn contemporary artists. Recollection of his own desperate position during the 1830s made Jeanron exceedingly sympathetic to the plight of others. Along with other members of the provisional republican government, Jeanron wanted to initiate a support system for artists whereby specific commissions be given to artists or the works they had produced for the yearly Salons be purchased for the national museums. There are cases of painters working on realist themes, such as Charles Jacque and Jean-François Millet, among others, receiving support at the moment when the new government was interested in funding contemporary painters. Jeanron, and his colleagues, were eager to see that the government took an active stance and that no opportunity for supporting art and artists was neglected. Most importantly, Jeanron clarified the status of the Luxembourg Museum – which had been recognized as the living artists' museum since 1818 – by making certain that the direction of the museum depended on the National Museums' administration, which, in turn, was under the responsibility of the Interior Ministry.[16] This meant that those works that were secured by the state from living artists would be shown in a continually changing museum dedicated to what would be called contemporary art. This second museum would also free the Louvre from having to worry about issues of contemporaneity so that more attention could focus on the past. Jeanron's reforms also encompassed other aspects of the Louvre. He remained concerned that the paintings in the Louvre (not to mention other sections of the collection) be properly housed, hung, and shown to the public. As a painter, with a solid grasp of the art historical past, Jeanron wanted existing paintings, and those that were being brought back from outlying buildings, to be presented within a clearly organized art historical context. The question that remained to be discussed was what type of context was to be established for these works. Jeanron was making decisions about the ways in which a collection would be shown based upon fundamental principles: historical context, aesthetic appreciation, and the ways

in which both of these qualities could be combined to convey an impression of the taste of the time. Jeanron remained open to the relocation of artists who had been neglected, to the championing of painters who deserved attention, including the integration of artists from the French past – Chardin and the Le Nains for example – who had to be rescued from obscurity.[17] He recognized the mission of the art museum in giving a visitor a chance to appreciate the past, but he wanted this study and appreciation to take place in a way that was to be effective and controlled.[18] A disparate organization of paintings was to be both avoided and eliminated. Jeanron's hanging of the paintings in the Louvre, both in actuality and in theory, demonstrates what he had in mind and what he was able to do during the short duration of his directorship of the National Museums of France.

## TOWARD THE HANGING OF THE LOUVRE

At the heart of Jeanron's attention to the painting collection of the Louvre was his belief that order had to be brought out of chaos. Different schools of painting were not to be shown together, and an ahistorical hanging was to be avoided at all costs by assigning to each artist his proper period designation. Even more importantly, Jeanron began to turn his attention to painters at the beginning of his own century, to the works of Jacques-Louis David, for example, in order to rescue them from neglect and decay, and to integrate them into the arrangement and the hanging of collections. This was especially the case with artists who showed any kind of revolutionary leanings and whose images reflected their convictions in any way.

Throughout his discussions on the rehanging of the collection Jeanron was guided by two fundamental concerns: works of art, especially paintings, had to be rescued from deplorable storage conditions and, most importantly, the collection should be rehung according to a chronological system based on historical schools.[19] With the first issue before them, Jeanron and his colleagues set out to assemble, register, classify and eventually exhibit works.[20] As the paintings were regrouped, including canvases that were brought back from collections outside of the Louvre, Jeanron insisted that a systematic method of inventorying be initiated.[21] These actions show that he was cognizant of the need to record what was in the collections and that he was sympathetic to the creation of a catalogue that would be available to the public.[22] By working as a historian Jeanron was doing everything possible to establish the role of a Director as not only an administrative chief, but a figure who cared about the works of art that were placed in his charge.

Jeanron was dedicated to bringing to further visibility the painters from the early part of the nineteenth century. From Versailles he brought back Baron Gros' *Pesthouse at Jaffa*, and hung the canvas with the romantic school. Jeanron also set out to reconstruct David's revolutionary *Oratory in the Jeu de Paume*, which he wanted to make one of the centerpieces of his rehanging in Versailles

(where Jeanron was also in charge), even though the painting had never been completed by the artist.[23] Displaying his anger at the way in which the administration of Louis Philippe had appropriated works of art for his and his friends' advantage, Jeanron brought back two works by Théodore Géricault – *Le Chasseur* and *Le Cuirassier* – which he wanted to exhibit in the Louvre next to *The Raft of the Medusa*.[24] Once this was accomplished, Jeanron believed, Géricault's significance as an early romantic would be enhanced and visitors would gain a better understanding of how his works were to be seen as a unit. These were very significant shifts in the way in which the nineteenth century was being regarded, revealing that Jeanron was extremely sensitive to locating those artists who had a strong didactic message to convey and whose works now had to be hung next to examples from the older schools. In effect, Jeanron was among the first to locate and effectively hang those works which would be regarded during his period, and into ours, as the cornerstones of modern art based on reactions to the events of the time.

As Jeanron, and his colleagues, reexamined the works before them, it was apparent that an older system – of exhibiting works according to size with great works being off view – was dismissed. He applied, for the first time, a logical visual system whereby larger paintings were grouped in the center of the wall and smaller canvases on the sides. Works by a central master (e.g. Géricault) were grouped according to style, with works by followers or students being placed nearby. The basic emphasis was on seeing the best works clearly so that aesthetic distinctions could be made in the context of a historical hanging.

## AN INSTITUTION REBORN: THE LOUVRE

As they worked through the disarray and sense of chaos, Jeanron, and his colleagues, thought about ways to use the entire building to their advantage.[25] The ground floor of the Louvre was to be used for the placement of sculpture, the first floor was to be rehung with paintings, with supplementary art objects and drawings added; the second floor was dedicated to the Musée de la Marine, the ethnographic collection and the origins of the Far Eastern collection.[26] The most important decisions, given the size and scope of the collection, were reserved for the paintings.

Based upon reports of a visit to the Uffizi Collection in Florence, Jeanron and Villot worked out a comprehensive and vast plan that was devised to apply art history to a newly reinvigorated institution. All the great masters were to be reunited in a "tribune" gallery dedicated to the leading creators from the past; all other paintings were to be grouped chronologically and by school.[27] The "Salon carré," because of its vast size and scale, became the tribune gallery where homage was extended to the leading masters from earlier times. In the "Grande galerie" Jeanron wanted to place works from the foreign schools and those French painters through the seventeenth century. This was most likely the location where Jeanron positioned the *Forge* by the Le Nains, which was to

become an example of the revived interest in forgotten painters initiated in the 1840s under the critical leadership of Charles Blanc.[28] The Le Nains were not only appreciated by Jeanron, but in 1848 the art critic Clément de Ris, in an essay on the reshaping of the Louvre, noted that these artists, along with Fragonard, Pater, Chardin, and Oudry among others, were unjustly dismissed.[29] With Jeanron's plan in place, it was possible to reconfigure the French school of the seventeenth and eighteenth centuries along broader art historical lines accounting for the national contributions of many previously neglected painters to the heritage of France.

As the organizational scheme for the Louvre evolved, Jeanron also recognized that he had to find considerable room for the paintings by David and his students. Taking over the "Salon des Sept Cheminées," Jeanron decided to dedicate this space to the major works of the French school of the nineteenth century. A second area, the Galerie du Bord de l'eau, was given over to what were considered to be the secondary paintings from the eighteenth and nineteenth centuries. But in order for this plan to work it was necessary for work to be done on the building: the Gallery of Apollo had to be remodelled to provide a connecting space and for this it was necessary to raise two million francs. This was given, rather quickly, by the national government. When the galleries opened in November 1848, with the reconfiguration of some galleries completed, and with the majority of the paintings in place, the critical response was laudatory. While not everything was fully done, and some rooms were opened after Jeanron's departure from the Louvre, it was clear that both he and Villot were the figures who were most responsible for rehanging the collection and for making logical sense out of a disastrous confusion.

## THE CONTRIBUTION

The efforts of Jeanron, among others, during the period 1848–50 were significant for a number of reasons. As an activist Director, he was able to put into practice the ideas of the liberal republicans who wanted art to be available to all: the masses as well as those who had had social status were to be educated about the history of art. It was clear that the only way to do this was to make the collections of the Louvre both accessible – in a larger space – and intelligible through the ways in which the collections were hung and arranged. Since it was important that the French school compete with other countries, and the history of the French school be presented cogently, painters who had not been shown in sequence or who had been neglected were given significant places on the walls. Some of these painters, such as the Le Nains, were significant historically. Because their vision of creativity also meshed with the newer tenets of realism, which were being espoused by Jeanron and others in 1848, this made their placement that much more apparent to the masses who came into the Louvre to see what had been achieved.

As the venerable Louvre was redone, and the collections rehung for clarity and interpretive purposes, it was clear that the painters of the first part of the nineteenth century were also to be given places of honor. David, Gros, Géricault, among others, were positioned in accordance with their aesthetic and historical contributions; by locating works by these artists that were found outside of the Louvre and regrouping them in the "palace for the people," Jeanron signified that all types of painting had a place in the national museum. He was firmly advancing the history of a national art that was intelligible for the people and which was being so honored in a collection that had, as a principle, an all-inclusive agenda. In addition, the nineteenth century, at least the first part of the century, was receiving serious attention from curators.

There is little doubt that Jeanron's actions, along with those of his curators, saved the Louvre from debasement and continued decay. His professionalism, care of objects and his lucid plan, based on history and on aesthetic considerations, meshed with his revolutionary agenda. It was because of these actions that the Louvre eventually became a comprehensive collection with a didactic message that subliminally treated French art as of equal or superior status to that in the rest of Europe. In effect, many modern museum approaches were launched by Jeanron at a time of intense political change and unrest, making the Louvre the beneficiary of revolutionary activity that changed its face forever and provided the foundation for continued rehanging of the collections well into the twentieth and twenty-first centuries.

## NOTES

1 On Jeanron's role initially see the groundbreaking work of M. Rousseau, *La Vie et l'oeuvre de Philippe-Auguste Jeanron, peintre, écrivain, directeur des Musées nationaux 1808–1877*, Paris, Réunion des Musées Nationaux, 2000, and G.P. Weisberg, "Proto-Realism in the July Monarchy: The Strategies of Philippe-Auguste Jeanron and Charles-Joseph Traviès," in P.T.D. Chu and G.P. Weisberg, eds, *The Popularization of Images: Visual Culture under the July Monarchy*, Princeton, Princeton University Press, 1994, pp. 90–112. Rousseau's work, a thesis done for the École du Louvre in 1935, waited sixty-five years until publication. It was far in advance of the time in which it was written. It contains the seeds of the recognition of Jeanron's long neglected role in art and aesthetic theory. The author gratefully acknowledges the interest shown by Madeleine Rousseau, numerous years ago, when she made it possible for her dissertation to be consulted by this writer at an early date. This chapter builds upon some of Madeleine Rousseau's documentation and clarifies the ways in which Jeanron nationalized the Louvre collections. The accessibility of art objects, the use of art for a didactic program, foreshadow the ways in which the Louvre currently interprets its collections. Rousseau's political agenda, meshing with that of Jeanron's, provided a popular didactic basis that is at the foundation of much of what the Louvre collection is trying to do today.

2 The rediscovery of artists from the past is discussed in S. Meltzoff, "The Revival of the Le Nains," *Art Bulletin*, 1942, vol. 24, pp. 259–86, and by F. Haskell, *Rediscoveries in Art: Some Aspects of Taste, Fashion and Collecting in England and France*, Ithaca, Cornell University Press, 1976. These rediscoveries must be placed within the broadened context of which artists had to be reclaimed and restudied so

that the general public would appreciate them when their works were exhibited in museums.

3  Jeanron's interest in nationalism as a basis for artistic recognition is echoed in a recent publication, stressing these issues as they affected both France and Germany. See M. Zimmermann, ed., *Jenseits der Grenzen: Französische und deutsche Kunst vom Ancien Regime bis zur Gegenwart*, vol. II, Kunst der Nationen, Cologne, Dumont Buchverlag, 2000.

4  For recognition of this aspect of Jeanron's painting see Weisberg, "Early Realism," in *The Art of the July Monarchy*, exh. cat., Columbia and London, University of Missouri Press, 1989, pp. 101–15. Also see M.M. Dubreuil, "Philippe Auguste Jeanron," *Archives de l'art français*, 1988, vol. 29, pp. 57–61; *Exigences de réalisme dans la peinture française entre 1830 et 1870*, exh. cat., Chartres, Musée des Beaux-Arts, n.d..

5  One of the paintings that best revealed these sympathies was the *Street Scene* of 1834, (Musée des Beaux-Arts, Chartres) as discussed in Weisberg, *Art of the July Monarchy*, Columbia. Also see M.-C. Chaudonneret, "Jeanron et 'l'art social': *Une scène de Paris*," *Revue du Louvre*, 1986, no. 4/5, pp. 317–19. Jeanron's concern for the well-being of the dispossessed and for those who had served their country in the 1830 Revolution was clearly underscored by this work. There were few who would not have understood the didactic message of this work once it was publicly displayed at the Salon.

6  For a discussion of these works see T. Thoré, *Salons de Thoré-Burger*, Paris, 1869. In recent years a few of these works appeared on the art market after being out of the public view for over 150 years. The current whereabouts of these works remains unknown. The author had the opportunity to examine several of them when they were in the possession of a Parisian dealer a few years ago and the works fully reinforced the original critical statements that Jeanron was working on a series that was dedicated to a democratic understanding of the rights of man.

7  A complete listing of the works that Jeanron presented to the Salons from 1830 to 1852 is found in the *Archives du Louvre* (listed under Jeanron). These notations record those works that were admitted to the Salon and those, often drawings with a strong realist inflection, that were consistently rejected by the Salon juries. It is a valuable indication that many of Jeanron's works were too strong for public consumption after the 1830 Revolution.

8  For a discussion of this aspect see *Art of the July Monarchy* and M.-C. Chaudonneret, pp. 317–19.

9  The belief is that Théophile Thoré was first selected to be the head of the National Museums but when he refused, believing that he had much else to do outside of charting the course of an institution, the revolutionary government turned to Jeanron. See Rousseau, pp. 83–5, for a brief description of this particular moment in history. For further discussion of Jeanron's place as Director see P. de Chennevières, *Souvenirs d'un directeur des Beaux-Arts*, Paris, Arthena, 1979, where the political controversy as to who did what first is outlined. Chennevieres, writing after the fact, has a tendency to contradict Jeanron's actions.

10  As described in Rousseau, pp. 65–6.

11  See Rousseau, pp. 66ff. for a clear description of what Jeanron did to preserve the Louvre from the vengeance of the crowd and from total destruction. Other curators in the nineteenth century rivaled Jeanron in the defense of the Louvre. An example is Ravaisson Mollien, who saved all the classical works from destruction at the time of the Franco-Prussian War and the Commune. There have been other moments in the history of the Louvre, such as during the Second World War, when curators from within came to the defense of the national legacy at a time of distress.

12 As discussed in Rousseau, pp. 66–7. Jeanron seriously objected to any further glorifi-cation of any member of the family of Louis Philippe in the Louvre or elsewhere.

13 Rousseau, who bases her discussion on the availability of documents housed in the Archives du Louvre. See Archives du Louvre, A5, A6, AE6–18, Z215, Vo, P12–15, for numerous files pertinent to these aspects. The emphasis on cataloguing the Louvre collection was found in articles in the press, including L. Clément de Ris, "Remarques sur le Musée du Louvre," *L'Artiste*, 20 February 1848, vol. 11, pp. 248–50.

14 As Rousseau states (p. 182): "it is necessary to improve the working of the adminis-tration in order to insure its proper function."

15 These archives, now called Archives des Musées Nationaux, have been dramatically enriched over the years and allow for a well-rounded knowledge of the collections of the National Museums and of the individuals who were responsible for them. The importance of documenting collections is discussed in L. Clément de Ris, "Remarques sur le Musée du Louvre."

16 On the role of this museum see G. Lacambre, *Le Musée du Luxembourg en 1874*, exh. cat., Paris, Grand Palais, 1974. The debate over the substance of the Musée du Luxembourg continued into the late nineteenth century, encompassing the director-ship of Léonce Bénédite, who was the Director of this museum for a long period of time. Also see G.P. Weisberg, "The French Reception of American Art at the Universal Exposition of 1900," in D. Fischer, ed., *Paris 1900: The American School at the Universal Exposition*, New Brunswick, Rutgers University Press, 1999, pp. 145–79.

17 While Jeanron cannot be considered as the only figure involved in rescuing these artists from neglect, he was part of the general tendency of the era that was dedicated to finding realist models from the past that would be appropriate to the present. Rousseau states that Jeanron wanted "to reveal the unknown and forgotten painters, to make known the role of artists' corporations and associations." On the Chardin revival see J.W. McCoubrey, "The Revival of Chardin in French Still-Life Painting, 1850–1870," *Art Bulletin*, 1964, vol. 24, pp. 39–53; on the Le Nains see Meltzoff, cited abovein Note 2, and on the general interest in the Dutch painters being revived see P.T.D. Chu, *French Realism and the Dutch Masters*, Utrecht, Haentjens Dekker and Gumbert, 1974.

18 Rousseau notes (p. 205) that Jeanron believed that: "The Versailles museum, one of the most important national museums, had been created as a history museum and dedicated to all its glory."

19 This is discussed, fleetingly, in Rousseau, pp. 196–7 and reiterated in J. Raymond, "Une dette Nationale," *L'Art*, 1876, vol. 29, pp. 189–91. The nature of the estab-lishment of a historical school, and how this was first achieved, remains unclear in this early phase of art history and connoisseurship at the Louvre. It is apparent that the Louvre curators were being influenced by practices in Italy, England, and Germany with regard to the hanging of public collections. For further discussion see L. Clément de Ris, "Musée du Louvre, Grande Galerie," *L'Artiste*, 15 January 1849, pp. 149–52.

20 Jeanron was extremely concerned about issues of restoration. He believed that works had been harmed when restoration was not adequately carried out. He was adamant that restoration be done by outside restorers (not those in the Louvre) who had to pass a national exam in order to be tested for their work. This is discussed in Rousseau, pp. 195–6.

21 Jeanron wrote that (Rousseau, p. 193): "If one wants to know exactly the state of the treasures housed in the Louvre and reestablish order where confusion reigns, it is urgent to establish as soon as possible a complete general inventory."

22 The responsibility of cataloguing, and the type of system used, is discussed in Rousseau. Jeanron stressed the collective work involved in the cataloguing effort, suggesting that he saw this as a type of socialistic enterprise that brought various individuals together in the effort of preserving and discussing an art collection.

23 On the location of this painting see *Jacques Louis David, 1748–1825*, exh. cat., Paris, Réunion des Musées Nationaux, 1989, pp. 242–66. Rousseau notes that the work existed in three pieces and had to be restored (p. 191). Jeanron had just seen the Salle de Jeu de Paume designated as a historical monument, so it was appropriate that this work be hung there. There is considerable confusion as to the history of this incomplete painting and where it was found between 1836 and 1921.

24 For discussion of the situation of these paintings in the new galleries hung by Jeanron see L. Clément de Riz [sic], "Nouvelle galerie française du Musée du Louvre," *L'Artiste*, 1 December 1848, pp. 110–12.

25 For discussion see L. Clément de Ris, "Remarques sur le Musée du Louvre," *L'Artiste*, 20 February 1848, pp. 248–50. Clément de Ris emphasized that the French collections could not compete with the way collections were shown or hung in other European countries such as England and, more pointedly, Italy. The latter country provided excellent examples (e.g. the Uffizi collection) of ways to hang paintings.

26 Rousseau, p. 197.

27 The success of the hanging is discussed in L. Clément de Riz [sic], "Nouvelle galerie française du Musée du Louvre," pp. 110–12.

28 As quoted in Meltzoff, p. 264. He cited *L'Artiste* for 1845, where the emphasis was placed on bringing to light "many wonderful people." Blanc was a crucial writer in championing the cause of democracy and in noting that there were many neglected painters who needed to be reappreciated.

29 L. Clément de Ris, "L'École française au Louvre, *L'Artiste*, 26 March 1848, pp. 39–40. Clément de Ris mentions many other artists as being worthy of recognition and revival.

# 12

# SILENT MOVES

## On excluding the ethnographic subject from the discourse of art history

*Claire Farago*

Teleology and hierarchy are prescribed in the envelope of the question.

> Jacques Derrida, "The Parergon"

So, you *studied* us, huh? Were we *interesting?*

> Peter Whitley, *Deliberate Acts*, citing "an older
> Hopi man, on learning of my prior research"

The perception of ethnography as an innovative, albeit potentially problematic, supplement to other research methods,[1] has a long history in the discourse of institutionalized art history. This chapter, in continuing the current critique of the transparencies once claimed for visual representations of ethnographic subjects, argues that the history of ethnographic illustration masks a complex rhetorical exchange between word and image that has equally informed the practice of art history as such. In particular, it argues that the persuasive combined power of word and image in framing ethnographic subjects played a key role in art history's professionalization in the nineteenth century in assigning subordinate positions to non-Western material culture.

Such a critique cannot be dissociated from the subject positions of contemporary art historians, and my own personal experience as an art historian, along with my research in a complex network of institutionalized forms of power, implicate a very specific set of ethical considerations. Articulating the ways in which one is entangled with the imperatives of one's profession is no easy matter. The format of diachronically organized microstudies has increasingly appeared to offer a cogent and effective way to address the political consequences of religious, political, scientific, and academic institutions.

I'd like to begin by asking how ethnographic illustrations came to be seen as "natural" in the first place; that is, appearing to require no particular techniques of analysis or feats of self-reflexion to distinguish between representations of ethnographic subjects and direct experience of the same (subjectivized) subjects in the world. My own interest in this topic – and the reason for presenting it in

191

the context of a volume dedicated to the institutions and institutional discourses of art history – developed in the wake of a study of the recent scholarship on Aby Warburg's trip to the American Southwest in 1895/6. Warburg's essay on the Hopi "serpent ritual" was first published posthumously in 1939 on the basis of his lecture notes of 1923 about events that took place three decades earlier.[2] His study of the Hopi has recently become something of an art historical cult piece, with amplified versions of his lecture notes also appearing in English, French, German, and Italian over the last decade.[3] It has come to be widely acknowledged that Warburg's youthful adventure was a formative experience for his study of Renaissance art, and in fact it has been argued in recent years that we should emulate his precocious ethnographic interest in material culture by writing an "anthropology" of the Renaissance.[4]

What has been absent in the present interest in Warburg's brief and belated study of the Hopi has been a corresponding interest in or even knowledge about the complex and highly contested discourse on cultural identity. The current picture of Warburg's actual ideas about the Hopi is a puzzling omission in a body of scholarship that praises the art historian's innovative methodology and the continuing relevance of ethnography to art history. The ongoing reception of the essay in the academic community is significantly different from Gombrich's intellectual biography, which, originally published in 1970, called quite explicit attention to the untenable racialist underpinnings of Warburg's study. Gombrich writes:

A convinced evolutionist he [Warburg] saw in the Indians of New Mexico a stage of civilization which corresponded to the phase of paganism ancient Greece left behind with the dawn of rationalism. It was this belief which accounts for the importance of the experience of Indian ritual for Warburg.[5]

As innovative as Warburg's views might have appeared in 1896 – and we now have a much clearer understanding of his intellectual development in relation to the emerging fields of the "psychology of perception" and the "psychology of religion" – it is difficult to conceive of any cultural anthropologist today upholding his claims about "primitive" Hopi mentality.[6]

Yet oddly the same is not true for the historians and art historians writing today about Warburg's study of Hopi symbolism, who unanimously seem particularly unconcerned that Warburg equated the "primitive" mentality of modern Native Americans with both the "primitive" nature of Man at the dawn of Western civilization and the "primitive" core of human emotions transhistorically understood. Nor has the instability of the "primitive" as a signifier in Warburg's thinking been acknowledged. Ongoing historical studies of Warburg's innovative use of ethnographic techniques also ignore the burgeoning literature on the roots of cultural anthropology in the nineteenth-century science of race, to which Warburg's evolutionist views are indebted, nor have any of these recent art historical commentators addressed the contentious nature of identity politics in the Southwest today.

As important as Warburg's essay on the Hopi might seem to the historiography of *Renaissance* art history, the essay is completely unknown in the regional scholarship on the American Southwest. If the essay were known, it would clearly offend even the most traditional anthropologists – not to mention the descendants of the Pueblo Indians who were Warburg's subjects of study. Contemporary European art historical interest in Warburg's ethnography of Hopi ceremony and beliefs, by contrast, focuses on the innovative aspects of his methodology, such as his comparison of two vastly different cultures unrelated in time, and his theoretical interest in the polysemic nature of visual symbolism.[7]

Ethical issues such as contemporary academic insensitivity to the esoteric nature of the beliefs he studied (Warburg's violations of Hopi privacy are considered far more egregious by the Hopi today than records that remain indicate they were in 1896) and his personal contacts with entrepreneurial archaeologists and art dealers who supplied European museums with Native American material culture – depleting the region of its material cultural remains in a matter of decades – have not even been articulated.[8] The tone of current Warburg scholarship can be described, charitably, as apologetic and conflicted. A good example is the following:

> Warburg not only violated the tradition that forbade one to look at a bareheaded Kachina: he also wanted to set up a scenario, gathering the dancers' masks and arranging them in a precise order, and placing himself at the centre with the Indian.
>
> *There must have been some valid reasons for violating the Indians' customs in this way.* (my emphasis)[9]

Narratives such as this obscure the very complex ethical issues that arise when ethnographers (whether their base of operation is anthropology, art history, or some other field) violate the decorum and privacy of their subjects of study. Ethical concerns about the ownership of intellectual property are currently on the table elsewhere in Native American studies, notably in the context of repatriating sacred objects, including human remains, housed in museum collections.

Should images, in this case photographs, be treated any differently from the objects and beliefs they document? There is a double impropriety to consider, from the Pueblo point of view: Warburg's original transgressions, and the transgressions of contemporary scholars who promote his ideas.

Ongoing debates about the ownership of cultural property have involved the physical remains of the past and perceptions of the past in equal measure. In New Mexico the role of the critical historian is inscribed in a history of institutional repression of Native belief systems and practices. What, responsible historians need to ask in these circumstances, are the political consequences of our research and publication as scholars inevitably supported by powerful state and private institutions? If we force access to knowledge that intentionally excludes outsiders, we reenact the historical role of the Church and State to

police the actions of the community and impose an institution's normative values. In my own practice as an art historian, having recently completed a decade-long study of New Mexican Catholic religious art, it has proven wisest to acknowledge the resiliency of the coerced culture and the essential hetero-geneity of a society composed of subgroups seeking their own autonomous goals (to borrow a phrase from sociologist Nestor García Canclini) than to betray the right of individuals and communities to rule over their own visions – as Warburg might be judged in retrospect to have done.

Not that this position has been easy to practice – finding Native Americans willing to contribute to such collaborative efforts is commonly difficult and frequently unsuccessful. At the same time, the dominant culture's institutions (to which I belong), challenged to accommodate dissenting voices without subsuming them into overarching, totalizing structures, have proven equally reti-cent to give up control over their own visions. For example, the obvious relevance of a critique of *visual ethnography* to a collection dealing with *art history's* insti-tutions and institutional practices has not been unanimously clear to those unfamiliar with the institutional histories of these fields, including external reviewers. Part of the problem stems from the fact that the connections between foundational critiques of disciplinarity as such and the concrete project of critiquing a given disciplinary practice are often obscure. It may be one thing to critically assess practices that conform to existing disciplinary expectations, but it is often quite another to question the configuration itself. Yet unless the subject position of the critic in the institution is brought into the equation, the most significant epistemological and ethical issues remain obscure.

In a similar fashion, it appears to be one thing to critically engage our modernist practices, institutions, and professions, and quite another to question the configuration of modernity or modernities as such, as the present chapter in fact aims to do by locating the construction of one "modernity" at least outside the modern period. The objections often still voiced, for example, by anony-mous expert readers at leading presses and in leading institutional settings, as seen in what follows, reproduce at the meta-critical level the very same long-standing debates over cultural property that historically produced hierarchical power relations and hegemonic practices in the broad social arena beyond (but not apart from) academia. Misunderstanding such historical and epistemological complexities is not limited to the institutions of art history or ethnography, but endemic to the problems of disciplinarity as such, as other chapters in this volume also address.

At the (not-so-hidden) core of contention in New Mexican identity politics today is a fundamental disagreement between contemporary Western assump-tions that knowledge should be accessible to everyone, and the esoteric nature of certain Native American beliefs. According to Joseph Suina, a resident member of Cochiti Pueblo who teaches at the University of New Mexico, Native esoteric traditions account for the unwillingness of contemporary Pueblo people to discuss their sacred beliefs with outsiders:

Misinterpretation of Pueblo secrecy is partly due to differing views of knowledge held by different cultures. In the Anglo world, knowledge is highly regarded and its acquisition is rewarded in a variety of ways, including admiration of knowledge for its own sake ... But that is not the case in the Pueblo world. Like the Anglos, Pueblo Indians consider knowledge to be of high value. Some types of knowledge, however, are accessible only to the mature and responsible. This is particularly the case with esoteric information that requires a religious commitment.[10]

Many leading Native scholars and community leaders are more extreme than Suina in their rejection of the academic mainstream considered progressive and revisionist elsewhere.[11] "Westerners" are baffled by their resistance – which, in the final analysis, is not resistance to *ownership*, but rather resistance to the very *idea* of ownership. Some Native scholars, like Suina, express their engagements with society in terms such as "knowledge" familiar to the dominant culture, but it is important to bear in mind that the translation into the terms of the dominant culture is, unavoidably, only an approximation. Language itself carries a world view and, as Latin Americanists including James Lockhart, Sabine MacCormack, Louise Burkhart, Serge Grusinski, and too many others to name here, have studied in depth, terms such as "knowledge" and "religion" are bursting at the seams with culturally determined connotations. Again, it appears to be one thing to weigh critically practices that conform to existing disciplinary expectations, and quite another to question the configuration itself.

The latest generation of Warburg specialists as yet appears unwilling to address the possibility that elements of cultural evolutionary theory linger unrecognized in the master's innovative work. Yet it is patently contradictory to applaud a scholar's innovative approach to art as a form of material culture, while simultaneously extricating his interests in Indians from the popular culture of his own day, where romanticizing notions of "noble savages" resonate with his own mindset. The question goes to the heart of the contemporary concern with a critical understanding of the institutional origins of art history. In that regard, those aspects of Warburg's work that are no longer tenable need to be scrutinized *alongside* those aspects that still appear to be; anything less would be a mark of profound disrespect to a remarkable scholar.

In terms of the present chapter, it has been my reflection on the lack of an adequate historiographical and epistemological framework in recent Warburg scholarship that has led me to consider the historical sources of the representational conventions that Warburg employed in his photographs of ethnographic subjects. The following is a contribution to articulating the broader historical contexts of the institutionalization of art history.

# WARBURG AND THE "WILDWEST"

Roll film cameras were a very recent invention when Warburg used a handheld Kodak to document the Hemis katsina dance. The modernity of his technology aside, Warburg also relied on a pictorial genre established in the sixteenth century. His photographs of sacred (and private) Hopi ceremonies and of individual Hopi people are currently praised for the "spontaneity" of their composition. Yet images such as the famous shot of Warburg posing with an (unnamed!) Hopi "chief" are far from neutral representations (Figure 12.1).

Warburg employed formal conventions with a long history of serving as effective rhetorical strategies. The epistemological assumptions that inform his ethnographic images – in Derridean terms, the "teleology and hierarchy ... prescribed in the envelope of the question" – fall into the seams between art history and anthropology. As of this writing, neither profession charges itself with the responsibility of uncovering assumptions embodied in *images* of ethnographic subjects.

Given this history of institutional neglect, perhaps it not so surprising that Warburg's debts to popular culture have been overlooked, while his situatedness

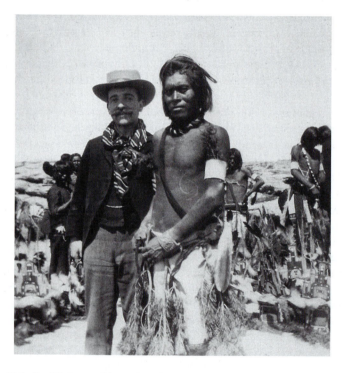

*Figure 12.1* Aby Warburg with unidentified Hopi Dancer, Oraibi, Arizona, May 1896.
*Source*: London, Warburg Institute Archives. Photograph courtesy of the archive.

with respect to elite culture and vanguard ideas have received such thorough attention. There are obvious parallels between Warburg's fascination with Indians and the contemporaneous popularity of the "Wildwest" in Germany, first in translations of novels by James Fenimore Cooper and painted images by German and American artists that were widely disseminated through prints, but also in other forms of popular material culture, such as the Columbian World's Fair Exposition of 1893 held in Chicago only three years before Warburg's American journey. The Exposition featured a scale model of the cliff dwellings at Mesa Verde, where Warburg began his own real life adventure.[12] German fascination with the American West attained unprecedented popularity through the writings of novelists like Karl May, one of Warburg's immediate contemporaries, who adopted the literary form of a firsthand report, even though he never set foot in the Southwest, and even promoted his self-fashioned identity visually, dressed as a cowboy in widely distributed photographic postcards. Such romanticizing records of cowboys and "noble savages" provide close contemporary parallels to the surviving photographic records of the German scholar-turned-tourist, dressed as a cowboy posing with an "Indian" (Figure 12.1). Warburg could not have been unaware of the ongoing German flirtation with the "West" any more than someone living almost anywhere on the planet today could be entirely ignorant of American Westerns.

Warburg's most uncanny debt to the existing typology of ethnographic portraiture, as the following inquiry into its initiating moment suggests, is his intention to study the "primitive" symbolic structures of "noble savages" in order to critique contemporary "civilized" society. Warburg's enterprise cannot be adequately understood without considering how his contested photographic images from the territory of New Mexico in fact constituted but one late nineteenth-century echo of a long practice of ethnographic study, one of whose initiating exemplars was the sixteenth-century Calvinist minister-turned-missionary Jean de Léry. Whether or not he was aware of the traces of this history embedded in his photographs is beside the point: what matters is that scholars not mask the actual epistemological, historical and, above all, political issues in our institutional critiques of disciplinary practices. In the second part of this chapter, I hope to show that, even when the epistemological concerns on the table *appear* to be contained within "purely" scientific and philosophical contexts (extricated from racialist thinking, as the current Warburg scholarship would like to believe), they require the same sensitivity to historical alliances between scholars and the institutions that support them as methods of analysis such as ethnography, long recognized within the domains of anthropology and the social sciences, whose ideological implications have received extensive criticism in recent years.

## DELIRIUM

Jean de Léry's *History of a Voyage to the Land of Brazil* (*Histoire d'un voyage fait en la terre du Brésil*), first published in 1578, was an instant success.[13] It was

Michel de Montaigne's main source of information for that famous critique of European society *Des Cannibales*, which established the noble savage as a utopian theme in modern thought.[14] De Léry's study of the Tupinamba people has recently attracted attention again. Claude Lévi-Strauss remarks in *Tristes Tropiques*, published in 1955, that he carried a copy of "that masterpiece of anthropological literature" when he arrived in Rio de Janeiro in 1934.[15] Michel de Certeau has called *History of a Voyage* the equivalent of a primal scene in the construction of ethnographic discourse.[16] *Tristes Tropiques* is itself a literary landmark because it is one of the first studies to call attention to the expository conventions of anthropological discourse. By 1988, when it was a commonplace in and outside the field of anthropology to study the relationship between systems of interpretation and their historical contexts (the history of the text as text), de Certeau referred to the lasting effect of *History of a Voyage* in negative terms. He argued that its author both preserves and masters alterity. The Calvinist missionary Jean de Léry turned revelation into a scientific concern for upholding the truth of things. Through his act of writing about the Tupinamba, de Léry made them appear fascinating to a European audience, while suppressing the natives' uncanniness.[17] Anthropologist James Clifford doesn't mince words either: ethnography has been a form of representation that establishes the ethnographer in a transcendent and transcendental position, "over-seeing" and explaining his subject according to his own categories of signification. Writing produces culture.[18]

Given the extent to which de Léry's *Voyage* has been studied, its acknowledged role as a foundational text for the discipline of anthropology, and the great critical interest that has recently fastened onto the history of vision in a number of fields, it is surprising that no one has ever examined de Léry's innovative illustrations. This oversight indicates how writing still exerts its logocentric power in anthropology. Outside the discipline proper, it suggests how the canonical hierarchy of Western art and its attendant distinctions between art and artifact continue to be maintained and reproduced in the scholarship: art historians have stayed away from this exemplary product of material culture, despite de Léry's recognized historical importance – recognized in another field, that is. De Léry informs us that he is personally responsible for the illustrations, and perhaps this unusual circumstance has exacerbated the problem of historical interpretation. Perhaps because he was not a trained artist – he has no oeuvre, no place at all in the historical roster of artists – we are not sure who is responsible for the remarkable woodcuts in the first edition.

In the first illustration of the book (Figure 12.2), we would tend to see a family portrait with a very large pineapple and a hammock in the background. However, as de Certeau and Clifford remind us, it is extremely important to exercise caution, so as not to project twentieth-century assumptions unnecessarily onto the material. The internal evidence of de Léry's text and the scene of European discourse in which I am going to locate his contribution suggest, rather, that this image registers information primarily about the typical forms of

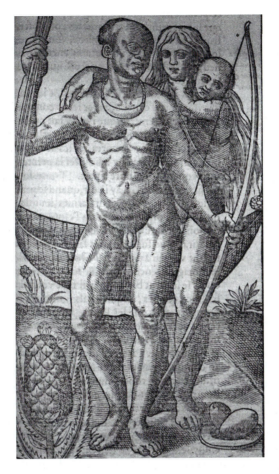

*Figure 12.2* Jean de Léry, illustration for Chapter 8 of *Histoire d'un voyage fait en la terre du Brésil autrement dite Amerique*, Geneva, 1578. Wood engraving.

*Source*: Photograph by Ken Iwamasa.

the Tupinamba nation – male, female, child, along with typical productions of nature and of human ingenuity. "Family" is a category that de Léry inherited, most immediately from sixteenth-century cosmographers like Johann Boem and Jean Bodin, who regarded it as the cornerstone of society.[19] In de Léry's narrative, discussion of customs different from our own predominate. De Léry confronted the problem of cultural difference, but his perceptions were filtered through inherited categories. His open-mindedness toward his subject, given that he was working with culturally determined and textually sanctioned categories like "family," "religious rites," "marriage customs," "food habits," and "burial practices," earned him his position at the foundation of modern ethnographic study. De Léry ennobled a people who were previously known only for

their sensational habit of cannibalism, but this is not the focus of the following discussion. On the contrary, I am interested in the rhetorical conventions that contribute to the credibility of de Léry's account – why did his original readers believe him? Why do we still view his illustrations and others like it as "scientific," without artifice, completely objective?

Before addressing these issues, let me note that I have used the words "nation" and "people" intentionally. The modern concept of "race" is applied completely anachronistically to this period. As a category, racial thinking emerged fully only in the nineteenth century.[20] In sixteenth-century Europe, the unity of all humankind was explained by our common descent from Adam and Eve. There was no abstract concept of or word for "race" in the sense of black or white, caucasian, negroid, oriental, and so forth. The sixteenth-century choices were different from our own: either the Tupi people were members of the human race, descended from wandering Ham or the lost tribes of Israel, or they were humanoids – that is, they were human in form only, lacking the distinctive rational powers that distinguish people from brutes (to use period language again).[21] Since de Léry addressed these very issues with his scientific reportage, it is important to bear in mind that sixteenth-century vernacular terms such as *natione, gente, raza* do not correspond to our own categories.

The text I am examining is at the foundation of later habits of classifying people according to their visual appearance. This is an important aspect of my interest in de Léry. But I am getting ahead of the discussion – let me return to the history of his illustrations. Since anthropologists and historians have been the only scholars to examine de Léry's work, it has been doubly awkward to deal with the problems of authorship and authenticity presented by his images, which ideally call for an art historian to review the record.[22] In turning to the problems of attribution – as a way of introducing more significant conceptual issues – let me clarify which illustrations I am talking about. I am not going to discuss the three narrative scenes which were added to subsequent editions, such as one depicting combat between Tupis and the Margaias in the foreground and a cannibalistic barbecue prepared by the victors in the background. No doubt these tried-and-true formulas borrowed from earlier travel accounts, as were the illustrations in the publication by de Léry's arch rival André Thevet were intended to meet public demand, that is, to increase sales.[23]

The illustrations that played an important role in the development of visual ethnography are quite unlike the narrative scenes derived from decorative paintings and manuscript illuminations. There are altogether five images of full-length figures engaged in typical daily activities. I would like to discuss the image (Figure 12.3) that illustrates the chapters on war and cannibalism.[24] Two extraordinarily muscular warriors are depicted with their weapons – we see not individual portraits, but two views of a single type, Tupi mannequins who display how their instruments of war function – how the bow is drawn, how well the combatants' physiques are developed to make it work. No violence. The reference to cannibalism is suppressed, but not excluded altogether, since

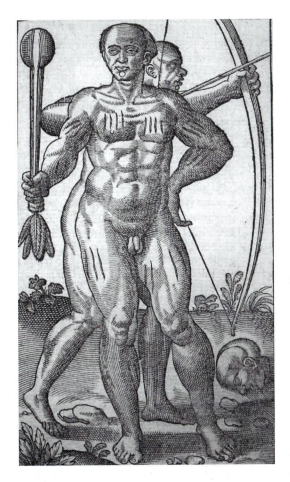

*Figure 12.3* Jean de Léry, illustration for Chapters 14 and 15 of *Histoire d'un voyage fait en la terre du Brésil autrement dite Amerique*, Geneva, 1578. Wood engraving.

*Source*: Photograph by Ken Iwamasa.

the head on the ground, conveniently cut off at the neck by the frame, refers discreetly to the dismemberment described elsewhere in the text, in the following unillustrated chapter on ceremonies of war, which precedes the chapter on religious rites.

Even today, ethnographic illustrations based on the format de Léry developed are considered "neutral," which is, as I hope to demonstrate, far from the case.[25] The pictorial conventions that we have been observing – iconic, sculpturally conceived figures, modeled in light and shadow, with only a bare indication of setting, are presented along with clear, conceptual contrasts – by which I mean the deliberate juxtaposition of subordinate features such as one head in frontal view next to the side view; or the juxtaposition of a pineapple in

the foreground with a hammock in the background. Without other distracting elements (and in the case of the pineapple, with sufficient knowledge of Aristotle to recognize the rudimentary comparison of the products of nature and man), the visual juxtapositions can be "read out" of the image as a conceptual contrast.[26] De Léry's organization of the picture on this methodological level is striking. His visual syntax allows the image to function in close correlation with the literary text. Clear visual juxtapositions direct the viewer to draw specific comparisons.

The visual antitheses in de Léry's illustrations mirror more complicated contrasts described in the text. A dialectic between image and text reinforces certain habits of conceptualization. For example, when de Léry describes the Tupinamba warrior, he treats his human subject as if it were a plant or animal – something you might see in real life or in a zoological or botanical text, but not a portrait of an individual, not a real person to engage in conversation. De Léry explains, moreover, that he has constructed this visual reference with specific contrasting elements for the reader's benefit, so that one can connect the appearance of the Tupi warrior (and, I might add, trigger one's memory) with the author's discussion of a nonvisual topic, namely the ritual context in which cannibalism is practiced among the Tupi people. The visual substitution of body decor for war activities makes the subject more attractive and less threatening – as de Certeau says, it turns the Tupis into the object of the viewer's pleasure – while the emotionally charged topic of Tupi anthropophagy is cut up and dispersed throughout the body of de Léry's work. We might say that the author's textual practice reproduces the ritual dissection and reassimilation of the fragmented subject into a new body, namely the ethnographic text. In the chapter under discussion, the subject of cannibalism is occluded under the neutral category of "life and manners," subcategory "dress," that de Léry inherited ultimately from Herodotus. De Léry avoids a sensationalist presentation and writes with scientific detachment:

> As for those who have committed these murders, they think that it is to their great glory and honor; the same day that they have dealt the death blow, they withdraw and have incisions made, to the point of drawing blood, on their chests, thighs, the thick part of their legs, and other parts of the body. And so that it may be visible all their lives, they rub these slits with certain mixtures and with a black powder that cannot ever be effaced. The more slashes they carry the more renowned they will be for having killed many prisoners, and they are consequently esteemed the more valiant by others. (So that you can understand this more clearly, I have repeated the illustration of the savage covered with slashes, next to whom there is another one drawing a bow.)[27]

It is impossible to say whether de Léry saw the same correlations between his authorial activities and the subject of his study that we might construe in terms of the continuity between literal and literary "cannibalism." We can be certain, however, that he consciously manipulated his discourse in numerous ways that I would now like to consider more fully. As we have already observed, he controls the reader's reading by illustrating some passages and not others, thus directing attention (and memory) to certain topics and certain thematic connections over others. With this skillful play of word and image in mind, let us first examine the immediate sources for de Léry's illustrations. No direct studies for the five woodcuts survive, but part of their history can be pieced together from extant copies of watercolors by the Huguenot artist Jacques Le Moyne de Morgues. Some of Le Moyne's studies survive second hand, in copies made by the English watercolorist John White when Le Moyne was in England from 1572 until his death in 1588.[28] Both Le Moyne and White were trained artists who accompanied early explorers and afterwards worked for Theodor de Bry, a Frankfurt printmaker who, beginning in 1588, published lavishly illustrated accounts of European explorations. We might think of his *Great Voyages* as *Life* magazines or *National Geographic*s of the early modern period. De Bry engraved drawings by both White and Le Moyne. Some of these illustrations accompanied his new edition of de Léry's *Voyage*.[29]

Various solutions have been proposed to account for the relationship among the images produced by de Léry, Le Moyne, White, and de Bry. Based on the surviving visual evidence and documentation, a straightforward explanation would be the following. Le Moyne's drawings, known through White's copies, must either be studies for the woodcuts or copies after them. Discrepancies between the woodcuts and the watercolors rule out the possibility that Le Moyne depended on the published illustrations, as is often assumed.[30] Revisions were made to conform with de Léry's text. The visual evidence strongly suggests that Le Moyne's watercolors were preparatory studies. Even though no direct link has ever been established between Le Moyne and de Léry, they must have come into direct contact through their Huguenot involvements.

Regardless of the complex problems of authorship, in the present context what really matters is that the illustrations were *and still are* accorded a kind of veracity, as if they were direct evidence of de Léry's firsthand experience with the Tupinamba. Yet the visual formulas are indebted to costume book illustrations. A considerable number of sixteenth-century publications were devoted to this topic. An innovative example would be the illustrations in one of the most lavish collections of manners and customs of the period, Braun and Hogenberg's *Civitates Orbes Terrarum*.[31] Sixteenth-century European audiences learned about voyages of discovery and conquest through the publication of sumptuous illustrated atlases organized by "nation" or "people." These "cosmographies," as they were often called, filtered information through long-established categories in the manuscript tradition of Herodotus, Pliny, Solinus, Isidore of Seville, Bartolomaeus Anglicus, and their printed counterparts beginning with

the *Nuremberg Chronicle*.[32] One reason for the continued popularity and credibility of this textual tradition must have been its flexibility – that is, due to the nature of the genre, pictorial encyclopedias were continually assimilating new information. Printing technology encouraged the constant development of novel visual models to attract a broad readership. Although the scale of de Léry's *Voyage* is modest judged against the most elaborate illustrated cultural geographies, his innovations were part of this new market for popular culture.

In comparison with White's watercolors, the figures in the printed edition of de Léry's *Voyage* are more muscular, the compositions are more compressed, the empty page is closed in around the figures. These formal elements, along with a sophisticated engraving technique employing multiple kinds of crosshatching to give the sculpturally conceived figures strong relief, the artist's command of anatomy, the energetic contours and daring foreshortening of his figures, all indicate that (an)other professional artist(s) played a role in the production process after Le Moyne. A professional engraver and a trained artist must have been responsible for the bold graphic designs of the final composition. De Léry's education only prepared him for the ministry. Yet he claimed to be responsible for the images – "speaking out of my own knowledge, that is, my own seeing and experience" – in a different sense from our modern understanding of artistic authority. The sixteenth-century idea that the patron of the work is its author encouraged de Léry to use a rhetorical technique as old as John Mandeville's account of dogheaded people and other monsters that de Léry actively sought to discredit.[33] The difference in de Léry's appeal to experience is that no one questioned the veracity of his images, not even modern revisionist writers like de Certeau who have studied the expository conventions of his writing.

## ANATOMY OF A TEXT

To better understand the rhetorical power of de Léry's scientific prose and pictorial presentation, I would now like to introduce another source, or rather context, for de Léry's designs, one that no anthropologist or historian has yet investigated. I would like to suggest that de Léry's presentation of the Tupinamba culture was indebted and to some extent perhaps even directed to ongoing debates about scientific method.[34] Aristotle and the second-century medical authority Galen were the most important textual authorities in these widespread discussions, which often took the form of polemical arguments published in commentaries or prefaces to other works. The greatest development of method took place within the medical tradition, which was the focus of considerable controversy.

De Léry's presentation, consistent with his theological views, is in the spirit of Galen's method to combine theoretical knowledge with direct experience. His precedents included Protestant reformers like the Lutheran Philip Melanchthon, who advocated a linear method of mathematical proof and spe-

cifically recommended the "anatomical method" of considering each subject according to the ten Aristotelian categories, proceeding by the analysis of phenomena into their parts and the examination of their interrelated function.[35] Andreas Vesalius's revolutionary anatomy text, entitled *De humani corporis fabrica*, and its companion volume, the *Epitome*, both published in Basel in 1543, arguably contain the most famous anatomical illustrations in all of medical history.[36] Vesalius provided de Léry with a compelling scientific model of illustration in the analytical mode. The rhetorical effectiveness of the *Fabrica* rests on the same equation as de Léry's between the author's direct experience and its artificial analogue in the visual presentation.[37] Vesalius, also like de Léry, claimed that he drew his own images directly from nature but actually employed professional artists working in a classicizing Renaissance style who were trained in the modern sciences of anatomy and optics, and were familiar with ancient theories of human proportion.

Even beyond these extensive similarities in aim and procedure, Vesalius's flayed muscle men provided de Léry with convincing visual prototypes for illustrating his text (Figure 12.4). Perhaps we could cautiously suggest that Vesalius's illustrations even conditioned the terms in which de Léry described the Tupinamba – their classicizing but excessively developed musculature, their bold but strange rhetorical gestures, the patterns incised in their skins, filled with black powder and worn as the sole body adornment, the representation of fragments – mimic the most characteristic and cherished qualities of the Vesalian muscle men: the overt references to classical sculpture appreciated in its modern decay; the humorous device of presenting a cadaver as a speaking, moving figure; the technique of modeling the forms with parallel lines of hatching and bold simplifications of the main lines of musculature.

I do not wish to argue, however, that de Léry's illustrations are indebted to Vesalius only for their convincing visual formulas or references to ancient sculpture. Vesalius's *Fabrica* and *Epitome* coordinate word and image in a minutely methodological sequence.[38] Vesalius balanced visual economy with anatomical completeness so that his reader could experience the procedure of dissection through the illustrations as if he were an eyewitness. The illustrations generally follow a linear method of demonstration from superficial to deep structures, but with sufficient complexity to incorporate visual comparisons, didactic devices to guide the student through the verbal, critical commentary. As Martin Kemp has discovered, sometimes Vesalius included details referring to the authority he disputes and sometimes he synthesized multiple dissections in a single image.[39] In other words, Vesalius's images, like de Léry's, function in an artificially constructed dialectical relationship with his verbal descriptions, masquerading under the sign of the natural. Reprinted in a revised and enlarged edition in 1555, plagiarized by a wide variety of authors who quickly disseminated Vesalius's ideas into English, French, German, and Spanish, there is no chance that the illustrated anatomical method of Vesalius was unknown to de Léry.

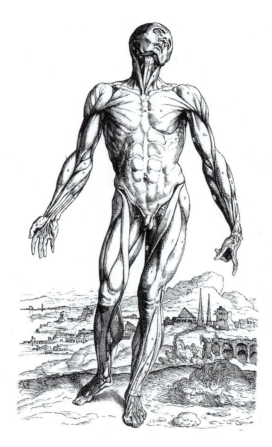

*Figure 12.4* Andreas Vesalius, "Anterior View of the Body," Plate 1, Book 2, *De humani corporis fabrica*, Basel, 1543. Wood engraving.

*Source*: Photograph by Ken Iwamasa.

The unusual circumstances that led de Léry to publish his account have been told many times.[40] A brief recapitulation at this juncture will clarify the specific historical context in which his appropriation of anatomical demonstration arose. De Léry trained for the ministry with Calvin in Geneva, from where he was summoned in 1556 by Admiral Gaspard de Coligny, a Huguenot sympathizer, and Nicolas Durant de Villegagnon to establish a reformed refuge and mission in Brazil. Villegagnon also engaged as his chaplain the Franciscan friar and Royal Cosmographer André Thevet. Such bitter disputes broke out between the Calvinist and Catholic factions in Brazil that de Léry sought shelter with the Tupinamba while he waited for a ship to take him home in 1558. The bitter dispute continued in Europe, where the main participants published rival accounts of the conflict between the Catholic and Huguenot missionaries and the Tupinamba. De Léry first drafted his in Geneva in 1563

but, due to his involvement in the Huguenot resistance, it did not appear in print until 1578.

De Léry's preface is written in a polemical style entirely different from the scientific exposition of the rest of his text. This shift in expository techniques should alert us to his sensitivity to different modes of argumentation. In the extended preface to the 1585 edition, de Léry contrasts Thevet's "*paradigme cosmographique*," with its false representations and geographical errors, its rhetorical figures that are "more appropriate to paintings and other metallic things that can be engraved and decorated artistically," with his own authentic report of what he has seen with his own eyes.[41] In the context of the present discussion of the unity of text and image in de Léry's discourse on the Tupinamba, and considering the care that he put into the production and description of his scientific illustrations, it is significant that he used an example of pictorial seductiveness to criticize Thevet's rhetorical method of argumentation. On the contrary, de Léry's own dissection of the evidence is grounded in Aristotelian methods of scientific demonstration, with its clear definition of the subject and subordinate sets of comparisons and contrasts. In keeping with these scientific underpinnings, his criticism of Thevet points away from the value of optical naturalism *per se*: a text can be embellished with superficial luster, but praiseworthy *elocutio* also has substance, because it is the manifestation of scientific method.

In conclusion, to emphasize why it is so important to recognize the rhetorical strategy of de Léry's scientific presentation – why the persuasive power of word and image in framing the ethnographic subject is of such great historical significance – I would like to refer his illustrations to the general context of printed images produced by Reformation writers. There is no room to develop this discussion here, but perhaps I can briefly indicate a productive direction for further investigation. Ambiguities circulating within de Léry's text – internal contradictions that I have characterized as rooted in tension between rhetorical and scientific modes of discourse – point to even greater ambiguities experienced by his readership. The strange French experiment in Rio de Janeiro that brought Catholics and Huguenots to blows 350 years before Lévi-Strauss disembarked in his tropical paradise was a tempest in a teapot compared to religious conflicts brewing in Europe. Both Reformation and Catholic factions used the Tupinamba and other Native American societies to make points about the religious opposition, and these complicated political allusions introduced a great deal of ambiguity into the new, ostensibly secular iconography.[42] Current scholarly debate over the reception of Reformation broadsheets indicates how difficult it is to interpret the so-called popular imagery.[43]

The politics of Reformation images are important to bear in mind, however, because de Léry was himself a Calvinist minister who, only two years before *History of a Voyage* appeared, published a scientific, descriptive account of the devastating siege of Sancerre, in which he participated.[44] The earlier publication confirms de Léry's commitment to peaceful resistance and also suggests that his representation of the Tupinamba conceals an ironic dimension. As de Léry

himself notes in his account of the famine he endured in the besieged city following the St. Bartholomew's Day Massacre, the Tubinambas' programed, ritual practice of war and cannibalism is a striking contrast to arbitrary acts of savage cannibalism and mob violence associated with the ongoing European religious conflicts.[45] Judging from the brief observations on the Tupinamba in the Sancerre volume, it is likely that de Léry also intended to provide his readers with a hortatory example in his extended, second account of Brazilian society. Most significantly for the modern discipline of anthropology, his implicit comparison between good Brazilian savages and bad European civilians, while it ennobles the savage, it also assigns the Tupinamba to an inferior position in the social and intellectual hierarchy – the equation is between all Indians (regardless of the actual structure of their own society) and all unruly peasants and artisans. In other words, a diametric contrast issuing from the double inversion of a negative stereotype endowed both Indians and Peasants with the attributes of a generalized category of humanity and relegated them both to an inferior position in society. Even in de Léry's verbal descriptions the pictorial dominates; and in the case of his *History of a Voyage*, as we have already seen in the comparison with Vesalius, he treats the image as primary evidence. The relations of power are embodied in his illustrations in conjunction with his text.

This chapter, unlike most of the contributions to this volume, stages an argument for the importance of understanding the construction of "modernism" that *preceded* the modern period. In opening the discussion with Warburg's problematic study of Hopi ritual, I wanted to plant a suggestion in readers' minds about the manner in which de Léry's rhetorical strategies continue to be reproduced in current disciplinary practices. The conjunction of word and image on the cover of the Warburg Institute's recent republication of Warburg's American photographs powerfully illustrates this phenomenon in play. In the book itself the title *Photographs at the Frontier* is superimposed directly on top of that (in)famous shot of the young Warburg pretending to be a cowboy, posing with a Hopi dancer whose ceremonial dress and bodypaint, although "authentic" in themselves, fictionalize his identity for most viewers. That is, for most contemporary as well as historical viewers – familiar with popular culture stereotypes of Indians but not with actual Hopi lifeways – such attire (mis)identifies the dancer as an Indian "warrior." As should now be clear from the foregoing discussion, the objectifying ethnographic frame of reference in the original photograph was conveyed visually through conventions of pose, framing, and costume. As a contemporary dust jacket, the photograph-cum-caption replays the same silent rhetorical strategies as operate in de Léry's book with a self-reflexive irony that is, nonetheless, incapable of divesting its former colonial ideology.

The *intended* irony of the dust jacket, conveyed by the superimposed title *qua* caption, is that Warburg's progressive ideas defined the frontier of a new field of study. An additional, presumably unintended, metacritical effect of the words-with-photographic image, however, reiterates (and wordlessly condones) the former colonial frame of reference: for, in effect, the dust jacket conveys that

the American subject matter in which Warburg pioneered his theoretical contribution to art history is still marginal to the field of art history. The American Southwest once was Europe's as well as art history's "frontier," but from a contemporary perspective this can no longer legitimately be the case. We live and work in a global network of social, political, and economic relationships – and uneven though the field of social production is from an economic point of view, there is no universally recognized set of ontological priorities operating within it. On the dust jacket, however, there is only room for Warburg and his unnamed companion to celebrate the Euro-American Wildwest fantasy while referring to Warburg's actual trip. The current, politically sensitive status of any Pueblo image of an esoteric, private ceremony – much less one that shows a katsina dancer without his mask – is denied any other status than that of "Other."

At a more general level, then, what I hope my study has done is articulate a major problem inherent in every center/periphery model of art history, because, in fact, the structure itself unavoidably reiterates the historical relations of power that its critical reemployments attempt to dismantle.

## NOTES

This chapter incorporates some of the research material originally published in a venue that is not easily accessible, as "Jean de Léry's Anatomy Lesson: The Persuasive Power of Word and Image in Constructing the Ethnographic Subject," in G. Szöny, ed., *European Iconography East & West*, Jozsef Attila University, Leiden, E.J. Brill, 1995, pp. 109–27. Deepest thanks to the editor of this volume, Elizabeth Mansfield, and Donald Preziosi for their extensive insights about the framing of this study. I am especially grateful to Beeke Sell Tower, who shared her own unpublished research on Karl May and nineteenth-century German fascination with the American West; and to my London audience at the International Congress on the History of Art, session on "Chronology" chaired by Donald Preziosi and Stephen Bann, 5 September 2000. For a more extensive discussion of Warburg's visit to the Hopi, written from the viewpoint of New Mexican religious art, see my chapter, "Re(f)using Art," in C. Farago, D. Pierce, with M. Stoller *et al.*, *Suffering History: Art, Identity, and the Ethics of Scholarship in New Mexico*, University Park, Pennsylvania State University Press, forthcoming.

1 For an excellent critical discussion of ethnographic research methods, see W. Madsen, "Religious Syncretism," in R. Walpole, ed., *Handbook of Middle American Indians*, vol. 6, Austin, University of Texas Press, 1967, pp. 369–91.

2 A. Warburg, "A Lecture on Serpent Ritual," *Journal of the Warburg Institute*, 1938–9, vol. 2, pp. 277–92.

3 A. Warburg, *Images from the Region of the Pueblo Indians of North America*, intro. and trans. M.P. Steinberg, Ithaca and London, Cornell University Press, 1995; *idem*, *Schlangenritual: Ein Reisebericht*, ed. U. Raulff, Berlin, K. Wagenbach, 1988; *idem*, "Image in Movement; Souvenirs of a Voyage to Pueblo Country (1923), and Project from a Voyage in America (1927)," ed. P.-A. Michaud, *Cahiers du Musée National d'Art Moderne*, Spring 1998, vol. 63, pp. 113–66; P.-A. Michaud, *Aby Warburg et l'image en mouvement suivi de Aby Warburg. Souvenirs d'un voyage en pays Pueblo (1923) et Projet de voyage en Amérique (1927)*, preface by G. Didi-Huberman, Paris, Macula, 1998; *idem*, *Il rituale de serpente*, afterword by U. Raulff, Milan, 1996.

4 Citing P. Burke, "Aby Warburg as Historical Anthropologist," in H. Bredekamp, M. Diers and C. Schoell-Glass, ed., *Aby Warburg: Akten des internationalen Symposions Hamburg 1990*, Weinheim, VCH, 1991, p. 44. See also K. Forster, "Aby Warburg: His Study of Ritual and Art on Two Continents," trans. D. Britt, *October*, Summer 1996, vol. 77, pp. 5–24.

5 E.H. Gombrich, *Aby Warburg: An Intellectual Biography, with a memoir on the history of the library by F. Saxl*, Chicago, University of Chicago Press, 1970, p. 91.

6 A clear statement of Warburg's objectives is the introduction to his lecture, omitted from the 1939 article but recently published by Steinberg (as in note 3), who translates: "In what ways can we perceive essential character traits of primitive pagan humanity? How did it [pagan humanity] maintain itself 'incapable of life, crippled by a dark superstition,'" a phrase eliminated as Warburg revised his manuscript. (Steinberg, "Aby Warburg's Kreuzlingen Lecture: A Reading," in Warburg, *Images from the Region of the Pueblo Indians*, p. 80.) On Warburg's relationship to the psychology of perception, especially R. Vischer, *Über das optische Formgefühl; ein Beitrag zur Aesthetik*, Leipzig, H. Credner, 1873, and Vischer's predecessors including Johann Hebart, Hermann Lotze, Nietzsche, and others, see most recently M. Rampley, "From Symbol to Allegory: Aby Warburg's Theory of Art," *Art Bulletin*, March 1997, vol. 79, pp. 41–55. These interests in "primitive" man cannot be disentangled from anthropology, especially important to Warburg's formation being Hermann Usener, his teacher: see U. Raulff, "The Seven Skins of the Snake: Oraibi, Kreuzlingen and back: Stations on a Journey into Light," pp. 64–74, and P. Burke, "History and Anthropology in 1900," pp. 21–7, both in B. Cestelli Guidi and N. Mann, ed., *Photographs at the Frontier: Aby Warburg in America 1895–1896*, London, Merrell Holberton with the Warburg Institute, 1998.

7 The burgeoning literature is too long to cite, but in addition to those references cited above, see in particular K.W. Forster's introduction to Aby Warburg, *The Renewal of Pagan Antiquity: Contributions to the Cultural History of the European Renaissance*, trans. D. Britt, Los Angeles, Getty Center, 1999, pp. 1–74; C. Naber, "Pompeii in Neu-Mexico: Aby Warburgs amerikanische Reise," *Freibeuter*, 1988, vol. 38, pp. 88–97; P.-A. Michaud, "Un Pueblo à Hambourg: Le Voyage d'Aby Warburg au Nouveau-Mexique, 1895–1896," *Cahiers du Musée national d'art moderne*, 1995, vol. 52, pp. 43–73; C. Schoell-Glass, "An Episode of Cultural Politics during the Weimar Republic: Aby Warburg and Thomas Mann Exchange a Letter Each," *Art History*, March 1998, vol. 21, pp. 107–28; M. Iverson, "Aby Warburg and the New Art History," in H. Bredekamp, M. Diers and C. Schoell-Glass, ed., *Aby Warburg. Akten*, pp. 281–7, and other essays in the same volume.

8 Despite a thorough rehearsal of the facts by Steinberg, Forster, and others, cited above. The only writer to my knowledge who has questioned the literature from a perspective even vaguely critical of collusions between contemporary scholars and Warburg's cultural chauvinism is the review of Steinberg's book by J.L. Koerner, "Paleface and Redskin," *The New Republic*, 24 March 1997, pp. 30–8.

9 B. Cestelli Guidi, "Retracing Aby Warburg's American Journey though his Photographs," in B. Cestelli Guidi and N. Mann, ed., *Photographs at the Frontier*, p. 28. The text continues: "With this image Warburg meant probably to emphasize the dancer's double identity, as a member of a symbolic world when wearing the mask and as a rational being when not. Warburg takes up this twofold identity the Indians assigned to all human beings, portraying himself as the protagonist of a magical transformation, when he draws a kachina mask over his own head."

10 J. Suina, "Pueblo Secrecy Result of Intrusions," *New Mexico Magazine*, January 1991, vol. 70, p. 60. Thanks to Zena Perlstone for bringing this article to my attention.

11 The most prominent example in the recent past is the negative response by Native American academics Alison Freese, Joe Sando, and others to the controversial book

by Chicano writer Ramón Gutierrrez: "Commentaries on Gutierrez, Ramón, *When Jesus Came, the Corn Mothers Went Away*," *American Indian Culture and Research Journal*, Fall 1993, vol. 17.

12 C.M. Hinsley, "The World as Marketplace: Commodification of the Exotic at the World's Columbian Exposition, Chicago, 1893," in I. Karp and S.D. Lavine, ed., *Exhibiting Cultures: The Poetics and Politics of Museum Display*, Washington–London: Smithsonian Institution Press, 1991, pp. 344–66. On Warburg's relationship with the Wetherhill Brothers, see Steinberg and Forster, as cited above, who never criticize the German art historian for his entrepreneurial activities.

13 J. de Léry, *Histoire d'un voyage faict en la terre du Brésil autrement dite Amerique, le tout recueilli sur les lieux par Jean de Léry*, Geneva and La Rochelle, Antoine Chuppin, 1578. Subsequent editions were published in 1580, 1585, 1594, 1599–1600, and 1611, and excerpts were incorporated in other works. For modern critical editions with further information on the publication history of the book, see de Léry, *Viagem à terra do Brasil*, trans. and notes by S. Milliet, ed. P. Gaffarel, notes on the Tupinamba by P. Ayrosa, São Paulo, Editora da Universidade de São Paulo, 1980 [orig. 1941]; and de Léry, *History of a Voyage to the Land of Brazil, Otherwise Called America*, trans. and intro. J. Whatley, Berkeley, University of California Press, 1990. Subsequent references will be to the Whatley edition.

14 M. de Montaigne, "Des Cannibales," in *Les Essais*, ed. M. Rat, 2 vols, Paris, Garnier, 1962, p. I. On Montaigne's unacknowledged dependence on literary sources, see B. Weinberg, "Montaigne's Readings for *Des Cannibales*," in G. Bernard Daniel, ed., *Renaissance and Other Studies in Honor of William Leon Wiley*, University of North Carolina Studies in the Romance Languages and Literatures, n. 72, pp. 261–79. On the continuity of de Léry's ideas in later early modern texts, see F. Lestringant, "The Philosopher's Breviary: Jean de Léry in the Enlightenment," *Representations*, Winter 1991, vol. 33, pp. 200–11, with further references.

15 C. Lévi-Strauss, *Tristes tropiques*, Paris, Plon, 1955; translation cited from *Tristes tropiques*, trans. J. Russell, New York, Atheneum, 1972.

16 M. de Certeau, *The Writing of History* [1975], trans. T. Conley, New York, Columbia University Press, 1988.

17 De Certeau, *The Writing of History*, p. 217.

18 J. Clifford, *The Predicament of Culture: Twentieth-Century Ethnography, Literature, and Art*, Cambridge and London, Harvard University Press, 1988. See also Clifford's useful historiographical overview of anthropology in his introduction to *Writing Culture: The Poetics and Politics of Ethnography*, ed. J. Clifford and G.E. Marcus, Berkeley and London, University of California Press, 1986, pp. 1–26.

19 On de Léry's textual precedents, see M.T. Hodgen, *Early Anthropology in the Sixteenth and Seventeenth Centuries*, Philadelphia, University of Pennsylvania Press, 1971 [orig. 1964].

20 See N. Stepan, *The Idea of Race in Science: Great Britain 1800–1960*, Hamden, Archon Books, 1982, with an extensive bibliography.

21 A. Pagden, *The Fall of Natural Man: The American Indian and the Origins of Comparative Ethnology*, Cambridge, Cambridge University Press, 1982; R. Bernheimer, *Wild Men in the Middle Ages: A Study in Art, Sentiment, and Demonology*, Cambridge, MA, Harvard University Press, 1952.

22 P. Hulton and D. Quinn, *The American Drawings of John White, 1577–1590, with Drawings of European and Oriental Subjects*, 2 vols, London, British Museum, and Chapel Hill, University of North Carolina Press, 1964; P. Hulton, *The Work of Jacques Le Moyne de Morgues, a Huguenot Artist in France, Florida, and England*, 2 vols, London, British Museum, 1977.

23 See F. Lestringant, *André Thevet: Cosmographe des derniers Valois*, Geneva, Droz, 1991; R. Schlesinger and A.P. Stabler, *André Thevet's North America: A Sixteenth-*

*Century View*, Kingston and Montreal, McGill-Queen's University Press, 1986. On the impact of printing technology, see L. Febvre and H.-J. Martin, *The Coming of the Book: The Impact of Printing 1450–1800* [1958], trans. D. Gerard, ed. G. Nowell-Smith and D. Wootton, London, NLB, 1976.

24 This illustration occurs twice: it accompanies Chapter XIV, entitled "Of the War, Combats, Boldness, and Arms of the Savages of America," and Chapter XV, entitled "How the Americans Treat Their Prisoners of War and the Ceremonies They Observe Both in Killing and in Eating Them" (translation cited from de Léry, *History of a Voyage*).

25 For example, Hulton and Quinn, *The American Drawings of John White*, p. 10, describe the "revolutionary naturalism" of White's figure style in terms of the artist's "unusual ability to free himself from European artistic conventions." The authors note the emergence of renderings made with "scientific detachment," but they do not provide a cultural critique of the historical notion of "scientific detachment" or touch upon the political implications of treating human subjects as depersonalized objects for scientific analysis. It would be a distorted representation of the authors' argument to suggest that they were insensitive to White's pictorial conventions, however. Hulton and Quinn note that White's watercolors are not drawn from life (see p. 9), and the following discussion in the present chapter is fundamentally indebted to their investigation of White's dependence on costume book illustrations and on the drawings of Jacques Le Moyne de Morgues.

26 A rich and varied commentary tradition is based on Aristotle, *Physics*, Book II (192b8–200b10). I have discussed the Renaissance artistic heritage of these neo-Aristotelian ideas in C. Farago, *Leonardo da Vinci's 'Paragone': A Critical Interpretation with a New Edition of the Text in the Codex Urbinas*, Leiden, E.J. Brill, 1992, especially pp. 137–53.

27 Translation cited from de Léry, *History of a Voyage*, p. 128. The immediately preceding paragraphs, not illustrated, describe (in terms that de Léry states are partly drawn from Francisco López de Gómara's *Historia general de las Indias* ... [Saragossa, 1552]) how the Tupinamba practice cannibalism.

28 Hulton and Quinn, *The American Drawings of John White* (as in note 10), includes an illustrated catalogue of White's drawings. To complicate matters further, some of White's drawings are known only in copies, made by members of his family between 1593 and 1614: on the "Sloane copies" and the British Museum copies, see pp. 24–30, pp. 145–7. The authors note that small differences between these and reproductions in de Léry's book show that the copies were not made directly from the woodcuts. It will be argued here that these differences indicate that White depended on preliminary drawings prepared for de Léry's book. On Le Moyne's tenure in England, see Hulton and Quinn, p. 8, where it is noted that White used Le Moyne's studies of Indian subjects to make his own general map of eastern North America, and further, on p. 23, that Theodor de Bry supplied White with drawings by Le Moyne of Florida.

29 T. de Bry, *Americae, tertia pars: Memorabile provinciae Brasiliae historiam* ..., Frankfurt, T. de Bry, 1592; and *Dritte Buch, Americae darinn Brasilia durch Johann Staden* ..., Frankfurt, T. de Bry, 1593.

30 Even the current editors of White's drawing corpus, Hulton and Quinn, *The American Drawings of John White*, are reticent to set out the lines of transmission among these sources, arguing that White's drawings are "after" de Léry, that White is "likely to have been influenced" by Le Moyne (pp. 7–10), that an intermediary source ("a lost original," p. 32) existed between de Léry's woodcuts and White's drawings. They accept at face value (p. 31) de Léry's account that his designs are truthful because they originated in drawings made in Brazil around 1555. For a longer discussion of problems of attribution, see my "Jean de Léry's Anatomy Lesson," as cited in the acknowledgments above.

31 G. Braun, S. Novella, and F. Hogenberg, *Civitates Orbes Terrarum*, 6 vols, Cologne, 1572–1618. The first important example of this illustrated literature on manners and customs is J. Boemus, *Omnium Gentium: mores, leges, and ritus* ... (1520).

32 See Hodgen, *Early Anthropology*, pp. 20ff., as cited in note 19.

33 On de Léry's repudiation of Mandevillian lies, which have been extensively studied with relation to his arch rival André Thevet, see Whatley's introduction to de Léry, *History of a Voyage*, pp. xxii ff. and following discussion in the present chapter. On the legitimacy of Mandeville, see further M. Campbell, *The Witness and the Other World: Exotic European Travel Writing, 400–1600*, Ithaca, Cornell University Press, 1988. I thank Eloise Quiñones Keber for calling this excellent study to my attention.

34 For an introduction to this history and the extensive scholarship, see the fundamental studies by O. Temkin, *Galenism: Rise and Decline of a Medical Philosophy*, Ithaca and London, Cornell University Press, 1973; N. Gilbert, *Renaissance Concepts of Method*, New York and London, Columbia University Press, 1960; W. Ong, *Ramus, Method, and the Decay of Dialogue: From the Art of Discourse to the Art of Reason*, Cambridge and London, Harvard University Press, 1958. A considerable part of these debates was addressed to the applied or productive sciences – a category in which painting was often included – that occupied a (disputed) place between routine skills and demonstrated knowledge. On debates concerning painting, see further Farago, *Leonardo da Vinci's 'Paragone'*.

35 See Gilbert, *Concepts of Method*, p. 39, on Aristotle, *Topics*, p. 100a18; and Gilbert, pp. 100–25, on methodological controversies from Padua and Bologna to Melanchthon's *Loci communes theologici*, which includes remarks on method in the preface by the Lutheran theologian Victorinus Strigelius (d. 1569).

36 A. Vesalius, *De humani corporis fabrica libri septem*, Basel, J. Oporinus, 1543 [facs. ed. Brussels, Culture et Civilisation, 1964; 2nd ed., 1555]; and *De humanis corporis fabrica librorum Epitome*, Basel, J. Oporinus, 1543; and *Icones anatomicae*, Munich, Bremer Press, 1934, printed from the original woodblocks used in the 1555 edition. The plates and generally reliable publication history of Vesalius's writings are conveniently available in J.B. Saunders and C. O'Malley, *The Illustrations from the Works of Andreas Vesalius of Brussels*, New York, World Publishing Company, 1950. The scholarship is too extensive to cite here, but recently see K.B. Roberts and J.D.W. Tomlinson, *The Fabric of the Body: European Traditions of Anatomical Illustration*, Oxford and New York, Clarendon Press, 1992, pp. 125–206, and specialized studies cited in the following notes.

37 Vesalius's debt to ancient sculpture has been treated most cogently by G. Harcourt, "Andreas Vesalius and the Anatomy of Antique Sculpture," *Representations*, Winter 1987, vol. 17, pp. 28–61, who argues that the illustrations are the visual equivalent of Vesalius's rhetorical attempt to establish the *opera manus* as the positive philosophical ground for the united science of medicine combining both theory and practice.

38 As stated by M. Kemp, "A Drawing for the *Fabrica*; and Some Thoughts upon the Vesalius Muscle-Men," *Medical History*, 1970, vol. 14 , pp. 277–88. This essay is particularly valuable for the simultaneously sober and extensive deductions it draws about the widely discussed topic of Vesalius's interaction with the artists who helped him design the plates, based on the fragmentary visual evidence that is available. A similarly systematic routine must have existed between de Léry and his assistants, though on a much more modest scale.

39 See note 38.

40 See notes 13–16.

41 J. de Léry, *Histoire d'un Voyage faict en la terre du Brésil*, 3rd ed., Geneva, 1585, p. 6 recto. In a different context, the importance of these passages has also been recognized by Frank Lestringant, "L'excursion brésilienne: Notes sur les trois premières éditions de l'*Histoire d'un Voyage* de Jean de Léry (1578–1585)," in P.-G. Castex,

ed., *Mélanges sur la littérature de la Renaissance à la mémoire de V.-L. Saulnier*, Geneva, Droz, 1984, pp. 53–72.

42 Whatley, Introduction, de Léry, *History of a Voyage*, p. xxix.

43 For an introduction to the issues, see K. Moxey, *Peasants, Warriors, and Wives: Popular Imagery in the Reformation*, Chicago and London, University of Chicago Press, 1989, who argues that some of the broadsheets are political satires of the subjects they depict, produced by artisans with a vested interest in keeping civil order (see p. 140, note 1, for further references); and M. Carroll, "Peasant Festivity and Political Identity in the Sixteenth Century," *Art History*, 1987, vol. 10, pp. 289–314, who takes the position that the same images construed peasant festivity in positive terms. In a future article, I will extend the analysis of de Léry's images to consider their relation to these Reformation broadsheets, which I can only mention here in passing.

44 G. Nakam, *Au lendemain de la Saint-Barthélemy: Guerre civile et famine*, with Jean de Léry, *Histoire mémorable du Siège de Sancerre (1573)*, Paris, Éditions anthropos, 1975. For the complicated publication history of *History of a Voyage*, see the clear synopsis in Whatley's introduction.

45 De Léry in Nakam, *Au lendemain de la Saint-Barthélemy*, pp. 290–3.

# 13

# ART HISTORY ON THE ACADEMIC FRINGE

## Taine's philosophy of art

### *Mary G. Morton*

Among Parisian intellectuals in the 1860s and 1870s, Hippolyte Taine had a reputation as a dynamic and sometimes controversial writer. He was prolific and polymathic, producing works of history and literary history, philosophy and psychology, criticism and journalism. In 1865, fresh from the publication of his well-received *Histoire de la littérature anglaise*, he initiated a series of lectures at the École des Beaux-Arts on the history of art which over the following five years were published in brief synopses under the title *Philosophie de l'art*. Through his lectures, Taine developed a systematic sociological approach to art history unprecedented in its breadth and rigor. Objectivity, empirical observation and careful documentation were positivist values that, according to Taine, could advance the study of history and culture to the level of progress and modernity attained by the natural sciences. By 1913 *Philosophie de l'art* was in its fourteenth edition, and had been translated into English, German, Danish, and Russian.

Taine's contextual approach to art history, extrapolated from his work on literature, was enormously influential. His name became associated with a method of interpreting art that would in the later twentieth century be labeled "social art history." The connections he drew between artistic production and its environment were compelling to several generations of artists and critics (including, notably, Emile Zola, who claimed Taine as his theoretical master). Taine's method of art history was not born within a formal "institution" of art history. As recent scholarship has elaborated, the discipline of art history was founded later in the century, and then in Germany and Austria.[1]

In addition to outlining the origins and nature of Taine's art historical method, this chapter describes the way in which Taine's method developed outside an art historical institution. That Taine operated largely on the margins of academia, establishing his profession as an independent journalist prior to attaining his position at the École des Beaux-Arts, distinguishes his non-specialized, un-disciplined art history from the German models with which the current field of art history is more familiar.

# TAINE AND THE ACADEMY

The French academic world during Taine's student years was contentious and highly partisan. The revolution of 1848, the chaotic years of the Second Republic, and Napoleon III's *coup d'état* in 1851 are often marked as watershed events in French intellectual history.[2] While the 1830s and 1840s are described as the crowning decades of romanticism and the development of liberal idealism, these mid-century events are credited with provoking a turn towards realism, both political and artistic. The perceived failure of ideology, both liberal and conservative, left many thinkers politically de-moralized. Taine's response to the Second Republic and Napoleon III's coup was one of defensive disengagement. He complained about the self-serving complicity between Napoleon and the Church, reserving his reformist faith for what he considered to be the disinterest of science.[3]

Taine's feeling for the great potential of science was influenced by a major figure in his early intellectual life, the seventeenth-century Dutch philosopher Benedict Spinoza. The Spinozist conception of the world as an organic system ordered not by God but by nature, the universal laws of which are rationally comprehensible to man through science, was revelatory to Taine as a young lycéen. During the same period, Taine immersed himself in the rational empiricism of Locke and French Enlightenment thinkers such as Condillac and Montesquieu who, like Spinoza, sought to integrate man into his natural and social environment. The power of rational empiricism to strip the world of the unknown, the mysterious, and the intangible, and to place the possibility of achieving certain truths within reach of the scientifically minded individual was enormously exciting to Taine. Also appealing was the positivists' sense of liberation from the dogmatic authority of official state and clerical philosophy. Positivism promised the displacement of the power of knowledge from *a priori* assertion to the empirical observations of the autonomous individual.

Equally influential during Taine's student years was the philosophy of Hegel, to which Taine was introduced by his philosophy professor at the Collège Bourbon, Charles Bernard. Bernard translated several of Hegel's works, completing *Poetics* in 1855. Following Spinoza, Hegel rejected the Christian world view in favor of one holding the world as a rationally comprehensible system, organized by dynamic laws. Taine was inspired by the breadth of Hegel's philosophy of history, which included analyses of a civilization's politics, ethics, aesthetics and religion, and by Hegel's ability to weave all of these aspects into a synthetic whole.[4] In 1851 Taine planned a thesis on the subject of Hegel, but was dissuaded by his advisor Étienne Vacherot. Given the conservative academic environment of the early 1850s, Vacherot's advice was wise and well-taken.

Official French philosophy in the early Second Empire was dominated by the eclecticism of Victor Cousin. Cousin championed what he called "an intelligent rehabilitation of spiritualism" in French thought through liberation from the oppressive cold logic of the Cartesian tradition and eighteenth century

empiricism. His work was central to the foundation of the romantic-idealist temperament that reigned in the decades preceding 1850. A professor at the Sorbonne and member of the French Academy, Cousin was appointed Minister of Public Education for Adolphe Thiers' cabinet in 1840. Transferring his philosophical agenda to the public realm, he defended the rightful role of religious instruction in schools in the interest of public morality and order. He conceded control of state religion and of public education to the Catholic clergy. By his critics, Cousin was known as "chief of police in the philosopher's world," protecting the Church against intellectual offense.[5]

Though Cousin resigned from the Sorbonne in 1851, he and his followers continued to control French academia well into the Second Empire. During the 1850s the government kept a vigilant eye on university instruction in the interest of protecting society from the threat of atheism and socialism. Under these circumstances, for an academic to publicly express doubts regarding the presence of the holy spirit in man or nature was to place his career in jeopardy.

Taine's first submission in 1854 to one of the annual contests sponsored by the Académie Française exacerbated an already difficult relationship with the Academy. The subject, issued by the Academy, was an interpretation and analysis of the work of the ancient Roman historian Livy. Taine's *Essai sur Tite-Live* was a manifesto for a new kind of history, one that would model its practice after that of science. Taine's new history was defined against the classical tradition, which erred in Taine's view in attempting to place judgment, exhort to virtue, instruct politically, excite emotionally or reform morally. The duty of the historian, Taine claimed, is not to persuade with eloquent or passionate language, but to suppress the distance of time, to put the reader face to face with the monuments and documents of the past. History, like science, should work only from the "true," and be based solely on objectively observed facts. Furthermore, to reconstruct a complete picture of the past, the historian must recognize that all aspects of institutions and human thought are linked to one another, as if organically, requiring a non-specialized, holisitic understanding. Finally, as in all scientific inquiry, the historian must proceed with great care to minimize inevitable errors and alterations of the truth. In sum, the new history was to be objective, empirical, synthetic, and systematic.

Taine's submission was denied the award, and his rejection by the Academy's committee, which included Victor Cousin, drew considerable attention.[6] According to the reports of members of the committee reviewing submissions in 1854, Cousin had been volubly disturbed by Taine's essay.[7] In letters to friends at the time, Taine railed against Cousin, to whom he referred as the *gendarme intellectuel*, for destroying art and science by making them instruments of pedagogy and government.[8] It is difficult to tell whether Taine's passionate embrace of positivism and German philosophy was the act of an uncompromising apolitical thinker, a clumsy careerist, a provocateur, or a blend of all three.

Taine's conflict with the Academy over his essay on Livy was one in a series of official rejections. At the end of his third year at the École Normale in Paris, during which he had received the highest praise from his professors, Taine suffered a crushing refusal of *agrégation* to the doctoral level. According to his own account and that of his biographer François Leger, the *agrégation* committee had been offended by Taine's hubris, as well as the strong strain of positivism running through his scholarship.[9]

As a consolation, Taine was offered an undistinguished position as a substitute teacher at a collège in Nevers, but was transferred to Poitiers after one year for disturbing parents and administrators with his materialist "doctrines." At the end of his year in Poitiers, he turned down what he considered to be an even more degrading position in Besançon, and returned to Paris in the fall of 1852 to earn his living as a private tutor and, he hoped, as a published critic.

## AN INDEPENDENT MAN OF LETTERS

Denied a place in the Academy, Taine's intellectual output of the 1850s appeared largely in journals and reviews. Having decided to pursue a career as an independent writer, a Parisian *homme de plume*, he debuted with essays on history and literature in the *Revue de l'instruction publique*, a journal with a reputation for publishing promising young writers. His articles with the *Revue de l'instruction* opened the door to the *Revue des deux mondes*, and in 1856 to the *Journal des débats*, the latter with which he shared a life-long collaboration. He also published volumes of travel notes, from trips to the Pyrenees (1855), Belgium, Holland and Germany (1858), England (1860) and finally Italy (1864). (It was from his Italian travelogue, *Voyage en Italie*, that Taine drew much of the "empirical research" for his École des Beaux-Arts lectures on Italian painting.)[10]

His essays and reviews of these years, as well as his preface to a collection of his essays published by Hachette in 1858, reflect an increasing immersion in the natural sciences. Beginning in 1853, Taine enrolled in courses in physiology at the Sorbonne, botany and zoology at the Muséum, and anatomy at the Salpêtrière. Taine's enthusiasm for the life sciences corresponded to an explosion in biological studies in Paris in the 1850s. As illustrated in the work of Jacob Opper, Taine was not alone in mining biology as a source of concepts, analogies, and metaphors.[11]

### Histoire de la littérature anglaise

Taine's first major publication was his epic survey of English literature, *Histoire de la littérature anglaise* (1863–9). Perhaps his best known and most durable text, *Littérature anglaise* developed some of the historiographical themes of *Tite-Live*. The text demonstrates the application of his "scientific" historical method to literature, setting up the art historical method presented in his École des Beaux-Arts lectures two years later. (Editor's note: see essay by Philip Walsh in this volume.)

Throughout *Littérature anglaise*, Taine proclaims the modern victory of positivism. According to Taine, this positivist revolution had come about not only through vast developments in natural science, but also through the influence of English positivist philosophy. During the early 1860s Taine submerged himself in English positivism, particularly in the work of J.S. Mill and Herbert Spencer. Mill's assertion that no real knowledge exists outside of laboratory work, and Spencer's study of the influence of the environment on mental health encouraged the evolution of Taine's methodology.[12]

In the introduction to *Littérature anglaise*, originally published as an essay in the *Revue germanique* under the title "L'Histoire, son présent et son avenir," Taine promises an application of this modern positivist method to literary history, establishing the biological sciences as a theoretical and methodological model. The historian, according to Taine, should view a civilization as the naturalist views a plant or animal, that is, as a system of interrelated parts. Borrowing from the anatomist Geoffroy Saint-Hilaire, Taine invokes the law of mutual dependencies, which enables the naturalist to divine the whole through knowledge of its parts. Introducing the phrase that Emile Zola would later help make infamous, "vice and virtue are products, like vitriol and sugar," Taine claimed that human ideas and sentiments participated in the phenomenal world as much as did physical matter, and that man's moral life, just like physical "facts," has discernible causes.[13] The scientific method, then, was equally appropriate to the physical and moral realms.

Taine then presents his signature "scientific" formula for analyzing historical phenomenon: *race*, *moment*, and *milieu*. In his published travel notes, Taine invoked the term *race* in describing the particular forms of behavior and mental and emotional characteristics of national groups. His concept of race, both in his travel diaries and as a part of his methodological formula, was not fixed on biology, and had little to do with issues of purity. It was neither determined nor definitive, always mediated by the other two factors in his formula, *milieu* and *moment*. *Race*, which he defined in his introduction to *Littérature anglaise* as the "internal mainsprings" of a civilization, incorporated elements of heredity, climate, geography, and psychology. It was equally applicable to both an ancient tribe dispersed across a continent, and a modern nation defined by its borders.

*Moment* and *milieu* were no more definitive. *Moment* signified a stable period of time as well as acquired momentum, and incorporated historical changes as well as continuity and tradition. In literary and art history, it included artistic precursors and successors. *Milieu*, the most comprehensive of the three causal elements, and the one which dominated Taine's analysis in both *Littérature anglaise* and *Philosophie de l'art*, included climatic, geographical, political, social, and psychological conditions. Taine's use of milieu carried scientific pretensions to a complete and precise explanation of the relationship between environment and literature. Where previous writers had suggested casual associations between milieu and culture, Taine sought causal connections that he labeled "laws."[14]

Central to the new kind of history Taine was advocating, and justifying *Littérature anglaise* as a historical project, was the role of art. Following his organic law of mutual dependencies, as well as cues from Hegel's *Aesthetics*, Taine posited art as a priviledged historical source. As an index of the psychological state of the individual artist and by extension of the broader culture, art served the new historian as superior empirical evidence. Art's primary value in Taine's method, then, was historical. Indeed, Taine defined an object's artistic beauty by the degree to which it served historical interests. That art was not only the product of its milieu but derived its value as a representation of its milieu was a concept that Taine would further develop in *Philosophie de l'art*.

## *Philosophie de l'art*

By the early 1860s Taine had achieved a reputation among intellectuals as a *dynamic* progressive thinker. *Littérature anglaise*, which initially appeared in installations in *Revue des deux mondes* and was published by Hachette as a complete volume in 1864, was widely read and well received. Taine published critical essays regularly in *Revue des deux mondes*, *Journal des débats* and *Revue de l'instruction publique*, some of which would be compiled and published in 1865 in a second volume of essays entitled *Nouveaux essais de critique et d'histoire*. He had also begun collaborating with an old friend from his lycée days, Emile Planat, called "Marcelin," on his chic new journal *La Vie parisienne*.

Despite his success as an independent writer, Taine still aspired to the steady income and research time afforded by an institutional position. In 1863 he applied for a post as examiner in history and German for the military academy of Saint-Cyr, and for a professorship in history and archaeology at the École des Beaux-Arts. His applications were again troubled by his reputation among academics and administrators as a dangerous thinker.[15] In the spring of 1863, provoked by publications like Taine's introduction to *Littérature anglaise*, the clerical academician Monseigneur Dupanloup launched an attack on Taine and two other positivists, Emile Littré and Ernest Renan, in an article entitled "Warning to the Young and to Fathers of Families." *Journal des débats* came to their defense and the exchange drew attention, further troubling their academic aspirations.[16] Littré's candidacy to the Academy the same year was declined, vigorously opposed by Dupanloup. (Littré was not admitted until 1870, an event to which Dupanloup responded by resigning.) The previous year Renan's progressive course at the Collège had caused such a commotion among the students that it was suspended by "superior order" four months after its inception. Taine's denial by the Academy of the Bordin Prize in 1864 again caused a journalistic skirmish, much to Taine's dismay (though, no doubt, to his publishers delight).[17]

Eventually, with the help of well-placed friends like the historian François Guizot and the minister of public instruction Victor Duruy, Taine was granted a

part-time position as examiner for the military academy at Saint-Cyr. In 1866 his appointment was again questioned and, having by then obtained the École des Beaux-Arts post, he gave up his post at Saint-Cyr.

Taine's attainment of the Beaux-Arts position was as much a result of academic politics as had been his earlier academic failures. The art historical content of the traditional curriculum had been presented through *Histoire de l'architecture* and *Histoire et antiquités*. The course of *Esthétique et histoire de l'art* was introduced to the Beaux-Arts curriculum in January of 1864. The new art history course was taught by Viollet le Duc, the medieval archaeologist and architectural historian. However, the course was so disturbed by the unruliness of the students that it was suspended after the sixth lesson.[18] Viollet le Duc, having been heckled from his first lecture, resigned his post.

The cause of the disruption in Viollet le Duc's course most likely was attributable more to recent changes made by the school's administration than to any specific content in Viollet le Duc's lectures. In his essay in Part I of the present anthology, Philip Hotchkiss Walsh accounts for and critiques the institutional negotiations surrounding the appointments of both Viollet-le-Duc and Taine. What follows, then, is a sketch of the issues salient to this chapter. In a decree of 13 March 1863, Superintendent of Beaux-Arts Nieuwerkerke essentially transferred control of the École des Beaux-Arts from the Academy to the imperial government, taking responsibility for the appointment of professors, administrators and competition jurors, and significantly modifying school rules.[19] Part of a more comprehensive attempt by Napoleon III's administration to gain authority over the arts, the changes seem to have displeased the students. An 1864 report from the Director of the École des Beaux-Arts, Robert Fleury, to Superintendent Nieuwerkerke implicates the 13 March decree in describing measures taken to maintain order.[20]

Taine had been suggested by Victor Duruy, the minister of public instruction, to his colleagues at the École des Beaux-Arts as a candidate capable of rallying those students discontented with the recent innovations. Where Viollet le Duc was perhaps seen as a symbol of the administration responsible for the changes, Taine stood for progressive, anti-authoritarian free thinking, a reputation born of his publications and the controversy surrounding them.[21] In *La vie parisienne* Marcelin reported that, on the first day of Taine's lectures, the ebullient crowd welcomed Taine with thundering applause. The cheering students followed his lecture with a long ovation, spilling out into the street to carry Taine to his carriage. Taine's popularity as a professor seems to have continued throughout his tenure, and to have attracted an audience beyond those enrolled in the École des Beaux-Arts.

Taine began his Beaux-Arts course on 29 January 1865 with two introductory lectures presenting his art historical method, followed by twelve lessons on Italian painting from the early thirteenth century to 1500. The following year Taine delivered eleven lessons on Italian painting from 1500 to its "decadence" in the late sixteenth and seventeenth centuries. In his third year he presented

ten lectures on the schools of Venice, Bologna and Naples, as well as two theoretical lectures on the ideal in art. In 1868 he delivered twelve lectures on Netherlandish painting, and in 1869 twelve lectures on the history of sculpture in ancient Greece. He would repeat this complete cycle three times.[22]

Following each year of this cycle, Taine published material from his lectures, first in either *Revue des cours littéraires* or *Journal des débats*, and then in small volumes published by Bailliére. The volumes were titled as follows: *Philosophie de l'art par H. Taine: Leçons professées à l'École des Beaux-Arts* (1865), *Philosophie de l'art en Italie* (1866), *De l'idéal dans l'art* (1867), *Philosophie de l'art dans les Pays-Bas* (1868), and *Philosophie de l'art en Grèce* (1869). In 1881 all of the above Balliére volumes were compiled by Hachette into a two volume set entitled simply *Philosophie de l'art*. The published texts include a summary portion of the material prepared by Taine for presentation at the École des Beaux-Arts. Taine's lecture notes, held in his archive at the Bibliothèque Nationale, give a more complete picture of Taine's art historical methodology and its application to specific artists and periods.[23]

Taine's method, the application of which rhetorically drives and structures the lecture series, consisted of re-inserting art into its historical "ensemble," a process that, he claimed, would effectively explain its meaning. As in *Littérature anglaise*, Taine argued that the production of art was not an isolated phenomenon. In order to be understood, art must be considered within the context of the career of the artist, the school to which he belonged, and the society and culture that surrounded it. Essential to his definition of *milieu* was a kind of psychological community which he called "the general state of mind and mode of behavior" (*l'état général de l'esprit et des moeurs*) common to both the artist and his public. Artists shared with their society not only their nationality and historical moment, but also their basic education and lifestyle. Furthermore, artists were obliged to accommodate public taste in order to be generally understood and approved of. This necessary relationship between art and its social environment, in Taine's credo, was the primary law governing art history.

## TAINE'S POSITION WITHIN ART HISTORICAL DISCOURSE

In his opening lecture, Taine claimed that his philosophy of art offered "scientific" knowledge that was disinterested and universal. He articulated his positivist philosophy of art against what he described as the dogmatic "old method," which defined beauty as an expression of an invisible ideal on the authority of which it condemned, absolved, and guided. Taine thus expressly rejects the pedagogical role of the École des Beaux-Arts professor, defining himself as a more liberal, unbiased demonstrator of "facts." His was the self-proclaimed "modern method," a scientific mode of analyzing the causes and dominant characteristics of human works, which rather than proscribing or pardoning, merely stated and explained. Each individual was left the liberty to

study that which conformed to his temperament and contributed most to the development of his own mind. The modern method had sympathy for all forms and schools of art, valued equally as so many manifestations of the human mind. In its rigor and objectivity, Taine claimed, his method followed the "contemporary movement" (positivism) which sought to bring together the moral and the natural sciences, endowing the former with the principles, direction and precautions of the latter, as well as its sense of solidity and progress.

The emphatic response of the Beaux-Arts students to Taine's introductory lecture was likely inspired in part by the radical sound of his propositions, their democratizing, decentralizing tone. Casting his method of instruction as tolerant and progressive, he implied a transfer of power from the authority of the Academy to the individual student. At the same time, Taine was allying the study of art history with the most progressive, intellectually exciting discipline of the moment, the natural sciences. Taine's art history, through its association with science, appropriated that discipline's aura of rigor and regulation, as well as a place alongside it on the cutting edge of contemporary intellectual activity.

By the mid-1860s the natural sciences had achieved an unprecedented level of prestige and popularity.[24] Scientific debates were conducted in the public arena as a vast number of both popular and specialized publications appeared, influencing the way non-specialists thought about their world. Recognizing the natural sciences as the center of vibrant thought in France, Taine envisioned a rejuvenation of French philosophy through contact with science. He was particularly impressed by the work of the anatomist Charles Robin and of the physiologist Claude Bernard, whose *L'Introduction à l'étude de la médecine expérimentale* of 1865 was an immediate best-seller.[25] In a letter to Sainte-Beuve during the summer of his first year at the École des Beaux-Arts, Taine cited Robin's anatomy course, published by Baillière, as a model of reasoned investigation and methodical classification. He goes on: "It's this that every historian of soul must extract. Like Claude Bernard, he surpasses his specialty and it is with specialists like him that poor unhappy philosophy, surrendered to the gloved and perfumed-by-holy-water hands, will find capable husbands to give her children again, a rare and scandalous operation in France."[26]

Thus Taine saw his scientific aesthetic as an antidote to such impotent evils as spiritualist eclecticism, to which his "gloved and perfumed" comment refers. The Christian metaphysical aesthetic of Victor Cousin and his followers was a clear Tainian target. Cousin claimed in his *Du vrai, du beau et du bien* (1837) that the goal of art should be the expression of moral and spiritual beauty with the aid of physical beauty. Théodore Jouffroy, Cousin's most ardent disciple, located the aim and expression of art within the timeless and universal realm of the soul.[27] These critics defined art as spiritual rather than empirical revelation.

Taine's aesthetic also countered elements of the prevailing romantic aesthetic. Though, as his lectures unfolded, Taine did not completely discard the notion of genius, his repeated assertion that art was not an isolated act of caprice rejects the romantic view of art as the idiosyncratic expression of a

uniquely gifted individual. Taine's emphasis on the external conditions of artistic production, and on the socially integrated role of the artist counters the romantic emphasis on the artist's inner life, and on his transcendence over collective society. Intimations of madness and disease which clung to the romantic artistic conception were also antithetical to Taine's ideal of art as the result of a sane, rational mind.[28]

Taine's demand that critics perform objectively, witholding judgment and supplying only the "facts," was contrary to the self-perception of 1860s critics influenced by romanticism. Writers such as Théophile Gautier, Charles Baudelaire and the Goncourt brothers saw themselves as cultivated men of taste, professional aesthetes uniquely sensitive to the special gifts and talents of artists. The elitist, aristocratic tones of Gautier's doctrine of *l'art pour l'art*, which explicitly removed art from social praxis, reserving for it a world apart, free of utilitarian demands, stood opposite Taine's quasi-populist definition of art.

Another Tainian target was the academic view of art as a vessel in the transmission of classical tradition. One dominant voice in art historical discourse that championed the absolute, timeless ideals of classicism was that of Charles Blanc, director emeritus of the École des Beaux-Arts and founder of the *Gazette des beaux-arts*. From 1860 to 1866 he published in the *Gazette* his *Grammaire des arts*, addressing what he saw as a national weakness in the area of aesthetics. Viewing his *Grammaire* as a work of public instruction, he stated his mission as the improvement of artistic conditions and taste through the revitalization of classical ideals. In Blanc's theory the significant stages of the artistic process are autonomous of milieu, taking place in the inner world of the soul and spirit. Art history, in Blanc's account, is an equally autonomous process in which artistic quality rises or declines according to its respect or neglect of its own "internal laws."

Among the most common styles of art history, one utilized by both romantic and neo-classical writers, was the monograph. Blanc's popular *Histoire des peintres* (1849–76), for example, whose collaborators included Théophile Thoré, Paul Mantz, Théophile Silvestre and Marius Chaumelin, was a series of monographic accounts of the old masters. The art historian and critic Charles Clément wrote monographic articles for *Journal des débats*, some of which Taine collected for use in his Beaux-Arts lectures. Art historiographical descendants of Vasari's *Lives*, these works were odes to individual genius and consisted of biographical information and descriptions of the artist's works with varying degrees of critical analysis. Taine's concentration on the artist's milieu provided an alternative art historical focus, one more encompassing and, in Taine's mind, closer to a true picture of the artist and his work.

## TAINE'S CONTRIBUTION TO ART HISTORIOGRAPHY

Though, as suggested above, Taine's positivist prose was a response to contemporary intellectual currents in a variety of fields (biology and anatomy, art and

literary criticism, philosophy, and psychology), it was also a response to the need he saw in historical studies for a more systematic methodology and a less subjective approach. Taine's emphasis on "facts" was an attempt to distinguish between the conscientious, methodical analysis of evidence, on the one hand, and history writing which served overtly propagandistic or purely literary ends on the other. He conceded that history was an art, drawing on the imagination, but he demanded that it strive for objectivity, and that it operate according to quantifiable rules and methods. Taine's methodological struggle is familiar to debates in intellectual and cultural history of the last few decades regarding the distinction between literature and history.[29] Like the liberal humanist position in contemporary debates, Taine professed his belief that knowledge of human history is empowering and liberating, and that our own historical moment is in part determined by the past.[30] Such a position values the effort to maintain a disinterested inquiry. Though Taine's attempt at such an inquiry was not entirely successful, he can be credited with having thoroughly articulated a position of enduring relevance.

Perhaps Taine's most significant contribution to art historiography was his extension of art historical discourse beyond issues of artistic biography and stylistic evolution. In his theorization and demonstration of a socio-historical method applied to art, Taine took his cue from a long line of critics viewing art within its context, including most eminently Hegel, but also Goethe, Montesquieu, Madame de Staël, Guizot, Stendahl and Sainte-Beuve. Taine's innovation was the systematic articulation and demonstration of the relationship between art and its environment, a relationship only vaguely expressed by eighteenth-century aestheticians and nineteenth-century romantic critics. His explicit illustrations of the potential ways in which artistic production might be affected by a society's political and economic structure, social habits, communal psychology, and physical environment, and his steady focus on the nexus between art and milieu, were unprecedented. He invalidated the aestheticist conception of art as an isolated phenomenon, demonstrating in case after case the variety of ways in which milieu played a role in art's production, and in which artists were symbiotically tied to society.

Taine's "historical aesthetic" reaffirmed the value of art in historical interpretation, and suggested ways in which historians might use artworks as primary sources. His innovative approach to artworks as historical documents elicited not merely literal, narrative information, descriptive scenes of life and figures of the time, but synthetic evocations of socio-psychological meaning. Refuting idealist, neo-classical and spritualist aesthetics, Taine argued the historical relativity of beauty. As the historian Gabriel Monod stated in *Revue blanche* in 1897: "He penetrated into every mind the idea, today banal, that an artwork is not interesting as a piece of research of an ideal of beauty identical across all ages, but as an expression of the sentiment which that age, country, man had of beauty."[31]

The institutionalization of art history as an academic discipline did not take place until the 1870s and 1880s, and then it happened in Germany, not France.

Taine's integrative style of art history would be developed and practiced by historians like Karl Lamprecht, Anton Springer and Henri Pirenne as an alternative to the formalist methods of writers like Conrad Fiedler, Alois Riegl and Heinrich Wölfflin. Theorists like Wölfflin explicitly enlisted Taine as a target against which to define a formalist method which restored the concept of art as a socially autonomous object produced by a disinterested creative genius. In part as a result of pressures on the new discipline to distinguish itself from other disciplines such as cultural history, early twentieth century art history was dominated by this camp, narrowing its scope to focus on the art object, and away from its context.[32] Formalist art history followed the line of anti-Tainian art criticism of the 1870s, 1880s and 1890s in attacking Taine's limitation of artistic expression to the social, and his neglect of the artistic drive to transcend and escape mundane reality.[33] Not until the 1960s and 1970s, under the influence of radical ideologies including Marxism and feminism, would academic art history turn again to a more contextual approach.

## NOTES

1   See for example M. Podro, *The Critical Historians of Art*, New Haven and London, Yale University Press, 1982; M.A. Holly, *Panofsky and the Foundations of Art History*, Ithaca and London, Cornell University Press, 1984; M. Iversen, *Alois Riegl: Art History and Theory*, Cambridge, Mass., MIT Press, 1993; M. Olin, *Forms of Representation in Alois Riegl's Theory of Art*, University Park, Penn. State University Press, 1992; and K. Brush, *The Shaping of Art History: Wilhelm Voge, Adolph Goldschmidt and the Study of Medieval Art*, New York, Cambridge University Press, 1996.

2   See for example I. Babbitt, *Masters of Modern French Literature*, Boston, Houghton Mifflin, 1912, p. 130; A. Guérard, *French Civilization in the Nineteenth Century*, London, T.F. Unwin, 1912, p. 144; and V. Giraud, *Essai sur Taine: son oeuvre et son influence*, Paris, Hachette, 1902, pp. 177–85.

3   "We must work; as Socrates said, we alone are occupied with the true politics, politics are science." *H. Taine: sa vie et sa correspondance*, ed. P. Dubois, Paris, Hachette, 1902, vol. I, p. 171.

4   For the influence of Hegel on Taine's thought, see D.D. Rosca, *L'Influence de Hegel sur Taine*, Paris, J. Gamber, 1928.

5   J. Simon, *Victor Cousin*, trans. M. Anderson, Chicago, University of Chicago Press, 1888.

6   Other members included Villemain, Béranger, Vigny, Saint-Marc, and Girardin. See Taine, *Vie et correspondance*, vol. I, p. 60. For an account of Taine's candidacy for academic honors for his Livy essay, see P. Lombardo, "H. Taine: Between Art and Science," *Yale French Studies*, 1990, vol. 77, pp.117–33.

7   As Taine put it in a letter to Guillaume Guizot: "One doesn't admit that there is another philosophy of history, and above all else that it could be taken from contemporaries and worse, from Germans." *Vie et correspondance*, vol. II, p. 60.

8   Taine, *Vie et correspondance*, vol. II, p. 122.

9   Taine, *Vie et correspondance*, vol. I, pp. 121–30, and F. Leger, *Monseiur Taine*, Paris, Critérion, 1993, pp. 58–64.

10   *Voyage en Italie*, Pairs, Hachette, 1864.

11   Opper cites Goethe, Hegel, Comte, and Spencer as thinkers who used the biological

root metaphor of the evolving organism. J. Opper, *Science and the Arts: A Study in Relationships from 1600–1900*, Rutherford, NJ, Fairleigh Dickinson University Press, 1973, p. 37.

12 See Taine's 1864 study of Mill in *Le positivisme anglais, étude sur Stuart Mill* (Paris, Baillière) and his references to Mill and Spencer in *History of English Literature*, trans. H. Van Laun, New York, Henry Holt, 1879.

13 Hippolyte Taine, *Histoire de littérature anglaise*, vol. 1, Paris, Hachette, 1863–9, p. xv.

14 "Milieu" as a term occurs in Balzac's preface to his *Comédie humaine*, in which it is borrowed from Saint-Hilaire's zoology, to signify the habitat of an animal. Comte also made frequent use of the term. The concept of *milieu* as a way of explaining literature through its relationship with its environment, particularly its climate and social condition, has a long tradition. Montaigne, Montesquieu, Goethe and Mme. De Staël all used *milieu*. See R. Wellek, "Hippolyte Taine's Literary Theory and Criticism," *Criticism*, 1959, vol. I, no. 1, pp. 1–18, and vol. I, no. 2, pp. 123–38, and H.A. Needham, *Le Développement de l'ésthetique sociologique en France et en Angleterre aux XIXe siècle*, Paris, H. Champion, 1929.

15 In a letter of 4 January 1863, to François Guizot, Taine informs him that his candidacy was compromised by the "passionate or mediocrely sincere" representation of him as a "dangerous man imbued with perverse opinions." Taine, *Vie et correspondance*, vol. II, p. 266. Unless otherwise indicated, all translations are author's.

16 Taine, *Vie et correspondance*, vol. II, p. 193.

17 "I give you my word I never dreamed in writing to make a scandal," Taine claimed in a letter of 1864 to Cornelis de Witt. Taine, *Vie et correspondance*, vol. II, p. 305.

18 AJ 52–440: *Discours et rapports des directeurs. Archives de l'École Nationale Supérieur des Beaux Arts* in the Archives Nationales, Paris.

19 For a discussion of the École des Beaux-Arts reforms of 1863, see A. Boime, *The Academy and French Painting in the Nineteenth Century*, London, Phaidon, 1971.

20 Measures taken included the placement of a guardian in each studio with instructions to evacuate and shut down troublesome studios for a time period appropriate to the gravity of the disorder. See AN AJ 52–440, Archives Nationales.

21 Taine, *Vie et correspondance*, vol. II, p. 274.

22 Taine remained on the faculty roster at the École des Beaux-Arts until 1888. See AN AJ 52.39–40, Archives Nationales.

23 For an extensive account of Taine's Beaux-Arts lectures, see M.G. Morton, "Naturalism and Nostalgia: Hippolyte Taine's Lectures on Art History at the École des Beaux-Arts, 1865–1869," Ph.D. diss., Brown University, 1998.

24 See L.J. Jordanova, ed., *Languages of Nature: Critical Essays on Science and Literature*, New Brunswick, NJ, Rutgers University Press, 1986, p. 26.

25 Emile Zola was particularly influenced by Bernard's text.

26 Taine, *Vie et correspondance*, vol. II, pp. 320–21.

27 Théodore Jouffroy, *Cours d'esthétique*, Paris, Hachette, 1843.

28 For the relationship between Taine's decadent view of romanticism and the discourse of degeneration in mid-century France, see Morton, "Naturalism and Nostalgia," Chapter 3.

29 See, for instance, Georg Iggers' response to Hayden White's assertion that all history is literature. Iggers maintains a fundamental difference between poetry or fiction on the one hand, and historical analysis practiced with methodological and conceptual rigor on the other. He defends history as a discipline guided by consensual rules of inquiry and methodology (H. White, *Metahistory: The Historical Imagination in 19th Century Europe*, Baltimore, Johns Hopkins University Press, 1973; and G. Iggers, *New Directions in European Historiography*, Middletown, Conn., Wesleyan University Press, 1984). See also Thomas Crow's review of Donald Preziosi's

*Rethinking Art History*, in which he defends the modernist project to distinguish history from fiction, to discipline the historical imagination, and to set limits on what can be seen as constituting a historical event. T. Crow, *Art in America*, April 1990, vol. 78, pp. 43–5.

30 See for instance Taine's response to critics of his determinist attitude, in which he claims that his aim in practicing history like a science is to secure the kind of power and control granted man by the natural sciences. Preface to *Essais de critiques et d'histoire*, 2nd edition, Paris, Hachette, 1866, pp. iii–xii.

31 "Quelques opinions sur l'oeuvre de H. Taine," *Revue blanche*, 15 août, 1897, p. 279.

32 For an account of the development of cultural history and art history as separate disciplines in Germany and Austria in the 1880s and 1890s, see K. Brush, "The Cultural Historian Karl Lamprecht: Practitioner and Progenitor of Art History," *Central European History*, 1994, vol. 26, no. 2, pp. 139–64.

33 On anti-Tainian art criticism, see A. Bougot, *Essai sur la critique d'art: ses principes, sa méthode, son histoire en France*, Paris, Hachette, 1977, p. 359.

# Part III

# THE PRACTICE OF ART HISTORY

## Discourse and method as institution

# 14

# "FOR CONNOISSEURS"

## *The Burlington Magazine* 1903–11

*Helen Rees Leahy*

In March 1978 the editor of *The Burlington Magazine*, Benedict Nicolson, celebrated the 900th number of the journal by reflecting on the enormous social changes that had occurred during the seventy-five years since the *Burlington* had first appeared in March 1903. As he said, 1903 "was a different age": during that year, Lord Rosebery held a party for the inmates of the Epsom workhouse to celebrate his son's coming of age and Edward VII became the first English monarch to be received by a Pope since the Reformation. Nicolson also noted "many pleasing symbols of continuity" that had survived the vicissitudes of the twentieth century, including *The Burlington Magazine* itself.[1] For in 1978 the *Burlington* remained dedicated to the exposition of "scientific" connoisseurship that had inspired its creation in 1903. The same is true today for, apparently immune to the impact of critical theory on the discipline of art history, the authority of the *Burlington* still resides in its reputation for publishing the most significant attributions and discoveries made in Italian archives and the corridors of English country houses, and their impact on the unending project of (re)forming the canon.

When the *Burlington* was founded in 1903, art history was, according to Nicolson, "developing rapidly" as was demonstrated by the number of scholarly publications issued that year, including Bernard Berenson's *Drawings of the Florentine Painters*, Lord Balcarres' monograph on Donatello, and volume seven of Wilhelm Von Bode's magisterial Rembrandt catalogue.[2] And yet, despite all this activity, "… a strange and curious anomaly" existed, "… namely that Britain, alone of all cultured European countries, [was] without any periodical which makes the serious and disinterested study of ancient art its chief occupation."[3] It was to fill this vacuum, and so restore British scholarly credentials on the European stage, that *The Burlington Magazine* was founded. On this basis alone, its creation can be regarded as an important moment in the institutionalization of art history in Britain.[4] However, as this chapter shows, from the moment of its inception the *Burlington* was the focus of a series of connected struggles which, far from being "disinterested," were engaged over the legitimization of art historical expertise and, by extension, over the power to authorize acquisitions by both public museums and private collectors.

Undoubtedly the most powerful figure in the history of *The Burlington Magazine* from 1903 to 1911 was Roger Fry. Although he did not officially become editor until 1909,[5] Fry's influence over editorial issues was evident throughout the period.[6] At the beginning of 1904 Fry became *de facto* publisher of the *Burlington*, having effectively formed the company that bought the journal from the liquidators into whose control it had fallen within six months of its launch. For the next few years he also did the most to raise the money required to keep the venture afloat, not least by exploiting his "curious power ... of charming millionaires" to extract support for the journal from the art collecting plutocracy of America.[7] Reflecting his keen involvement with the magazine, the campaigns waged by the *Burlington* during the 1900s were, inevitably, the causes dearest to Fry. And whenever he disputed an attribution made by a contributor to the magazine, Fry reacted as if its inclusion in the *Burlington* was a reflection on his own scholarship.

Ever since his first visit to Italy in 1891, the Italian School had become a subject of intense interest and study for Fry, and the publication of his short monograph on Giovanni Bellini in 1899 had established his credentials in the field. By dedicating the volume to Bernard Berenson, Fry acknowledged both his friendship with Berenson at that time and also his regard for his connoisseurship. For, like Berenson, Fry (a natural scientist by training) had been greatly influenced by Giovanni Morelli's morphological method of identifying paintings and his insistence on the primacy of systematic observation.[8] When travelling in Italy in 1894, Fry had written that he and his companion Augustus Daniel[9] "... work here at the galleries all day long and read Morelli in the evening."[10] Presumably, it was on such a visit to Italy that Fry first met Berenson in the 1890s. Although the circumstances of their introduction are not known, by the fall of 1898 the two men were corresponding regularly.

Four years later *The Burlington Magazine* was founded and the tenor of the relationship between Berenson and Fry had shifted from master and disciple to wary rivalry, as Fry became both more ambitious and more successful. For his part, Berenson admired Fry's elegant style of writing but was increasingly critical of his "superficial method."[11] Outwardly, the pair sustained a prickly friendship, consolidated by their shared antipathy towards their competitors in the study of Italian old masters, notably R. Langton Douglas and Sandford Arthur Strong. With the publication of his *History of Siena* in 1902, Douglas, a former Church of England chaplain at Siena, had assumed the rights of sole proprietor over the Sienese school in general and over Sassetta in particular.[12] Douglas was also a friend of Robert Dell, the first editor of the *Burlington*, and the bitter dispute that had simmered for some years between Douglas and Berenson quickly erupted in the pages of the new journal as each man battled to promote his expertise at the expense of the other.

In a similar dispute with S.A. Strong, Fry argued that the authority of himself, his friends, and the *Burlington* would be jeopardized if certain attributions made by Strong were not explicitly contested in the magazine. Strong,

librarian for the 8th Duke of Devonshire, had published the first catalogue of the Chatsworth old master drawings in 1902 and, according to Fry, the catalogue contained "... one or two really obvious howlers in the matter of attributions." These, he said, would have to be pointed out in the *Burlington* in view of the fact that "Berenson, [Herbert] Horne and I are the Italian advisers."[13] However, not for the first nor the last time, the exercise of pure judgment was compromised by the practical business of magazine publishing: Strong controlled the supply of plates of the Devonshire drawings for reproduction in the *Burlington* and, in Fry's view, secured a friendlier review than he deserved.

There are no surviving archives of *The Burlington Magazine* before 1920 and so the precise circumstances of its creation, and the role of Fry, Berenson, and Horne as "an inner group of activists" on the project, are unknown.[14] However, the surviving correspondence between, and the memoirs of, some of the leading protagonists (including Fry, Charles Holmes, and the Berensons) reveals much about its disputatious formation and early years. From these sources, it is clear that what was at stake in the battles between Fry, Berenson, Douglas, Dell, Strong *et al.* was dominance of a powerful platform for the promotion of art history, at a time when it was impossible to take a degree in the subject in a British university and when a "professional" art historian had yet to be appointed to the directorship of the National Gallery.

The prospectus announcing the creation of *The Burlington Magazine* listed an impressive Consultative Committee, combining a judicious blend of aristocracy and scholarship. In addition to Fry, Berenson, and Horne, the Committee included Lord Dillon, Lord Balcarres, D.S. MacColl, Sir Martin Conway, Sir Charles Holroyd, Sidney Colvin, Sir Herbert Cook, Campbell Dodgson, and Claude Phillips. Perspectives from the United States and from Germany respectively were provided by Charles Eliot Norton and Dr Wilhelm Von Bode.[15] The design of the magazine's first cover and distinctive page layout was provided by the versatile Horne.[16] The founding editor was the journalist Robert Dell, a defector from the *Connoisseur*, which had been founded just two years earlier, in 1901. The *Connoisseur*, which at that time did not share the intellectual aspirations of the *Burlington*, carried the strapline "For Collectors"; by contrast, the *Burlington* declared (somewhat confusingly) that it was "For Connoisseurs."

The first issue of the *Burlington* appeared in March 1903, and by the following fall it had already run into severe financial difficulties and its survival was in the hands of its printers and other creditors. The crisis prompted a battle not only for the survival but also for control of the magazine, from which Fry emerged victorious, while both Berenson and Dell were, to a greater and lesser degree, marginalized. Dell's own effort to rescue the magazine had the influential support of Lord Windsor and the financial backing of the diamond and ostrich feather millionaire Alfred Beit. However, Dell's attempts to recapitalize the business were dealt a severe blow when he discovered that he had lost the confidence of the printer, Spottiswoode, in whose

hands the future of the magazine appeared to reside. For without either his or Fry's knowledge, the printers had approached the art critic of the *Saturday Review*, D.S. MacColl, to take over as editor. MacColl turned down their offer, but in first revealing it to his friend Fry he greatly strengthened Fry's own efforts to save (and take over) the journal.

Fry did not yet propose himself as editor, but instead installed his assistant art critic on *The Athenaeum*, Charles Holmes, in the new position of joint editor alongside Dell. The following remark of Holmes's indicates the nature of the relationship between him and Fry at the time: as articles in *The Athenaeum* were unsigned, "... it was essential that there should be no glaring discrepancies in presentation, and I was flattered when Miss Fry confessed that she had mistaken one of my articles for her brother's writing."[17] It was, therefore, in the manner of a senior partner to his junior that Fry summoned Holmes to London on 7 September 1903 to join the mission to rescue the *Burlington*.[18]

At this stage, Fry's other ally on the *Burlington* was Bernard Berenson. Like Fry, Berenson had a strong personal interest in the survival of the journal as a medium for the promotion of *his* reputation as a connoisseur and critic.[19] Berenson accompanied Fry to meetings with the printers while he was in London during that busy September, and Fry hoped that he and his wife, Mary, would elicit support for the journal during their subsequent trip to America. In the event, no such funds were forthcoming via the Berensons, and it fell to Fry and Holmes to "tramp" around London "money-begging" to save the periodical.[20] Meanwhile, number seven was published as a joint September–October issue, and *The Burlington Magazine* went into voluntary liquidation at the end of October. Further numbers were published in both November and December under the *de facto* management of Holmes and Dell.

By 17 November Fry could report to Mary Berenson that he had raised £2,500 and now only needed a further £1,500 in order to form a new company to publish the *Burlington*. The plan was to issue 100 ordinary shares, of which Fry and Holmes would retain a controlling majority. The remaining shares would be allotted *pro rata* to other subscribers and Fry was – at least ostensibly – keen that Berenson should buy some. "Hasn't B.B. sold any pictures," he asked Mary, "... and couldn't he take at least a few hundred?"[21] The answer was an emphatic "no": Berenson evidently regarded the invitation to buy shares without influence as a snub which effectively ended his involvement with *The Burlington Magazine* for the next thirty-six years. In Mary's view, Fry "... must have known ... that B.B. would not go on, unless he were certain of being consulted about the Italian things, and I do think it is very stupid of him to calmly kick us out of all authority and yet expect to make use of us."[22]

The break was conclusive, and henceforth Berenson's name was removed from the list of the magazine's Consultative Committee. His departure was not, however, unexpected as, in addition to the financial tensions of the fall, the first nine months of publication had been marked by jealous argument between

Berenson and other contributors to the young *Burlington*, notably Douglas. At issue were the competing claims to a superior knowledge of art history between, on the one side, the shaky alliance of Berenson, Fry, and Horne and, on the other, Douglas (who was a friend of Dell) and Strong. And, as with all questions of attribution, there was a commercial interest at stake. At the time, Fry, Horne, Douglas, and Berenson were all involved in dealing and each knew that the financial rewards of the commercial application of "disinterested" scholarship could be considerable.[23]

Initially, Berenson's authority as *the* leading expert on Italian painters appeared to be confirmed by his authorship of the leading article in the first edition of the *Burlington*. The subject of the piece was his successful construction of the "artistic personality" whom he called "Alunno di Domenico."[24] Although the article was, according to the author, written several years prior to its publication in the *Burlington*, its hypothesis was elegantly vindicated by the revelation of new evidence while it was "in the press": namely, the discovery of a contract of 1488 which not only established the existence of Berenson's putative artist, but which also gave his historical name as Bartolommeo di Giovanni. Here was documentary proof of what Berenson ironically described as "the deductions of mere connoisseurship."[25] The article was a triumphant exposition of Berenson's application and development of Morelli's method, and its prominence in the founding issue signaled the *Burlington*'s recognition of his primacy among his peers.

However, Berenson's authority in the *Burlington* did not remain unchallenged for long. Two months later an article on Sassetta by Douglas, pointedly entitled "A Forgotten Painter," appeared in the magazine.[26] The piece opened with a direct assault on Berenson's former neglect of the Sienese master: "[Sassetta's] name did not occur in Mr. Berenson's list of Central Italian Painters ... "[27] Ironically, it was Mary Berenson herself who had approved (presumably an earlier version of) Douglas's article when it was sent to her by Dell in an attempt to diffuse the entirely predictable row that would erupt when Berenson learned of Douglas's attack on his expertise.[28] Aware that recently Berenson *had* developed an interest in Sassetta, Douglas continued: "Neglect is the forerunner of exaggeration. The man who realizes keenly that a dogma or individual has been overlooked is prone to over-rate the one or the other." In writing this, Douglas may or may not have been aware of Berenson's own plans to publish a study of Sassetta, also in the *Burlington*.

Berenson's essay "A Sienese Painter of the Franciscan Legend" appeared in two parts in September–October and November 1903 against the backdrop of the financial crisis at the *Burlington*.[29] In contrast to Douglas's rather dry discussion of Sassetta's life and *oeuvre*, part one of Berenson's essay was an emotive exploration of Sassetta's achievement in depicting the "Franciscan ideal." In his view, Sassetta's use of "imaginative design ... , as a bearer of the true Franciscan perfume of the soul, has no rival."[30] For Berenson, the work that demonstrated this most clearly was the polyptych altarpiece created by

Sassetta for the Borgo San Sepulcro, the rear of which showed eight stories from the life of St. Francis. Berenson also used the article to reveal that he himself owned one of the St. Francis panels from the altarpiece: it was news calculated to fuel Douglas's anger. For, according to Samuels, the Berensons had found the panel in a junk shop in Florence in 1900, but had not revealed their discovery to Douglas, who was in the process of writing his *History of Siena*.[31] Such an incursion onto the Sienese territory over which he felt that he alone presided was intolerable to Douglas.

In part two of the article, Berenson reverted to a reconstruction of Sassetta's Sienese *oeuvre* and influences, as a means of illuminating his "artistic personality." However, prior to the publication of the second part, Dell gave his friend Douglas permission to annotate Berenson's text (presumably with the knowledge of Holmes and Fry). As a result, it appeared in the *Burlington* with editorial notes crediting Douglas for discoveries which he claimed that he, rather than Berenson, had made.[32] Then, to compound the insult, Douglas was given a further opportunity to respond to Berenson's articles in the December issue, pointing out past discrepancies in Berenson's published views and sarcastically congratulating him for recently adopting "the views of his more serious and sympathetic critics."[33] So far as outstanding disagreements between the two were concerned, Douglas attributed them to Berenson's "occasional" susceptibility to a "partial or complete atrophy of the sense of quality."[34] In short, Douglas occupied ten pages of the *Burlington* with an outpouring of highly personal vitriol.

The publication of Douglas's attack, combined with what he regarded as Fry's maneuvers to marginalize him from the management of the journal, signaled the end of Berenson's involvement with the *Burlington*. He did not write for the journal again until 1940, sixteen years after Fry's death. Relations between Berenson and Fry never fully recovered from this episode, although they did achieve a tentative rapprochement on news of the death in 1916 of their former colleague on the *Burlington*, Herbert Horne.[35]

By the end of 1903 Fry and Holmes held effective control of *The Burlington Magazine*. Holmes's name preceded Dell's on the business pages of the journal, and he and Fry planned future issues over a monthly dinner *à deux*.[36] However, the extent to which Fry still regarded Holmes as the junior partner in their relationship became clear when, in 1904, much to the annoyance of Fry, Holmes defended the National Gallery's purchase of a putative Dürer from the collection of the Marquess of Northampton. Even at the time, the attribution to Dürer was widely contested and its optimistic acceptance by the National Gallery trustees was, as Holmes later noted, "severely criticized."[37] In fact, the *Burlington*'s support for the purchase was highly unusual because in 1904 the magazine was about to embark on a concerted campaign of criticism of the National Gallery board. As a later editor of *The Burlington Magazine* has commented, "picking the scabs of the Edwardian art world" would become a feature of her predecessors' editorials.[38]

On the occasion of the "Dürer" purchase, Holmes's immediate difficulty was that the eminent critic Claude Phillips had originally agreed to write about the work and, in honor of the occasion, he had ordered an expensive photogravure plate to be made and printed.[39] When Phillips withdrew his article in the face of growing doubts about the attribution, Holmes felt obliged to defend his costly frontispiece.[40] Fry's *amour propre* was injured by association with Holmes's judgment and he immediately "disowned" his article as "a hasty and unscholarly attribution."[41] The following month the *Burlington* printed a group of short pieces on the issue, the most authoritative of which (by Campbell Dodgson and Fry himself) explicitly rejected the hypothesis that the work was autograph Dürer.[42]

In 1904 the struggle was thus engaged between *The Burlington Magazine* and the trustees of the National Gallery for the right to authorize acquisitions for the national collection. The charge of collective incompetence leveled against the Gallery trustees by the *Burlington* was compounded by their continued failure to resist the export of works of art from British private collections to collectors and museums in America, France, and Germany. The flow of old masters out of Britain had been signaled by the sale of pictures from the collection of the Dukes of Marlborough at Blenheim Palace in the mid-1880s, and would continue unabated for the next twenty-five years.[43] Criticism of the National Gallery in the *Burlington* repeatedly returned to the issue of the erosion of British patrimony until, in 1911, events reached a crisis with the export of Rembrandt's *The Mill* from the collection of the 5th Marquess of Lansdowne. Lansdowne was himself one of the senior trustees of the National Gallery and the spectacle of a custodian of the national collection selling his finest painting to an American millionaire provided the critics of the National Gallery with their most potent charge to date.

In the years 1903 to 1911 the assault on the Gallery trustees was not confined to the pages of the *Burlington*: campaign allies included Claude Phillips in the *Daily Telegraph* and D.S. MacColl in the *Saturday Review*. But it was the *Burlington* that provided the most consistent focus of attack: its editors' repeated denunciations were invariably based on the contrast between their own and their contributors' expertise and authority, and the inept judgment of the National Gallery board. Just as the internecine squabbles and jealousies that broke out between writers for the *Burlington* were symptomatic of a new institutional formation, so the journal's battle with the National Gallery demonstrated the desire of a new generation of professional connoisseurs to infiltrate the most powerful art institution in the country. The rest of this article discusses the effects of the campaign up to the climactic year of 1911.

In the 1900s the alliances between plutocratic and aristocratic fortunes and families that were changing the character and mores of society in the years preceding the First World War were scarcely evident in the composition of the National Gallery board. For the first eighty years of the Gallery's history, the

board had been dominated by men in political life, largely drawn from the landed aristocracy and gentry. Yet during the 1890s and 1900s, when the Gallery became increasingly dependent on new wealth to support its purchases, the pace of plutocratic – let alone professional – recruitment to the Board slowed rather than increased.[44] On the contrary, the tradition of what Holmes called "hereditary patronage" persisted so that, in his words, the trustees had "political and social influence; they represent great private accumulations of art treasures; and they directly control the National Gallery."[45]

The editors of the *Burlington* objected to the notion that private ownership of an art collection (particularly one that was inherited) still connoted the right to manage the national collection, to the exclusion of professional men with superior expertise – like themselves. Moreover, as members of the landowning elite, the trustees belonged to (and thus represented) that class of owners who, by selling their paintings for the highest price, were failing to recognize a legitimate national interest in their family inheritance. According to the *Burlington*, the trustees were therefore doubly unfit for their role: property (rather than expertise) was no longer a credible qualification for the custody of the national collection; and, as the peers of those men who were now selling their inheritance abroad, the implausibility of their claim to represent the national interest had been exposed. The aim (and indeed the result) of the Burlington's campaign was what Fyfe describes as "an aesthetic partnership between the state, the professional class and a declining aristocracy."[46]

At issue was not only the competence of the trustees themselves, but also their failure to appoint a suitably qualified director: that is to say, an art historian. From 1894 to 1904, Sir Edward Poynter had occupied the position, but Poynter was also President of the Royal Academy and, therefore, in the view of the *Burlington*, lacked both the time and the credentials required to do the job properly. According to D.S. MacColl, who agreed with Holmes and Fry on this issue, Poynter was stretched too thinly and so was "at a disadvantage, even supposing his competence in knowledge and taste to be of the highest ... "[47] When it came to the question of his replacement, instead of the British tendency to appoint a comfortable committee man or even a good administrator, the *Burlington* pressed the view that: "Critical knowledge is ... far more essential than administrative capacity."[48]

As President of the Royal Academy *and* Director of the National Gallery, Poynter was also vulnerable to a charge of conflict of interest over the administration of the Chantrey Bequest which, at the time, provided the primary source of funding for the purchase of modern pictures for the national collection.[49] The campaign to reform the administration of the Bequest was led by MacColl, who showed that the Academicians had consistently misused the bequest to buy pictures by their own number, rather than, for example, by deceased British artists or by foreign artists residing in Britain, both of which categories qualified for purchase under the terms of the bequest. MacColl's indictment of the RA was echoed by Holmes in the *Burlington* who, in characteristically pompous

style, commented that MacColl had "some apparent reason" for his accusations.[50]

However, the reform of the Chantrey Bequest was really MacColl's cause and, in the early years of the *Burlington*, Holmes and Fry repeatedly returned to *their* abiding obsession: namely, the management of the nation's old masters and the power of the National Gallery trustees over acquisitions. One problem was that, under the Gallery's constitution, even a well-qualified director would be subordinate to the collective will of the amateur trustees. Under the terms of the Treasury Minute of 1894, the director had become a member of the board, which henceforth assumed collective power to take all important decisions, including the choice of acquisitions. From the start, the effects of the Minute were regarded as disastrous: five days after it came into effect, the trustees exercised their collective judgment for the first time by rejecting the 6th Earl of Darnley's offer of the *Rape of Europa* for the very reasonable price of £15,000. Two years later, the painting was sold by the 7th Earl to Isabella Stewart Gardner for £20,000, with Berenson acting as intermediary.[51]

As Holmes later commented, "from an autocrat, the Director became one vote on a Board of seven," adding that "now ... the trustees had to get inured to reading in the papers about the many grave blunders for which they were responsible and the masterpieces they were constantly allowing to leave the country."[52] The fact that throughout the 1900s Fry, as well as Berenson, was an active protagonist in the transatlantic trade in old masters was, not surprisingly, ignored in the editorials of the *Burlington*.[53] Indeed, Holmes and Fry shared the view that it was not the Americans (or their agents) who were at fault; rather, the problem lay with the greed of British sellers, combined with the passivity of National Gallery board. In 1909 Holmes noted ironically that the "few important works of art which still remain in private possession here ... are of no interest to the modern Englishman who inherits them, and the money for the real necessities of life – more motors, more frocks, more dinners – has to be found somewhere."[54] Two years later, Fry commented: "The American side of this vexed question is by far the brightest. Possessed of the requisite wealth ... the financial magnates of the United States are prepared to devote a considerable portion of this wealth to the acquisition of certain objects of historical and artistic interest which the country itself cannot produce or acquire in any other way."[55]

Meanwhile, whenever the director of the National Gallery did, occasionally, succeed in resisting the trustees' collective will, he could be assured of support from the *Burlington*. A subsequent sale from the Darnley collection illustrates the point. In January 1904 the 8th Earl offered to the Gallery a *Portrait of the Lords Stuart* by Van Dyck for £30,000 and a *Portrait of Ariosto* by Titian for £35,000. In response, the trustees offered just £40,000 for the pair. Darnley rejected the offer, sold the Van Dyck elsewhere and then, after months of stalemate, dropped the price of the Titian to £30,000. The Gallery trustees were now divided between those in favor of the purchase and those who were

emphatically against it at this price.[56] However, Poynter was eager to buy the picture and began to solicit discreet support for the purchase from wealthy supporters of the Gallery. As a result, he raised £21,000,[57] and the remaining £9,000 for the purchase was made up from a special Treasury grant and the Gallery's own resources.

The completion of the acquisition was a victory for the director in the face of trustee opposition and, as such, it received both extensive coverage and praise in the pages of the *Burlington* where it was applauded as evidence of directorial initiative and good art historical judgment. Holmes believed that the acquisition of the portrait filled a significant gap in the representation of Titian's *oeuvre* in the national collection, while Fry reopened a lively debate that had been instigated by Herbert Cook, who believed that the painting was by Giorgione.[58]

A few months later, at the end of 1904, following the debacle over the Dürer and the controversy over the Titian, Poynter resigned as director. The ensuing delay of over a year in the appointment of his successor created a vacuum within the management of the National Gallery that its critics were quick not only to condemn, but also to fill via direct action. In May 1905 Holmes's familiar call for reform was infused with a call to private initiative in the face of official inaction: "Almost everywhere we see a change in the attitude of private individuals towards the State ... men of intelligence are taking the law into their own hands and doing what the State is always too busy to do. The movement is an entirely healthy one ... "[59]

By the end of 1905 the editorial could have been interpreted as a declaration of intent, as action followed rhetoric and a voluntary society, the National Art-Collections Fund (NA-CF), launched its first major public appeal to purchase Velázquez' *Rokeby Venus* for the National Gallery.[60] The inaugural general meeting of the NA-CF had taken place on 10 November 1903, just six months after the launch of *The Burlington Magazine*.[61] As Elam has noted: "This conjunction was not pure coincidence."[62] For a start, many of the founders of the *Burlington* were also instrumental in the creation of the NA-CF, including Fry, Holmes, Philips, Cook, MacColl, Balcarres, Martin Conway, and Lionel Cust. Moreover, the early agency of the NA-CF was just as much an assault on the autonomy and authority of the National Gallery trustees as a typical editorial in the *Burlington*: the difference was that, whereas the magazine was overtly critical, the NA-CF thinly disguised its attack in the form of philanthropic support.

There is no evidence to suggest that the National Gallery trustees wanted to buy Velázquez' *Rokeby Venus* when it came on to the market at the end of 1905. Its provenance made no irresistible claim on the national collection[63] and, on the market for some £50,000, it was also exceptionally expensive. Under such circumstances, any scheme to buy the picture would be an act of calculated audacity, designed to court both publicity and controversy. Yet this was precisely the course that the NA-CF decided to pursue, with the full support of *The Burlington Magazine*. The position of Gallery director was still unfilled when

the *Rokeby Venus* came on to the market at the end of 1905; after waiting for eleven months for the vacancy to be filled, the launch of the appeal was the moment at which the NA-CF assumed *de facto* the role of the absent director.

In the event, the *Rokeby Venus was* bought for the National Gallery, but at the thirteenth hour. When the deadline on the option to purchase passed, there was still a substantial deficit between the price of the picture and the money raised by public appeal.[64] Finally, after some discreet lobbying by courtiers, the intervention of Edward VII ensured that the gap was filled and the acquisition was, at last, completed in January 1906.[65]

During and after the campaign both MacColl and Holmes explicitly linked the purchase of the *Rokeby Venus* with the inaction of the Gallery trustees, in contrast to whom the NA-CF committee promoted itself as energetic and effective on behalf of the nation's interests.[66] Holmes took up the theme when he wrote that "the excitement over the Rokeby Velazquez [and] the keen interest aroused by the vacant directorship of the National Gallery ... indicate that the artistic public had been dissatisfied with our haphazard way of managing our affairs ... "[67]

Ironically, the National Gallery directorship was eventually offered to Fry in January 1906, but by then he had already accepted a position working for J. Pierpont Morgan at the Metropolitan Museum of Art in New York (effectively, as a competitor to the London gallery) and was obliged to decline.[68] The subsequent appointment of Sir Charles Holroyd as Poynter's successor at least partially allayed the frustration felt by Fry and his colleagues at this turn of events. Holroyd had been the first keeper of the Tate Gallery from 1897 to 1906, had published a book on Michelangelo, helped to found the NA-CF in 1903 and, last but not least, was a member of the Consultative Committee of *The Burlington Magazine*.

Even so, the dominance of the trustees over the affairs of the Gallery continued throughout Holroyd's directorship, from 1906 to 1916. Meanwhile, Fry returned from America disillusioned by his experience of working for Morgan. Having relinquished any hope or expectation of public office in England, Fry reinvested his energies in the *Burlington* – at last becoming editor of the magazine at the end of 1909.[69] Yet the circumstances in which the editorship became vacant indicated the extent to which both the connoisseurial *and* the campaigning voice of the *Burlington* had been heard. Not only had Holmes been appointed Slade Professor at Oxford in 1904, but now he had also been appointed as Director of the National Portrait Gallery – thereby leaving his former job to be filled by his former mentor.

Although Fry's growing fascination with (particularly French) modern art was increasingly apparent in the articles that he wrote and commissioned during his editorship from 1909 to 1918,[70] he continued to campaign for the reform of the National Gallery where the problems of the 1900s still persisted – as demonstrated by the sale of *The Mill*. Of all the famous old masters exported from Britain before the First World War, none was more celebrated, nor its

"loss" more scandalous, than Rembrandt's *The Mill*. For the trustees of the National Gallery, the sale represented an unprecedented crisis by virtue of the position of the vendor, the 5th Marquess of Lansdowne, as a senior trustee of the Gallery. In the *Burlington*, the sale of *The Mill* invoked complaints about the trustees that echoed the broader demand voiced in the country and in parliament that the ownership of land should no longer confer political privilege without constraint. Fry was unambiguous: "The time has come when it is no longer possible to conceal the deep indignation of those who have the interests of our National Collections at heart ... it is now our duty to state plainly that the trustees of the National Gallery have, as a body, conspicuously failed in the trust which has been placed upon them."[71]

By the end of the year the energetic Lord Curzon, who was newly appointed to the board, signaled his tacit agreement with Fry when he established a committee of the trustees "to Enquire into the Retention of Important Pictures in this Country and Other Matters Connected with the National Collections."[72] As a prelude to the establishment of the committee, Curzon had spoken at the opening at the Grafton Galleries of an exhibition of old master paintings in British private collections, which had been organized by Fry.[73] The following month's editorial in the *Burlington* was supportive of Curzon's views of the "old master question" and of his desire to find a remedy to the problem.[74]

In establishing his committee of inquiry, Curzon's self-appointed remit was to investigate the most pressing problems facing the National Gallery, namely the retention of old master paintings in Britain, the administration of the Chantrey Bequest, and the relationship between the various galleries in which the national collection was housed, with particular regard to the status of modern foreign paintings within the collection.[75] These were, of course, the same issues that had provoked such vehement criticism of the Gallery in the pages of the *Burlington* during the previous decade. Now those same critics, including Fry, Holmes, and MacColl,[76] were invited to give evidence as witnesses before Curzon and his committee. Their views on the management of the national collection, which were so familiar to readers of the *Burlington*, now became part of the official record: it was a masterly exercise in the institutionalization of dissent.

Although Fry himself never held an academic or curatorial post, by the end of 1911 the editor of the *Burlington* had ceased to occupy a rhetorical bridgehead. During the first eight years of its existence, the *Burlington* had redrawn the networks of power within the metropolitan artworld: first, by defining and promoting a field of cultural authority which had previously lacked an institutional base in Britain; and second, by asserting the supremacy of that field over existing institutional practice. The eventual appointment of Holmes as Holroyd's successor as Director of the National Gallery in 1916 signaled the extent of the shift that had occurred. Yet the radical impulse of the young *Burlington* was for reform, and not for revolution. It was never the desire of the *Burlington* to remain in opposition, but to establish scientific connoisseurship as a normative practice within the most powerful art institutions in Britain.

## NOTES

1 B. Nicolson, "Editorial," *The Burlington Magazine*, 1978, vol. CXX, no. 900, pp. 121–2.

2 Nicolson, "Editorial," p. 122.

3 R. Dell, "Editorial Article," *The Burlington Magazine*, 1903, vol. I, no. 1, p. 5.

4 C. Elam, "The Burlington Magazine, 1903–1914," *The Art Quarterly of the National Art-Collections Fund*, 1993, vol. 16, p. 41.

5 Due to his commitments at the Metropolitan Museum of Art, Fry spent much of each year in New York or Europe between 1905 and 1909, yet still retained his connection to the Burlington.

6 D. Sutton, ed., *Letters of Roger Fry*, Vol. I, London, Chatto and Windus, 1972, p. 13.

7 V. Woolf, *Roger Fry, A Biography*, London, Hogarth Press, 1940, p. 131; C. Holmes, *Self and Partners (Mostly Self)*, London, Constable, 1936, p. 223.

8 Giovanni Morelli's *Italian Painters* was published in two volumes in English in 1892–3.

9 Sir Augustus Daniel became Director of the National Gallery from 1929 to 1934.

10 Quoted in Woolf, *Roger Fry, A Biography*, p. 91.

11 E. Samuels, *Bernard Berenson, The Making of a Connoisseur*, Cambridge, MA and London, Belknap Press, 1979, p. 372.

12 Sutton, *Letters of Roger Fry*, Vol. I, p. 200.

13 Sutton, *Letters of Roger Fry*, Vol. I, p. 202.

14 Elam, "The Burlington Magazine," p. 41.

15 Bode resigned from the Consultative Committee in 1910 following the controversy over the acquisition by the Berlin Museum of the wax bust of Flora, which was revealed as a forgery.

16 Elam, "The Burlington Magazine," p. 43. Horne contributed articles on Botticelli and Andrea del Castagno to early editions of the *Burlington*, and his monograph on Botticelli was published in 1908.

17 C. Holmes, *Self and Partners*, p. 191.

18 Sutton, *Letters of Roger Fry*, Vol. I, p. 212.

19 Samuels, *Bernard Berenson, The Making of a Connoisseur*, p. 398.

20 Holmes, *Self and Partners*, p. 214.

21 Sutton, *Letters of Roger Fry*, Vol. I, p. 214.

22 B. Strachey and J. Samuels, ed., *Mary Berenson: A Self-Portrait from Her Letters and Diaries*, New York and London, Hamish Hamilton, 1983, p. 114.

23 In January 1899 Horne had entered into a contract with Berenson to sell paintings in London for a half share of the profits.

24 B. Berenson, "Alunno di Domenico," *The Burlington Magazine*, 1903, vol. I, no. 1, pp. 6–20.

25 Berenson, "Alunno di Domenico," p. 20.

26 L. Douglas, "A Forgotten Painter," *The Burlington Magazine*, 1903, vol. I, no. 1, pp. 306–18.

27 Douglas, "A Forgotten Painter," p. 306. Berenson's *Central Italian Painters of the Renaissance* was published in 1897.

28 Samuels suggests that the hostility between the two men stemmed from an incident in 1899 when Berenson dismissed Douglas's suggestion that a painting he had discovered was by Duccio. Samuels, *Bernard Berenson, The Making of a Connoisseur*, p. 315.

29 B. Berenson, "A Sienese Painter of the Franciscan Legend, Part 1," *The Burlington Magazine*, 1903, vol. III, no. 3, pp. 3–35; Berenson, "A Sienese Painter of the Franciscan Legend, Part 2," *The Burlington Magazine*, 1903, vol. III, no. 4, pp. 171–84.

30  Berenson, "A Sienese Painter of the Franciscan Legend, Part 1," p. 32.

31  Samuels, *Bernard Berenson, The Making of a Connoisseur*, p. 395.

32  Samuels, *Bernard Berenson, The Making of a Connoisseur*, p. 398.

33  L. Douglas, "A Note on Recent Criticism of the Art of Sassetta," *The Burlington Magazine*, 1903, vol. III, no. 5, p. 265.

34  Douglas, "A Note on Recent Criticism of the Art of Sassetta," p. 275.

35  Strachey, *Mary Berenson: A Self-Portrait*, p. 209.

36  Sutton, *Letters of Roger Fry*, Vol. I, p. 13.

37  C. Holmes and C.H. Collins Baker, *The Making of the National Gallery 1824–1924*, London, National Gallery, 1924, p. 68.

38  Elam, "The Burlington Magazine," p. 44.

39  In 1904 Phillips was also keeper of the Wallace Collection.

40  Holmes, *Self and Partners*, p. 219.

41  C. Holmes, "The History of our new Dürer," *The Burlington Magazine*, 1904, vol. V, pp. 431–4; Sutton, *Letters of Roger Fry*, Vol. I, pp. 221–2.

42  C. Dodgson, Sir M. Peartree, R. Fry *et al.*, "The Portrait of Dürer the Elder," *The Burlington Magazine*, 1904, vol. V, pp. 570–2. The National Gallery would later acknowledge that "the quality of the painting itself, especially of the hands and body, have frequently raised doubts about Dürer's authorship." C. Baker and T. Henry, *The National Gallery Complete Illustrated Catalogue*, London, National Gallery, 1995, p. 205.

43  H. Rees Leahy, "Art Exports and the Formation of National Heritage in Britain, 1882 to 1997," unpublished Ph.D. thesis, University of Manchester, 1999.

44  Just three men appointed to the Board during the ten years from 1890 to 1900 could be described thus, Alfred de Rothschild in 1892, Sir Charles Tennant in 1894 and Henry (later Sir Henry) Tate in 1897.

45  C. Holmes, "The Lesson of the Rokeby Velasquez," *The Burlington Magazine*, 1906, vol. VIII, p. 226.

46  G. Fyfe, "A Trojan Horse at the Tate: theorizing the museum as agency and structure," in S. MacDonald and G. Fyfe, ed., *Theorizing Museums*, Oxford, Oxford University Press, 1996, p. 204.

47  D.S. MacColl, "A National Art Collections Fund," *The Saturday Review*, 1903, p. 394.

48  C. Holmes, "The Affairs of the National Gallery," *The Burlington Magazine*, 1905, vol. VI, no. 24, p. 428.

49  D.S. MacColl, *Confessions of a Keeper, and Other Papers*, London, Alexander Maclehose, 1931; G. Fyfe, "The Chantrey Episode: Art, Classification, Museums and the State, c.1870–1920," in S. Pearce, ed., *Art in Museums*, London, 1995, pp. 5–41; Fyfe, "A Trojan Horse at the Tate."

50  C. Holmes, "The Chantrey Trustees and the Nation," *The Burlington Magazine*, 1904, vol. V, p. 116.

51  Hendy states incorrectly that *The Rape of Europa* was sold by the 8th Earl in 1896; in fact, the 8th Earl did not succeed until 1900. P. Hendy, *European and American Paintings in the Isabella Stewart Gardner Museum*, Boston, Trustees of the Isabella Stewart Gardner Museum, 1974, p. 259.

52  Holmes and Baker, *The Making of the National Gallery 1824–1924*, p. 66.

53  On his return from New York in 1909, Fry continued to advise and act as agent for American collectors such as Morgan, John Graver Johnson, and Henry Clay Frick.

54  C. Holmes, "Thoughts on the American Tariff," *The Burlington Magazine*, 1909, vol. XV, no. 74, p. 69.

55  R. Fry, "The Passing of Rembrandt's 'Mill'," *The Burlington Magazine*, 1911, vol. XIX, no. 98, p. 66.

56  The trustees opposed to the purchase were Alfred de Rothschild, the Marquess of Lansdowne, and Sir John Murray Scott.

57  The contributors were the financiers Waldorf Astor and J. Pierpoint Morgan, Alfred Beit, the brewing magnates Lord Burton and Lord Iveagh, and Lady Wantage, the daughter of the banker Samuel Loyd.

58  C. Holmes, "Titian's Portrait of Ariosto," *The Burlington Magazine*, 1904, vol. V, p. 516; R. Fry, "Titian's 'Ariosto'," *The Burlington Magazine*, 1904, vol. VI, pp. 136–8.

59  C. Holmes, "Private Enterprise in Public Affairs," *The Burlington Magazine*, 1905, vol. VII, p. 94.

60  *The Toilet of Venus* (1647–51) by Diego Velázquez was popularly known as "The Rokeby Venus" from the name of the home of its first English owner, John Bacon Sawrey Morritt of Rokeby Hall.

61  M. Lago, *Christiana Herringham and the Edwardian Art Scene*, London, Lund Humphries, 1996.

62  Elam, "The Burlington Magazine," p. 41.

63  Collection of Don Gaspar Méndez de Haro, 1651; given by the Duchess of Alba to Don Manuel Godoy in 1799/1800; in England in 1813, and bought in the following year by John Bacon Sawrey Morritt of Rokeby Hall, Yorkshire; presented by the NA-CF, 1906 (Baker and Henry, *The National Gallery Complete Illustrated Catalogue*).

64  D.S. MacColl, "The Loss of the Velasquez," *The Saturday Review*, 13 January 1906, pp. 43–4.

65  Rees Leahy, "Art Exports and the Formation of National Heritage in Britain," p. 92.

66  C. Holmes, "The Lesson of the Rokeby Velasquez," *The Burlington Magazine*, 1906, vol. VIII, pp. 225–8; C. Holmes, "The Future Administration of the Fine Arts in England," *The Burlington Magazine*, 1906, vol. VIII, pp. 375–8; D.S. MacColl, "Untitled," *The Saturday Review*, 25 February 1905, p. 135; D.S. MacColl, "The Loss of the Velasquez."

67  Holmes, "The Lesson of the Rokeby Velasquez," p. 224.

68  Woolf, *Roger Fry*, p. 132; F. Spalding, *Roger Fry: Art and Life*, London, 1980, p. 88.

69  Robert Dell had resigned his co-editorship with Holmes in 1906. He moved to France, where he worked as a dealer and, for a while, wrote a "Newsletter" as Paris correspondent to *The Burlington Magazine*.

70  B. Nicolson, "The Burlington Magazine," *Connoisseur*, 1976, vol. CXXI, no. 769, p. 180.

71  R. Fry, "The Passing of Rembrandt's 'Mill'," *The Burlington Magazine*, 1911, vol. XIX, no. 98, p. 66.

72  The members of the committee were Earl Curzon of Kedleston (chairman), Sir Edgar Vincent and Robert Benson (both trustees) and Sir Charles Holroyd. Robert Witt acted as Honorary Secretary.

73  The exhibition was held in aid of the National Art-Collections Fund, and was opened by their Royal Highnesses the Duke and Duchess of Connaught on 3 October 1911.

74  R. Fry, "Our Patrimonio Artistico," *The Burlington Magazine*, 1911, vol. XX, no. 104, pp. 65–6.

75  Committee of the Trustees of the National Gallery, *Enquiry into the retention of important pictures in this country and other matters connected with the national art collections*, London, 1915, Cd. 7878; *Enquiry into the retention of important pictures in this country and other matters connected with the national art collections, Minutes of Evidence*, London, 1915, Cd. 7879.

76  MacColl was appointed Keeper of the Tate Gallery in 1906 and then Keeper of the Wallace Collection in 1911.

# 15

# PHOTOGRAPHIC PERSPECTIVES

## Photography and the institutional formation of art history

*Frederick N. Bohrer*

The photographic reproduction of artworks as a phase in the struggle between photography and painting.
Walter Benjamin, *The Arcades Project* [Y1a, 3]

Could there be art history without photography? Photography has arguably been *the* indispensable technology of modern art history. Thus Ivan Gaskell remarks that: "Photography has subtly, radically and directly transformed the discipline of art history ..."[1] Few would dispute his statement that: "Almost all [art historians] make daily use of [photography] whether as illustrations, aids to memory, or as substitutes for objects depicted by its means."

Still, at least at first glance, one can only puzzle at the equally inarguable fact, also mentioned by Gaskell, that: "Most members of these professions [such as art history] have avoided explicitly considering the consequences of photography as it affects their own work, as well as on a larger scale."[2] This strange fact might be taken to indicate just how socialized into their discipline art historians must be to largely ignore the precise thing constantly before their eyes. It may not be too much to suggest that this situation hints at an almost conscious refusal to explore the many issues raised by photography as it conditions and constrains art historical practice. This brief chapter can only touch on a few aspects of art history's effective overlooking, or even repression, of the distinct representational, historical and didactic significance of photography, as art history's chosen visual medium. One hopes at least that the (potentially vast) stakes of this examination can be intimated.

This chapter will be divided into two sections, each of which takes up a fundamental question brought up by art history's embrace of photography. First, has photography fulfilled the claims made for it? To consider this fundamentally historical question I want to assess in contemporary terms some of the moments in the later nineteenth century in which photography was first adopted to art history. Second is a related, but more broadly theoretical

question: What does photography enable (or disable) in our apprehension and understanding of art? Here I will consider some of the implications and conundrums of our dependence on photography, before ending with a brief glimpse of one alternative.

<div align="center">I</div>

"Photography," as Pierre Bourdieu points out, "is considered to be a perfectly realistic and objective recording of the visible world because (from its origin) it has been assigned *social uses* that are held to be 'realistic' and 'objective.'"[3] As Bourdieu suggests, then, we here approach photography not in terms of any "essential" nature, but rather by considering the functions it has fulfilled. Certainly within art history, photography, perhaps the most lasting product of the "culture of realism" of the nineteenth century, has served to emphasize related, realist assumptions of objecthood and presence. But it has done this in so many ways that it virtually contradicts itself.

Photography's initial adoption by scholars of art is a shadowy matter. In the mid-nineteenth century, and for decades thereafter, it was one of a number of competing systems of visual reproduction, with both boosters and detractors. By the 1870s photographic reproductions were clearly used by English scholars at least as *aides-mémoire* (such as J.C. Robinson's pioneering catalogue of Renaissance drawings), even when resulting publications were illustrated by the more traditional engravings.[4] But the photograph could also play a more active, and public, role as functional simulacrum of the art object. A landmark here is the trip to Florence in 1869 made by officials of the National Gallery to compare a photograph of a newly acquired work, attributed to Michelangelo, to the Doni tondo. The attribution was upheld. Both cases present clear social uses, in Bourdieu's terms, in which the photograph functions as stand-in for the art object, validating the resultant judgment as an objective comparison.

The new prestige of connoisseurship by the end of the nineteenth century can be found tied directly to the subsequent reification of photographic repro-duction. Analyzing the colorful and laudatory terms of one of its leading proponents, Bernard Berenson, reveals much about the conditions of its adop-tion, in terms that are still resonant today. An article of 1893, for instance, hails new developments in photographic film and the work of photographers like the Alinari Brothers as the fount of a veritable revolution.

> Is it surprising, then, that really accurate connoisseurship is so new a science that it has as yet scarcely found its way into general recogni-tion? Few people are aware how completely it has changed since the days before railways and photographs, when it was more or less of a quack science ... Of the writer on art today we all expect not only that intimate acquaintance with his subject which modern means of conveyance have made possible, but also that patient comparison of a

<div align="center">247</div>

given work with all the other works by the same master which photography has rendered easy. It is not at all difficult to see at any rate nine tenths of a great master's works (Titian's or Tintoretto's, for instance) in such rapid succession that the memory of them will be fresh enough to enable the critic to determine the place and value of any one picture. And when this continuous study of originals is supplemented by isochromatic photographs, such comparison attains almost the accuracy of the physical sciences.[5]

For Berenson, the new, gleaming, "scientific" prestige of connoisseurship is a direct result of its taking up modern technologies, not only photography but also the modern railway. But while the railway's function is instrumental, extending the scholar's presence, the essay as a whole reveals that the function of photography is fundamentally constitutive, at times actually improving on, or even replacing, the need to visit the art object.

Thus Berenson's article begins with a lengthy description of the state in which the visitor, no doubt arriving by railway, actually finds the objects of his quest.

… many of the finest pictures left upon the altars for which they are painted are practically invisible. Even at the hours at which Baedeker advises or the local guide takes you to see them, they are often mere dim outlines, hidden in the gloom of overhanging arches or deep cornices. Or else the restorer's brush has converted them into sparkling mirrors of dusty varnish which are far more tantalizing than enjoyable. Every one will remember the impossibility of getting a good look at the great Bellini in San Zaccaria … and the disappointments that attend the attempt to peer through the darkness that hides such pictures as the Bellini at San Francesco della Vigna, or the Sebastianos in San Bartolommeo in Rialto.[6]

Berenson here emphasizes, in terms recalling the jacket blurbs of innumerable coffee-table art books, that photography presents artworks in a state far different from their actual appearance to the actual viewer, reprocessed so that the works are indeed far *more* accessible in photography. Despite its fundamental contradiction with the objectivist claim of photography, photography is here vaunted not for capturing, but for improving upon the actual experience of art. Berenson goes on to praise photographers like the Alinari for tricks of lighting art objects and of photographic development and printing which can change an image in ways which sound to modern criteria comparable to over-cleaning an oil painting. How else is the image to be rescued from "the restorer's brush"? But what is inadmissible for the physical art object is praiseworthy in the photographic rendition.

As he makes clear, Berenson's goal, like that of any connoisseur, is to assemble a corpus of images, divorcing individual art objects from their local contexts. As a botanist, say, groups individual specimens by appealing to broader classes, Berenson considered his method's very claim to scientific value its comparative nature, inserting individual works into a wider *oeuvre*.[7] The connoisseur's practice is panoptic. But it is not precisely or necessarily centered on actual artworks. As Berenson states explicitly, the connoisseur is a repository of "acquaintances" with artworks whose outward and visible signs consist, most often, of photographs.

Whereas the photograph may have entered into art historical practice, as we have seen, as a sort of *aide-mémoire*, here at the end of the nineteenth century it has already come to play a far greater role. The elision (or, better, reduction) of art object to its photographic image is the very key to both the productiveness and limitation of modern art history.[8] This very deferral of the actuality of art for a world of ideal visibility has been the discipline's key move, as the use of photography has spread widely throughout the many periods and cultures in its scope. Berenson himself, more than fifty years after the above essay, admitted that he had found photography ultimately more reliable than personal inspection.[9]

Today, the photographic image retains this immense value, rivaling the artwork itself. The photograph enables deductions, connections, and interpretations which would be otherwise difficult or even impossible. Despite the vast improvements in travel since Berenson's day, the role of the photograph has waxed as that of the railway has waned. The visit to an artwork *in situ* is often framed as an occasion to confirm information first gleaned from a photographic rendering (and perhaps look for a nice restaurant nearby).

Thus, the photographic "Museum without Walls" celebrated (albeit ambiguously) by André Malraux continues to provide a framework for apprehending art. In 1949 Malraux wrote: "For the last hundred years art history (if we except the specialized research-work of experts) has been the history of that which can be photographed."[10] All that needs changing today in this formulation is, except for a very few, the exception for experts.

Connoisseurship still occupies an important space in art history, but by no means now a dominant one. While its rise coincides with that of photography, and the two are fundamentally linked, the apprehension of artworks as photographic images has another tie to art history, connecting with its entire range of subjects and methodologies. It is not just that photography is a useful simulacrum for the artwork, which is assumed to have its own authenticity. Rather, for most students of art history (at least in Europe and North America during the twentieth century) art was introduced *as* photography.

With the development of reliable lantern slide projection, in the later 1880s, the photographic reproduction of art became essential to the formation of art history as academic discipline. While previously mistress (as in the earlier personal and often unacknowledged use of photographs for research), photography became proper wife and mother of a discipline. The rise of graduate study

in fine arts in America, beginning in 1885 at Harvard and the following year at Yale, took place just a few years after the introduction of illustrated slide lectures at these universities.[11] Further, this development mirrors almost precisely the discipline's academic situation in Germany, land not only of art history's "native tongue," but also then at the height of its prestige (certainly in America) as a model of higher education and the organization of scholarly research.

Heinrich Dilly has shown how photography provided the fundamental "teaching apparatus" (*Lehrapparat*) for art history in Germany, establishing it as a "respectable" (*ordentlich*) discipline.[12] Indeed, Berenson's claim to the "scientific" nature of photographically aided connoisseurship derives from this very same development, presenting the study of art as a rationalized, objectifiable matter. This same scientific aim was a fundamental impetus to the early development of the photo archive in England.[13] In all three countries, photography's mechanical objectification of art was essential in qualifying it as a positivist science, and was the virtual badge of its entitlement to intellectual respectability.

And yet the photographic art image, as exemplified in slide projection, served a variety of aims. The slide lecture was first made popular in Germany by Herman Grimm, Ordinarius Professor of Art History at Berlin University.[14] The extroverted, late-Romantic Grimm's approach was anything but scientific. Instead, he used slides as the basis of what were dramatic performances, whose goal was a sort of ideal presence, magically transporting audiences to Raphael's frescoes or Michelangelo's sculpture, in search of a spiritualized, cultural-historical vision.

After the success of the apparatus introduced with Grimm, it spread rapidly throughout the German university system, as elsewhere in academia. What was founded here was not just a mechanized visual arrangement, but a style. Lecturing on art in the newly darkened spaces gave the topic a character which still virtually defines the discipline and distinguishes it within the humanities. To be an academic art historian, as we have all learned at some point, is in part to be a giver of slide shows. The professor presides in what serves, essentially, as art history's own primal scene. At the same time, this lecture in darkness resembles another cultural innovation in Germany during the period, the placement of theatrical audiences in darkness, then just starting to be practiced systematically at the Wagnerian theatre in Bayreuth, which opened to the public in 1876. Photography, then, enabled art history to stake out a position one might call "dramatically intellectual" in a way that complements the newly developed "intellectual drama" of Wagner, if not tapping into some of the same audience.

While Grimm's achievement confronts us with some of the stylistic implications of the photographic slide lecture, we must look to his successor at Berlin, Heinrich Wölfflin, to exemplify the substantive articulation of a photographically based, dual slide-projected art history. Wölfflin's innovation, the fount of more than a century of slide lectures, is two-fold. First, it makes fundamental use of the twin-projector method, facilitating comparing and contrasting

different works. Second, it establishes a method of interpretation, a brand of formalism, based directly on the proffered visual evidence. In his *Principles of Art History*, first published in 1915, Wölfflin codifies this approach by means of five stylistic oppositions, further inflected into national and chronological typologies.

Despite the many differences between the two, Wölfflin's use of the illustrated lecture format was nearly as enthusiastic as that of Grimm.[15] Toward the end of his life, while admitting reservations about overdoing illustrations in book form, he acknowledged "the juxtaposition of contrasting pictures ... may well render good service in a lecture." The lecture allowed more subtlety and complexity than the book format because:

> Not only can more examples be shown, but variants and exceptions can be brought forward without danger of distracting the hearer, since the keynote may be immediately struck anew. Finally, the lecturer has in great measure the freedom to make use of exaggerations for purposes of clarification (and entertainment), inasmuch as it is in his power to retract them at any time.[16]

Whatever ambivalence Wölfflin may have had about photographic illustration of works of art in "the rigid format of a book" (a matter which we will examine in more detail below), the attitude here expressed toward the impact of photography on academic teaching seems steadfastly enthusiastic. For Wölfflin as well, the very format of the slide lecture specifically (in his own term) empowers the professor over the darkened listeners. Even as his approach to understanding art differed vastly from that of Grimm, then, it also solidified the very roles of active speaker and passive listener thereby engendered.

The relation of lecturer to audience in the slide lecture is now so common as to seem almost natural. Yet I hope this brief account of aspects of photography's very naturalization in art history at least begins to make evident the contingencies and idiosyncrasies of the context in which photography was adopted. Photography lent art an objective, commodifiable aspect which facilitated the transfer of information about it in the contemporary scientific methods then ascendant in both research and teaching. From Berenson's connoisseurship to Wölfflin's slide lectures, the essential role of data openly available to support the researcher's proffered hypotheses was provided not by works of art themselves, but by photographically reproduced images of artworks. With a sense now of this situation, we can consider more directly the effects of the medium itself.

## II

In her characteristically cautionary tone, Susan Sontag states: "It is not reality that photographs make immediately accessible, but images."[17] But what seems

a structural limitation has functioned, perhaps ironically, as a clear setting of boundaries. Photography's transformation of the actuality of works of art into the photographic images employed in art history is not merely reductive but also fascinatingly productive. Considering the glossy black and white prints that have been our stock-in-trade from Berenson's day to the present, it is not difficult to see that much is simply not transferred from object to photograph. A recent analysis lists eight separate features of paintings that are either distorted or withheld from photographs of them.[18] This includes not only color, but also such other major factors in basic art historical analysis as scale, surface, and lighting, not to mention the ever-vexed question of the removal of the work from its frame. Moreover, if this is the situation of painting, the visual format most similar to that of the photographic image, and thus most likely to be adequately reproduced, how much more is missing in action in the photographic reproduction of sculpture and, even more, of architecture. Indeed, it is hard to escape the conclusion that the predominance of painting and other two-dimensional media in art history is itself related to the comparative ease and accuracy of making photographic reproductions of them. That is, despite our learned treatment of the photo as unquestioned stand-in for the object in question, of whatever sort, at some level it's still easier to talk oneself into accepting a photo of a painting as the painting itself, than to treat a photo of a building, say, as the building itself.

If photography merely presented us with specified aspects of artworks, however filtered by representation, we might still see it as a vehicle of presence, conveyor, at least to some degree, of the unmediated authenticity of the work. However, photographs do not ever only present us with second-order artworks, but also with what must be acknowledged as works of photographic art. The camera's work is not only subtractive, but also additive. It never only captures, but also constructs appearances.

A trenchant analysis of the effect of photographic artifice in an art historical context is that of art historian/photographer Ralph Lieberman. A rare double agent, Lieberman describes in authoritative detail the inventions of photography. As he insists,

> when done thoughtfully, photographing a work of art is not a passive, unintellectual and non-art historical means of acquiring a visual substitute for it, but a form of active, analytical description. [19]

Focusing particularly on architectural photography (the case, as we have just seen, especially resistant to belief in photographic truth), Lieberman works to historicize photographic architectural rendering itself, fixing the putatively timeless and objective photographic image to specific technical devices and cultural moments. Even more, Lieberman details the construction of the photographic apparatus itself to bend optical phenomena in order to obey the strictures of conventional perspective. Though the eye treats all parallels equally, the camera

was made to follow the system codified in the Renaissance, by which horizontally running parallel lines meet at a vanishing point but vertical parallels do not. Thus "the claim that the camera proves perspective to be correct is entirely off the mark, for in its youth the camera was remade into an instrument of Renaissance perspective."[20]

Indeed, one of the camera's most insidious roles in art history has been that of ideologue of Renaissance perspective, an effect hardly confined to the medium of architecture. Art history's traditional dependence on photography seems directly linked to its traditional lionization of the art (and especially the painting) of the Italian Renaissance. It is, of course, to this narrow portion of world art that Berenson and many of the other pioneers of photographically based connoisseurship (such as J.C. Robinson, or Crowe and Cavalcaselle) were devoted. Thus, to rely on photography today, even with a sense of its limitations, still functionally demands that art objects be evaluated on their responsiveness to visual criteria centered on the Italian Renaissance. The centrality of Italian Renaissance painting within art history and subsequent emphasis on two-dimensional linear perspective are not just documented, then, but reified by the conditions of photographic rendering.

In this sense, our uniform and widespread dependence on photography in art history works to spread throughout the vast domain of world art the dominance of these same criteria. If this sounds like a sort of neo-imperialist project, it is to underline that relations of power, cultural and even geo-political, are almost inevitably involved in photography. From this angle, an examination of photography must consider what is being constrained, or excluded, in our acceptance of the photographic vision.

The effect of photography's enforcement of Renaissance perspective was clear to Erwin Panofsky. Far from a natural system, Panofsky's analysis of perspective as a "symbolic form" included consideration of this very question: what photography keeps us from seeing. Considering Kepler's initial inability to understand how straight-lined physical features (from lines of buildings to tails of comets) could be perceived as curvilinear, he states:

> Kepler fully recognized that he had originally overlooked or even denied these illusory curves only because he had been schooled in linear perspective. He had been led by the rules of painterly perspective to believe that straight is always seen as straight ... And indeed, if even today only a very few of us have perceived these curvatures, that too is surely in part due to our habituation – further reinforced by looking at photographs – to linear perspectival construction.[21]

Photography, then, has a double effect in its power on the viewer. It both enforces the perspectival vision, and withholds (in effect argues away) some of the raw evidence of the senses. Far from only capturing an external world, it works as well to superimpose a pre-constructed one.

Photography is an exercise of power in other, perhaps more obvious, ways as well. First, the photographer is clearly seen as the subordinate to the scholar. The latter provides the criteria for the former's work. In this, there is more than a touch of condescension to Berenson's praise of workmen like the Alinari for their nimble and ingenious inventions. It is a relation, of course, which harks back to the age of the gentleman-scholar, a continuing trace of the social relations in which art history was born.

In the academic setting of the slide lecture, photography imbricates power in other ways. An early slide catalogue bears the following note, indicating what must have seemed a potentially alarming feature:

> Lecturers should note that these slides cannot be seen to advantage when standing close to the screen. At a little distance the bright spots of apparently arbitrary colour merge into one another and give the correct colour, in many instances to a remarkable degree.[22]

This is certainly an effect still known today, only magnified by the increasing size of screens and lecture halls. The professor, standing by the screen and facing the audience, is in a far better position to see the imperfections of projected images than is the more distant audience. But what holds together the projected images for the audience is not merely the theatrical effects of the seating arrangements. It is, perhaps even more, the effect of a "habituation" like that mentioned by Panofsky. The images are held together not merely by an optical effect, but by the student's very investment in them and acceptance of the professor's authority. In this sense, an art history lecture never merely illustrates art objects, but also illustrates an authority's power over them, and over their audience. Hence the ironic situation that the art history lecturer fixes for the audience what he or she is in the least privileged position to actually see.

All of which brings us back to Wölfflin, whom we have left above almost reveling in this very stance. Even as he functioned actively and fully as photographic lecturer, one can also find enunciated in Wölfflin's later life and work a sense of the ambivalence of photography in art history. Thus his words quoted above in praise of the photographic lecture favorably contrast this use of photography with its employment in scholarly publication. Strikingly, the entire passage denigrating photography of art in publication stands at the preface to what is none other than a photographically illustrated publication, Wölfflin's *The Sense of Form in Art*. In it, he notes further:

> I have generally avoided the obvious procedure of demonstrating the national differences through the demonstration of contrasting pictures ... a well-grounded misgiving kept me from making too extensive a use of this means of elucidation in the rigid context of a book. After all, to wring a specific effect of contrast from every picture does violence not only to the reader but also to the work of art.[23]

Wölfflin eschews over-dependence on photography for the sake not only of the reader but of the artwork. Implicit in his comment is a certain ambivalence over the very academic institution represented by the "rigid context" of the book. Wölfflin wrote those words in 1931, seven years after he had voluntarily given up his academic chair in Munich in disappointment at the constricted course of the discipline he himself had done so much to found.[24] This anxiety about the over-use of photography of art may well be seen as a figure of ambivalence about the entire discipline that such photography came to support. Within this conception of photography as synecdoche for art history per se, Wölfflin's comment about the violence of wringing "a specific effect of contrast from every picture" bears also a more personal reference to Wölfflin's own famous *Principles of Art History*, the very foundation of a brand of formalist contrasts in art, first published in 1915. A few years before the above comments, in 1926–7, he returned to the university at Munich, delivering in a series of lectures a critique of this work.

Remarkably, an examination of photography's employment in *Principles of Art History* intimates not only Wölfflin's consistent ambivalence about photography, but the subsequent neutralization of these concerns in art history's rush to photography. Wölfflin's original text is shot through with reflections on the difficulties of understanding the actuality of art through its reproductions. Among the most prominent is this observation, central to the discussion of his first major opposition: linear vs. painterly:

> We are so used to see everything from the painterly angle that even when confronted with linear works of art, we apprehend the form somewhat more laxly than was intended, and where mere photographs are at our disposal, painterly blurring goes a step further, not to speak of the little zinc plates of our books (reproductions of reproductions).[25]

Much to its credit, *Principles of Art History* does not merely register this fact, but was even visually designed to counter it. Hence, Wölfflin made much use of drawings as primary stylistic sources, for their greater amenability to reproduction. Even more, at a key point in his exposition, discussing planar vs. recessional in Vermeer's *The Art of Painting*, Wölfflin reproduced a modern print rather than a photograph of the painting. A note tells us this was done "in order for the light effect to be left completely clear."[26]

This gesture may be surprising to the English-language reader of Wölfflin, or indeed any modern reader. For over time Wölfflin's particular ambivalence about photography has been effaced by … photography itself. Thus in what is still the only published English translation of the work, which first appeared in 1932, Wölfflin's choice of image and text is changed. One finds simply a photograph of Vermeer's painting, and no trace of Wölfflin's original note.[27] This same operation can be found at work in later German editions of the book as well.[28]

The relation to photography of Wölfflin's *Principles of Art History* crystal-lizes the larger trends we have sketched, bringing us back to Gaskell's observation about art history's avoidance of considering photography. The triumph of photography in art history, that is, brings with it a silencing of concerns about the very nature of photography, even underwriting a subtle remaking of a founding work. The essence of the photography of art is its ability to fix, or arrest, an image of an artwork, while also necessarily subtracting elements of the work which are not amenable to the process. At the end of this short tour through some moments in art history's adoption of photography, it seems clear that photography's effect on the discursive practice of art history as discipline has been similar to its effect on individual works of art. Photography has fixed our very thinking about art. Our dependence on it discourages our ability to consider and communicate those aspects of art which are not well served by the medium.

Photography has been a most productively mixed blessing for art history. Any project to rethink the history of art must surely also rethink its relation to photography. It hardly seems sensible, or even conceivable, to banish photography from art history. Rather, photography must be understood with a sense of its limitations and contingencies, not as the only way to experience or communicate art, but as one among many. On this topic, a final figure intrudes. In 1915, the very year of publication of *Principles of Art History*, Walter Benjamin attended Wölfflin's lectures in Munich. Benjamin was profoundly disappointed. While recognizing "all the energy and resources of his personality," in looking beyond his spirited lecture style Benjamin stated of Wölfflin "he has a theory which fails to grasp what is essential."[29] Much as Benjamin appreciated Wölfflinian formalism as a break from earlier practice, it failed to fully consider the very meaning of the transformations it, for Benjamin rather mechanically, registered. In this, Benjamin found more satisfying the lesser-known work of Alois Riegl and related figures of the "Vienna school."

Benjamin's only extended treatment of this topic, the 1933 essay "Rigorous Study of Art," delves into the host of methodological questions involved in the contrast between these figures. This essay provides a real context within which to rethink questions of the representation of artworks, one which necessarily stretches far beyond the question of the current chapter. A single point within it, however, provides us a place to conclude, in a non-photographic form of apprehending art objects.

Benjamin's essay is ostensibly a book review, of an edited volume of *Kunstwissenschaftliche Forschungen*.[30] It begins with reference to Wölfflin, who emerges as grudging avatar to the approach perfected in Riegl, whom Benjamin counts as a major influence on the essays of the volume under review. Among the most compelling of the studies for Benjamin was Carl Linfert's essay on architectural drawings. Examining the "abundant number of plates" in Linfert's essay, by architectural designers such as Boullée, Benjamin reported an extraordinary effect.

As regards the images themselves, one cannot say that they *re*-produce architecture. They *produce* it in the first place ... [forming] a completely new and untouched world of images, which Baudelaire would have ranked higher than all painting ... such architecture is not primarily "seen," but rather is imagined as an objective entity and is experienced by those who approach or even enter it as a surrounding space sui generis, that is, without the distancing effect of the frame of the pictorial space.[31]

We have seen above how the constructions of photographic/perspectival vision work particularly to constrain the representation of architecture. Benjamin here offers a supplemental vision where it is most needed. His intervention calls up a fundamental alternative: an image medium that "produces" rather than "re-produces" its architectural object, allowing an experience of architecture somehow seemingly independent of the framing perspectival construction.

Benjamin's vision is quite heterodox to scholarly norms, and no doubt rather odd to a scholarly reader. That is just its value here, as a real alternative to the photographic conception. At its heart is the insight contained in the epigraph to this chapter: that the relation of art to photography is fundamentally antagonistic. It is a principle diametrically opposed to that which animates most of the other figures we have considered here, from Berenson to Wölfflin, for whom photography is somewhere between willing servant and necessary evil.

The "struggle" between art and photography posited by Benjamin highlights the very incommensurabilities and disjunctures between the two. Yet in another sense Benjamin's vision is not so different, and a fascinating extension of the established repertoire we might associate with Berenson and Wölfflin. After all, we have seen above that Berenson describes a fundamental goal of his method as providing "acquaintance" with an image. Benjamin too is at work in this direction, opening onto a realm of images which overlaps and extends the realm of visual acquaintance.

At the same time, the "completely new and untouched world of images, which Baudelaire would have ranked higher than all painting" described by Benjamin is one whose history remains largely unwritten. How might it overlap, or precondition, or embellish, or undermine, or enhance the vast and fascinating domain of images articulated by contemporary art history? The question itself is part of a larger question: "Could there be art history without photography?"

### NOTES

1 I. Gaskell, "History of Images," in Peter Burke, ed., *New Perspectives on Historical Writing*, University Park, PA, Pennsylvania State University Press, 1992, p. 171. See also I. Gaskell, *Vermeer's Wager: Speculations on Art History, Theory and Art Museums*, London, Reaktion Books, 2000, pp. 140–64.

2 This observation is almost a leitmotif of the (strikingly tiny) body of literature on photography and art history. Cf. A. Hamber, "The Use of Photography by Nineteenth-century Art Historians," in H. Roberts, ed., *Art History Through the Camera's Lens*, Amsterdam, Gordon & Breach, 1995, p. 89.

3 P. Bourdieu, *Photography: A Middle-brow Art*, trans. S. Whiteside, Stanford, CA, Stanford University Press, 1995, p. 74.

4 Hamber, pp. 103, 106–7.

5 B. Berenson, "Isochromatic Photography and Venetian Pictures," in Roberts, ed., 1995, pp. 128–9. First published 1893.

6 Ibid., p. 127.

7 B. Berenson, *Aesthetics and History in the Visual Arts*, New York, Pantheon, 1948, pp. 203–4.

8 H. Dilly, "Lichtbildprojektion – Prosthese der Kunstbetrachtung," in I. Below, ed., *Kunstwissenschaft und Kunstvermittlung*, Giessen, Anabas, 1975, p. 153. "The objects of art-historical writing are not the things known as artworks, but rather their photographic reproductions" (my translation).

9 Berenson, 1948, p. 204. "I am not ashamed to confess that I have more often gone astray when I have seen the work of art by itself and alone, than when I have known its reproductions only."

10 A. Malraux, *Museum Without Walls: The Psychology of Art*, New York, Pantheon, 1949, pp. 28, 32. On Malraux, see H. Zerner, "Malraux and the Power of Photography" in G. Johnson, ed., *Sculpture and Photography: Envisioning the Third Dimension*, New York, Cambridge University Press, 1998, pp. 116–30.

11 H.B. Leighton, "The Lantern Slide and Art History," *History of Photography*, April–June 1984, vol. 8, no. 2, p. 108.

12 H. Dilly, *Kunstgeschichte als Institution: Studien zur Geschichte einer Disziplin*, Frankfurt, Suhrkamp, 1979, pp. 151–60.

13 Cf. L. Grant, "Time and the Conways: The Beginnings of Art History and the Collecting of Photographs in Britain," *Visual Resources*, 1998, vol. 13, pp. 299–307.

14 On Grimm's lectures, see T. Fawcett, "Visual Facts and the Nineteenth-century Art Lecture," *Art History*, December 1983, vol. 6, no. 4, pp. 454–5; Dilly, 1979, pp. 158–60; W. Freitag, "Early Uses of Photography in the History of Art," *Art Journal*, winter 1979/80, vol. 39, no. 2, p. 122; Dilly, 1975, pp. 162–6.

15 On Grimm in relation to Wölfflin, see M. Warnke, "On Heinrich Wölfflin," *Representations*, summer 1989, vol. 27, p. 176.

16 H. Wölfflin, *The Sense of Form in Art: A Comparative Psychological Study*, trans. A Muehsam, N.A. Shatan, New York, Chelsea, 1958, pp. 4, 3. First published in 1931 as *Italien und das deutsche Formgefühl*.

17 S. Sontag, *On Photography*, New York, Farrar, Straus and Giroux, 1977, p. 165.

18 B.E. Savedoff, "Looking at Art Through Photographs," *Journal of Aesthetics and Art Criticism*, summer 1993, vol. 51, no. 3, pp. 455–62.

19 R. Lieberman, "Thoughts of An Art Historian/Photographer on the Relationship of His Two Disciplines," in Roberts, ed., 1995, p. 222.

20 Ibid., p. 245.

21 E. Panofsky, *Perspective as Symbolic Form*, trans. C. Wood, New York, Zone Books, 1991, p. 34. First published 1927. Cf. M.A. Holly, *Panofsky and the Foundations of Art History*, Ithaca, NY, Cornell University Press, 1984, p. 135.

22 "A Catalogue of Lantern Slides in the Library of the Societies for the Promotion of Hellenic and Roman Studies (1913)," p. 11, quoted in Leighton, 1984, p. 114.

23 Wölfflin, 1958, p. 4.

24 As early as 1920, "... the very scholar who did the most to make art history into a scholarly discipline, to relieve it of its idealistic and moral obligations, now felt

hemmed in and constricted by the disciplinary narrow-mindedness and evacuation of meaning ... ," Warnke, 1989, p. 182.

25  H. Wölfflin, *Principles of Art History*, trans. M.D. Hottinger, London, Bell, 1932, p. 41.

26  H. Wölfflin *Kunstgeschichtliche Grundbegriffe*, Munich, Bruckmann, 1915, p. 85. "Um die Lichtführung ganz deutlich werden zu lassen, ist der Abbildung statt einer Photographie eine moderne Radierung (W. Unger) zugrunde gelegt worden." Unchanged at least through the second edition, Munich, 1917. "In order for the light effect to be completely clear, the plate is taken from a modern etching (W. Unger) rather than a photograph." (my translation)

27  Wölfflin, 1932, p. 78.

28  It is evident at least in the book's ninth German edition, Munich, 1948, p. 85, if not earlier.

29  See T.Y. Levin, "Walter Benjamin and the Theory of Art History: An Introduction to 'Rigorous Study of Art'," *October*, October 1988, no. 47, p. 79.

30  W. Benjamin, "Rigorous Study of Art. On the First Volume of the *Wissenschaftliche Forschungen*," trans. T.Y. Levin, *October*, October 1988, no. 47, pp. 84–90.

31  Ibid., pp. 89–90.

# 16

# INSTITUTING GENIUS

## The formation of biographical art history in France

*Greg M. Thomas*

## INTRODUCTION: BIOGRAPHICAL ART HISTORY

In *The Art of Art History* Donald Preziosi interprets the discipline of art history as a system for establishing relationships among art objects from around the world and between art objects and historical actions or intentions.[1] He further sees this Western art historical project as a way of creating and legitimizing some of the ideological apparatus of the modern nation state. Yet in delineating the major intellectual trends of early art history – aesthetics, formalism, national history, iconography – he brushes over one of the most fundamental methodologies of the art historical system: biographical history. The biographical paradigm, I believe, is not widely recognized as such for two reasons: it is so ingrained in the process of relating art objects to history that it hardly seems like a methodology at all; and since Vasari, no outstanding individuals have emerged (ironically enough) to theorize it – no Wölfflin or Panofsky to serve as a modern progenitor.

As art history developed in Europe and the United States, however, the author function, to put it in Foucault's terms, remained pivotal in the linking of art objects to ideological intention and national identity.[2] Individual artists – their lives and experiences – continued to act as the interface between the physical sensations of paint and the intentional ideas they supposedly evoke, between unique material objects and unified national cultures. I will argue, furthermore, that in France biography was really the *primary* art historical methodology in the nineteenth century, one supported by early art historical institutions as it established key components of modern art history. Although French scholars were caught up in the same nation-building trends as in Germany, England, and the United States, the forging of a national character and a national school tended in France to be based on establishing a pantheon of individual geniuses rather than delineating national styles or iconographies.

The effect of what I would call the biographical discourse has extended far beyond the now antiquated texts of nineteenth-century French art history. As shown below, France began producing memoirs of recently deceased artists from the 1840s on, making biography the established vehicle for ordering and

interpreting an artist's output. This means that for virtually every avant-garde French artist of the nineteenth century, the basic historical record upon which historians today must still rely is already deeply skewed by the biographical form through which historical reality has been filtered. Even more insidious, artists themselves adopted many of the tenets of biographical discourse. Though there is not space enough to demonstrate it here, artists frequently acted out in various ways the lives that biography expected of them. Biography thus evolved from a mode of historical analysis to a mode of contemporary analysis, and ultimately to a mode of actual practice. And while new methodologies have supplanted formalism and iconology, the tools of biographical discourse continue to prevail in art and art history alike.

To illustrate the impact of biography on the construction of both past and contemporary art history in nineteenth-century France, as well as the institutional supports of both, I will use Charles Blanc as a key example. Blanc was France's first official art historian, in that he was the first occupant of the "chair of aesthetics and art history" created at the Collège de France in 1878. This chair, argues Lyne Therrien in an exhaustive study of early art historical instruction in France, marked the first definitive recognition of art history as an academic discipline independent of archaeology.[3] But before this, Blanc had already had a hand in instituting nearly every facet of the multifarious practices that now make up art history. After beginning his career as a printmaker in the 1830s, he became renowned as a major art critic in the 1840s and gained editorial experience publishing a Republican journal.[4] During the Second Republic, from 1848 to 1852 (and again in 1872–3), he ruled the state arts administration as *directeur des beaux-arts*, proving himself mildly liberal though not as radical as his more famous brother Louis.[5] In 1859 he founded France's first professional art history journal, the important *Gazette des Beaux-Arts*, and in 1867 he published the most influential and most widely disseminated art history textbook of the time, the *Grammar of the Arts of Design*.[6] On top of it all, Blanc staked a claim as the leading practitioner of the new discipline by writing numerous art historical studies of both past and contemporary artists, crowned by the fourteen-volume *History of Painters of All Schools*.[7] Blanc was thus a pivotal figure in the formation of the core institutions of art history in France, contributing to criticism and journalism, arts and museum administration, publishing, and university education, as well as the writing of specific art historical texts. And by examining the principles and prejudices of his actual writings, deeply imbued with the biographical model, we can begin to see how strongly the artist biography has shaped the subsequent practice of art history.

## 1. BIOGRAPHY, BLANC, AND THE INSTITUTIONS OF ART HISTORY

Biography is a genre of writing with a long pedigree, and the artist biography was arguably the first form of Western art history, codified in Vasari's *Lives of the*

*Most Eminent Painters, Sculptors and Architects.* But biography began truly to flourish only in the later eighteenth century, when the standard title *Life* gave way to *Biography* and the modern biographical form took shape as a mixture of positivistic fact-finding and the dramatic fiction of the novel.[8] The new genre grew largely from romanticism and drew sustenance from various new conditions of modernity: individualism, an expanded middle class reading public, the ideology of the nation state. Catherine Soussloff argues in *The Absolute Artist* that the artist biography in particular became a highly standardized genre of writing embedded in modern discourse that spawned the modern myth of the artist as an "absolute" figure, an autonomous persona unconstrained by particular historical circumstances.[9] The burgeoning of the genre in the nineteenth century had deep repercussions in France. As art history took shape, the institutions supporting it – new journals and university programs, book publishers, government bureaus, art dealers and critics, museums, and international expositions – all embraced the biographical model as the fundamental methodology of the new discipline. The myth of the artist as a genius, as an originating subject, became the founding principle for interpreting the past.

Blanc's *History of Painters of All Schools*, which appeared between 1848 and 1876, is symptomatic of the trend. Intended to be a comprehensive description of all European art since the Renaissance, the fourteen-volume text is organized around the two key terms of its title – painters and schools. Individual volumes are devoted to national and regional "schools," a ubiquitous term that implied a close alliance between an artist's style and his or her national origin. Within each volume, an introduction describes the nation's or region's specific history (economy, climate, and the like), as well as the dominant features of its artistic style. The main body then presents a series of disconnected biographies, each paginated separately and each graced with a portrait of the artist at the beginning and a list of sale prices and sample signatures at the end.[10] Between these keynote features – one reconstituting the artist's bodily presence, the other providing collectors with appropriate tools for authenticating and evaluating individual works – each text weaves the life and representative works of the artist into the fabric of the national school.

The nation-based rubric of the *History* was nothing new in Europe; it mirrored art historical trends in Germany and England while reflecting the inter-*national* conception of the contemporaneous Universal Expositions. But the extreme reduction of the text to disjointed biographical units, whose only common bond is national origin, seems to mark a particular French bias in composing history. And Blanc's dry approach resembles that of the vast and very successful biographical encyclopedias that appeared in France at the same time – Michaud's eighty-five volume *Universal Ancient and Modern Biography* (1811–62) and Firmin-Didot's imitation, the forty-six volume *New Universal Biography* (1852–66). These sets remind us of the power publishing houses exercised in promoting a biographical view of history, as well as the commercial interests that helped fuel the genre.[11]

In the same years that Blanc's *History* was appearing, French art history flowered with the publication of dozens of biographical monographs on past artists. Between 1840 and 1875 the Bibliothèque Nationale acquired eighteen books devoted to Raphael (the earliest published in 1845) and nine on Michelangelo (from 1846), six on Leonardo, six on Rubens, five on Rembrandt, four on Poussin, three on Dürer, and two on Correggio, but none on Titian, Hals, or Claude Lorrain, nor any on Boucher, Fragonard, Greuze, or Chardin (although Blanc himself published a book on France's Rococo painters in 1854).[12] The favored artists were those Renaissance and Baroque painters whose genius seemed most rooted in divine inspiration or personal emotion. The statistics reveal, incidentally, a similar bias in the case of contemporary artists: seven books on the Raphaelesque Ingres, six on the Michelangelesque Delacroix, six on Horace and Joseph Vernet (dry exceptions to the rule), three on Decamps, two on David, and one each on Géricault, Charlet, and Prud'hon.

Blanc's own contribution to the genre – two books on Rembrandt – are typical. The first, *The Works of Rembrandt Reproduced by Photography*, was published in twenty lavish installments beginning in 1853, with the clear intent of offering print collectors high quality substitutes for Rembrandt's original etchings, which were especially valued for seeming directly to embody Rembrandt's physical and emotional genius.[13] Blanc states in the introduction that photographs are far cheaper than the scarce originals, and he gushes over the fact that "this mysterious science has made possible a veritable reimpression of engravings through light."[14] Pasted onto folio sheets that were blind-stamped with a plate mark to better resemble intaglio printing, the forty photographic prints are accompanied by texts as professional as any modern catalogue entry. Generally, one paragraph describes the picture and subject; then the different states are explained, along with dimensions and the numbers given to each print by previous catalogues raisonnés; and then Blanc gives his own effusive interpretation, with much discussion of Rembrandt's magical technique and heart-inspired conceptions. He often quotes others and uses footnotes to cite pertinent facts.

Blanc's goals in the book – excellent reproductions, reliable cataloguing information, and personal description confirming Rembrandt's mastery – are those of both collectors and modern art historians. And he immediately expanded on them in his second Rembrandt study, *The Complete Work of Rembrandt*. First published in two volumes in 1859 and 1861, it was reprinted and issued in a luxury edition, again indicating the book's profitable potential.[15] Here, too, the bulk of the book is devoted to the cataloguing of 353 prints and a number of paintings and drawings, with each entry repeating the factual features and personal commentaries (and often the same text) of the 1853 book, with etched copies of the etchings scattered throughout the book. The shorter catalogue of paintings, organized according to collection, generally gives only a title and brief description, but some entries also discuss particular questions of attribution, iconography, provenance, exhibitions, and similar

factual concerns. Closing with a concordance table for the prints, the book is a model of modern empirical art historical analysis.

Again, Blanc's goals suited both art history and the art market. Apologizing for the incompleteness of his list of paintings, he states that "at least we will have the satisfaction and peace of mind of having given the public a nearly definitive catalogue of the master's etchings, of having newly described, brought to light, expurgated, and truly completed his *oeuvre*, in the sense that collectors give the word."[16] This defense of the *catalogue raisonné* is tied to a strong biographical bias expressed in his general introduction. There, following a frontispiece reproducing a Rembrandt self-portrait (and a discussion of the high cost of Rembrandt's prints), Blanc includes a twenty-six page biographical analysis, which lauds the artist's religious sincerity and spiritual superiority ("No one has surpassed Rembrandt in expression, which is the soul of painting");[17] describes his upbringing; and clarifies the facts of his marriages, bankruptcy, and death. This is augmented by fifteen pages of documents from the bankruptcy trial.

Here, then, are the essential principles and basic techniques of the biographical model. Establishing the *oeuvre* unifies the work under the rubric of an originating author. The author, meanwhile, appears as a coherent and distinct individual whose coherent and distinct work derives from individual experience and genius, free of environmental influences. Even the limited historical background Blanc would later include in his *History* is utterly absent in the biography. Instead, he repeats the principal features of most nineteenth-century French artist biographies: he grounds the meaning of the work in the artist's life story; he ties artistic quality to spiritual greatness; and he uses documents, anecdotes, and pictures to reconstruct the artist's physical appearance and real historical presence.

These same analytical biases, accompanied by the same rhetorical devices, reappear throughout artist biographies in France. As early as 1824 Quatremère de Quincy's *History of the Life and Works of Raphael* helped to modernize and codify the genre.[18] The three illustrations in the 1835 edition all emphasize Raphael's bodily reality; the frontispiece is a print after Raphael's painted self-portrait, and two prints at the end show his funerary chapel in the Pantheon and his coffin, accompanied by two appendices with documents concerning Raphael's reburial in 1833. Beginning literally with Raphael's birth – the first sentence is: "The small town of Urbino, in the Ecclesiastic State, gave birth to Raphael Sanzio in 1483."[19] – the text proceeds through Raphael's life chronologically, alternating between events and artistic works. On the one hand, Quatremère de Quincy describes Raphael in mythological terms, beyond the influence of history; a true history, he says, is "one of the artist's genius," not a mere catalogue, and Raphael's genius had few successors.[20] On the other hand, he works hard to disentangle subtle distinctions of fact in Vasari's history, citing specific sources and quoting letters from the time, and his heroizing description of Raphael's body and moral character at the end is also tempered by documented facts.

We now take these rhetorical practices to be standard tools of good empirical art history, and yet the extreme bias and artificiality of such writing is evident when one sees how formulaic it became. For example, Charles Clément's 1861 study of Michelangelo, Leonardo, and Raphael precisely duplicates many of Quatremère's devices, from the triple portrait at the beginning to the combined chronology and catalogue raisonné at the end.[21] The part on Michelangelo begins "Michelangelo was born 6 March 1475, near Arezzo, in Valentino."[22] The factual text moves chronologically from work to work, supported with footnotes and quotations of eye-witness accounts. Just as Quatremère had done, Clément adds details of Michelangelo's character immediately after describing his death. And exactly like Raphael as described by Quatremère, Michelangelo as described by Clément was a genius who could not be surpassed, someone who lived simply despite his success, and someone who was generous and kind (despite evidence to the contrary).[23]

Most important, Clément now articulates a general view of history based on these formulae of artistic genius. He describes the Renaissance as essentially the first era of individual genius and expression, with Leonardo, Michelangelo, and Raphael culminating a long line of successive geniuses, from Dante and Giotto to Gutenberg and Luther.[24] Unlike the works of the great artists of antiquity, which were still dominated by a "general, collective character," those of Michelangelo and the others "are more individual and more than ever marked by the imprint of the author."[25] With the stirrings of "regained liberty" people retrieved their personal life. "The artist's character showed itself clearly in his work, which, growing more lively, at the same time developed a more distinct individuality and clearly reflected his own ideas, inclinations, emotions."[26] The Renaissance was in essence a flourishing of individuality.

Most of the devices mentioned above had already been standardized in earlier biographical writing. In their 1934 study of the image of the artist, Ernst Kris and Otto Kurz identified ancient tropes still common in the nineteenth century: the insistence that an artist learned directly from nature rather than from tradition, the idea that a great artist had magic power or divine inspiration, the tale of the artist rising in social rank.[27] And the more specific rhetorical devices of Renaissance artist biographies identified by Soussloff also recur in the nineteenth century, including a standardized structure tied to biological life and death and the key narrative technique of combining anecdote with ekphrasis.[28] In developing into a general theory of history, however, biography became not only a formal methodology for the new discipline of art history, but also the dominant mode of narrating the nation's contemporary art practice. Spurred on by romanticism, the French Revolution, and David's imagery, the biographical model of individual genius and liberty evolved from a mode of history to a mode of criticism. The very same writers, publishers, and institutions that were creating art history began simultaneously to construct an art historical future, casting France as the successor to Florence, casting Ingres and Delacroix as the successors of Raphael and Michelangelo. The change was critical; rather than

reinterpreting facts left by Vasari and others, art writers were now establishing the historical record itself, stacking the deck of *future* art history in favor of the biographical model.

## 2. CONTEMPORARY BIOGRAPHY, NATURALISM, AND NATIONALISM

Like most art historians of his day, Blanc also wrote about contemporary art. His major work in this vein, *The Artists of My Time* of 1876, was a compilation of Salon reviews, each devoted to one artist. He himself described this jumbled assortment of figures as "a gallery of portraits" whose value rested on his personal knowledge of each artist discussed. "If we attach so much value to Vasari's *Lives of the Painters*," he wrote in the introduction, "it's that the famous biographer is always more or less mixed up with the events he recounts and that he was either the friend, the rival, or the enemy of almost everyone he spoke about so naively and so well."[29] Clearly, Blanc recognized the importance his personal accounts could hold as the basis for future art history.

His major contribution to contemporary biography was his 1870 *Ingres: His Life and Works*.[30] Written, typically, immediately after the subject's death, the biography repeats the structure, logic, and rhetoric of Quatremère de Quincy's Raphael biography virtually trope for trope. It opens with a print after Ingres' early self-portrait and closes with a catalogue raisonné and a facsimile of one of Ingres' letters. The main body of the text, a single chronological biography organized into seventy-seven episodic subdivisions, begins with an assertion of the correct date of Ingres' death, which leads into his birth and upbringing. Blanc inserts plenty of praise and personal commentary, backed by occasional footnotes and frequent anecdotal quotations from Ingres' letters, which, he states in the introduction, form the foundation for the entire book; they make it possible to follow Ingres' thoughts and development step by step, "to know both the variations in his mood and the unbending unity of his character, his daily emotions, his temporary discouragements, his acts of strength, his heroic efforts to reach the highest summits, and finally, his ideas about art and his opinions of others and of himself."[31] The standardized "facts" from biographies of past artists are being transferred to France's most contemporary, just-fallen genius; we will learn about his rise to fame, his magical powers, his heroism, and above all his personal feelings and experiences. These are the bits of data Blanc intends to preserve and, needless to say, countless other facts and data will be left aside as he constructs an image of Ingres as one of France's heroic geniuses.

While they replayed old stereotypes, such contemporary biographies did bend the genre in distinct new directions. The most significant change, I think, was in locating France's modern national character in what I have elsewhere called "impassioned naturalism."[32] The term *naturalisme* was used very loosely in France to describe any art rooted in personal observation and realistic description, and "impassioned naturalism" recognizes the concurrent assumption that

an artist's description should be filtered through personal emotion. The tendency appears in one of the very first, paradigmatic examples of a contemporary biography, Delestre's 1845 life of Gros, republished in 1867 by the publisher of Blanc's *Ingres*.[33] Like Blanc's work, Delestre's is rooted in personal recollection, and the text is factual and chronological, while ascribing to Gros magical power. The specific nature of Gros's genius, however, is his naturalism, his ability to transmit "his vivid impressions" of the world around him.[34] While Delécluze's famous biography of his teacher David, published a decade later in 1855, was an exception to the trend,[35] de la Combe's 1856 biography of Charlet follows the naturalist formula. With a catalogue of Charlet's prints and, in the manner of Leslie's *Constable* of 1843, extensive quotations from his letters, the book locates Charlet's originality in his faithful description of his world, in this case the Napoleonic era.[36] Even Delacroix was aligned with a kind of naturalism in his first posthumous biography, published in 1864.[37] The author, Cantaloube, locates Delacroix's genius in his erudite soul and heroic imagination, but he also describes Delacroix's colorism as "the transposition in the human drama of the effects of what is called inanimate nature."[38]

The naturalist biography reached a kind of culmination of modern scholarly rigor with Clément's study of Géricault, first serialized in 1867 in Blanc's *Gazette des Beaux-Arts* and then published in a revised book form in 1868 and 1879.[39] A catalogue raisonné, quotations from Géricault's letters, archival documents, and recollections from friends all contribute to the chronological recitation of the artist's life and the construction of Géricault's image as a heroic figure describing his experience and his emotions. Nearly as prolific as Blanc, Clément similarly worked in a variety of art historical genres: he published works on the Italian Renaissance (1857) and Michelangelo (1859), as well as the Michelangelo–Leonardo–Raphael work discussed above (1861); studies of Prud'hon (1872), Léopold Robert (1875), his own teacher Gleyre (1878), and Decamps (1886); and the more general *Studies on the Fine Arts in France* (1865) and *Ancient and Modern Artists* (1876). Like Blanc, he thus helped institute not only the art historical practices used to analyze past art, but those used to analyze contemporary art as well. And the influence of their writings and the biographical tradition in general is evident in a spate of biographies on contemporary artists that rushed out in the two decades following Ingres' death in 1867, most significantly Alfred Sensier's biographies of the great naturalists Théodore Rousseau and Jean-François Millet.[40]

As in the case of historical biographies, contemporary biographies served various institutional interests at once, all of which were instrumental in the development of art history. Like Blanc, Clément had government ties, serving as a curator for Napoleon III's art collection and publishing a catalogue of the jewelry section.[41] He also was active in professional and popular journalism; succeeding Delécluze as art writer for the *Journal des débats* in 1863, he also wrote on Renaissance and modern art for the *Revue des deux mondes* and Blanc's *Gazette*. And like Blanc again, he published *many* books, riding the

waves of a publishing industry that was expanding rapidly after the 1820s with the support of a growing middle class audience. The many different publishers of artist biographies concentrated primarily on literature and history, but the fact that they all began dabbling in art as well suggests that art history was beginning to have a broader audience. Indeed, Quatremère's book on Raphael and Blanc's *Artists of My Time* (as well as the *New Universal Biography*) were published by the most successful house of the day, Firmin-Didot.[42]

One must acknowledge, finally, that France's unique Salon system exerted subtle but profound influence on the entire biographical discourse. To meet many of its basic aims – attracting crowds, spurring journalists, fueling auction prices, and establishing masters to represent the nation in state museums and international exhibitions – the Salon needed heroes (and martyrs), each of whose life story was an essential link in the formation of France's pantheon of genius. Likewise, French art history, to be compelling, had to show its relevance to contemporary culture and politics. Biographies of Michelangelo, Raphael, and Rembrandt were popular among collectors, artists, historians, and a growing public at large. But they also helped focus attention on France's own contemporary art. By producing the new myth of modern French artists as free-spirited heroes, art historians showed the nation state of France to be fulfilling the roles that Italy and Holland had played before: leader of European art and the modern seat of genius itself.

## NOTES

1  D. Preziosi, ed., *The Art of Art History: A Critical Anthology*, Oxford, Oxford University Press, 1998, pp. 13–18.

2  M. Foucault, "What is an Author?" in *Language, Counter-Memory, Practice: Selected Essays and Interviews*, ed. D.F. Bouchard, trans. D.F. Bouchard and S. Simon, Ithaca, Cornell University Press, 1977.

3  See L. Therrien, *L'histoire de l'art en France*, Paris, Editions du comité des travaux historiques et scientifiques, 1998, pp. 133–42.

4  My information on Blanc is taken from the *Dictionnaire de biographie française*, ed. J. Balteau *et al.*, Paris, Letouzey et Ané, 1933– (1954), vol. 6, pp. 578–9; G. Vapereau, *Dictionnaire universel des contemporains*, 3rd ed., Paris, Hachette, 1865, p. 204; and M. Song, *Art Theories of Charles Blanc, 1813–1882*, Ann Arbor, UMI Research Press, 1984.

5  On Charles' role as director of fine arts, see T.J. Clark, *The Absolute Bourgeois: Artists and Politics in France, 1848–1851*, 2nd ed., Princeton, Princeton University Press, 1982, pp. 49–57.

6  *Grammaire des arts du dessin*, with multiple editions from 1867 to 1908. Therrien gives an indication of its influence on pages 138 and 141. For a detailed analysis of the *Grammaire*, see Song, *op. cit.*

7  The *Histoire des peintres de toutes les écoles* was published in book form between 1861 and 1876. But Vapereau states (*op. cit.*) it was first published in 280 installments, 1849–59, and Therrien (*op. cit.*, p. 138) sets the beginning date at 1848.

8  See R. Holmes, "Biography: Inventing the Truth," in J. Batchelor, ed., *The Art of Literary Biography*, Oxford, Clarendon Press, 1995, pp. 15–25; and C.M. Soussloff, *The Absolute Artist: The Historiography of a Concept*, Minneapolis and London, University of Minnesota Press, 1997, p. 37.

9  Soussloff, ibid.

10  I was unable to examine all the volumes; my observations are based primarily on the first two volumes, devoted to Dutch art.

11  L.-G. Michaud, *Biographie universelle ancienne et moderne*, 85 volumes, Paris, Michaud frères, 1811–62; and F. Hoefer, *Nouvelle biographie universelle*, 46 vols, Paris, Firmin-Didot frères, 1852–66. The Michauds specialized in books glorifying the ancien régime. Firmin-Didot, one of France's biggest publishing firms, specialized in classical literature and multi-volume historical and geographical books. For both houses, the biographical encyclopedias were part of a campaign to modernize business practices and attract larger audiences; see R. Chartier and H.-J. Martin, ed., *Histoire de l'édition française*, 4 vols, Promodis, 1982–6, vol. 3, pp. 176–244.

12  These statistics are derived from the catalogues of the Bibliothèque Nationale.

13  C. Blanc, *L'Oeuvre de Rembrandt reproduit par la photographie*, Paris, Gide et J. Baudry, 1853–8. I have only found, in the Bibliothèque Nationale, the first series of ten installments, each of which had four prints and sold for twenty francs. But an advertisement in Blanc's second Rembrandt book (1864 edition) states that the full series appeared in two sets of ten installments each, presenting a total of 100 photographs at a cost of 400 francs. It also mentions an introduction on the life of Rembrandt, which seems not to be in the set I consulted.

14  "cette science mystérieuse a rendu possible une véritable réimpression des gravures par la lumière." Ibid., p. 2.

15  C. Blanc, *L'oeuvre complet de Rembrandt*, Paris, Gide, 1859–61. The Bibliothèque Nationale has two or three versions of this set, and some volumes are not available for consultation, but their content seems to be identical. The set I discuss here is in octavo and labeled volume one and volume two, but is missing one installment midway through. It is at the back of another set, in quarto, that an advertisement mentions a few copies printed on large paper available for forty-five francs, whereas the regular price was eighteen francs.

16  Ibid., vol. 2, pp. 374–5: "... nous aurons du moins la satisfaction et la conscience d'avoir donné au public le catalogue presque définitif des eaux-fortes du maître, d'avoir décrit à nouveau, mis en lumière, expurgé et véritablement complété son *oeuvre*, dans le sens qu'attachent à ce mot les amateurs."

17  "Personne n'a surpassé Rembrandt dans l'expression, qui est l'âme de la peinture." Ibid., vol. 1, p. 28.

18  A.-C. Quatremère de Quincy, *Histoire de la vie et des ouvrages de Raphaël*, Paris, Rignoux, 1824; 3rd ed., Paris, Firmin-Didot and Le Clere, 1835.

19  Ibid., p. 1: "La petite ville d'Urbin, dans l'État ecclésiastique, donna naissance à Raphaël Sanzio en 1483."

20  "une histoire proprement dite, c'est-à-dire celle du génie de l'artiste, par l'ensemble et la nature de ses oeuvres, doit différer du genre d'un inventaire ou d'un catalogue ..." (ibid., p. 11). The second point is made on page 368.

21  C. Clément, *Michel-Ange, Léonard de Vinci, Raphael* [sic] ..., Paris, Michel Lévy frères, 1861.

22  "Michel-Ange naquit le 6 mars 1475, près d'Arezzo, dans le Valentino." Ibid., p. 51.

23  Ibid., pp. 50–1, 150–66.

24  Ibid., pp. 47–9.

25  "le caractère collectif et général ..." and "les oeuvres sont plus que jamais individuelles et marquées du sceau de l'auteur." Ibid., p. 49.

26  "Le caractère de l'artiste s'accusa nettement dans son oeuvre, qui, devenue plus vivante, acquit en même temps une individualité plus précise, et refléta nettement ses idées propres, ses penchants, ses passions." Ibid., pp. 49–50.

27  E. Kris and O. Kurz, *Legend, Myth, and Magic in the Image of the Artist*, New Haven, Yale, 1979; originally Vienna, 1934.

28  Soussloff, *op. cit.*, pp. 2 and 19–42, especially 33.

29  C. Blanc, *Les Artistes de mon temps*, Paris, Firmin-Didot, 1876, pp. v–vi: "Si nous attachons tant de prix aux *Vies des peintres* de Vasari, c'est que l'illustre biographe est toujours plus ou moins mêlé aux événements qu'il raconte et qu'il a été ou l'ami, ou le rival, ou l'adversaire de presque tous ceux dont il parle si naïvement et si bien."

30  C. Blanc, *Ingres: sa vie et ses ouvrages*, Paris, Veuve Jules Renouard, 1870.

31  Ibid., p. i: "de connaître à la fois les variations de son humeur et l'unité inflexible de son caractère, ses émotions de chaque jour, ses découragements momentanés, ses actes de vigueur, ses efforts héroïques pour atteindre aux plus hauts sommets, enfin, ses idées sur l'art et ses opinions sur les autres et sur lui-même."

32  G.M. Thomas, *Art and Ecology in Nineteenth-Century France: The Landscapes of Théodore Rousseau*, Princeton, Princeton University Press, 2000, p. 77.

33  J.-B. Delestre, *Gros: sa vie et ses ouvrages*, Paris, Labitte, 1845; 2nd ed., Paris, Jules Renouard, 1867.

34  "ses vives impressions ..." Ibid., p. 2.

35  E.J. Delécluze, *Louis David: son école et son temps*, Paris, Didier, 1855. Delécluze's account is surprisingly anti-heroic.

36  J.F.L. de La Combe, *Charlet, sa vie, ses lettres* ..., Paris, Paulin et le chevalier, 1856; and C. Leslie, *Memoirs of the Life of John Constable* ..., London, J. Carpenter, 1843. De la Combe seems to have been a friend from Charlet's military circle, not from the art world.

37  A. Cantaloube, *Eugène Delacroix: L'homme et l'artiste* ..., Paris, Dentu, 1864.

38  Ibid., p. 10: "... la transposition dans le drame humain des effets de la nature dite inanimée ... ."

39  C. Clément, *Géricault: Étude biographique et critique avec le catalogue raisonné de l'oeuvre du maître*, Paris, Didier, 1868; revised edition, Paris, Didier, 1879. The latter was reprinted (Paris, L. Laget, 1973) with an introduction and supplement by L. Eitner.

40  *Souvenirs sur Th. Rousseau*, Paris, Leon Techener, 1872; and *La Vie et l'oeuvre de Jean-François Millet*, Paris, A. Quantin, 1881. See Thomas, *op. cit.*, for some analysis of Sensier's biography of Rousseau; for a fuller analysis, see my doctoral dissertation, "Théodore Rousseau and the Ecological Landscape," Harvard University, 1995.

41  Information on Clément is from the *Dictionnaire de biographie française*, *op. cit.*, vol. 8 (1959), p. 1435.

42  See O. and H.-J. Martin, "Le monde des éditeurs," in *Histoire de l'édition française*, *op. cit.*, vol. 3, pp. 176–244. On individual publishers, see *Dictionnaire de biographie française*, *op. cit.*

# 17

# A PREPONDERANCE OF PRACTICAL PROBLEMS

Discourse institutionalized and the history of art
in the United States between 1876 and 1888

*Eric Rosenberg*

It is hardly the case that the history of art was a commonplace in higher educational curricula in the United States in the late nineteenth century. If such a discourse could be said to have taken institutional form at this time, it would be more accurate to look for it in nascent museum and private-collecting patterns, and myriad written examples existing and circulating above and beyond those educational organs more readily associated with the dissemination, or the professing, of the history of art in the present day.[1] There was, however, no shortage of publications in the period between the end of the Civil War and the turn of the century devoted either periodically or in singular book form to offering American audiences some sense of a history of art for a culture finding its feet as consumers of world-historical artifacts and some sense of their order and significance in relation to an emerging nationalism committed to determining how to locate and situate the American participation in world history.

One quite visible manifestation of this interest was the emergence of significant, influential and consistently published periodicals devoted either in part or on the whole to the fortunes of modern art and the place of previous examples of artistic production as encountered in the modern world. Journals like *Scribners*, *The Century*, and *The Critic*, while largely devoted to cultural and literary interests, almost always offered space to visual art phenomena of the present or past in any given issue. Meanwhile, magazines like *The Art Interchange*, *The Art Exchange*, the *Magazine of Art*, and the *American Art Review* were prominent forums for mediating the impact of modern and historical art as its production and reception intersected with contemporary American culture and its concomitant interests.

After the Civil War, a burgeoning art world came to professionalization. As a result, systems of exchange were further institutionalized. The dissemination and proliferation of world-historical art marked an aspect of the surge to professionalize. In turn, meaning making and facilitation were ever increasing projects

meant to insure a place for American participation in something – a history of art – that had been going on for quite some time. Therefore, language and writing, as means to securing such a position, answered often to the demands of ideology. The terms of criticism were, if not always, quite often, already structured and directed to provide a set of prescriptive associations and arguments serving simultaneously to determine just precisely where and how art history might be evident and where and how it was immanent, or inflected and inflected by, the American.

A brief case in point: a passage from an article by Henry James, appearing in the *New York Tribune* on 19 February 1876, under the heading "Parisian Topics." After parsing with alacrity the virtues and drawbacks of Delacroix's *Sardanapalus*, on view at Durand-Ruel's at the moment – "it takes early youth to attack such subjects as that … Delacroix has not solved its difficulties" – James goes on to say:

> The other picture, painted in 1848, an "Entombment of Christ," is one of the author's masterpieces, and is a work of really inexpressible beauty; Delacroix is there at his best, with his singular profundity of imagination and his extraordinary harmony of colour. It is the only modern religious picture I have seen that seemed to me painted in good faith, and I wish that since such things are being done on such a scale it might be bought in America …[2]

There is a lot of history and a lot of art history in James' comments. It is not for nothing that a painting such as *The Death of Sardanapalus* should, by association, and as transmitted by James, not seem, or be allowed to seem, successful to American audiences. In 1876 it is not the days of wild youth, pre-revolutionary days, that are recommended to the growing nation, but rather the painting – the *Entombment* – that is product of or even corrective to 1848, another moment of sedition and revolutionary fervor. James starts, in fact, from the evidence of 1848 as a year that has clearly informed the arrival of "singular profundity … and … extraordinary harmony" in Delacroix's work.

Mention of 1848 cannot help but inform the fact of James writing in and to America in 1876. French rebellion would have had to signal America's own history, its claiming of independence, and its emerging and coming celebration of such. Not to mention the complications attending the proximity of French radicalism on American shores as a result of fear of the spreading influence of the recent Commune. James could have understood the complexity of references let loose by invocation of Delacroix alongside 1848, but he is careful not to forecast comprehension of the painter's allegiances as a part of the drive of discourse. The critic seems almost predisposed to offer American readers an art-historical teleology within, and perhaps corrective to, the larger movement of history, which by comparison can make no claim whatsoever for satisfying inevitability. James solves the problem of seemingly threatening social upheaval in the Centennial year by foregrounding Delacroix's natural,

virtually instrumental, practically unwitting movement from inchoate beginnings to aesthetic culmination in modern religious motive.

Meanwhile, what do we do with the fact that *Sardanapalus* is not to James a complete failure? As he asserts "much of the picture is very bad, even for a neophyte. But here and there a passage is almost masterly, and the whole picture indicates the dawning of a great imagination." Something must come before apogee and thus in *Sardanapalus*:

> One of the women, half-naked and tumbling over helpless on her face against the couch of her lord, with her hands bound behind her, and her golden hair shaken out with her lamentations, seems in her young transparent rosiness, like the work of a more delicate and more spiritual Rubens.[3]

Moving from the earlier to the later painting, we follow "lamentations" to Lamentation. Along the way, James traces a history of art that moves from more inchoate and youthful, almost baroque expression, to profound, harmonized, virtually classical, but inexpressibly beautiful form.

Despite the infelicities of *Sardanapalus*, we find here the work of "a more delicate and more spiritual Rubens." As later Delacroix trumps early Delacroix, so the nineteenth century must advance beyond the seventeenth. A virtual history of civilization is implicated in the development of a single painter, and a recommendation for the comprehension of history is embedded in the semantics of James's criticism.

It is no accident, then, that on the eve of the Centennial, it is the apex of the painter's work that is recommended to American collectors for purchase and, by extension, edification, on a larger scale of display. The lesson is as much about American potential as it is a demonstration of the critic's discernment in regards to Delacroix. Though the latter too must resonate in and for a national context.

James's discourse is dense and assumes a complicated, if in some ways schematic notion of how history and art history work. At the same time, and perhaps as a result of such thinking – how its determinism is inseparable from what distinguishes it – it is very difficult to assess whether a consistent or coherent history of art circulates through writing concerned with such matters in late-nineteenth century America, without reading much of it similarly. Thus, I want to work in the remainder of this chapter to tease out of a few words, pregnant in their configuration and assumptions about history and the history of art, and located in a criticism as concerned with the art of the present as it is with that of the past – a criticism that in essence sees both as one in the same, and to that end fudges boundaries between history and the contemporary – a trace of the historical. Or at least the recognition of the historical demand that each conception of time be folded into the other in some way or another, as a hedge, perhaps, against what one or the other might be in and of themselves, especially in the event that either present itself as something undesirable, or pointing in that direction.

My aim here is not to preclude, however, approaches to such issues that would focus more directly on the establishment of professorships of Fine Arts or Art History in universities, the publication of books on the history of art, or the burgeoning museum trade and practices of collecting in late-nineteenth century America. These are utterly central ways into the institutionalization of art history in the nineteenth century, in the United States as elsewhere. Speech patterns, discourse, modes of interpretation and exegesis are, however, institutional as well – we call them discourse or ideology – and, perhaps, institutions in and of themselves, whether we identify those institutions as hermeneutics, or history.

For these purposes, I use as my further foundation the short-lived publication of a journal out of New York City called *The Art Review*. The magazine had a brief life, carrying articles between 1886 and 1888 on a variety of both contemporary and more historically inflected art interests. A number of the most prominent and most accomplished and sophisticated American art critics of the moment appeared between its covers, including Charles De Kay, Helena De Kay, M.G. Van Rensselaer, John C. Van Dyke and Charlotte Adams. There is little reason to believe that the appearance of the journal in 1886 had anything to do with an emerging avant-garde voice in American aesthetic discourse, but for a moment *The Art Review* does embody a liberal agenda sympathetic with shifts in the character of social and political relations as a result of phenomena such as immigration.

I want, however, to commence with – and I fear I won't get much further than – a curious valedictory sentence that closes an article on Rembrandt by Harold Godwin published in 1886:

> Rembrandt is undoubtedly the master of the art of the future, for no other painter of the past but he could have met and successfully interpreted the needs of the nineteenth century – needs emanating first of all from a complete extinction of religious art, from the growth of democratic institutions, and from the preponderance of practical problems.[4]

Godwin's phrasing is at once extraordinary and mundane. The reader is simultaneously unmoored and anchored from the start of the statement. Rembrandt, in name alone, will surely keep us rooted; yet, as painter of the future, he will also seem an anomaly, out of his element, removed from history. History itself appears to the reader as something destabilized, unable to be articulated in received, commonplace terms. What can it mean for a painter of the past to become a sign of the future? Are all contemporary artists bound to emulate this one historical figure?

History's character is not captured here simply in terms of anticipation. Rembrandt is not seen to have embodied the future as he lived the past. Rather, Godwin credits the painter with having "met and successfully interpreted the

needs of the nineteenth century." In other words, the seventeenth-century artist has somehow been transported to the nineteenth, exists outside of his own time, could not be fully realized as an artist in his moment, and only finds definition of his achievement in the present. There is something virtually Hegelian in the fulfillment of a life of the spirit here, claimed as sign of contemporary artistic production. There is perhaps something Jamesian too – inverted perhaps – as we recall the way in which Delacroix became the better Rubens, became the nineteenth-century Rubens in the space of a brief passage. What strikes the reader first is that an environment has been described in which Rembrandt could not help but be reimagined as something other than, or in addition to, any notion of what he might have been in the seventeenth century. What kind of understanding of the painter could have been had in order to find him suitable to the present?

The drama and force of the first clause of the quoted phrase sets immediately the terms of reconstruction: "… a complete extinction of religious art … " Whatever period or quality of historical material is assumed as foundation for such a definition, it is unquestionably thunderous. It is as if Rembrandt has been lifted from the era of Protestant instantiation and dropped onto another planet. With Rembrandt as a touchstone for historical order and movement, something implied by the semantics of the entirety of the quoted phrase, a sign by which sense is made of the present and the future, the nineteenth century becomes a time beyond time. How else to read a coupling like "complete extinction?" It is absolute in its description of a moment dislodged from history, unable to hold the past save in its reframing as something of the present. The demand for a new Rembrandt becomes inevitable. A Rembrandt sympathetic to the disappearance of religious art would be a Rembrandt selectively groomed for reappearance in the future. The whole of his practice would have to be assumed to be other to its thrust in its original moment of production.

What, in fact, seems irrevocably lost to history in this instance is any possibility of origin. This is perhaps the key to the writer's confidence in claiming an artist of the past as painter of the future. Insecurity of relation between historical moments is somehow undone for Godwin in his consideration of the present. His conception of present is without precedent, save, perhaps, for what might be retained in memory. History leaves no external traces. How could anything survive complete extinction? Especially when it is the demise of a form of meaning making previously paramount for a history of art. Rembrandt becomes an internalization of a moment no longer accessible, a moment the present is entirely out of sympathy with, a moment he himself, as recollection, cannot sustain. Thus, his status as cipher.

It could hardly do, however, to imagine Rembrandt as a blank void in which the writer might store the aspirations of the present for fulfillment in the future. It behooves us, as a result, to ask how the association of Rembrandt with the complete extinction of religious art might still seem to allow for the utilization of a historical example that is clearly intended to ease the destabilized and

shifting material relations of the present with some kind of invocation of a mastered past. Rembrandt must then be seen to have had something to do with the eradication of the religious in art, despite any arguments that might be made for his investment in the same. Such an understanding speaks to the writer's careful consideration of the artist's work as a step in the process of theorizing history, producing a history of art that accounts for the present as somehow made out of the past, despite the seeming disavowal of the traces of the latter. It is as if the past cannot be used unless it is experienced as dead. It can, in other words, be reincarnated.

Rembrandt's "religious" art must, therefore, have embodied its own extinction. The writer cannot have been convinced of the intention of such work. Or, perhaps, the present extinction of religious art provides a lens through which Rembrandt's work appears without its original intention as binding agreement to the embrace of meaning. It is true that the "subject" of the article is a portrait by Rembrandt referred to as the *Gilder*. This fact alone can hardly account for a conception of Rembrandt's work that questions the depth of religiosity in his religious painting. Rather, like religious art in and of itself, the religious in Rembrandt's work cannot be nurtured and its life extended in the present day. An image of Christ by Rembrandt may once have signified Christ in its entirety. In the nineteenth century it will read as simply a portrait of a living being. This is not, however, to argue for an ultimate material realism or social realism overtaking the vogue for the religious associated with the history of art prior to the present day. But remember that Henry James himself, about Delacroix's *Entombment*, said: "It is the only modern religious picture I have seen that seemed to me painted in good faith, and I wish that since such things are being done on such a scale it might be bought in America … "

As Godwin acknowledges a few passages prior to the close of his article, it is possible to overstep the boundaries of the real, something James himself sees happening in *Sardanapalus* but corrected in the *Entombment*:

> On the threshold of the subject, new and vast possibilities seem to stretch out before one, but here it must be left for others to take up the thread. There are difficulties to be met which none but painters of long experience and knowledge can overcome. What our art demands is an expansion of this kind. Prevalent methods have certainly not the elasticity necessary for the work of the day. The result has been the establishment of the Impressionist school – a body of painters who mark an epoch in the history of art because their very existence shows to how low an ebb the art of to-day can reach. They magnify the very defects from which art suffers. Opacity of pigment, want of detail and inanity of subject are the glories toward which they tend.[5]

The production of history would seem to be essential to the facilitation of a history of art that is coincident with a satisfying contemporary artistic practice.

The complete abdication of history results in the opacities of the Impressionists and a regard for the real that results in inanities of subject. Still, it is the real that is wanted, that is recognized as unavoidable, necessary to the needs of the nineteenth century. Thus the press to reconfigure Rembrandt as something suitable to the present. As Godwin goes on to say just beyond the recently quoted passage: "The natural reaction of the day against [Impressionism] and other prevailing tendencies is toward greater realism, tempered, as it is in the works of Rembrandt, by simplicity."[6] There is realism and there is realism. In a sense, the writer is simply staking a claim to this phenomenon as central to the history of art in its totality. At the same time, he is making distinctions within distinctions crucial to his understanding of variegated manifestations of similarity and resemblance in the history of art. Realism may not be, in 1886, one thing; it may be many, and it may still be something else in 1646. Rembrandt is simply one measure of such distinctions, though a very particular one at that, capable in his discursive manipulation of stemming the tide of "inanity" produced in the moment by the Impressionist school and perhaps redolent as well of a period in which the "complete extinction of religious art" is a mark of history.

The above is secured, of course, by draining the artist's work of meaning, aside from that produced by materials, another sign of the reconfiguration of the painter as contemporary, as, perhaps, modern. It is Rembrandt's technique that is the real focus of the article and it is his handling of tones and pigments and varnishes, to produce a luminosity and transparency – deeply loaded terms for the evaluation of contemporary painting – associated with precious gems and securing his value for the present day. Rembrandt alone is able to measure the proper relationship, as subtle as can be imagined, between what the writer calls surface and underground. And it is a talent that in its extrapolation for the purposes of the nineteenth century allows for distinctions within the history of art:

> Rembrandt represented light by the subdivision or thinning of opaque colors, thereby classing all colors as transparent ones; and ... he maintained both their purity and their transparence by giving them the appearance of swimming, or being held in suspension, in a transparent medium. Rembrandt's painting differs signally in the last particular from the work of the great Italian colorists. They understood the art of glazing to perfection, as a careful examination of the works of Titian or of Tintoretto will show. While therefore their color may be aptly compared with that of the flower (that is color emanating from the surface), Rembrandt's assume the depth of the precious stone together with its luminosity.[7]

It is clearly important to get right the quality of Rembrandt's technical achievement as it allows for an introduction of metaphor crucial to the embrace of the painter as lynchpin for understanding contemporary painting. It is simply not

acceptable in a moment marked, for instance, by the complete extinction of religious art for a mode of representation to emerge as dependent solely on surface qualities. To invoke a Titian or Tintoretto as the painter of the nineteenth century or the future would be to sacrifice a moral underpinning still necessary to the endeavor of the history of art, a moral underpinning carried by the suggestion that the process of painting involves the foundation of representation as well as its appearance. In fact, Titian and Tintoretto might seem in the present too much the Impressionists, all opacity because all surface; no luster because no depth. Rembrandt, on the other hand, works nuanced relationships between surface and underground to achieve a level of value beyond that of the more ephemeral natural (the flower) and in favor of a materiality more valuable in its longevity and resonance for the market (the gem).

The most potent metaphor is of course that of the painting of light, the thrust of the passage from its outset, what the painter is, after all, after. With light comes illumination, visibility, understanding. Enlightenment metaphors of comprehension and the production of knowledge virtually mark the aim of a contemporary history of art as both post-Rembrandt and Rembrandtesque. All painters are in search of understanding, only some can find it. And then, certain methods will insure the success of this quest. For the nineteenth century, the complete extinction of religious art means simply the transference of metaphor as agent of understanding from the realm of the divine to the realm of the real, an old story, but a tenacious one. And thus, the other characteristics of the moment that seem to demand Rembrandt as reference point for Godwin as he closes his article: "the growth of democratic institutions, and ... the preponderance of practical problems."

Here, in fact, is the problem in a nutshell: how to measure the distance attendant upon the construction of history, between opportunity and mastery, between anonymity and identity, between equality and privilege. At once, we are landed in the world of Marx and the Robber Barons, Darwin and Spencer. The growth of democratic institutions in and of itself, syntactically situated in this very string of clauses, is rolled on to the stage to question the very tenacity and hegemony of the religious. Such growth will lead inevitably to a new hierarchy, one subsequent to the religious, one wherein the masters of the practical (for practical read real) will hold sway over those who embrace democracy as their ideology, while expecting it to work for them, rather than vice versa. Within the history of art, the movement implied in such a construction is from Renaissance to Baroque to modern; from surface, to volume, depth and value, to illegibility and nonsense. In turn, history finds itself at a juncture wherein it is hypothesized that some past example might temper the distance that has been traveled from origin to present. A reminder of past models of order and reason is demanded at a time when anarchy and inanity seem to be encroaching.

In the middle of such a stew of social constructs, it is necessary to identify an exemplar simultaneously of history and beyond it; situated and transcendent. Rembrandt, not Titian, nor Tintoretto, is that sign, a precedent who might in

his invocation encourage the Impressionists to see the errors of their ways, or at least add a touch of translucency to the muddy opacity of their pigment. For, as Godwin maintains, the most "difficult of all questions to the painter [is] ... the maintenance of transparence." Transparence is, of course, the goal of the painter of light, the seeker of understanding and enlightenment. What is constituted is an owning to the conditions of modernity. Or, in a moment of the "growth of democratic institutions, and ... the preponderance of practical problems" all one can ask of the representation of the modern is that each producer, each unit in the growth of democracy, each master of the practical, offer him or herself up as a transparent vessel, signifier, cipher of his or her moment, intentions, ideology. As painting turns ever more centrally on its identification with and of its own means, so democracy will hinge on the "honesty" or at least readability, the realism, of each of its members. This is virtually described as the responsibility of modernity, the responsibility insured by citing a figure such as Rembrandt as prototype for the embodiment of such qualities in art and art history.

The maintenance of transparence has, needless to say, another side to it as well. As a goal of representation it implies the continual uncovering of the nefarious, the underground to use Godwin's enticingly loaded term, the illegible, the hidden and concealed. To this end, the example of Rembrandt becomes a kind of historical policeman, insuring that the wrong elements (Impressionists?) do not gain too much ground in the academy, while conceding perhaps that something of what they are after might better be secured, in a fashion, tinged with the patina of history, if Rembrandt's method is seen as both means and end within the context of the nineteenth century. What is dangerous about the nineteenth century, about the complete extinction of religious art, about the growth of democratic institutions, about the preponderance of practical problems, is the extent to which such conditions, in and of themselves, are the breeding ground of a history altogether anarchic in its implications.

The job of positing a history of art that lives and breathes, and is capacious enough to embrace the contemporary, is, in essence, the problem at hand. And it is one that necessitates a certain sensibility to what distinguishes the audience for art and how that audience might translate as the social, a demographic, or demographics. In a subsequent issue of *The Art Review*, of 1888, the critic and historian John C. Van Dyke, in an article entitled "The Beauty of Paint," puts it this way:

> Of those who patronize the gallery during the art season the father of the family goes to see something funny, the mother to see the pathetic "ideal," Miss Fanny looks for a romantic story on canvas, and Young Hopeful is carried away with a theatrical group of athletic models or a historical tragedy containing the moral-sublime. But the art-learned connoisseur, the diligent amateur, the shoppy artist, and the carping critic – what do they go forth to see? Why paint ... Whether at

Amsterdam or Venice among the ancients, or at Paris or Munich among the moderns, it is the same; the quest is for paint.[8]

For Van Dyke, paint, pigment, sheer material, are the only shelter, the only place of safety in the combustible atmosphere of Godwin's nineteenth century. Just look at how the family itself divides in its regard for art. If consensus is impossible there, how might it be expected on a larger social scale? The whole history of art is, in fact, implicated: ancient, modern, the present day. In all temporal definitions of aesthetic experience, fulfillment has been winnowed down, necessarily, to an essential ingredient without which there is no history, and most certainly no present or future; or at least none in which the essential ingredients of safety and order are promised.

Thus, again, the importance for Godwin of Rembrandt's transparence, the luminosity of his pigment, his paint. Medium becomes bearer of meaning as the clarity of history is carried in the pregnancy of material, its ability to bear and betray meaning. In the character of Rembrandt's paint it is possible to read an ethics, perhaps, or morality; at least, in any event, ideology. It is this last requisite ingredient of the historical, of which paint bears the most tenacious imprint. For some reason, Rembrandt's, the pigment of the ancients, according to Van Dyke – for Amsterdam as a site of encounter with the art of the ancients can only mean Rembrandt – is the material most readily manipulated, in the arena of reception, to insure a meeting of the present and the past. It is not, of course, Rembrandt's pigment that is the catalyst for historical trajectory. It is rather that Rembrandt, ironically, got away with the very act of subversion he is now supposed, by Godwin, to be a hedge, for the art of the present day and the future, against. That, precisely, is the point: Rembrandt offers an ideal, tested in history, of a practice that, unlike Godwin's description of the painter's meeting the needs of the nineteenth century, coped with the seventeenth century by anticipating the later moment or epoch. In other words, the seventeenth century made modernity necessary, unavoidable. How else, then, to satisfy the needs of the present day, than by locating its architect? Is this not the quest engendered in the process of reception carried out by Van Dyke's family: how to understand, how to make sense of the present within a totality that is the history of art?

To some extent, Godwin and Van Dyke offer no surprises in their constructs of history. Epoch succeeds epoch and the anxiety of influence is secure in its complexity and inevitability. If anything, these late nineteenth century critics trust too completely that the solutions of the present are inherent in some of the experiences of the past. James avoids such investment by recommending Americans purchase Delacroix at his best. (They took the hint – the *Entombment* ended up in the Museum of Fine Arts in Boston.) But this trust is mandated by the instabilities of the present, by the sense that a future is perhaps implied in the nascent age of democracy for which the present offers no reliable or ideologically sound map. The question is however begged, a begging Godwin and Van Dyke and most critics attending the place of painting in

American life at this time seem almost to invite in the quality of their language, in their syntax and semantics: What's missing from this picture? What really makes necessary a history of art institutionalized in this case as a discourse that demands the maintenance of the past in the present, even as that past is reinvented to "meet the needs of the nineteenth century?"

The proximity of anarchy for one – the three year period in which *The Art Review* is published is a culminating moment in a series of threats to dominant orders and ideologies emerging regularly in American life since the inception of an almost continually renewed depression in 1873. It is, for instance, the moment of the Haymarket Riots. Since 1873, in fact, American critics had been on the watch for elements in American painting given to disorder and chaos, hostility and contempt. By the mid-1880s no greater sign of the proximity of social upheaval was apparent than that carried by a phenomenon known as colorist painting – the work of an Albert Pinkham Ryder or a J. Frank Currier – unAmerican painters whose work's formlessness and illegibility denoted a type of visual anarchy. Godwin's article on Rembrandt is nothing if not a prescription for the correct method of colorist painting, a guide to when and where history got it right. How much more metaphor could be packed into a passage like this:

> Recognizing the necessity first of an underground which shall reflect a single tone through all the colors thinly superimposed upon it, [Rembrandt's] works show that he furthermore knew that he could obtain not only more brilliant coloring, but far greater transparency by painting over this underground with highly attenuated color and in a thoroughly transparent medium.[9]

Now it is important to understand that one of the fugitive qualities of American colorist painting at this time, in its most extreme manifestations, in the work of a Currier, or Ryder or Fuller, was its methods of concealment. Colorist paintings were said to "extort" approval from viewers, despite their hostility to the eye. Rembrandt promises a solution – one that simultaneously insures that the underground be defused in its remaking as one tone, one homogeneous formal or social entity, rather than a stew of participants – and that that newly found unity will remain visible at all times as the surface achieves greater and greater transparency. In contemporary social terms, the cognate is a reformation of fugitive elements in the image of the dominant and the superimposition of a mode of surveillance that will insure rehabilitation into the future, the incorporation of the marginal, or radical, into the dominant formation. As two-dimensional as such metaphorics seem, they are nonetheless the level of meaning making to which the discourse of American painting and its historical grounding aspires in this moment. Or is made necessary and unavoidable by the anxieties and fears manifested in a world given over to the complete extinction of religion, the growth of democracy and the preponderance of problems attending the growth of materialism.

An extraordinary article by Charlotte Adams, published in *The Art Review* in the year between Godwin's and Van Dyke's, names the threat in one of its other forms as well. In "Color in New-York Streets,"[10] Adams, a critic who had been writing on art for American periodicals since the late 1870s, identifies a new sense of heightened color awareness – in both the experience of traversing the streets of New York and the most contemporary, vanguard painting to be seen in the city – with the influx of immigrants and the diversification of cultures repopulating the urban environment at this time.

As Van Dyke has it in 1888: "Rembrandt admits of no classification, for he stands alone, an exception to all rules … results justify any means whatsoever that he may have used."[11] The possibility of art history is fluid, open, disordered perhaps, capable of great results, of culminating moments, but slippery as to plotting narratives comprehensible in their route to desired ends. Rembrandt, the term, the memory, the material evidence, is art history, as well as, perhaps even more than, art. How, then, could the problem of the colorist not incite extraordinary levels of anxiety in a patrician class of critics devoted to facilitating one history as opposed to another? (We are back in the space necessitating the analysis of Delacroix provided by James, the distinctions he makes, the subtleties he draws close to the eye.) Where could the history of art settle comfortably within the implication that it might be institutionalized at all? History itself seems almost impossible in this moment, a luxury ill afforded by the present day and its rampant signs of deterioration, disaffection with order and homogeneity, and desperation around the retention of such. A history of art would have to be circuitously, convulsively imagined. It would have to be both present and future, while always past. It would have to wait for modernity's own institutional validation. How else to insure a painting of democracy as we know it?

## NOTES

1 See A. Wallach, *Exhibiting Contradiction: Essays on the Art Museum in the United States*, Amherst, University of Massachusetts Press, 1998, for a fascinating collection of essays on aspects of this issue.
2 H. James, *The Painter's Eye*, Madison, University of Wisconsin Press, 1989, p. 113.
3 James, *The Painter's Eye*, p. 113.
4 H. Godwin, "Rembrandt's Gilder," *The Art Review*, vol. I, no. 3, January 1887, p. 7.
5 Godwin, "Rembrandt's Gilder," p. 7.
6 Ibid., p. 7.
7 Ibid., p. 6.
8 J.C. Van Dyke, "The Beauty of Paint," *The Art Review*, vol. III, no. 1, July–August 1888, p. 26.
9 Godwin, "Rembrandt's Gilder," p. 7.
10 C. Adams, "Color in New-York Streets," *The Art Review*, September, October and November 1887, Vol. II, nos. 1, 2 and 3, pp. 17–19.
11 Van Dyke, "The Beauty of Paint," p. 27.

# 18

# *EMANCIPATION AND THE FREED IN AMERICAN SCULPTURE*

## Race, representation, and the beginnings of an African American history of art

*Steven Nelson*

In 1916 Freeman Henry Morris Murray (1859–1950) self-published his book *Emancipation and the Freed in American Sculpture: A Study in Interpretation.*[1] This volume began as a series of illustrated lectures the author gave in 1913, in part to mark the fiftieth anniversary of the 1863 Emancipation Proclamation, at the African Methodist Episcopal Church's (AME) Summer School and Chautauqua of the Religious Training School in Durham, North Carolina. Some of these also appeared in the *AME Church Review*. Passionate and pointed, political and personal, *Emancipation and the Freed* is a catalogue raisonné of sorts, one that charted and critically analyzed the image of black people in American sculpture. What resulted is an incredibly complex volume, one that not only explores the intersection of race and representation but also seeks to teach its reader how to "read" representations of blacks in art. While Murray tells his viewer in no uncertain terms where representation succeeds and fails, *Emancipation and the Freed*'s most riveting feature rests in how the author combined the very act of looking, historical context, the relationship between history and blackness, as well as his own experience and political beliefs to address the presence and absence of black people in American sculpture as a means not only to insist upon but also to create a black subjectivity.

*Emancipation and the Freed* stands out as the first text of African American art history. The issues Murray addresses, most notably the relationship between representation and the self, are not only at the center of African American art history, but also, as Donald Preziosi has suggested, at the core of art history itself. Preziosi reminds us: "From its beginnings, art history was a site for the production and performance of regnant ideology, one of the workshops in which the idea of the folk and of the nation state was manufactured."[2] Murray's art historical prose falls squarely in line with Preziosi's proposition, for in his analysis of American sculpture, Murray invoked nineteenth- and early twentieth-century

work to codify a black subjectivity in the face of a racist society. Murray's goal was a deconstruction of the images of blackness in American sculpture in order to produce a black body politic. In other words, to deconstruct images of blackness was a means through which Murray could literally write the black subject into representation. By making such a move, Murray also insisted upon, as Albert Boime has noted, the centrality of black experience and its critical role in the ascendance of American sculpture.[3]

In the history of African American art history, a field that largely grew in a politicized climate in which the white American art world only saw and addressed art produced by white (and almost exclusively male) artists, there stands an overriding concern with three intricately related issues. First, a desire to reveal black achievement in the visual arts of the United States in order to show that black visual production has always been a part of American culture-at-large. Second, an exploration of the representation of black Americans (as well as peoples of African descent more generally) by both blacks and non-blacks in American visual culture. And third, an insistence and focus on black identities and black subjectivites and how they are related to representation and visual production in the United States and the Afro-Atlantic Diaspora.

Why did Murray, an editor and journalist, turn his attention to art? According to John Wesley Cromwell, who wrote the introduction to *Emancipation and the Freed*, Murray began to pursue studies of "Black Folk in Art" when he realized that many of the illustrations of the Adoration of the Magi failed to include what he called "proper representation of the darker races." Cromwell continued: "These omissions excited his protest ..." (xxvi). Murray had originally planned to create a series of books that would chart the representation of blacks in art from antiquity to the early twentieth century; however, such plans were never realized. Sins of omission, representational silences, the inability to see oneself represented in history propelled Murray to perform an archaeology of sorts, to find images of black people and to suggest what such images mean in political and racial terms in a period Michele Bogart has called "the great age of public sculpture in the United States."[4]

Murray's project may seem radical for its time, but if *Emancipation and the Freed* is considered within the framework of African American intellectual activity in the first decades of the twentieth century, it is clear that the book encompasses both art history's desire to construct a selfhood and an African American intellectual desire to construct a *black* selfhood during a period in which black Americans were politically, socially, and psychologically disenfranchised in a racist American society. Underlying *Emancipation and the Freed* is the search for a black self, and the author's intention to educate black Americans in the art of deciphering representation in a critical fashion. Murray rests his inquiry on the following suppositions:

> Hence, when we look at a work of art, especially when "we" look at one in which Black Folk appear – or do not appear when they should –

we should ask: What does it mean? What does it suggest? What impression is it likely to make on those who view it? What will be the effect on present-day problems, of its obvious and also of its insidious teachings? In short, we should endeavor to "interpret" it; and should try to interpret it from our own peculiar viewpoint. (xviii–xix).

What the above statement suggests is that the reader will not read a history of black representation per se, but rather a conversation among objects, politics, history, and the author. Richard J. Powell sums up Murray's project quite well:

> [Murray] presupposed that there was a world in which black peoples and their cultures, rather than always being filtered through white supremacist eyes and mindsets, could be seen and represented differently: either through the non-racist (or at least, multi-dimensional) lens of whites, or through the knowing and racially self-conscious eyes and imaginations of blacks themselves.[5]

In Murray's mind, such an undertaking was not only critical but, given the abysmal state of race relations in the United States in the early twentieth century, it was of the utmost urgency. Murray uses art history and criticism to sound an alarm:

> We can hardly press too strongly the importance of careful, perspicacious interpretation. I am convinced that, for Black Folk – in America, at least – this is of paramount importance. Under the anomalous conditions prevailing in this country, any recognition of Black Folk in art works which are meant for public view, is apt to be pleasing to us. But it does not follow that every such recognition is creditable and helpful; some of them, indeed, are just the opposite. (xx)

As outward signs of "Culture" and "Truth" the high arts serve as one of the battlefields in the war over the representation and perception of black Americans. Inflected by the writings of both John Ruskin and James Jackson Jarves, Murray equates representation in high art, most notably sculpture, with universal truth and culture. Murray insists that the universal has a place for black Americans, and his belief in both the affective qualities of art and the notion that to understand art is to enter into "universal culture" drives his desire to use American sculpture as a vehicle for uplifting the black race.

Murray's move to place black Americans within the "universal" is not unusual in either art historical or African American intellectual realms. Moreover, his desire to teach the black masses is perfectly consistent with other black intellectual projects of the early twentieth century. Murray, while a self-educated man, was actively involved in black intellectual and political circles in Washington, D.C., during the late nineteenth and early twentieth centuries.

285

During the first decades of the twentieth century Murray knew W.E.B. Du Bois and was closely allied with Du Bois's ideals for the uplift of the black race in the United States. As a politically engaged journalist, Murray would no doubt have read Du Bois's writings. At any rate, it is clear that Murray, through his association with the Niagara Movement, knew Du Bois by 1905, and it is quite possible that the two men could have met earlier through meetings and events at the American Negro Academy.

The American Negro Academy, which was begun in 1897 by Alexander Crummel, Du Bois and others, was one of the few venues available for black intellectual expression in the early twentieth century. This group believed that, through participation and production in the arts, sciences, humanities, and letters, blacks could take their rightful place in "Civilization." In providing such an environment the American Negro Academy hoped to foster the emergence of black Shakespeares, Hegels, Beethovens, Michaelangelos, and Ruskins, and similar ideals were embedded in much of the black intellectual discourse of the day.

As a venue for intellectual expression, the American Negro Academy was also a place where Murray could associate with and indeed be considered as one of Du Bois's black Talented Tenth. For Du Bois, the Talented Tenth, or "exceptional" members of the black race, had always been the principal instigators of black racial uplift; moreover, he fervently believed that this group was the black race's only hope for advancement in American society. Du Bois stressed the necessity for the top black minds to receive a solid education in the Western liberal tradition in order to gain the tools that would enable them to pull up the rest of their people.[6] Du Bois knew all too well the connections between knowledge and power, declaring in 1906: "Education is the development of power and ideal."[7] Murray was familiar with the pamphlet containing this statement, and he would take on the role of transforming Du Bois's words into deeds.

Notions concerning the Talented Tenth were played out in a wide arena of black American culture. What they all had in common was the pursuit of racial uplift through a massive racial make-over, a complete revamping of the image of black Americans not only to a white society bent on denying them political, civil and social equality, but also, and just as importantly, to raise black self-esteem. Such moves constituted a war waged by black Americans on both racism and internalized racism.

*Emancipated and the Freed* is intricately related to such moves. Connecting to his concern that black viewers might like any image they see of blacks in sculpture, he guides these viewers through his own response to the works under scrutiny. Speaking about Thomas Ball's Emancipation groups in both Washington, D.C. (1876) and Boston (1879; Figure 18.1), Murray presents white writers' interpretations of the pieces. For example, Murray quotes Lorado Taft's impression of the Washington group: "[Ball's] conception is a lofty one ... One of the inspired works of American sculpture; a great theme expressed with emotion by an artist of intelligence and sympathy, who felt what he was doing" (27).

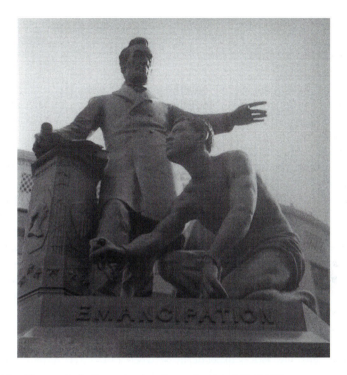

*Figure 18.1* Thomas Ball, *Emancipation Group*, Boston, MA, 1876.
*Source*: Author photo.

Murray then engages Ball's Washington group, Ball's own writings, and Taft
in an exegesis on emancipation and its conception, informing his reader that "it
need occasion no surprise for me to say that I regard this group, considering it
as an 'Emancipation' group, as far less adequate than it has popularly been
regarded" (27). Murray grants that the representation of Abraham Lincoln in
this group may be lofty, but his concern is directed at the depiction of the
kneeling black figure. Murray takes Taft as well as the artist to task here:

> As for the kneeling – or is it crouching? – figure, his attitude and
> expression indicate no elevated emotion, or any apparent appreciation
> of the duties and responsibilities of his new position and little if any
> conception of the dignity and power of his own personality and
> manhood, now first recognized and respected by others. He seems to
> have a hazy idea that he is, more or less, or maybe is about to be made
> free, but it appears probable that introspectively, he is yet a "kneeling
> slave." In his attitude, he more exemplifies a man who perhaps has
> escaped extreme punishment by commutation of a sentence ... than a
> man who feels he is one of those who, as the Declaration of

287

Independence expresses it, "are, and of right ought to be free"! If he should speak, he would probably murmur, dubiously and querulously, "O Mr. Lincoln! am I –?" (28).

As far as the Boston replica is concerned, Murray feels that it takes a huge stretch of the imagination to believe the claim – made in a booklet about the dedication and presentation of the Boston group – that the kneeling "slave is 'exerting his own strength with strained muscles'" (31).

What Murray tries to achieve through his highly personal interpretation is to reveal the incompatibility between what is represented and what he understands as the truth value of art as well as the historical record. In this discussion, the way that Murray writes as well as the process through which he looks are paramount. In the above passage, while Murray writes about the lack of subjectivity for the kneeling slave, he simultaneously constructs a contemporary black self. For example, the figure's "little if any conception of his own manhood" takes as a given that Murray and his readers have cognizance of their own. Likewise, through invoking the *Declaration of Independence* and the lack of the represented figure's knowledge that it applies to him, Murray overtly insists that the vital document does indeed belong to himself and to his readers. As such, black people, too, are America.

Murray's projection of himself onto an object, as in *Emancipation and the Freed* more generally, moves dialectically between a black self and a black other. In engaging the represented Murray either finds (identifies with) or *creates* his own place as an American subject. Hence, Murray has not taken representation as a given; furthermore, representation is the starting point for the construction of the subject. Joan Copjec, following Jacques Lacan, explains within the context of film theory: "The subject is the effect of the impossibility of seeing what is lacking in the representation, what the subject, therefore, wants to see." She continues, "it is what the subject does not see and not simply what it sees that founds it."[8] Murray concurs, insisting: "We cannot be too concerned as to what [sculptural groups] say or suggest, or what they leave unsaid" (xx). The absence of an ideal black subject constitutes a massive failure in representation, and this failure – tantamount to the obfuscation of "truth" – allows for its very construction. To construct the ideal black subject, then, is to find "truth." To construct the ideal black subject is to become part of "universal culture." However, this ideal black subject is one whose manifestation in reality is but an impossibility.

In imagining this ideal subject Murray creates a subject position for black viewers, showing the constructed nature of American sculpture as a sign of civil order and revealing gaps in the supposed hegemony of modern Western vision. Murray anticipates bell hooks's contention that the "ability to manipulate one's gaze in the face of structures of domination that would contain it, opens up the possibility of agency."[9] For hooks, such a possibility speaks to the kind of place that Murray carves out for the black viewer in *Emancipation and the Freed*. Murray takes his readers through the very process of changing one's vision with him. This

space, moreover, implies not the construction of a free-floating black subject, but a subject that is historically contingent, one that is part and product of lived experience. In that sense, Murray's black subject has the ability to go beyond representation as a means of transforming identity. It is the writing of the historically contingent black subject that makes *Emancipation and the Freed* so provocative. For in trying to conceive of the ideal black subject, Murray constructs a narrative that understands black identity as not only racial, but also social and political.

Like his intellectual proclivities, Murray's political inclinations were also a direct result of his association with Du Bois. Murray had much exposure to Du Bois's political beliefs, most directly from his involvement in the Niagara Movement, a civil rights organization founded by Du Bois in 1906, and through his work for *The Horizon: A Journal of the Color Line*, a publication conceptualized and begun by Du Bois in 1907. Murray not only served as one of *The Horizon*'s editors, but the journal was also printed on presses owned by Murray and his brother F. Morris Murray.

Murray was present at the Niagara Movement's first conference, held in 1905. Here Murray heard the group's "Declaration of Principles," which outlined the wrongs done to black Americans in a racist and exclusionary society. Under the guidance of Du Bois and William Monroe Trotter, the group painted a picture of blacks, described as a "stolen, ravished, and degraded" race, that underscored the roadblocks thrown in their upward paths by white American society.[10] Murray was also in attendance at the Niagara Movement's 1906 conference, where the group insisted on the granting of full equal rights to black Americans. At this meeting Lafayette Hershaw read the following remarks written by Du Bois:

> We will not be satisfied to take one jot or tittle less than our full manhood rights. We claim for ourselves every single right that belongs to a freeborn American, political, civil and social; and until we get these rights we will never cease to protest and assail the ears of America. The battle we wage is not for ourselves but for all true Americans.[11]

The Niagara Movement had thrown down the gauntlet, waging a no-holds-barred assault on racial discrimination in the United States. Such a political agenda would continue in the pages of *The Horizon*, a publication described by Levering Lewis as "Du Bois's rehearsal for a career in propaganda journalism."[12]

Immersed in such politics and armed with Talented Tenth ideals, Murray constructed a black subject in *Emancipation and the Freed* which fused race with the psychological and the political. Within such a merger, sculpture and its representation was used as the touchstone for a larger project that centered on an attempt to define a black subjectivity, one that was politically charged and vested, in the first decades of the twentieth century. From such a standpoint, the art object became the visual manifestation of political realities – either historic or contemporary – and a vehicle for articulating a larger political agenda. In such a

framework, Murray interpreted Hiram Powers's *Greek Slave* (1843) "as American art's first anti-slavery document in marble" (3). The political is also infused with Murray's understanding of truth. Defining truth on social, psychological, and political levels, he views the success or failure of representation on such grounds.

Politics, for Murray, is not only an inseparable part of the black subject in *Emancipation and the Freed*, but Murray's use of sculpture and his interpretation of it allows him to write about the deplorable political climate for black people in the United States at the beginning of the twentieth century. While he proceeds in constructing the ideal black subject, Murray elaborates on the disenfranchisement of black people in American culture. In the case of Ball's aforementioned emancipation groups, Murray critiques the politics behind the kneeling slave as a means to issue a call for black equality under the law.

The author underscores such connections even more forcefully in his analysis of John Quincy Adams Ward's *The Freedman* (1863). His discussion of the statue is one that is bound by the very fact of emancipation, the ways in which a black person in the 1910s might interpret such a piece, and his own position as a somewhat privileged black interpreter of art. Murray conducts a conversation with earlier and contemporary art writers to underscore his own ideological leanings and their connection to the reception of Ward's work. Murray begins by quoting Jarves, who wrote about the piece in 1864:

> "Completely original in itself, a genuine inspiration of American history, noble in thought and lofty in sentiment ... A naked slave has burst his shackles, and with uplifted face thanks God for freedom. We have seen nothing in our sculpture more soul-lifting or more comprehensively eloquent. It tells in one word the whole sad story of slavery and the bright story of emancipation." (12–13)

After citing Jarves, Murray stresses that *The Freedman*, "like many other great works of art and profound literary compositions, reveals itself differently to different minds and temperaments," adding: "These differences in interpretation – these varying responses of individual souls – are inherent in that which is profound and sublime" (13). In making such a rhetorical move, Murray clears a space through which he and others can insert their own respective subjectivities and engage with the piece on their own respective terms. What is so effective here as well is the manner through which Murray opens the interpretive door.

From Jarves, Murray, noting the differences in interpretation, then cites Charles C. Caffin's 1903 book *Masters of American Sculpture*:

> "[*The Freedman*] shows simply a Negro, in an entirely natural pose, who has put forth his strength and is looking very quietly at the broken fetters. The whole gist of the matter is thus embodied in the most terse and direct fashion ... solely as an objective fact into which there is not intrusion of the sculptor's personal feeling." (14)

Murray accepts Caffin up to a point. Murray can live with Caffin's formal analysis, but he balks at the suggestion that the artist's personal feelings are absent. Murray responds: "It would probably be more correct to say that Ward put into it as much as he could of his personal feeling, having regard for artistic considerations and for his habitual, self-imposed restraint" (14). Murray wants to allow for the notion that the artist's emotions are rightly bound by the dictates of his formal style, which belies the fact that for Murray, while great and profound art may indeed foster varying revelations, some revelations are more accurate than others. But this also reveals Murray's own need for personal validation, something he rarely finds in his engagement with representation.

Murray cites others as well, ultimately finding none of the these descriptions to be satisfactory. He insists: "It is not difficult to see prophecy as well as history in its form, pose, and accessories: and even more, perhaps in its lack of accessories" (16). Murray, as if placing himself in the position of the artist, continues: "Indeed, if Mr. Ward were living now, fifty years after Emancipation, he could scarcely state the case more truly" (16). But "prophecy"? Here is the space into which Murray then aggressively asserts his own voice:

> The freedman's shackles are broken, it is true, but still he is partially fettered; still un-clothed with the rights and prerogatives which freedom is supposed to connote – a "Freedman" but not a free-man.
>
> Observe that the "Freedman" still grasps several links of his chain. May we not think of some of these links as: separation – in schools, in public places, in social life; exclusion from political life; a curtailed school curriculum purportedly adapted to his special needs and limited capabilities; etc? To these links he – or at anyrate [sic] a considerable part of his posterity – yet clings with a fearsome, fatuous hope that in some way they may serve his supposed "special" needs; may possibly be "useful" when he attempts to stand erect and make his way forward (16).

Such a soliloquy explicitly underscores the use of these objects for Murray. Following Victorian notions surrounding the relationship between art and truth, Murray looks at this piece not as a historical document, not as a representation of a single event, but rather as one that gives visual form to the lived reality of most black Americans in the 1910s. In that sense, Murray's prose constitutes not a historical narrative, but rather the use of the past as well as the object to address and to change a present reality. The object also becomes a tool for Murray to declare that in the 1910s the emancipation of black Americans is an incomplete project. The use of the object in this fashion goes hand in hand with the author's construction of black subjectivity, showing the political and ideologically charged undertones of his project.

Murray's most moving essay, the last in his text, focuses on Augustus Saint-Gaudens's *Shaw Memorial* (1897; Figure 18.2) in Boston. A monument to Colonel Robert Gould Shaw and the 54th Massachusetts Colored Regiment,

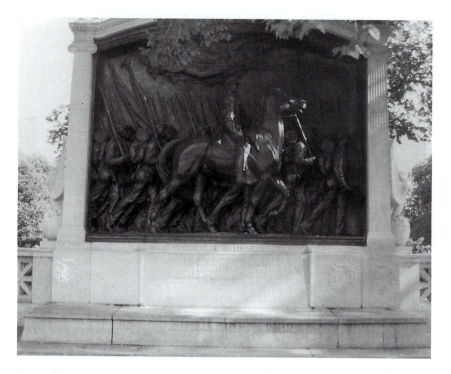

*Figure 18.2* Augustus Saint-Gaudens, *Shaw Memorial*, Boston, MA, 1901.
*Source*: Author photo.

this bronze panel, unlike most of the other objects in his book, wins his unabashed praise. In his own words: "Indeed, this masterpiece is, at once, a memorial to a man, a race, and a cause" (165). Liberally quoting Taft's 1903 *The History of American Sculpture* as well as other sources, Murray spins a narrative around the *Shaw Memorial* that brings together the political, the personal, the object, race and representation, religion and history. The half-naked black bodies in this work do not bother him. In fact, he ironically sees black nudity here as a sign of black strength. In the end, this piece fulfills Murray's requirements for a successful black representation, that is, the "truthful" display of black historical agency and subjectivity (and this is not the same thing as the aforementioned ideal black subject).[13] He again engages Taft, who calls the bronze panel "the fit and adequate expression of America's new-born patriotism" (171). In this case, instead of taking Taft to task, as he has done in other sections of *Emancipation and the Freed*, Murray agrees with him, and adds only one comment:

> It seems strangely providential that this greatest of American military memorials should have been inspired primarily by the valor and the devotion of Negro-American soldiery. (172)

In the end, blackness is seen overtly as that which has enabled greatness in art.

Murray then makes a surprising and somewhat bizarre twist, asking the reader to excuse him for closing with a personal reference:

> As I stood before this hallowed monument in Boston ... I felt myself strangely moved; and a flood of memories swept over my mind ... Particularly did one tall handsome fellow push into my memory ... this stalwart fellow gently pushed aside a slip of a girl and said to her quietly: "Now, Katie, don't forget; you are to wait; and if I get back – you know." (173)

Murray then describes these men going off to war, and narrates the hardships and losses experienced in battles at Wagner, Olustee, and Honey Hill. Soldiers were killed, maimed, left for dead, and taken prisoner by the Confederate troops. The soldier of his memory was taken prisoner, spending months in captivity. Murray continues:

> he came back, and he found that Katie had waited. And I am gratified to tell you that he still lives, and Katie too; and often do I see my own little daughter put her arms lovingly around this old veteran's neck and call him, "Grandpa." (174)

Many of the soldiers who had enlisted in the 54th and 55th Massachusetts Colored Regiments were men from Ohio. Murray's father was one of these men.

Murray has in the end found the black subject, and it is his own family history embedded in the bronze of the *Shaw Memorial*. Here, Murray finally sees himself. For Boime, this personal attachment, and the overwhelming desire to find a positive black image in a sea of derogatory depiction resulted in what he rightly describes as "Murray's almost desperate need to validate Saint-Gaudens's monument."[14]

Perhaps *Emancipation and the Freed* ends where it should have begun. Murray had indeed found himself in American sculpture, and I would posit that *Emancipation and the Freed*'s final essay was the foundation, along with the absence of black figures in the Adoration of the Magi illustrations, that fueled, in an intellectually and politically charged climate, his drive to construct a black subject, to insist upon the primacy of black experience, to take hold of black agency, and to teach other black Americans to do the same.

Both Powell and Boime have rightly described themselves as heirs to Murray, and each author has self-consciously characterized their respective intellectual projects as having been framed, at least in part, by *Emancipation and the Freed*. Like Murray and his colleagues, African Americanist art history, in its continued understanding of representation as an interpretive battleground, has placed its priorities on the insistence on black subjectivity and the construction of a black subject. Murray's intellectual heirs would also situate themselves closer to

American mainstream art history, (almost obsessively) drawing on artists' biographies as a means of creating a black selfhood with respect to the larger art establishment. In doing so, African American art history has retained much of Murray's insurgent politics, yet it has also broadened its scope. The field has moved towards complicating further the ways in which we unpack the intersections and collisions of race, representation, black subjectivity and the very place and centrality of black achievement in the visual arts at large. And such a project is as necessary and politically charged today as it was in 1916, for today, seventy-five years later, Murray's ideal black subject – a black person who has gained full equality in American society – is still only an ideal. That subject does not yet exist.

NOTES

The author would like to thank Elizabeth Mansfield, Andrés Zervigon, and David Joselit for their encouragement and support on this chapter.

1 F.H.M. Murray, *Emancipation and the Freed in American Sculpture: A Study in Interpretation*, Freeport, NY, Books for Libraries Press, 1972 [First published 1916]. All page references are to this edition and appear in parentheses in the text.

2 D. Preziosi, *Rethinking Art History: Meditations on a Coy Science*, New Haven, Yale University Press, 1989, p. 33.

3 See A. Boime, "Emancipation and the Freed," in his *The Art of Exclusion: Representing Blacks in the Nineteenth Century*, Washington, D.C., Smithsonian Institution Press, 1990, particularly pp. 156–7. Boime's important exploration of Murray brought attention to a text that, by the end of the twentieth century, had fallen into obscurity.

4 M. Bogart, *Public Sculpture and the Civic Ideal in New York City, 1890–1930*, Chicago, University of Chicago Press, 1989, p. 2.

5 R.J. Powell, *Black Art and Culture in the 20th Century*, London, Thames and Hudson, 1997, pp. 16–18.

6 See W.E.B. Du Bois, "The Talented Tenth," in *The Negro Problem: A Series of Articles by Representative Negroes of To-Day*, with contributions by B.T. Washington, C.W. Chestnutt, W.H. Smith, H.T. Kealing, P.L. Dunbar, and T.T. Fortune, New York, AMS Press, 1970 [first published 1903], pp. 33–75.

7 W.E.B. Du Bois, "The Niagara Movement: Address to the country," pamphlet in H. Aptheker, ed., *Pamphlets and Leaflets*, White Plains, NY, Kraus-Thomson Organization Limited, 1986, p. 64.

8 J. Copjec, *Read My Desire: Lacan Against the Historicists*, Cambridge, MA, MIT Press, 1994, pp. 35–6.

9 b. hooks, "The Oppositional Gaze: Black Female Spectators," in her *Black Looks: Race and Representation*, Boston, South End Press, 1992, p. 116.

10 D.L. Lewis, *W.E.B. DuBois: Biography of a Race, 1868–1919*, New York, Henry Holt and Company, 1993, pp. 321–2.

11 Du Bois, "The Niagara Movement," p. 63.

12 Lewis, p. 338.

13 Boime adeptly points out the inconsistencies and blindspots in *Emancipation and the Freed*. For Boime, Murray's examination of the *Shaw Memorial* is perhaps the most egregious of them. Here, Boime points to Murray's need to find satisfying images of blacks, and it is his personal attachment to the Shaw monument that fuels what Boime sees as a fairly obvious misreading of the work. See Boime, pp. 199–219.

14 Boime, p. 218.

# 19

# ART PHOTOGRAPHY, HISTORY, AND AESTHETICS

*Catherine M. Soussloff*

Until the nineteenth century the institutions in art's histories categorized the visual arts according to distinctions between media.[1] As a result of the industrial revolution it became increasingly difficult to maintain the necessity of these earlier distinctions. The reclassification of made artifacts of all sorts proceeded along lines other than the traditional ones of comparing the arts in order to determine the characteristics distinctive to each. The use value of artifacts, their innovativeness in regard to mechanical or technological methods, and their distance from so-called aesthetic functions served to define the new products that resulted from the marriage of industry and science. Photography especially challenged both the old and the new categorization of artifacts and art because it so obviously exhibited characteristics of industry, science, and art. Initially, in contrast to the other representational media, photography was internally, rather than comparatively, defined.

Today no one would deny that photography, like the graphic media of painting, drawing, and printmaking, or the three-dimensional ones of sculpture and architecture, constitutes a legitimate object of study for the history of art. Just as we consider the photographer Edward Steichen a master artist, so too we appreciate the 1907 portrait photograph of him by Heinrich Kuehn, illustrated in Figure 19.3 on p. 302, as a work of art. In the institutions of art history, however, the photograph also functions on another, albeit similarly metaphorical, level. This function can be characterized as historicist and it can be located temporally with the coincident invention of photography circa 1840 in England and France and the institutionalization of art history in the university in Germany at the same time.[2] The disciplinary usage of photography serves an evidentiary or documentary function that endows the historical text and, at times, the object photographed with a heightened reality. As Francis Haskell observed, "artists once feared that photography would kill painting, and although it certainly did usurp many of the functions of painting as far as the recording of contemporary events was concerned, for the historian it had the paradoxical effect of strengthening the authority of all images, including those made long before its invention."[3]

Recently, scholars have sought to understand the importance of photography for the early research and teaching methods of the discipline of art history by investigating how photographic technologies, such as lantern slides and photographs, aided comparative approaches for the interpretation of art.[4] To its credit, art history recognized early on the realist potential of photography and profited from it. At the same time, arguments on behalf of photography as high art focused on a break with the commercialism or industrialism of photographic practices and sought an alliance with what were determined to be more aesthetic concerns. Photography in art history is as much about the discourse *on* photography as art, which occurred so prominently in the German and Viennese context at the end of the nineteenth century, as it is about the use of photographic technologies *by* art history. The story about how photography achieved its metaphorical relationship to art in the institutional contexts where it presently operates includes both practical and theoretical considerations.

This chapter addresses photographs and a group of texts that initially belonged to the historiography of German art and photography, although the Art Photography movement was from the beginning an international one. The artists discussed here manipulated photographic techniques in order to achieve the effects of the other graphic arts, particularly painting. The critics referred to here supported a discourse on photography that effaced its relationship to "the real" or to historicist efficacies that it already possessed in the discipline of art history. The practice known as Art Photography prompted a comparative approach in photographic criticism.[5] In this discourse, and in this discourse alone, photography was favorably compared to other artistic media. Although both the Art Photography movement and the discourse on art and photography did not originate in the German or Austrian context, a point which most of the contemporary accounts are quick to make, it nonetheless flourished there – as did the discipline of art history – until World War I. The first part of this chapter is a story, in part, of the discipline against itself. The truism that metaphor gives rise to paradox may be usefully illustrated in this account of the institution of photography as art.

In the final part of this chapter I will attempt to show how the contributions of Art Photography, so prominent by the beginning of the twentieth century, fell away in a later era. A strategic history of photography arose amidst the tumult of post-World War I Europe, one which chose to return to the earliest practice of photography for its model. The photographic criticism by the German-speaking avant-garde which came after World War I, and which has influenced so profoundly the recent art historical interpretation of both photography and "new media," must be viewed as a response to the claims of Art Photography. But the history of photography remained incomplete. The post-World War II art history appropriated this account of the medium by the avant-garde without historicizing it. The comparative potential for the theorization of the medium offered by Art Photography was lost. This chapter sets out to complete the picture changed so radically by the German avant-garde by

questioning their account, as well as the later appropriation of it by the discipline. The institutions of art history in Hamburg and Vienna where Art Photography flourished were among the strongest in Europe at the end of the nineteenth century and in the early years of the twentieth century. In recent years much has been written of them and of the influences of their approaches on current art history. What has been missing in this history has been a story about the failure of that art history to establish itself as the discipline which speaks for and about the media of its own time: photography, cinema and, now, new media. In most cases in the universities of the twentieth century these media have found the majority of their interpreters in departments other than art history.

To set the scene in its early historical and visual context, I begin with an example from the German-speaking context which demonstrates the claim I have made that by the end of the nineteenth century photography was internally defined, or non-comparative. G. Schiendl's *Artistic Photography* [*Die künstlerische Photographie*] published in Vienna, Pest, and Leipzig in 1889 advances the dominant view tellingly.[6] The full-page frontispiece for the series of publisher A. Hartleben's Chemical–Technical Library depicts the apparatus of a chemist's laboratory with the title of the book displayed in an open window at the top center of the image (see Figure 19.1). To the lower left of the center of the image a portrait camera stands surrounded by and incorporated into the tubes, chemicals, and instruments of the chemist's laboratory. Artistic photography and chemistry, science and art, are married in the new medium of photography. This marriage transforms chemical substances into new forms, symbolized here by the distiller that fills the center of the lower part of the composition.

In the institutions founded to promote the technology and processes of photography a constant tension exists between the artistic and the scientific and industrial, or functional, aspects of the medium. Schiendl and others take this dual structure to be the essential characteristic of the medium. The marriage of science and art, therefore, presents no conceptual problem in this view. Scientific processes of transformation, such as those caused by the chemical changes that occur when light produces an image, allow photography to be an art as well. Schiendl's book contains careful and prolonged discussion of the technical processes of lighting and negative manipulation required in portrait photography, in addition to the lengthy reminder that Rembrandt's print-making techniques, with their striking manipulation of light and shadow, provide the perfect exemplum for the contemporary photographer.[7] In contrast to the discourse on the other arts of design, which had occurred in the Early Modern period, the pressing issues for the definition of photography lay inside the medium's own borders.

By the end of the century this discrete, non-comparative discourse on photography constituted the prevailing understanding of the medium. Sufficient unto itself, photography's epistemology refrained from engagement

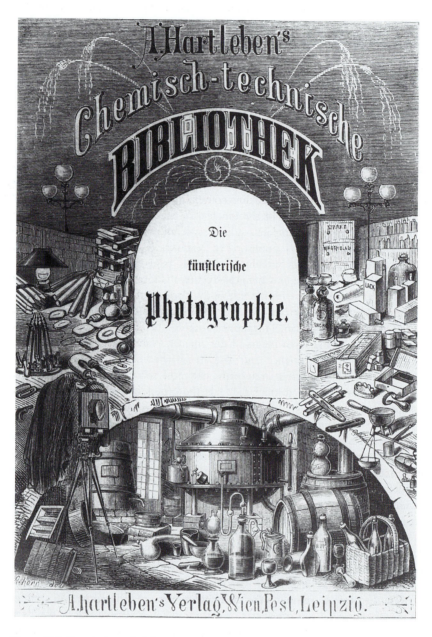

*Figure 19.1* Frontispiece, G. Schiendl, *Die künstlerische Photographie*. Wood engraving, 1889.

*Source*: Libraries of the University of California, Los Angeles.

with either social or aesthetic concerns. On the other hand, Art Photography, which arose at just this time, invited historians and theorists to compare it with other arts. Proponents of Art Photography realized that the medium could be "aesthetic," as the title of a book originally published in German by Willi Warstat attests: *A General Aesthetic of Photographic Art from a Psychological Point of View*.[8]

When photography comes to be compared to other art forms, such as painting or print-making, and justified solely in relationship to them, its justification as a medium is no longer self-contained. Photography now belongs to the institutions of art, such as art history and museums, which interpret and display it. It will receive scrutiny, and its definition, from the institutions designed to address art rather than science or industry. In a discourse where photography vies with the other representational arts, comparisons between photography and the so-called fine arts begin to offer the key to its definition. Photography submits to aesthetic philosophy's regimes of definition as the other arts already had after the grounds for comparison between them had been established in the Early Modern period. Furthermore, in Art Photography and its criticism photography threatens the other representational media. Comparisons work two ways and photography is not always found wanting. It too can achieve effects, such as color and the obliteration or blurring of outline. Just as painting had threatened sculpture in some earlier comparisons of media, it was now photography's turn to threaten and be threatened.[9] From its earliest institutionalization in the photo clubs and international exhibits of America, England, France, Germany, and Austria, Art Photography had insisted on the amateur's primacy over the professional photographer in the order of things.[10] Art Photography questioned the industrial and capitalized hierarchy of portrait studios, photographic landscape postcards for sale to tourists, and even the scientific uses, such as in medicine, to which photography had been put since its invention.[11] Art Photographers were not defined in the beginning solely by commercial interests, as portrait photographers, for example, had been. They were an international group who corresponded with each other, shared prints with each other, exhibited together, and read each other's journals, where articles on techniques and theory were to be found.[12]

Alfred Lichtwark (1852–1914), the Hamburgian art historian and Director of the Kunsthalle, did more than any other historian to promote Art Photography as an art form with social and aesthetic significance.[13] Lichtwark had argued in a number of his writings that photography deserved to be included in the history of art – indeed that it was essential to an understanding of painting. In 1930 the German biographer of David Octavius Hill, the British "father" of Art Photography, wrote: "today Lichtwark's prophetic words are being fulfilled: 'When a future history which knows the facts shall deal with the painting of the nineteenth century, it will have to devote to photography a special detailed chapter embracing the period from 1840 to the end of the century.' "[14] Lichtwark was responsible for establishing an important collection of David

Octavius Hill's work in Hamburg. Hill's artistic portraits in calotype were later promoted by "The Trefoil" of Vienna as the historical precedent for their work.

Lichtwark's view of photography's importance in the history of art rested on the genre of portraiture, arguably the most important subject for commercial photographers and one which Art Photography transformed. Richard Stettiner wrote in 1899: "For Lichtwark Art Photography was a class in a great system ... a life-making art, a rising above pure dilettantism."[15] Lichtwark expressed his views on artistic portrait photography in a number of places between 1900 and 1907.[16] His examples of contemporary, as opposed to precedent, photographic portraiture were drawn in the main from the Viennese context, as he indicates in his introduction to an important book, *Künstlerische Photographie* [Artistic Photography], Berlin, 1907, by the major promoter of the Viennese School of Art photography on the international scene, Fritz Matthies-Masuren (d. 1938).

In 1902 Matthies-Masuren had published in a sumptuous folio volume the pictorial work of the three Austrian photographers known as "The Trefoil" [*Das Kleeblatt*], *Gummidrucke von Hugo Henneberg, Wien, Heinrich Kühn, Innsbruck, und Hans Watzek, Wien* (Halle, Wilhelm Knapp). In the introduction he justifies the long-standing tradition of Art Photography, relates its effects to technological advances in the medium, particularly the bichromate color process, known as *Gummidrucke* in German, which, he says, can be manipulated to artistic effects by artistically inclined photographers, and provides lengthy discussions of the three Austrians. He includes forty-five black and white photographs of their work pasted into the volume. These are divided between landscapes, portraits, and still-lifes.

Just at the turn of the century Kuehn and the others began using complicated and innovative techniques in the manipulation of the photographic print to achieve color, which emulated contemporary painting. Kuehn's *Family Portrait* is a good example of this bichromate process, which had been perfected by amateur photographers in Vienna (see Figure 19.2). But even before gum bichromate these photographers had sought coloristic – specifically *chiaroscuro* – effects through the use of platinum prints. Kuehn's photographic portrait made in 1907 of one of America's best-known photographers and a leading proponent of Art photography, Edward Steichen, deserves close consideration in this regard (see Figure 19.3). In addition, this portrait, like all of Kuehn's portraits, illustrates the proximity of the practice of Art Photography to the theories examined here.

The young artist Steichen, who is pictured at the age of 28 in 1907, had exhibited with Kuehn and visited Vienna, although he lived at the time in Paris.[17] His figure in a dark suit emerges from the deep shadow of the platinum print. Although Steichen like Kuehn had been using the coloristic medium of the gum bichromate process to great effect by this time, he was still best known for his platinum prints. Prints on platinum papers result in a painterly effect because the platinum print has a broad scale of gray tonalities without the contrast of other black and white processes, such as silver prints. In this portrait

*Figure 19.2* Heinrich Kuehn, *Family Portrait*, 1910, George Eastman House, Rochester.

Source: Courtesy of George Eastman House.

*Figure 19.3* Heinrich Kuehn, *Portrait of Edward Steichen*, 1907, Los Angeles, Getty Museum.

*Source*: Getty Museum.

of Steichen Kuehn pays homage to the medium in which his subject excelled. Furthermore, because there appears in the platinum print "to be a less mechanical, more organic, union of image and paper" Kuehn's use of the medium relays a message about the image produced by that medium and his closeness to the very technology of this photograph.[18] In addition, platinum prints allowed for multiple reproductions of the same negative, an important factor in a culture of the international exchange and exhibition of photographs, which took place between Vienna and America, France, and England.

The very thought that photography or that a photographer could distinguish amongst media and medium techniques for expressive reasons emerged at this time and as a result of the practices of the Art Photographers. Indeed, Steichen came to be best known for the experimental use he made of a wide variety of media and of their reproduction.[19] Kuehn's portrait acknowledges this contribution of his subject to his medium. Kuehn uses the process of the platinum

print – known for the softening of details and textures through its black, white and gray tonalities – to work up from the darkest area at the center of Steichen's body to the lightest areas, the expressive features of the face and hands. Our information about the subject is gained by the separation of light from dark. Thus, white cuffs and collar emerge from the dark suit to frame the hands and face, much like they do in a Rembrandt portrait. Dressed like a gentleman, Steichen could be seated in a gentleman's club, or an amateur camera club. He grasps the cigar in a clenched fist and his other hand flexes on the arm of the chair. These hand gestures, the locks of hair draped across the high brow, the diagonal of lit areas of flesh and cloths in an overall haziness refuse clarity and exposure. Yet the figure possesses a presence which belies the surrounding obscuration. The formal aspects of the coloration and the composition insist on introspection and intensity. These traits are revealed as much as they must be, but no more than that, by the hands and face. There is no excess of individual identificatory markers. We do not know Steichen by his eyes or his mouth, both of which remain for the most part concealed. Rather, we know him by the somberness and severity of his dress, the strength of the hold that he has on his cigar, the thrust of his hand on the chair. Momentarily captured by light, like the burning tip of the cigar, Kuehn obliterates all the surface details that would distract from this figure. Yet this is distinctly a portrait of Steichen, as we can see easily by comparing this portrait with others of the artist.

Furthermore, what Kuehn gives us is a portrait of another photographer in total sympathy with his own artistic credo: a man most emphatically of his time, of the photographer's time and place, but also a man with a history in photography and art. This is a gentleman artist, in the tradition of Raphael, not a working man who produces photographs for sale. Kuehn, Steichen and the other Art Photographers relied in their pictures on painting's contributions. We can see this clearly in the reference to earlier portraiture, which we find in the both the coloristic effects and in the format of the photograph. It mimics the shape and proportions of the easel painting, a *tableau*. This horizontal rectangle is most unusual for a portrait painting, where the figure usually appears in the vertical format.

My point is not that photography copies a particular painting or school of painting here but, rather, that Art Photography portraiture insists on correspondences between past and present which emerge in empathies between photographer and subject. This photograph, Kuehn's *Family Portrait*, and virtually all so-called "pictorial" portraits exhibit this characteristic, which we could call intersubjectivity. Formally speaking, we find the following five characteristics in these photographs: 1) the faces of the figures are obscured, lost in shadow, with lowered gazes; 2) the outlines of the figures merge with the background or into the other figures; 3) the delineation of superficial effects of skin and features remains subsidiary to the overall effect of luminosity, reflections off the hair of the figures, and softness of flesh; 4) the figures are enclosed by light and color in a shared space or world; 5) the scale of the print is large, and often

303

the format is *tableau*. The coloristic effects define a subjectivity that depends on the whole composition for articulation. There is no sense of the portrayal of the singular individual.

The kind of subjectivity found in the Art Photographers' portraiture must be considered new to photography. As we will see, it came to be at odds with the later understanding of the role of portraiture in modern historical representation. In the Photo Club of Paris's journal of 1904 the German Fritz Loescher describes the pains to which the professional Hamburgian photographer Rudolf Dührkoop went in 1899 in order to change his studio over from a professional photographer's studio to a more "personal" one in keeping with the aesthetic of Art Photography. According to Loescher, a desire for a better "knowledge of the subject" drove the conversion to an Art Photography studio.[20] This method, which involved a "simplification of the means" and "the absence of artifice in execution," allowed for a new kind of portraiture.[21] Loescher describes the contrast in terms of studio ambience in the following way:

> The old atelier, bound to accessories, achieved the continual reproduction of a mass of uniform images more than the making of personal works. It is there that one finds that division of work which, in our times, kills genius and makes of man a machine … The portraits made in these conditions may well be identifiable and correct, but they are not personal works of art.[22]

Loescher says the new portraiture results in nothing but "the natural essence of man, whether bad or good."[23]

In his later book *Portrait Photography*, published in 1910, Loescher develops his views on Art Photography and contrasts it with "conventional" or professional portraiture.[24] He refuses to understand the differences between the older photography and the new photography as being based on technology, although he does spend much time in the body of the book on practical aspects of photography, such as coloristic techniques and innovations in photographic apparatus and lighting. However, as far as he is concerned: "The tools are basically the same; on the one hand they are used to produce a boring and superficial copy of a momentary natural phenomenon – on the other, to create an inspired picture, pulsing with life."[25] I have already explained that this quality of life is also what Lichtwark found in Art Photography. The differences which Loescher sees in Art Photography reside in subjectivities: the photographer's view of himself as an artist; the viewer's sense that a picture now "pulses with life," whereas the older portraiture presented a formal and lifeless representation of the exterior of being.

This kind of criticism not only separates photography from earlier professional photography and scientist views. Loescher rejected the idea that all photographs are "mechanically produced, without human intervention and interpretation, and thus objective."[26] The earlier non-comparative discourse,

dependent, in part, on photography's technological base and scientific uses, did not regard photography as art. Instead it stressed its objective potential and therefore its remove from the affective areas of human making considered by aesthetics.

The tension between the presumed faithfulness to the objective appearance of things in the photograph and "the medium's capacity to express something beyond the surface appearance of things" can be found throughout photography's history.[27] The discourse on Art Photography does not assert that objectivity or realism prevails in photography over other elements, such as "expression." It does not infer that that subjectivity or expression is less socially factual than any other kind of psychological realism. However, the avant-garde photographic theory that emerged in Germany and Russia after World War I turned back to the earlier, non-comparative views on photography, even as it too placed an emphasis on portraiture. This followed from a desire to understand and to justify photography's political, over its aesthetic, value. For example, in 1928 the Russian Aleksandr Rodchenko, who had recently exhibited his photographs in Germany, rejected the oil painting tradition of portraiture, and by implication the Art Photography indebted to it, when he wrote:

> It is essential to clarify the question of the synthetic portrait, otherwise the present confusion will continue. Some say that a portrait should only be painted; others, in searching for the possibility of rendering this synthesis by photography, follow a very false path: they imitate painting and make hazy by generalizing and slurring over details, which results in a portrait having no outward resemblance to any particular person – as in pictures of Rembrandt and Carrière.[28]

In Europe and America c. 1900 the portraits done by Art Photography did, in fact, fulfill the function of painted portraiture in style and social function. They even surpassed the older medium in popularity. The later avant-garde artists considered this portraiture practice antithetical to the ontology of the photographic medium that, for them, lay in its objective or scientific capacities. A comparative approach was entrenched within the discipline of art history from its beginnings. The avant-garde rejected the comparative approach to Art Photography, ensuring the exclusion of a comprehensive history of photography from within the bounds of art history itself. It is no surprise, then, that the dominant history of photographic theory does not come from art historians.

After World War I photography could be theorized in only two ways: either in terms of its metaphysical status, in contrast to the earlier aesthetic one given by Art Photography; or in terms of its privileged access to "the real" and hence to the documentation of the society out of which it developed and which it represented. This latter position was understood to be anti-subjective and anti-aesthetic, again in contrast to Art Photography.[29] These two self-reinforcing strands of criticism, what could be termed the anaesthetic and the anti-aesthetic,

support a non-comparative approach to the medium of film as well as photography in the first half of the twentieth century.[30] The primary theoretical source for the metaphysical or anaesthetic view can be found in Moholy-Nagy's book of 1925, *Malerei, Photographie, Film*.[31] In this chapter I shall not be pursuing the anaesthetic theorization of photography, which depended more upon technological distinctions, at least in argumentation, than on social ones.

The proponents of the documentary position considered photography to be the preeminent medium for the depiction of the historical and the depiction of the individual historical subject. Walter Benjamin insisted on the primacy of photography in regard to social value in his early essay of 1931, "A Small History of Photography," citing "the unresolved tension" between art and photography. He used portraiture as one of his major topics of consideration and the source of many of his examples.[32] Benjamin understands the extreme fidelity to appearance found in early nineteenth-century photographs to be an exact congruence between the mimetic capabilities of the technology and the taste of the clientele for this genre: "the photographer was confronted, in every client, with a member of a rising class equipped with an aura that had seeped into the very folds of the man's frock coat or floppy cravat."[33] Benjamin likes the 1850s technology because it backs his liking for 1850s photographic portraiture, where the bourgeois subject was portrayed for the first time in complete detail. This complete visual description of the political subject gave the historian or theorist for the first time an object for thorough analysis, identification, and interpretation.[34]

While the relation of Benjamin's essay to Siegfried Kracauer's radical statement of 1927 on photography has often been noted, it is not commonly known that other German writing of this period also looked at photographic portraiture in similar terms.[35] These critiques tied both the genre of portraiture and the medium of photography to the rising middle class and the social and political upheavals of the times:

> The burgher's picture of the world had been small and narrow. Now at once he expanded it on every plane of his middle-class existence, in a great, wide circle that spread from his spiritual focus and mental attitude. And with this expansion the need of pictorial witness to his newly awakened sense of life began to grow prodigiously. He felt a pressing desire to have the novel aspects of the new life expressed plastically in some new, unique, and especially appropriate medium. For, when the wide front of middle-class society took over the privileges and ambitions of the old dominant class, even the old ways of expression no longer sufficed for the new cultural and economic demands.[36]

Benjamin, Kracauer, and others sought in the photographic medium a form of documentary expression that they found in the subject matter of early photography.

For these purposes, Benjamin relied, in part, on the writing of Lichtwark who, as I have argued here, understood both the social and aesthetic significance of photography:

'In our age there is no work of art that is looked at so closely as a photograph of oneself, one's closest relatives and friends, one's sweetheart,' wrote Lichtwark back in 1907, thereby moving the inquiry out of the realm of aesthetic distinctions into that of social functions.[37]

In Benjamin's use of Lichtwark there is no evidence of the latter's preference for the Austrian Art Photographers. Benjamin writes Art Photography and the aesthetic dimension it incorporated out of Lichtwark's assessment. By the end of the nineteenth century, according to Benjamin, photographers, particularly portrait photographers, attempted in their techniques and styles to reproduce the aura which painting had lost due to the ascendancy of the new technologies of reproduction. Painterliness found its way into photographic portraiture – making it "murky" – to the detriment of both the medium and the genre. Benjamin reconstructed his own history of art that gradually became an institutional history, although not one originally produced within the institution of art history. He did so by eliding the period of Art Photography and returning to the late 1850s and early 1860s, whose aesthetic was more to his liking. Here he departs from Lichtwark, who had found so much to admire in Art Photography, particularly its approach to portraiture. Benjamin's reluctance to address Art Photography has gained the status of a persistent omission in most subsequent commentaries on photography.

Benjamin's own work on Baudelaire gives an excellent indication of how much he had to ignore or distort in the history of photography. Opposed to the portraiture of Art Photography, Benjamin prefers an antecedent moment in the history of portrait photography, one exemplified by the format of the *carte de visite* or the portraits by Nadar. Benjamin had been researching and writing about the Paris of Charles Baudelaire since the late 1920s. Somewhat perversely, he chose to admire exactly the sort of photography that Baudelaire despised, the photography of his time, c. 1860.[38] Baudelaire had protested against photographic portraiture in favor of the painting of modern life, such as that offered by Edouard Manet. This artist's 1860 portrait of his parents *M. and Mme. Manet* (see Figure 19.4) offers a prime example of painting's ability to supersede the photography of the day in terms of the visual complexity of the portrayal of the individual.[39] Manet chooses the somewhat unusual format of the double portrait to portray his parents. The figures are placed at a table and their bodies are foreshortened in order to display the possibilities of a spatial presence impossible in photography of the time. The later Art Photographers explored in portraiture such spatialities. The still-life elements, such as the basket of yarns held by Mme. Manet, enhance the coloristic possibilities seen in such portraiture by the later Art Photographers. The setting in the parents'

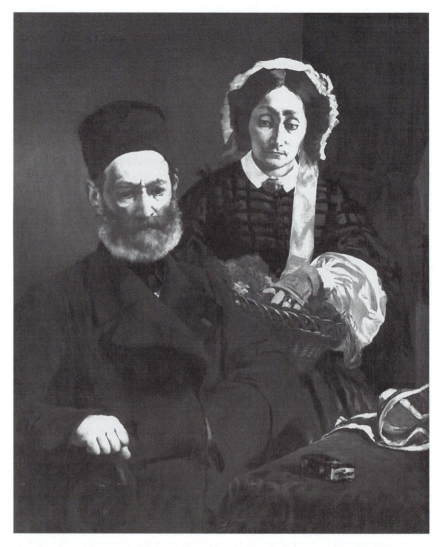

*Figure 19.4*  Edouard Manet, *Portrait of M. and Mme. Manet*, 1860, Paris, Musée
d'Orsay.

*Source*: Courtesy of the Musée d'Orsay.

home further suggests a domesticity not found in contemporary photographic
portraiture, dependent as it was on the professional studio. The same domestic
settings reappear at the end of the century in photographs by Kuehn. The inter-
relationship of the figures can be suggested by gesture and averted gazes
without a sense that one so often finds in photographic portraiture of this time
that the figure's gaze has been frozen by the camera's eye.

In 1935 Benjamin saw the history of nineteenth-century painting in terms of photography:

> The World Exhibition of 1855 was the first to have a special exhibit called 'Photography'. In the same year Wiertz published his great article on photography, in which he assigned to it the philosophical enlightenment of painting. He understood this enlightenment, as his own paintings show, in a political sense. Wiertz can thus be designated as the first person who, although he did not foresee, at least demanded montage, as the agitational utilization of photography. As the technique of communications increased, the informational importance of painting diminished. The latter began in reaction to photography, first to emphasize the coloured elements of the image. As Impressionism gave way to Cubism, painting created for itself a broader domain into which for the time being photography could not follow it.[40]

This account of the impact of photography on painting goes against Baudelaire and refuses the contributions made by Manet and the Impressionists. It constructs a strategic history of the medium in which political montage is ahistorically read back into the mid-nineteenth century. Benjamin reverses Lichtwark on the accomplishments of the later Art Photography in achieving exactly what painting had been able to do in portraiture. He makes the earlier photography the agent which turned painting to follow the route of colorism, such as that found in Impressionism, and away from the objective, and more political, mimetic regimes of photography. Benjamin resisted the history of photography he had found in Lichtwark and other art historians by rewriting it.

The lessons of a historiographical approach to the theory of photography that allow me to provide a revision of a commonly accepted history have significance for both art history and media criticism today. The comparative discourse used by Art Photographers and their interpreters did not hold when the avant-garde spoke about the newer representational media, despite its usefulness to art history since the time of the Renaissance. This suggests that these methods of discussing the arts do not have the political, or "agitational," effect desired by the avant-garde. For the same reason, the rhetoric of classical aesthetics, which also relied on media distinctions, could not be tolerated. In addition, I have suggested that the loss of an intersubjective portraiture may have been the cost of a more radical, but also of a less historicized, criticism. The moment of the political efficacy of avant-garde media criticism has long passed, as the brief history of the "new media" of today demonstrates. Media discourse is in the hands of global capitalists and *their* media. Yet, art history still remains committed to its traditional comparativities when it speaks of the new representational, or virtual, media. The art history of tomorrow must find the language and the approaches with which to write a media history in which the relationships among human beings matter both politically and aesthetically.

## NOTES

1  I am grateful to the Getty Research Institute and to the Department of Photographs of the Getty Museum for their support of the research for this project, which took place when I was a 1999–2000 Getty Scholar. At that time, I learned a great deal about photography through the generosity and knowledge of Roger Taylor and in discussions with Sarah Danius and Michael Roth. Discussions with Tim Clark on Benjamin and Baudelaire were also stimulating and useful. I thank Dean Robert Rosen of the School of Film and Television at UCLA for extending to me the privileges of a visiting scholar during the summer of 2000 when I wrote this chapter. Later discussions with Monika Faber and Astrid Lechner in Vienna helped me to understand the photographs better. Bill Nichols has been a generous and thoughtful reader through the duration of this project.

   In discourse the use of a method of comparison for distinguishing the essential characteristics of the representational arts of painting and sculpture goes by the name of the Paragone. It has a complex history in the literature on art of the Early Modern period. I will not be examining this discourse here but for bibliography and further elaboration, see C. Farago, *Leonardo da Vinci's Paragone: A Critical Interpretation with a New Edition of the Text in the Codex Urbinas* (Leiden and New York: Bill, 1992); L. Mendelsohn, *Benedetto Varchi's "Due Lezzione": Paragoni and Cinquecento Art Theory* (Ann Arbor: University Microfilms, 1978); D. Summers, *Michelangelo and the Language of Art* (Princeton: Princeton University Press, 1981).

2  The best institutional history of art history in the German-speaking context remains H. Dilly, *Kunstgeschichte als Institution: Studien zur Geschichte einer Disziplin* (Frankfurt am Main: Suhrkamp, 1979). For the impact of German historicism on the history of art, see C.M. Soussloff, "Historicism in Art History," in M. Kelly, ed., *The Encyclopedia of Aesthetics* (London and New York: Oxford University Press, 1998), vol. 2, pp. 407–12.

3  F. Haskell, *History and Its Images: Art and the Interpretation of the Past* (New Haven and London: Yale University Press, 1993), p. 4.

4  R. Nelson, "The Slide Lecture, or the Work of Art *History* in the Age of Mechanical Reproduction," *Critical Inquiry*, vol. 26 (Spring 2000), pp. 414–34, is the most recent of these studies and contains much useful bibliography. (Editor's note: see essay by Frederick N. Bohrer in this volume.) In general, art historians of today see the methods of Aby Warburg in regard to photographs as most illustrative of how photographed images and art history writing can work together comparatively; see A. Warburg, *The Renewal of Pagan Antiquity*, ed. K.W. Forster, trans. D. Britt (Los Angeles: Getty Research Institute for the History of Art and the Humanities, 1999).

5  The best discussion in English of this kind of photography remains Weston Naef, *The Painterly Photograph: 1890–1914* (New York: Metropolitan Museum of Art, 1973). See also M. Harker, *The Linked Ring: The Secession Movement in Photography in Britain 1892–1910* (London: Royal Photographic Society and Heinemann, 1979), pp. 15–22. For German and Austrian Art Photography specifically, see O. Steinert, ed., *Kunstphotographie um 1900* (Essen: Folkwangschule, 1964).

6  G. Schiendl, *Die künstlerische Photographie* (Vienna, Pest, Leipzig: U. Hartleben's Verlag, 1889).

7  Schiendl, Chapter 12, pp. 207 ff.

8  W. Warstat, *Allgemeine Ästhetik der photographischen Kunst auf psychologischer Grundlage* (Halle: Knapp, 1909; Reprint edition by Arno Press, New York, 1979). See also J. Hundhausen, "Grundzüge der photographischen Ästhetik," *Photographische Mitteilungen*, vol. 43 (1906), pp. 340–51, 363–70, 393–404.

9  For the beginning of the end of marble figure sculpture, see my forthcoming essay "Theoretical Protocols and Bellori's Idea of Sculpture in *Le Vite*." On the end of

sculpture in modernity, see R. Krauss, "Sculpture in the Expanded Field," in H. Foster, Ed., *The Anti-Aesthetic: Essays on Postmodern Culture* (Port Townsend, Washington: Bay Press, 1983), pp. 31–42.

10 For one of the earliest examples justifying the amateur's location in Art Photography, see *Première Exposition d'Art Photographique* (Paris: Photo-Club de Paris, 1894).

11 These topics are too large to go into here but on portraiture and how it changed due to Art Photography, see below and a chapter on photographic portraiture in my forthcoming book, provisionally entitled *The Subject in Art: Identity in Viennese Modernity*. Some work has been done on photographic postcards in the colonial context, see M. Alloula, *The Colonial Harem*, trans. M. and W. Godzich (Minneapolis: University of Minnesota Press, 1986). The collections of early postcards owned by the Getty Research Institute, virtually all of which bear the stamp of the professional photographer's studio in the European city where the photographic souvenir was purchased, would form the basis of an interesting study. For an interesting comparison of the use of photographs in medical and Art Photography contexts, see the work of the Austrian Art Photographer Heinrich Kuehn, who appears to have been trained in medical photography before he became "an artist." Bibliography on Kuehn can be found below.

12 A good indicator of the international aspects of this discourse is evident in the holdings of the libraries belonging to the camera clubs and photographic societies, although these have not been systematically studied. See, for example, the listing of books in English, French, and German held by the New York Camera Club: "Catalogue of the Photographic Library of the Camera Club, New York," *Camera Notes*, vol. 6 (July 1902), following p. 82. All of the contemporary criticism makes clear distinctions in the work based on national characteristics, see, for example, F. Loescher, "La Photographie Professionelle en Allemagne," *La Revue de Photographie* (January 1904), Photo Club de Paris, p. 80. See also H. Hinton, "Pictorial Photography in Austria and Germany," in C. Holme, ed., *Art in Photography: With Selected Examples of European and American Work* (London, Paris, New York: The Studio, 1905), G2.

13 Lichtwark was an art historian, museum director, collection builder, connoisseur of photographs, and immensely interdisciplinary art historian. His work deserves more recognition in the accounts of the historiography of art history. For an excellent bibliography of his work and works on him, see W. Kayser, *Alfred Lichtwark* (Hamburg: Hans Christians, 1977). See also F. Kempe, "Alfred Lichtwark und die Photographie," in Fritz Kempe, *Vor der Camera: Zur Geschichte der Photographie in Hamburg* (Hamburg: Hans Christians, 1976), which I have not yet been able to consult. For Lichtwark's interest in portraiture and photography, see his *Das Bildnis in Hamburg* (Hamburg: J.F. Richter, 1898).

14 H. Schwarz, *David Octavius Hill: Der Meister der Photographie* (Leipzig: Insel, 1931). I use the English translation here: H. Schwarz, *David Octavius Hill: Master of Photography*, trans. by H.E. Fraenkel (London, Bombay, Sydney: George G. Harrap & Co., 1932), p. 8.

15 R. Stettiner in F. Goerhe, *Die Kunst in der Photographie* (Berlin: Julius Buher, 1899), pp. 5–6 (my trans.).

16 Schwarz, p. 48, delineates the role of Lichtwark in the dissemination through his writings on and collection and display of Hill's work: "But it was the large exhibition organized in the year 1898 by the Royal Photographic Society in the Crystal Palace in London, bringing together nearly seventy of Hill's photographs, which first made his work widely known to the English public and gave him back the full measure of his importance. A year after the London exhibition, Ernst Juhl, stimulated by Alfred Lichtwark, showed in Hamburg a large collection of old and new photographs, the

only collection outside England which at that time contained works by Hill. The Hamburg Museum für Kunst und Gewerbe and the Department of Prints and Drawings of the Dresden museum thereupon began to make collections; and they are still the only public art collections in Germany – aside from the Berlin Staatliche Kunstbibliothek – which include a few of Hill's photographs."

17 J. Smith, *Edward Steichen: The Early Years* (Princeton: Princeton University Press and The Metropolitan Museum of Art, 1999), gives a good account of Steichen's movements during these years.

18 Naef, *The Painterly Photograph*, n.p.

19 W. Naef, *The Collection of Alfred Stieglitz: Fifty Pioneers of Modern Photography* (New York: The Metropolitan Museum of Art and Viking, 1978), pp. 443–4.

20 Loescher, "La Photographie Professionelle en Allemagne," pp. 41–2.

21 Loescher, "La Photographie Professionelle en Allemagne," p. 42.

22 Loescher, "La Photographie Professionelle en Allemagne," p. 79: "L'ancien atelier, bondé d'accessoires, convient à la reproduction continue d'une masse d'images uniformes plus qu'à l'enfautement d'oeuvres personnnelles. C'est là qu'on trouve cette division du travail qui, à notre époque, tue le génie et fait de l'homme une machine ... . Les portraits livrés dans ces conditions peuvent bien être identique et propres, mais ce ne sont pas des oeuvres personnelles." (my trans.)

23 Loescher, "La Photographie Professionelle en Allemagne," p. 80.

24 F. Loescher, *Die Bildnis-Photographie: Ein Wegweiser für Fachmänner und Liebhaber* [Portrait Photography: A Guide for Experts and Connoisseurs] (Berlin: Gustav Schmidt, 1910), p. ix.

25 Loescher, *Die Bildnis-Photographie*, p. x: "Wer sich mit den neuen Wegen des Lichtbildes publizistisch beschäftigt, wird immer dazu kommen, mehr über wesentliche Unterschiede in Empfindung und Auffassung, als über die neuen technischen Mittel zu reden. Das Handwerkszeug ist ja im grossen ganzen dasselbe; der eine benutzt es, um den langweiligen und äusserlichen Abklatsch einer vorübergehenden Naturerscheinung herzustellen, der andere schafft mit ihm ein wesentliches, beseeltes Bild, in dem der Pulsschlag des Lebens geht." (my trans.)

26 Nelson, p. 432.

27 G. Clarke, *The Photograph* (Oxford and New York: Oxford University Press, 1997), pp. 19–20. Clarke's discussion of portraiture is particularly good.

28 A. Rodchenko, "Against the Synthetic Portrait, For the Snapshot," in C. Phillips, ed., *Photography in the Modern Era: European Documents and Critical Writings 1913–1940* (New York: Metropolitan Museum of Art, 1989), p. 239 (first published in *Novyi lef* in 1928). On Rodchenko's contribution to photography and theory, see the excellent essay by P. Galassi, "Rodcenko and Photography's Revolution," in M. Dabrowski, L. Dickerman, P. Galassi, A. Rodchenko, exh. cat. *Aleksandr Rodchenko* (New York: The Museum of Modern Art, 1998), pp. 101–37. Galassi writes (pp. 102–103): "But photography's prospects as an art had invariably been identified with the emulation of painting, thus foreclosing in advance the possibility that photography might tread an untrodden path. In consequence, the notion of photography as art had produced not an evolving tradition but a sequence of dead ends, of which the most recent – the turn-of-the-century "artistic photography" movement – was the most vacuous." Galassi's recapitulation of Benjamin's preference for avant-garde photography blocks a historicized view of the medium and continues to devalue Art Photography to the detriment of interpretation.

29 On this anti-art position and its ideological meaning, see A. Hauser, *The Sociology of Art*, trans. K.J. Northcott (Chicago and London: University of Chicago Press, 1982), pp. 711–19. On the anti-aesthetic, see the essays in H. Foster, ed., *The Anti-Aesthetic: Essays on Postmodern Culture* (Port Townsend, Washington: Bay Press, 1983). Foster defines anti-aesthetic in the preface, p. xv: "Here then, 'anti-aesthetic'

is the sign not of a modern nihilism – which so often transgressed the law only to confirm it – but rather of a critique which destructures the order of representations in order to reinscribe them." None of the essays in this volume addresses the issue of modern or postmodern photography.

30 The relationship of the early theoretical literature on photography and film has not been thoroughly explored to date but it deserves attention given the importance of both media to the now-burgeoning literature on "new media." In the main it has been film historians promoting the ideal of "film as art" who have suggested such a history. For a preliminary discussion of this literature, see R. Stephenson and J.R. Debrix, *The Cinema as Art* (Baltimore: Penguin, 1965), pp. 13–36. The interpretations of the early literature on film as art founder on the supposition that art cannot be social, or even, at times, historical. The most extreme articulation of the similarity of photography and film in regard to their anaesthetic qualities may be found in A. Bazin, "The Ontology of the Photographic Image," in *What is Cinema?*, trans. H. Gray (Berkeley and Los Angeles: University of California Press, 1967), pp. 9–22. In light of my research here Bazin's essay deserves further attention from photographic historians. Significantly for my argument here this essay first appeared in 1945 in a collection entitled *Problèmes de la Peinture*.

31 L. Moholy-Nagy, *Malerei, Photographie, Film* (Munich: Langen, 1925).

32 W. Benjamin, "A Small History of Photography," in *One-Way Street and Other Writings* (London: Verso, 1979), pp. 240–57, 253.

33 Benjamin, p. 248.

34 Jonathan Crary's argument concerning the construction of the observer at this time in the medium of photography has much bearing on this statement, see J. Crary, *Techniques of the Observer: On Vision and Modernity in the Nineteenth Century* (Cambridge: MIT Press, 1990).

35 S. Kracauer, "Photography," trans. T.Y. Levin, *Critical Inquiry*, vol. 19 (Spring 1993), p. 423. "Die Photographie" appeared in the *Frankfurter Zeitung* on 28 October 1927. On the relationship between Kracauer, Benjamin, and the avant-garde, see B. Buchloch, "Gerhard Richter's *Atlas*: The Anomic Archive," *October*, no. 88 (Spring 1999), pp. 117–45.

36 Schwarz, pp. 3–5.

37 Benjamin, pp. 252–3. Note also p. 248: "Thus, especially in *Jugendstil*, a penumbral tone, interrupted by artificial highlights, came into vogue; notwithstanding this fashionable twilight, however, a pose was more and more clearly in evidence, whose rigidity betrayed the impotence of that generation in the face of technical progress."

38 For further suggestions along these lines concerning Benjamin's views of Baudelaire, see the recent review of *The Arcades Project* by T.J. Clark, "Reservations of the Marvellous," *London Review of Books*, vol. 22 (22 June 2000), pp. 3, 5–9.

39 On this painting, see the catalogue entry by F. Cachin in *Manet 1832–1883* (New York: Metropolitan Museum of Art and Harry N. Abrams, 1983), pp. 48–51.

40 W. Benjamin, *Charles Baudelaire: A Lyric Poet in the Era of High Capitalism*, trans. H. Zohn (London: Verso, 1976), pp. 162–3.

# INDEX

race, concept of 200
*race* (Taine's term) 219
racism 91
Radcliffe College, Mass. 79*n*
Rae, John 102
*Raft of the Medusa, The* (Géricault) 185
*Rape of Europa* (Titian) 239
Raphael 48, *49*, 54, 102, 149, 250, 263,
    264, 265, 266, 267, 268, 303
Ravaisson Mollien, Charles 188*n*
realism 277
Rebay, Hilla 60–1
*Rebekah quenching the thirst of Eliezer at*
    *the Well* (Poussin) 128
Reformation 43, 207
Regnault, Henri 6, 94, 165–77;
    *Automedon and the Horses of Achilles*
    167; *Execution without Judgment under*
    *the Kings of Morocco* 168, *169*, 172,
    174–6; *Salomé* 165, *166*, 167, 168,
    174
Regnault, Victor 165
religious art, "extinction" of 274–7
Rembrandt van Rijn 120, 146, 157, 237,
    241–2, 263–4, 268, 274–82, 303, 305;
    Bode catalogue 231
*Rembrandt: the Man in the Golden Helmet*
    (Velázquez) 116
Rembrandt Research Project 155
Renaissance 252–3, 265, 267, 309
Renan, Ernest 88, 220
Rennes-le-Château 118–19
Repin, Ilya 164
restoration 189*n*
*Revue blanche* 225
*Revue des cours littéraires* 91
*Revue des deux mondes* 87, 218, 220,
    267
*Revue germanique* 219
*Revue de l'instruction publique* 218, 220
Richardson, Henry Hobson 81*n*
Riedel, Johan Anton 152
Riegl, Alois 1, 226, 256
Rigaud, Hyacinthe 178
"Rigorous Study of Art" (Benjamin) 256
Rio de Janeiro 198, 207
Ris, Clément de 180, 186, 190*n*
Robbins, Warren 143
Robert, Hubert 57, *57*
Robert, Léopold 267
Robin, Charles 223
Robinson, John Charles 247, 253

Rockefeller Foundation 70
Rodchenko, Aleksandr 305
*Rokeby Venus, The* (Velázquez) 240–1
Roman art 122
Rome 50; French Academy 165; Villa
    Médicis 89
Roosevelt, Theodore 141
Rosebery, Lord 231
Rosenberg, Pierre 118
Roth, Michael 129
Rothschild, Alfred de 244*n*
Roujon, Henry 164–5, 167–70, 172
Rousseau, Madeleine 187*n*
Rousseau, Théodore 267
Royal Academy of Architecture (France)
    50–1, 56
Royal Photographic Society, Crystal Palace
    exhibition (1898) 311–12*n*
Rubens, Peter Paul 90, 155, 263, 273,
    275
Ruskin, John 24, 79*n*, 103, 125, 285
Russia 305
Ryder, Albert Pinkham 281

Sachs, Paul J. 69–74, 77–8
Sadler, Michael 134
Saenredam, Pieter Jansz. 152
*St. Augustine* (attr. Lippi) 23
St. Bartholomew's Day Massacre 208
St. Petersburg, State Hermitage Museum
    149
Saint-Cyr, military academy 92, 220, 221
Saint-Gaudens, Augustus 291–3, *292*
Saint-Hilaire, Geoffroy 219
Sainte-Beuve, Charles-Augustin 88, 223,
    225
Samuels, E. 236
Sancerre, siege of 207–8
Sassetta, Stefano di Giovanni 232, 235–6
*Saturday Review* 234, 237
Schapiro, Meyer 122
Schiendl, G. 297, *298*
Schildkrout, Enid 141
Schinkel, Karl Friedrich 58, *58*, 62–3
Schjeldahl, Peter 117
Schlegel, Dr. Arthur 83*n*
Schlosser, Julius von 108
scholarship, academic and museum
    146–62
"School of Athens, as it assimilates with
    the Mechanics' Institution, The"
    (Duterrau) 101